The Language of Twentieth-Century Art

A Conceptual History

Paul Crowther

Yale University Press
New Haven and London

Designed by Laura Church

Printed in Hong Kong

Library of Congress Cataloging-in-Publication Data

Crowther, Paul.
 The language of twentieth-century art: a conceptual history /
Paul Crowther.
 p. cm.
 Includes bibliographical references and index.
 ISBN 0-300-07241-4 (cl)
 1. Art, Modern—20th century. I. Title.
N6490.C76 1997
709'.04—dc21

 97-5248
 CIP

A catalogue record for this book is available from
The British Library

For Patrick Gardiner with gratitude

Contents

Preface ix

Introduction 1

Part I

1 Iterability, Pictorial Representation and Beyond 9

2 The Structure of Cubism 32

Part II

3 From Duration to Modernity:
 Bergson and Italian Futurism 51

4 Malevich, Philosophy and Non-Objectivity 71

5 Dialectic and Surrealism:
 From Breton to Pollock 87

6 The Dialectic of Abstract-Real in Mondrian 129

7 Barnett Newman and the Sublime 149

8 Aesthetic Ideas versus Conceptual Art 164

Part III

9 Simulation and Postmodern Representation 189

10 The Postmodern Iterable:
 Installation and Assemblage Art 203

11 Leaving the Twentieth Century:
 A Future for Art 215

Conclusion 228

Notes and Sources 235

Index of Visual Artworks 247

General Index 248

Preface

This is the third book in a series addressing the interrelations of art, philosophy, experience, and history.[1] I shall begin by outlining the fundamental argument that runs throughout the project.

It hinges on an answer to the question, why does art have a history? The conventional art-historian might reply as follows. Pictorial representation lends itself to an enormously diverse variety of functions which can change over time. It is this dimension of change which constitutes art's history. To interpret its structures, the historian must deploy strategies of technical and iconographical decoding and genealogical analysis. (The latter strategy is especially influential at the moment. It seeks to analyse the structure of pictorial artefacts in terms of their significance vis-à-vis gender, class, and power relations.)

This answer has only a partial validity, for whilst it addresses art's having a history, it does not address the actual basis of that historicity. What is it about pictorial representation that allows it to be used for so many different purposes by so many different human beings in so many different times and places?

One obvious answer is that pictorial representaion as a symbolic code is easily learnt and applied. But again one must ask, what makes that possible? And even if a satisfactory explanation can be offered, it must be broad enough to answer a further question, namely, what gives such representation its compelling character, its capacity to inspire the belief that it can fulfil the complex ritual, religious and persuasive functions which are so often assigned to it?

The significance of these questions is in their negation of the present. They burst open the current dogma that art is fundamentally a socially specific historical construct, determined by gender, race, and class. They point us to the fact that when iconography and genealogy have been given their due, the issue of the fundamental historicity of art remains. Too often this is obscured through a one-sided distinction between the historical and the 'ahistorical'. This is the main distinction which must be overcome.

The proper direction to travel in this respect is signposted in these remarks by Maurice Merleau-Ponty and Theodor Adorno (respectively):

'It is the expressive operation begun in the least perception, which amplifies into painting and art.'[2] 'It is as if [art] were re-enacting the process through which the subject comes painfully into being.'[3] On these terms, we must see artistic representation as exemplifying decisive aspects of the structure of self-consciousness itself. It is this theme which I have explored in previous volumes in the series, and will develop much further in the present work. Specifically, I will be concerned with the basis of meaning in certain twentieth-century works of visual art and, in particular, how the artists' use or anticipation of philosophical ideas enables them to generate objectively significant visual meanings – that is, ones that can be recognized through a work's phenomenal qualities and its relation to other works. These meanings are founded on reciprocal relations which are presupposed by any possible experience. However, the ways in which individual artists formulate and apply them is a function of their own historically specific circumstances and theoretical positions. My investigation will address this interaction of experiential constants with the historically specific. It will be a conceptual history.

The title of my book mentions twentieth-century art. However, sculpture is rarely discussed in the course of the text. I have nevertheless retained the more general title because my basic thesis can be applied with little modification to twentieth-century sculpture. Where pressing questions do arise is in the context of extreme conceptions of sculpture, such as certain forms of minimal art, or installation and assemblage works. These shall be addressed in the text, especially the last two.

A great debt of thanks is owed to Andrew Harrison for his probing critical comments on an earlier version of this book. I have also benefited from discussion over the years with Martin Kemp, Christina Lodder, Michael Podro, John Richardson, Carolyn Wilde, Andrew Benjamin, Patrick Gardiner and Peter Suchin. Much of the argument in the present volume has been shaped by work done as part of a project entitled 'The Contemporary Status of Art as a Form of Knowledge'. This was funded by the Slovenian Ministry of Science and Technology. The critical comments of my co-participants – Lars-Olof Aåhlberg and Aleš Erjavec – have been especially useful. Chapters 8, 9 and 10, indeed, are in part a sustained response to Erjavec.

Chapter 3 was originally published under the title 'Philosophy and Non-Objectivity' in the special Malevich issue of *Art and Design*, September, 1989, pp. 50–54; Chapter 7 was published as 'Barnett Newman and the Sublime', *Oxford Art Journal*, vol. 7, 1984, pp. 52–9; Chapter 10 was published as 'The Postmodern Sublime: Installation and Assemblage Art', in 'The Contemporary Sublime' issue of *Art and Design*, February, 1995,

pp. 9–17. All these essays have now been significantly revised and extended. Chapter 7 is a revised and extended version of a paper originally read to the Staff/Postgraduate Art History Seminar, 1983, in the University of St Andrews. I am indebted to participants in that seminar for their comments, particularly Martin Kemp, Mostyn Bramley-Moore and Louise Durning. Chapter 9 was originally presented at the 'Copying' colloquium held at the Museum of Modern Art, Ljubljana, in October 1991. I am indebted to participants for their comments.

Introduction

There are as many meanings to twentieth-century art as there are contexts of production, reception and dissemination. In this work, however, I shall argue that there is a specific dimension of meaning which is fundamental. This is not a fashionable view. One reason why it is not is due to the hegemony of the 'New Art History'. At the time of its emergence in the late 1970s and early 1980s this network of approaches was indeed provocative. However, it has now established itself as an orthodoxy into which young scholars are initiated without any attempt to negotiate the massive philosophical problems which it brings with it. Consider, for example, the following remarks from a book by Jonathan Crary concerning the conditions of nineteenth-century vision, which are confidently presented as more general truths.

> Whether perception or vision actually change is irrelevant for they have no autonomous history. What changes are the plural forces and rules composing the field in which perception occurs. And what determines vision at any possible moment, is not some deep structure, economic base, or world view, but rather the functioning of a collective assemblage of disparate parts on a single social surface. It may even be necessary to consider the observer as a distribution of events located in many different places. There never was or will be a self-present beholder to whom a world is transparently evident. Instead there are more or less powerful arrangements of forces out of which the capacities of an observer are possible.[1]

Some less dogmatic versions of this semiotic idealism (which I shall be criticizing in this book) can also be found in many contemporary approaches to the art-work itself. Norman Bryson, Griselda Pollock and (in twentieth-century studies) Victor Burgin and Rosalind Krauss are exemplars of the approach.[2] Their prime strategy is to emphasize the art object not as object, but rather as a configuration of signs sited within a more general field of signification. Meaning is seen as 'polyvalent' – an unstable function of many different factors usually involving race, gender, sexuality and class, as well as more specific historical and artistic considerations.

The immediate intellectual impetus for this comes from the work of the French thinkers Barthes, Lacan, Foucault and Derrida. The approach is also bound up (especially in Burgin and Krauss) with a broader need to ratify certain forms of conceptual art practice. One effect of this has been the elevation of Marcel Duchamp to the status of a quasi-divine prime mover. He is taken as paradigmatic of the fact that what is fundamental to art is its relation to ideas of one sort or another. On these terms, whatever is meant by 'meaning' in art is determined exclusively by its relation to specific contexts of production and reception, and the networks of 'discursive practices' involved therein. This means that the relation between the art-work and ideas is primarily construed as an external one, that is to say, an item has meaning conferred upon it, by virtue of its relation to specific contexts of origination and use.

Interestingly, some similar strategies can also be found in philosophical aesthetics of the analytic kind. In the so-called 'Institutional' theories of art propounded by Arthur Danto, George Dickie and others, what counts as art is anything which is designated thus by a member of the art-world on the basis of a theory about art.[3] Again, what is decisive here is not the nature of the object but the meanings which arise through its relation to specific contexts of generation and use. Duchamp's Ready-mades and (for Danto at least) Warhol's *Brillo Boxes* are taken as paradigms of a relation between objects and ideas that defines the very possibility of art.

The result is a colonization of twentieth-century art by those whose purpose is to analyse it in theoretical and historical terms. Art historians, curators and theorists are now in effect managers of meaning. It might seem that this colonization guarantees certain rights of art to the degree that it emphasizes original contexts of production and the artists' own theories. However, the subjection of twentieth-century art to the external relation model of meaning actually misrepresents its greatest achievement. For in making meaning dependent on context, the model offers no criteria whereby an art practice can be understood as having an enduring, 'trans-historical, transcultural'[4] significance. One might talk about creativity in an artist's relation to some immediate empirical context, but the creativity which really counts is surely much more than this. It is generated funda-mentally from the internal resources of the art-work as a symbolic phe-nomenal structure. 'Internal' here means not only the work's sensible presence, but also its relation to other works and to basic aspects of human cognitive experience. This dimension of aesthetic historicity is precisely that which the new approaches distort, deny or simply fail to comprehend. Indeed, these suppressions of the aesthetic bear as their corollary a devalua-tion of the visual itself. The visual aspect of a work is seen purely as a carrier

of signified meanings, or as appealing to such Eurocentric abstractions as the 'gendered' gaze. On these terms, meaning visualized means no more than vision as a 'site' for an interplay of signs determined solely by the historically specific.

These reductive effects might be seen as positive after the limitations of formalism. It is a characteristic of formalist doctrine to invest certain modes of visual form with something analogous to that enduring aesthetic significance mentioned above. However, whilst writers such as Greenberg and Fried are at times brilliant in their descriptions and evaluations of art, their philosophical groundings are flimsy.[5] Greenberg, for example, argues that the best Modernist painting declares that which is essential to any painting, namely planar flatness. Through this affirmation of purity, such painting prevents art from being assimilated by non-artistic functions. But why should art's purity matter to artists, let alone their audience? Or, to put this more generally, why should form *per se* be humanly significant? If it has positive 'felt' effects, how are these possible, and what is the link with our existence as historical beings? These questions are unanswered. We are left, at best, with a few arcane murmurings about 'instantaneousness' or 'intuition'.

It is, however, possible to negotiate between the extremes of semiotic idealism and formalism. In the most general terms, for example, Ellen Dissanayake's elegant evolutionary aesthetics returns to the basic function of decorative and representational activity in the genesis of consciousness and community.[6] Yve-Alain Bois and Thierry de Duve have offered approaches to some aspects of twentieth-century art which attempt to negotiate between the New Art History and the art-work's claims to 'specificity'.[7] However, none of these writers systematically addresses the deeper philosophical issues involved. I have begun to undertake such a task in the two preceding volumes in this series, *Critical Aesthetics and Postmodernism* and *Art and Embodiment: From Aesthetics to Self-Consciousness*.[8] The central thesis of these works is that what is fundamental in our cognitive relation to the world is our inherence in it as embodied beings. How the world is structured and how we negotiate it through the unified operation of all the senses are reciprocally correlated. It is not possible to define the form and functions of one without reference to the other. Human experience is grounded in reciprocal relations, and it is art which expresses this in the fullest terms.

To emphasize the 'principle of reciprocity' (as I shall call it) overcomes the glibness of the materialism versus idealism dichotomy. For the principle holds that the world is mind-independent insofar as it consists of a spatio-temporal domain of causally related finite items; but it also holds that this

domain is organized on the basis of the body's sensory and motor functions operating reciprocally as a unified field. Language and other symbol systems are the most complete expressions of this organizational function.

Elements consistent with various aspects of this view can be found in Kant, Hegel, Nietzsche, Bergson, Adorno, and Gadamer, amongst others. However, the definitive affirmations of the philosophical significance of reciprocity are found in Merleau-Ponty and (though it has scarcely been recognized) in Ernst Cassirer. In this work I shall draw on many aspects of this tradition, particularly on Merleau-Ponty and Cassirer.[9] My intention will be to show that the principle of reciprocity is of decisive importance for understanding the major achievements of twentieth-century art. My strategy, derived from the reciprocity tradition, holds that whilst all cognition involves historically specific acts of interpretation, these acts are both made possible and influenced by more universal factors bound up with the reciprocity of body and world. In other words, the fact that people create and classify things in the way they do is a function of specific historical circumstances, but the fact that they can create and classify at all logically presupposes a transhistorical set of competences, whose existence and co-ordination are functions of being an embodied subject.

I shall use this strategy in conjunction with one of Derrida's more acceptable arguments. This will enable me to refute the claim that meaning in twentieth-century art is sufficiently explicable in terms of variations on the external relation model. Derrida's argument concerns the importance of iterability. This is the capacity of a sign, or syntactically linked group of signs, to have a basic sense or intelligibility which can be recognized independently of any specific context of application. For Derrida, iterability is a necessary condition of any systematic signifying activity whatsoever.

In Chapter 1 I shall develop this notion much further, linking it both to the principle of reciprocity and to the basic structure of pictorial representation. I shall suggest that the reciprocity factor which makes iterability possible is latently present in all pictures, but it figures in more overt terms only when picturing becomes aesthetically significant, that is, becomes art. I shall then indicate how, in those twentieth-century movements which are non-objective, or which involve radical modifications of conventional representation, the principle of reciprocity must figure overtly in our descriptions of their visual structures. The conditions of visual iterability become the basis of an iterable code itself. The more specific iconographic intentions which inform the works in question are secondary to this. They are specific uses of the principle of reciprocity.

If I am correct, this approach means that a kind of distinctive language

pertains to much apparently disparate twentieth-century art. More specifi-
cally, it suggests that there is a fundamental level of meaning in such works
which is not empirically context-dependent, but is a function of the
relation between both individual works and the principle of reciprocity.
Meaning in this sense is embodied. The particular work visually exempli-
fies a structure which is a direct expression of the fundamental reciprocity
of body and world. And, in so far as further relational factors are involved,
these are (as I have just noted) constituted by the work's historical relation
to other works, rather than immediate empirical contexts of generation and
reception.

This being said, reciprocity is always historically mediated. Different
artists use different aspects of the principle of reciprocity for different
purposes and arrive at it from different directions. Hence, whilst in this
book I shall be concerned primarily with the iterable status of twentieth-
century works, the burden of analysis will fall on the particular ways in
which iterable meaning emerges from aspects of the artist's more specific
theoretical preoccupations, most notably their relation to philosophical
ideas. This approach has a useful ramification. The depth and subtlety of
twentieth-century art's engagement with philosophy is not, I think, often
appreciated.[10] Philosophical ideas are commonly interpreted as just one
element amongst others in the causal nexus governing the production and
reception of specific works or bodies of work. However, the artists often
develop these ideas in striking ways. Indeed, this sometimes involves
strategies which actually rectify problems in the philosophical sources. In
tracing the iterable outcome of this engagement, therefore, both source
ideas and the artist's theoretical negotiation with them will be expounded
in detail.

Now a caveat. It should be noted that this book does not pretend to
be an exhaustive analysis of the interrelation between philosophy and
twentieth-century art. I have focused on those tendencies which radically
transform or abandon the conventional structure of pictorial representa-
tion. It is these tendencies which form the basis of what is logically
distinctive about twentieth-century work: other artists – such as Cézanne,
Matisse, and the German Expressionists – are, of course, of massive art
historical significance, but their importance is derived, fundamentally, from
taking conventional pictorial representation to stylistic extremes. (I shall
touch on this matter again in Chapter 1.)

Finally, it is worth pointing out the pivotal role played by Chapter 8 in
this book. There I shall summarize and develop my most important
arguments and make a critical transition to more recent art.

Part I

Iterability, Pictorial Representation and Beyond

To understand the key achievements of twentieth-century art it is first necessary to understand some of the philosophical ramifications of pictorial representation. This is both an exciting and difficult task – exciting because such representation embodies relations which are fundamental to self-consciousness, and difficult because of the broad philosophical framework which is required in order to explain such relations.

The first part of the chapter will address the conditions of meaningfulness in any discourse. Particular emphasis will be given to the notion of iterability and its role in self-consciousness. This will involve both a tracing of its origins in the body's most basic relation to the world, and its role in organizing the human imagination. Under the next heading I shall consider all these issues in relation to the phenomenon of pictorial representation. Then, under 'The Picture as Aesthetic Object' I shall argue that it is only when the picture is appreciated as an aesthetic object that the factors which link it to self-consciousness begin to figure overtly in our engagement with it.

I shall go on, under the next heading, to outline the main argument which informs this text. It holds that those basic links to self-consciousness which emerge in the aesthetic appreciation of pictures are most manifest in radical twentieth-century tendencies. They figure in the immediate description of such works as well as in the aesthetic appreciation of them. To show this in a provisional and scene-setting way I shall finally consider the specific case of Kandinsky's work after 1910.

Iterability, Imagination and Self-consciousness

Nothing has meaning in itself. An item is meaningful only in relation to a context. Such contexts are usually provided by other signs, concepts or items and relations. In recent times, this simple logical point has proved crucial for that body of theory known as post-structuralism. Post-structuralism has many varieties and inflections, but there is one major claim (following from the point about meaning) which is common to all

post-structuralists. It is that, in the most general terms, the meaning of a sign is not simply a case of direct correspondence between the sign and that which it signifies. Rather the relation between these two elements is unstable and determined by their shifting position within a more general field of other signs and relations. The field itself, however, is not a closed totality. It is open and subject to constant reconfiguration.

The upshot of this view is a thoroughgoing scepticism about the fixity of meaning, categories and, indeed, the stability of the self.[1] Any attempt to define in fixed and specific terms is taken to be a case of 'closure' – an attempt to elevate some conception tied up with specific class, racial, or gender-based interests, into pseudo-objective truth. The task of intellectual inquiry then becomes a fundamentally genealogical project, that of showing how in historical terms, some transient symbolic formation is passed off as an enduring truth in order to consolidate the interests of specific socially dominant groups.

Now the ideas of a 'field' of meaning and the ubiquity of signifying functions are important notions, but they are not the whole truth. For we must ask the key question: how are signifying relations themselves possible? To answer this, we can use a term from Derrida (in a way that is actually partially destructive of post-structuralism, although I will not develop this point here). The term is 'iterability'. In respect of this Derrida remarks that

> The possibility of repeating, and therefore of identifying, marks is implied in every code, making of it a communicable, transmittable, decipherable grid that is iterable for a third party, and thus for any possible user in general.[2] . . . unity of the signifying form is constituted only by its iterability, by the possibility of its being repeated in the absence not only of its referent, which goes without saying, but of a determined signified or current intention of signification.[3]

For an English speaker, 'iterability' is an awkward term. However, it is worth using if only for the fact that through it Derrida is directing us towards an idea of enormous importance. Indeed – despite Derrida's characteristically complex way of presenting it – it is also quite a straight-forward idea. Put simply, the iterability of a sign or group of signs is their capacity to be recognized and repeated across many different contexts of use. Iterability is that stable dimension of meaning – bound up with the material identity of signs, and the definite rules concerning their interrela-tions and use – which is independent of any one specific context of employment. For example, the phrase 'the cat sat on the mat' can be uttered with different intentions on different occasions, and does not require the actual presence of a cat on a mat in order to be meaningful.

Consider also the sentence 'Tomorrow will be a gloomy day'. If we understand the English language we can recognize what kind of probability is being indicated here, irrespective of both who is using the sentence and the intentions behind any such usage. In respect of the latter, for example, one might be reporting an actual possibility, or one might be speaking metaphorically, or – as in my use of the sentence – one might be deploying it as an example in relation to some broader communicative purpose. However, even if we do not know which of these (or other) actual usages is intended, the sentence retains a basic sense which we all understand simply by virtue of knowing the language of which it is a part.

Language (and sign-systems generally), then, have an iterable character, when their terms and grammatically correct constructions are intelligible without either the immediate presence of the things to which they refer, or knowledge of the intentions or contexts which inform their specific uses. The importance of this iterable dimension is that it is a necessary condition of any systematic signifying activity whatsoever. If signs were not iterable in this way they would have no third-person force. They would not be shareable. Meaning would be locked into a putative wholly private space of personal intentions. This would not only rule out the possibility of systematic communication between humans, it would also (for reasons which I shall indicate shortly) exclude the possibility of self-consciousness itself.

Given the importance of iterability, we must now ask how it is possible; what does it presuppose? Without the existence of specific material signs there would be no field of rules and relations wherein they could be connected with other signs so as to be used for referential purposes; but, reciprocally, without this field of rules and relations there would be no framework wherein signs could be given a specific identity. Iterability presupposes a relation between sign and field of signification which is one of reciprocal dependence. And that dependence is one manifestation of a broader functional unity which stabilizes the whole sphere of human existence. Consciousness can only identify some item by subsuming it under a more general form – such as a group, a class, a kind, a whole, or a series, or whatever; but, reciprocally, it can only operate with such general forms in so far as it can comprehend them as functions of their individual instances. And this is not a passive correlation. Each encounter with a new instance of a general form modifies our sense of that form and through this enrichment our subsequent comprehension of its individual instances is, in turn, modified.[4]

This cognitive competence, the 'principle of reciprocity', both grows from and refines something much more basic – the direct correlation of the

human body with its surrounding world. For if we can see particular items as representative of more general forms (and vice versa) it is because this has evolved as a learned competence whereby the infant gradually co-ordinates its sensory and motor capacities as a unified field. Through this interaction, the enveloping physical domain is organized into a stable world of relations and things, defined both by their amenability and specific modes of access to bodily inspection and manipulation. This, in turn, modifies the infant's own sense of the scope of its bodily activity. The unity of the body and of the world are thus correlated and exist in a constant and mutually modifying interchange. It is only on the basis of this fundamental reciprocity that particular exercises of the child's vocal and other physical gestures can be co-ordinated to engage with general signifying systems such as language. Through initiation into such iterable frameworks self-consciousness itself becomes possible. For the self-ascription of experiences logically presupposes that the subject can refer to things which are not immediately present. This requires the use of a stable system of signs for ordering space and time. Only through them can a creature posit itself as having inhabited, or being able to inhabit, places and times other than those which it presently inhabits. Since, indeed, this connecting function of iterable signs is something into which the child is initiated, this also involves immersion in a shared social context. In learning its own self through iterable signs the child simultaneously learns the nature of other people. It is thus able to define its own individual being in terms of similarities to, and differences from, other humans.[5]

In this continuous transition from the unity of the body to the acquisition of language and the achievement of self-consciousness, there is a crucial link. Following Kant, I shall call it the 'productive imagination'. By this I mean the capacity to generate images (quasi-sensory mental constructs). The function and scope of this capacity is one of the most essential features of self-consciousness. Its importance in this respect is, however, rarely acknowledged; for its organization by, and refinement of, the principle of reciprocity involve issues of great complexity.[6]

One important example of this is the working of memory. When recalling events or series of events from one's past, it is easy to consider this as a replay, a mere retrieval and repetition of faded perceptual impressions. However, the decisive factor here is the signifying core of such activity. To recall an event from ten years age involves an exercise of productive imagination guided by a linguistic (that is to say iterable) description of fact. We posit the fact, say, that in February 1985 we went to a dinner at a certain person's house. And if we are seeking to remember the event as opposed to simply recalling the fact, this involves augmenting the factual

description of an event in our life by the generation of sequences of imagery which are consistent with it. Memories, in other words, do not come ready-made; they are created through the reciprocity between our knowledge of facts about the past, and our capacity to realize these through the exercise of productive imagination. They exist as memories only when they are re-created in the present; and in each new present of re-creation their character as particular memories is given new meaning and inflection by their shifting position in relation to the ever changing whole of the subject's experience. Indeed, through being explicitly remembered, a particular memory actively influences the developing whole. Again we find a thoroughgoing reciprocal interaction between a particular element and the more general form.

Similar considerations also hold true of the relation between present and future. To imagine the future or a counterfactual alternative to the present requires that some factual description of the relevant state of affairs is satisfied by producing sequences of imagery which are consistent with it. Suppose, for example, that one imagines what one will be doing at 5 p.m. on 14 February 2008. To imagine this now may involve a specific sequence of imagery, but to imagine it again in five years' time – even if one posits a similar situation to the one imagined now – will involve an image sequence with a very different style and accentuation. The reason for this is that the exercise of imagination is always guided by present interests. Indeed, even if it is seeking to (as it were) 'flesh out' a quite specific fact about the past or a possible future, the mode of that fleshing out – the character of the answering image which we produce – will be differently inflected as the whole of our experience accumulates through the passage of time.

Now an objection might be raised here. It is surely possible that in remembering a specific fact about the past or imagining one about the future, one brings to mind the same image-sequence, irrespective of the point in one's life at which one does this. However, this objection would hold only if memory and imagination were reproductive in a mechanical sense, if one's past and one's projection of alternative possibilities to the present had exact, constant and perfectly retrievable contents. They do not. Particular moments of experience do not come with exactly delimiting frames. They form a continuum such that, in recalling an experience – even from only a few moments ago – an element of indeterminacy and partial arbitrariness has already entered. This element is consolidated as further moments pass. Interpretation rather than reproduction is demanded. If, indeed, this were not the case, there would be no sense of the present. For all the moments of one's personal history would crowd up

in an indistinguishable blur. In such a situation no self-consciousness would be possible.

I am arguing, then, that the principle of reciprocity has its origins in the body's basic correlation with the world. The acquisition of language and other iterable codes both extends and refines this principle, and, by facilitating a structured sense of present, past, and future (via the productive imagination), allows the emergence of self-consciousness itself. The principle of reciprocity, of course, is also the basis of interchange between the objective and subjective dimensions of experience. For if one were not physically embodied as an object in active relation to an immediate perceptual field, there would be no sense of a present to both define and be defined against a recollected past and a projected future; but, reciprocally, without a sense of this subjective experience, the body would not be able to negotiate the immediate perceptual field in a coherent way. We can think of ourselves as physical or mental entities, or both, precisely because the principle of reciprocity is the common structural basis of each factor and their interrelation. It is the key to self-consciousness; it gives the self a functional unity.

Given this analysis, one might say that the principle of reciprocity is the organizational basis of an 'existential subconscious'. This subconscious derives from the fact that there can be no present moment of perception or self-awareness except in so far as that moment can be defined in relation to an accumulating whole of other such moments. Each present state draws on and modifies a vast network of background beliefs, values, and expectations, pertaining not only to an individual's past and future, but also, indeed, to counterfactual possibilities – paths which might have led to the present, but which did not in fact do so. In the normal course of things, we are not aware of this complex of interactions, but the point is that we can become aware of it. We can understand something of the reciprocal dependence which holds between the present and the broader forces which define it, and which it helps to modify. We explicitly interpret that which, in existential terms, is normally subconscious.

This domain of the existential subconscious is by no means a purely introspective phenomenon. It has equal applicability to the spatial realm. Consider, for example, the relation between whole and part in perceptual manifolds. The whole is a function of its individual parts; but these parts are invested with their specific individuality only by virtue of their relation to the whole. Again, consider the relation of figure and ground. An item can be recognized in perception by discriminating it in relation to a specific ground but, reciprocally, the ground can be characterized as ground only by orientating it in relation to an intended object (in spatial terms, a

'figure'). The point is, however, that we are customarily preoccupied only by the spatial wholes or figures which are immediately given in perception. We do not usually attend to the part relations or ground relations which define them, let alone the reciprocal dependence of all these elements.

Let me now summarize this complex section. First, I argued that iterability – the capacity to recognize and deploy the same kinds of sign across many different contexts – is essential to any systematic signifying activity; and that it embodies that principle of reciprocity which derives ultimately from the body's correlation with the world. I further argued that this principle also organizes the 'inner' life of self-consciousness, since iterable signifying activity directs the productive imagination, thus giving substance and unity to memory and our projection of futural and counter-factual alternatives to the present. The principle of reciprocity is the organizational basis of an existential subconscious. This is composed of the productive imagination and those generally unnoticed 'background' relations – both introspective and perceptual – which both define and are reciprocally dependent upon the present moment of consciousness.

I shall now consider the significance of pictorial representation in relation to all of these points.

Pictorial Representation and Imagination

A picture is an image generated from the productive imagination. Again this involves directedness: one 'intends to' picture such and such. But there is an immediate ambiguity. All pictures have their specific uses. An image can be generated so as to denote this particular man, this particular building, this particular historical event. However, in strictly logical terms, before a picture denotes any particular item, person, or state of affairs, it is a picture of a kind of thing. Titian's various pictures may denote Charles V, but more fundamentally they are pictures of a man; or to put this another way, if one wishes to depict a specific thing, the picture will also necessarily be 'of' the kind of thing in question. This latter level of reference – to kinds of subject matter rather than their individual instances – is decisive. For it is the basis of iterability in pictorial representation as a signifying code.

The minimum condition for something to be a picture is that it is a constructed configuration of marks within a virtual plane which is recognizably 'of' a specific kind of visual item in three-dimensional space. In common sense terms, this means that the configuration must resemble the kind of thing in question.[7] However, this has to be put in philosophically

more sophisticated terms, to avoid the well-known problems of how a picture can resemble a fictional entity. The reason why these problems arise is because pictorial resemblance is often construed on the model of 'correspondence' with a given visual reality. This is the wrong model. The more accurate one is scaled consistency with a possible kind of visual reality. On these terms, if something is a picture, it must be recognized as an artefact that presents qualities of shape or texture which recognizably individuate (in proportion) the visual appearance of specific kind or kinds of visual entity in three-dimensional space.

Once one has learnt this semantic convention of picturing – to make visual configurations that are consistent with the individuation of kinds of visual item – one has the basis of an iterable code. Language is iterable in so far as its terms and grammatical constructions have a basic sense. This sense is recognizable independently of both the immediate presence of the thing(s) referred to and of any knowledge concerning the intentions or contexts which inform any particular use of such terms or constructions. These features are paralleled by pictorial representation. In order to recognize in the most general terms what kind of item or state of affairs is being depicted we do not need to have a specific example of this kind immediately before us. Neither, indeed, do we need to have knowledge of what the creator's intentions are, or the context of reception for which the picture is created. A picture of a cat sitting on a mat, for example, can be just that. If this general image is made more specific in style and detail, it can secure correspondingly more specific denotation. We recognize it, for example, as a Persian cat on an oriental carpet. With further knowledge concerning the cultural conditions in which the picture was originally created and received, we might take it to be an image intended as an allegory of indolence, for example. Knowledge of these conditions is presupposed if we want to know what the picture is specifically attempting to communicate. It is not presupposed, however, in order to recognize it simply as a picture of a cat sitting on a mat. This capacity to recognize what general kind of thing or things is being depicted is the iterable core of pictorial representation.

One might say, then, that picturing relates to iterability in both a causal and a logical sense. Causally, its creation entails the satisfaction of a linguistic description – 'I intend to do a picture of (an) x'; and, logically, the pictorial format itself involves a codified iterable structure. The relation between these two factors is of extreme interest, in that it externalizes that reciprocity between descriptions of fact and the productive imagination which we saw to be central to the working of memory and to our sense of present and future. Indeed, given the 1996 discovery in southern France

of relatively sophisticated pictures some 30,000 years old, it may be that the development of language and self-consciousness are themselves linked in some correlative way to the capacity to make and read pictures. Here, meanwhile, let us focus on the significance of picturing as an externalization of the productive imagination.

In our mental life, the working of the productive imagination is rational to the degree that it is intentionally directed by descriptions. The means whereby the image is produced remains (as Kant aptly puts it) 'an art concealed in the depths of the human soul'.[8] With picturing, in contrast, the general means whereby the image is generated are – through the use of an iterable code and its techniques – rule-governed, constructive, and eminently accessible to understanding. At the same time, however, the picture exemplifies another reciprocal structure in self-consciousness. For to solicit and achieve recognition from, and to confer such recognition upon others is a necessary condition of any self-awareness. There can be no sense of an individual self without this context of interchange. The picture is especially fecund in relation to this. Through being made, the elements of style, expression, and personal emphasis involved in the productive imagination are here brought to a higher level. It is not (as in our 'inner life') simply a given capacity whose exercise shifts and changes as one accumulates experience. Rather, it is one which, through active inter-change with both the code and its techniques and the study of specific examples, can be improved and better defined and made accessible to others.

All these points indicate the profundity of picturing. Many have sup-posed that its intrinsic fascination is bound up with the phenomenon of mirror-images or powers of mimicry. I suggest, however, that its real fascination consists in that, as iterable code, it enables us to refine and deploy a general capacity – productive imagination – which is decisive for self-consciousness, and yet does so in form which can privilege the indi-vidual dimension. Those reciprocal relations which have their origins in the body's objective and subjective being are re-articulated in the product of a bodily act of rule-governed making. They are embodied. The signifi-cance of this is that, whilst one does not choose to become self-conscious, in the making of artistic pictures one can freely direct and extend structures which define self-consciousness. The finite creature thereby overcomes some of the conditions of its finitude.

★ ★ ★

The Picture as Aesthetic Object

Pictures have practical functions in all the cultures which create them, but even when they are created in order to fascinate for their own sake, they do not always succeed in doing so. Under what circumstances, therefore, does the intrinsic significance of picturing – its links with the existential subconscious – emerge? The most common-sense answer to this is when they function as aesthetic objects. But again this needs to be put in a more sophisticated form. To respond aesthetically to an object is to be fascinated by the order and structure of the way it appears to the senses. (The exact criteria of order and structure in this respect are controversial, but that need not detain us here.) As a sensory object, any picture can, in principle, occasion aesthetic responses. But again we must ask, under what circumstances? The notion of aesthetic formalism is enormously instructive here, albeit in a negative sense. As noted in the Introduction, the formalist approach has been influential amongst philosophers and art critics and historians. It founders upon the fact that whilst the formal qualities of artworks may have significance, this is of little interest unless we can account for why they are significant.

The reason why formalists do not engage with this question is bound up with the fact that the core of the aesthetic experience is directed towards sensible qualities. To analyse these would seem to cut against the grain of formalism. However, there is a basic confusion here. For example, in a paper of 1967 Clement Greenberg claimed that the aesthetic judgement is 'immediate, intuitive, undeliberative, and involuntary'.[9] This characterization would also square well with the approaches of Bell, Fry, and perhaps even Beardsley and Osborne. What makes it confused is the rigid separation of 'intuitive' from more rational factors. In our everyday cognitive dealings with the world, judgements are intuitive and immediate to the degree that we are not explicitly aware of the fact that we are making them. However, this does not at all imply that such judgements have no describable and corrigible content. If, indeed, this content were not present, they would be little more than blind spots or interruptions of the perceptual process. Similar considerations apply in relation to aesthetic judgement. For whilst these may in some sense 'transport' us or involve some felt 'loss' of self, these are not, as it were, cognitive breakdowns. If they release us from the mundane through special and positive psychological effects, we must, in principle, be able to analyse the structure of judgement which makes this possible. This is the task which aesthetic formalism has scarcely addressed since Kant. In one sense that is not surprising. For if our cognitive activity involves the unified operation of all the senses (organized by the principle

of reciprocity), then judgement of any kind is much more than a 'mental' function. To reconstruct it is a task of enormous complexity. It involves attentiveness to issues of perception, experience, and time. In what follows, I shall identify reciprocal relations which are always involved in our aesthetic attentiveness to pictures, even if, hitherto, they have not been properly emphasized.

Let us begin indirectly with the case of aesthetic responses to nature. In enjoying the formal structure of a natural configuration, one is never simply doing that. How one enjoys such a form is mediated, in part, by our previous experience of such forms; and the advent of the present experience will in turn mediate our future experience of such forms. The more familiar a form is, broadly speaking, the less emphatic our response will be. An element of novelty, in contrast, will accentuate our enjoyment and set up a new framework of expectation. Aesthetic responses, in other words, function in a temporal horizon of expectation based on the reciprocity between our present experience of the form and our past aesthetic experiences.

The fact that this horizon is so easily overlooked in relation to natural form is due to two factors. First the almost unlimited variety and widely contrasting ranges of such form; and second, the fact that the temporal dimension here functions purely as a condition – a mediating factor – rather than as the specifically human form of time, namely history. Matters are, of course, very different in the case of picturing. As an iterable code, whose specific employments are so pervasive throughout the history of so many cultures, it is an object of the greatest historical interest. This historicity, however, is of great complexity. One could put it by way of a contrast. History is a succession of interweaving continuities and discontinuities in terms of actions, events, and institutions. Individual agents form some general sense of this and it informs their present orientation, just as reciprocally their present position modifies the way they see history.

Related to this is the fact that, however singular a historical situation may seem, its singularity is intelligible only in its reciprocal relation with patterns of sameness and difference. It functions either as an extreme instance of a familiar kind of situation – one which alters our conception of the kind in question, or as a situation which, in its contrast with others, inaugurates a new term within our general classificatory framework. These patterns of reciprocity – the very basis of our historical being – are not easy to keep track of through the passage of time and upheavals of existence. At first sight, a similar situation may seem to hold in relation to pictorial representation considered historically. However, no matter how complex

the causal nexus – the framework of specific empirical circumstances which govern a work's production – the picture necessarily transcends those circumstances. For it is an inscription within an iterable code, and must be intelligible at that level, without recourse to external circumstances.

This leads us to the decisive point. When dealing with pictorial representation those patterns of reciprocity inherent in any historical situation are much more manifest. Let us consider an example. Suppose we compare and contrast George Lambert's *Moorland Landscape with a Rainstorm* (1751; pl. 1) and Jacob van Ruisdael's' *Landscape with a Waterfall* (c. 1655; pl. 2). Without any knowledge of who the specific artists actually are, we can already make some important points. In comparison with the Ruisdael, Lambert's rendering of the landscape is somewhat prosaic, and *vis-à-vis* the treatment of trees and vegetation extremely generalized. The prospect depicted by Ruisdael is more closely observed, and also much more visually complex in its organization of space in relation to the viewer. (The viewer's position, indeed, seems to be from within the course of the river, rather than the safety of the bank.) The point is that when we engage with the picture as iterable, similar kinds of 'statement' – such as landscapes – are played against a general diachronic knowledge of the pictorial code rather than relating the image to its original context of production and reception. Once we have experience of pictorial statements, we simply consume some in the act of recognition. (Anyone other than a specialist, for example, is unlikely to give the Lambert a second glance.) Others (such as the Ruisdael), however, engage us by the striking way in which they achieve their iterable structure. This involves more sustained attention form the viewer and a correspondingly more complex descriptive framework in terms of which the striking qualities are articulated. Central to this descriptive framework are such reciprocal relations as part/whole, figure/ground, actuality/possibility and real/ideal.

I am arguing, then, that the iterable dimension gives a context of sameness wherein individual styles and mere repetitions can be clearly comprehended in relation to both their predecessors and successors. We value those who innovate or refine in relation to the code; they rejuvenate and change our sense of visual life. In such a context, the temporal dimension is not just a mediating element (as in the case of natural forms) but neither is it the swampland of mere empirical history. Each work stakes a claim to attention on the basis of the reciprocity between its appearance and that diachronic history of the code and medium which precedes its creation, and the subsequent history which its appearance helps create. The original work, in other words, reflects the more fundamental – let us call

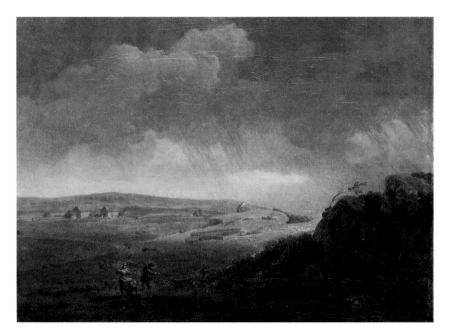

1 (*above*) George Lambert, *Moorland Landscape with a Rainstorm*, 1751. Tate Gallery, London

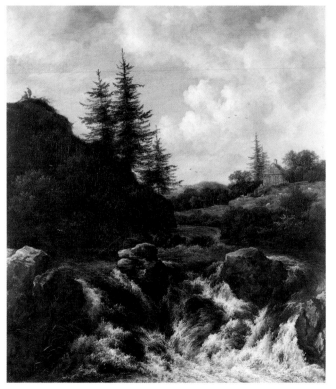

2 Jacob van Ruisdael, *Landscape with a Waterfall*, c. 1655. Ashmolean Museum, Oxford

it transcendental[10] – historical reciprocity of sameness and difference that sustains all empirical historical awareness.

If a work is viewed in these terms, we do not appreciate it simply as a formally harmonious configuration. The formal aspect becomes significant, rather, in its function within an individual style. We consider how it helps define the specific character of the image, how it helps embody all aspects of an individual exercise of productive imagination in relation to other such products. And this leads us to the picture's distinctiveness as an aesthetic object. One definitive characteristic of aesthetic responses is their disinterestedness.[11] This is a logical factor. In order to enjoy formal harmony in the way an item appears to the senses, it is not presupposed that one knows what kind of thing it is, or even whether it is real or not. One might view the aesthetic object as a purely formal configuration, but this would do no justice to it as a product of artifice and the productive imagination. We need, therefore, some notion of aesthetic disinterestedness that is distinctively artistic. And this is found, once again, at the level of the iterable. In recognizing a picture as an instance of the code 'pictorial representation', we can determine both what kind of item or set of items is being represented and, through our knowledge of other instances of the code, what is distinctive about the work's structure of appearance.

These factors can be determined in a basic way without recourse to the context of the work's immediate production and reception, or any knowledge of 'intentions', 'function' or other synchronic historical factors. To understand the work as a specifically historical artefact does, of course, require such knowledge. But to engage with it in terms of its artistic-aesthetic structure does not. Indeed, this is precisely its virtue. For, as a particular work viewed in relation to an iterable code, it presents an individual possibility of seeing yet one that is not tied to any empirical knowledge about the particular artist and context of production. We may have such knowledge and it may affect our enjoyment, but we do not need it in order to respond aesthetically. It is in this sense that our response is at least relatively disinterested. We focus on individuality of vision as defined in relation to the iterable visual code of productive imagination, and can thereby enjoy an aesthetic mode of empathy. This involves identifying with individuality in a transcendental rather than an empirical sense. The style of the particular work functions as a schema of possible seeing which we can adapt ourselves to, which we can relate to our own lives.

Let me now gather the salient points of the discussion so far. Having linked the necessary iterability of symbolic codes to the principle of reciprocity, the productive imagination, and the unity of self-consciousness, we then considered pictorial representation in relation to

these. Specifically, it was argued that such representation itself makes the visual aspect of the productive imagination an iterable code. The picture fascinates because it exemplifies different aspects of the existential subconscious – a set of relations and competences organized by the principle of reciprocity. Its fascination emerges only when the picture is considered aesthetically. Such consideration is activated when the work is viewed not in relation to the empirical circumstances of its production, but in its reciprocal relation with the diachronic history of the iterable code. This, in turn, makes possible a relatively disinterested mode of aesthetic empathy that is unique to art. The principle of reciprocity is pervasive throughout. It has its origins in human embodiment, and, through expression in iterable symbolic codes and the productive imagination, it transforms the schema of the body into a functional unity of self-consciousness. In the pictorial artwork, all the elements in this continuity are made accessible at the level of direct perceptual and imaginative comprehension.

Twentieth-century Art and the Principle of Reciprocity

Modernist art is usually seen as beginning with figures such as Courbet, Manet, and the Impressionist circle. The reasons why it arose, and the finding of an apt characterization of Modernism itself, are complex issues, but it is generally accepted that many Modernist pictures display common stylistic traits. In contrast with academic art's ideal form and relations, there is a diminution of perspectival accents, a relative lack of 'finish' and (from around 1880 onwards) a treatment of form and colour which is emphatically non-naturalistic. Now, even if we trace these traits into such twentieth-century movements as Fauvism and German Expressionism they remain broadly within the framework of conventional pictorial representation. That is to say, constructed configurations in a plane that are consistent with specific kinds of visual item or relation in three-dimensional space. It may be that Modernist tendencies thrust questions of aesthetic form more to the fore, but their embodiment of key reciprocal relations is still indirect. Such relations remain an aspect of what it means to be an artistic representation, rather than becoming part of the overt content of the representation.

The dominant radical works of twentieth-century Modernism change this. We look at them with expectations based on conventional representation: we expect them to be 'about' something; to open up semantically significant virtual spaces. If such a work has some figurative content this provides an initial orientation, but the links between this content and other

pictorial elements cannot be analysed wholly in terms of our usual notion of resemblance. This leaves two alternatives. The first is the formalist approach of critics such as Greenberg and Fried, which emphasizes relations such as figure and ground or part and whole but reads them primarily in terms of their psychological effects: for example, Greenberg's 'intuitive', 'unanalysable', 'aesthetic' experience, or Fried's states of 'absorption' and 'theatricality'. This approach is inadequate since it fails to explain how specific formal relations are able to occasion these specific psychological responses, and the range of formal relations that it is able to deploy is small. (One sign of this is Greenberg's notorious inability to acknowledge the significance of Futurism and Surrealism.)

The alternative approach is much more viable. It holds that in describing the problematic depicted spaces of twentieth-century works, we use the same terms as those which describe the basic structures of perception and self-consciousness themselves. Thus, let us use the notion of the existential subconscious. It comprises a number of different relations such as figure and ground and our capacity for productive imagination. We are not usually aware of their reciprocal structure, and they are, in existential terms, subconscious. But we become conscious of them when seeking to describe radical twentieth-century works. For if we cannot describe them through normal pictorial representation's code of resemblance, then we deploy terms which allow us to negotiate their structure in general. This necessarily involves reference to the existential subconscious. Any given item in experience – be it in direct perception or in depicted space – is meaningful only by virtue of its reciprocal relation with a broader field of items and relations. Whereas in normal perception we tend not to notice such relations, the perception of a problematic space makes them manifest. To describe such a space is to find an appropriate reciprocal relation or set of such relations around which it is organized.

Given this, one can say provisionally that the principle of reciprocity is the iterable basis of radical twentieth-century art. Even if we cannot say what a specific work resembles, we can describe the reciprocal structure(s) which it embodies. We can say that, whatever else the artist intends, it is at least 'about' this relation or set of relations. Such a content, indeed, gives an objective meaning to the work, since it exemplifies a structure inherent in human consciousness by virtue of our embodied condition. This iterable dimension also makes possible a specifically conceptual history of twentieth-century art. For we can trace how the artists' preoccupations with specific contexts of theories enable them to arrive at iterable visual outcomes which transcend these conditions of origination.

Before developing this, I shall now indicate briefly some of the main

directions which this book will follow. First, a present visual moment exists only in a reciprocal relation with past, future and counterfactual possibilities. In certain twentieth-century tendencies this usually subconscious relation is explicit. That is to say, whatever specific iconographical or theoretical meanings are intended by the artist, they are functions of a basic visualization of temporal reciprocity. I shall later consider this issue in relation to the problematic case of Cubism and the more straightforward example of Italian Futurism. Secondly, another key exemplar of the principle of reciprocity is the relation of figure and ground. There can be no visual perception without this relation. However, in conventional pictorial modes this is a merely tacit skeletal structure. What we 'read' is primarily that which is pictured – an object in a room, people in a landscape. To describe what the picture is 'of' entails that a figure–ground relation is involved, but it does not have to occur explicitly in our description. But in the case of much twentieth-century art – most notably some varieties of Geometric and Colour Field Abstraction – reference to the figure–ground relation necessarily features in our description of a work's appearance. Whatever else the work 'refers' to, a visual exemplification of this relation is its semantic core, as in the works of Kasimir Malevich and Barnett Newman.

Finally, it is worth noting one of the most complex of all the instances of the principle of reciprocity, the relation between actuality and possibility. What we comprehend in any one moment is given its character by the things we expect of it. In objective terms, the character of specific contents of consciousness is defined by our experience of contents of the same kind or by its contrast with other actual or possible contents. It is also defined by our (usually tacit) awareness of the finitude and contingency of such contents. The effect they have on our subsequent experience may be predictable or full of chance. In subjective terms, a content of consciousness gains a particular character from the specific patterns of our own personal experience and values. We may undervalue it, overvalue it, be indifferent to it or find that it provokes chains of idiosyncratic – even fantastic – associations. In conventional pictorial representation, this many-layered reciprocity of the actual and possible is always latently present in an artist's style. In handling the medium and the iterable code, he or she can give a work (in comparison with others) a distinctive individual inflection informed by all the factors just noted. However, the factors emerge only at a descriptive level when conventional representation's means are disrupted by the incongruous or unexpected in both posited subject-matter (or relations between elements of subject-matter) and modes of handling. This is the decisive feature of Surrealist art.

To summarize: there are continuities or analogies of presentational format between conventional representation and twentieth-century tendencies. These create a convention of expectations. We take the new tendencies to be 'about' something beyond what they are as strictly physical realities. If this 'aboutness' is to be iterable, it must be recognizable purely on the basis of what is contained in the individual work in relation to a more general code. In those key twentieth-century tendencies which involve abstraction or radical modification of conventional representation, this code is provided by the principle of reciprocity. Their visual exemplification of different aspects of this principle offers a basis for reading such works in objective terms. We can take each to exemplify not a specific visual appearance, but rather some aspect or aspects of the reciprocal conditions which sustain the possibility of visual appearance.

This approach could be developed in at least two ways. First, as a descriptive means of understanding the objective semantic significance of visually radical twentieth-century tendencies. This would involve an emphasis on phenomenological analysis and the mapping of diachronic and synchronic continuities and discontinuities at the same level. Such an approach would be fundamentally orientated to the viewer. An alternative approach would consider the development of twentieth-century tendencies in relation to specific theories used by the artists or ones which are applicable to their work. The intention here would not be to offer some general art-historical account of all those factors – causal, cultural and biographical – which led to a specific body of work being created. Rather, it would focus on the way in which artists deploy and develop reciprocal concepts in their theory and on the objectively significant – that is to say, iterable – visual outcomes which they generate.

In this book I adopt this latter, conceptual approach. Specifically, I shall address those aspects of theory which best clarify how the artists were able to develop an iterable mode of reciprocal representation. The kinds of theory to be addressed will be philosophical ideas and theories, since the very fact that artists (intentionally or not) are able to arrive at a radical new mode of representation suggests that, at the very least, significant changes of philosophical vision are involved.

Unfortunately, in the case of some major instigators, such as Kandinsky, Braque and Picasso, we have little in the way of philosophically substantial ideas to guide us. Therefore, I shall complete this chapter by offering a brief analysis of Kandinsky in relation to iterability. Chapter 2 will then analyse the cases of Braque and Picasso's Cubism.

<p style="text-align:center">★ ★ ★</p>

Kandinsky: A Provisional Case History

Wassily Kandinsky is of fundamental significance in the development of 'non-objective' art. In his work we find clear patterns of transition from overt representation to ambiguous pictorial idioms. Kandinsky's most important theoretical text, *Concerning the Spiritual in Art* (1912), can show us how he made that transition. His theory of art assigns a 'spiritual' (in fact, primarily emotional) significance to specific colours and forms, organized as follows:

(1) Simple composition, which is regulated according to an obvious and simple form. This kind of composition I call the melodic.

(2) Complex composition, consisting of various forms, subjected more or less completely to a principal form. Probably the principal form may be hard to grasp outwardly, and for that reason possessed of a strong inner value. This kind of composition I call the *symphonic*.

Between the two lie various transitional forms, in which the melodic principle predominates.[12]

Kandinsky's compositional principles serve to bring colours and forms – with their intrinsic 'spiritual' significance – into relations where they act upon and modify one another, and consequently deepen spiritual understanding. Through emphasizing these relations (rather than superficial correspondences with nature) the artist is able to advance art. In so doing he or she also advances the general spiritual state of humankind.

This quasi-mystical approach occurs in much twentieth-century non-figurative art, most notably that of Mondrian. It does not, however, take us very far in understanding such work's claim to iterability. The problem is that in order to 'read' art in Kandinsky's terms, we need specific external knowledge of which colours and forms are associated with which spiritual states. Cultures do make associations of this kind, but they differ from and are much looser than those envisaged by Kandinsky. They are also, for the most part, specific to the culture in question. At best, we might describe them as partially iterable.

Another approach to the iterability of Kandinsky's visual code would be through the constant analogies he makes between art and music, as in the passage quoted. This analogy is made by other artists, particularly Mondrian, but does not take us very far. Western music is dominated by scale systems, notably the tonal one. But in the visual arts there is no clear counterpart to the tonal system. Pictorial representation or, more specifically, perspectively ordered pictorial representation, might loosely fit the bill, but this would take us in exactly the opposite direction from that in which Kandinsky wished to move.

We are left then with this problem. Kandinsky offered a new 'spiritual' code for artistic creativity, but it can be applied legitimately only if we read the particular work in relation to an external code of quasi-mystical correspondences. In the case of language and picturing we have no such obscure metaphysical presuppositions. These ways of communicating are iterable codes. This means that we have clear and direct criteria of what kinds of states of affairs are posited in their individual 'utterances'. Kandinsky's rhetorical theory offers no such parallel. For even if we recognize that it is using quasi-mystical concepts, these are lacking in basic criteria of meaningfulness, since Kandinsky simply did not have an adequate philosophy of emotional or spiritual states. His associations are fundamentally iconographic. That is to say, they constitute a secondary, *ad hoc* code, whose deciphering is important for understanding his intentions, but which has no general validity beyond the empirical circumstances of his work's production and reception.

But consider the following passage from *Concerning the Spiritual in Art*:

Pure artistic composition has two elements:
1. The composition of the whole picture.
2. The creation of the various forms which, by standing in different relationships to each other, decide the composition of the whole. Many objects have to be considered in the light of the whole, and so ordered as to suit this whole. Singly they will have little meaning, being of importance only in so far as they help the general effect. These single objects must be fashioned in one way only; and this, not because their own inner meaning demands that particular fashioning, but entirely because they have to serve as building material for the whole composition.[13]

This commonplace description of the relation between part and whole is more potent when applied specifically to Kandinsky's and Kandinsky-type art. In partially figurative or abstract works, we are dealing with familiar representational media and formats, and our expectation is, accordingly, that these works are 'about' something other than themselves. But what could satisfy such expectations over and above the problematic iconographical meanings discussed earlier?

Kandinsky's remarks concerning whole and parts point us in broadly the right direction. Any visual manifold is characterizable as a reciprocity between whole and parts, which is a basic structural principle of sensible appearance. The presentness in appearance of sensible items and manifolds is based on complex patterns of continuous reciprocity, of which the part–whole relation is one of the most fundamental. Any 'part' of perception –

be it a property of a thing or an element within a manifold – is given its specific character by its relation to the whole. It tacitly represents that whole. This is made possible through a reciprocity between individual cognitive acts and the whole of the observer's experience itself. Our capacity to recognize and characterize particular appearances and their elements depends on a subconscious schema of past actualities and counter-factual possibilities. This existential subconscious is informed by the nature and scope of our bodily capacities and the particular pattern of our own personal history.

These claims have been convincingly argued by Merleau-Ponty:

> A thing is a thing because whatever it imparts to us is imparted through the very organization of its sensible aspects. The 'real' is that environment in which each moment is not only inseparable from the rest, but in some way synonymous with them, in which the aspects are mutually significatory and absolutely equivalent.[14]

> Each thing can offer itself in its full determinacy only if other things recede into the vagueness of the remote distance, and each present can take on its reality only by excluding the simultaneous presence of earlier and later presents . . . Things and instants can link up with each other to form a world only through the medium of that ambiguous being known as subjectivity . . .[15] [Hence, in the perception and experience of an embodied subject,] the living present is torn between a past which it takes up and a future which it projects. It is thus of the essence of the thing and of the world to present themselves as 'open' to send us beyond their determinate manifestations, to promise us always 'something else to see'.[16]

On these terms, the reciprocity of part and whole in appearance is not simply there; it is achieved, through instantiating a more general and continuous reciprocity between embodied subject and world. And in any pictorial representation the reciprocity is an outcome of specific acts of bodily positioning and cognition, exemplified in ordered sequences of gesture. With a picture, in other words, the dynamic and achieved nature of the reciprocity is, in principle, much more accessible to recognition than it is in the mere presentness of a natural configuration.

At last we can return to Kandinsky. In a work such as *Cossacks* of 1910–11 (pl. 3), there are a few fragments of conventionally represented form, but the dominant impression is one of abstract configuration. In works of strongly Geometric Abstraction (such as Malevich's or Mondrian's) our initial orientation will be towards identifying explicit kinds of form – such as squares or perpendiculars – in relation to the plane. However, in more

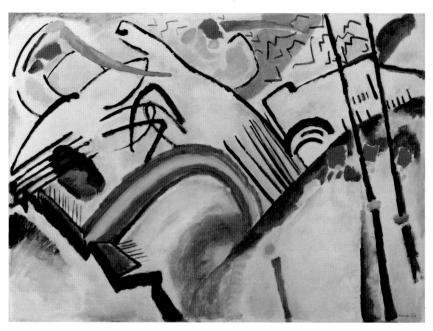

3 Wassily Kandinsky, *Cossacks*, 1910–11. Tate Gallery, London

painterly and gestural modes of Abstraction such as Kandinsky's, our primary orientation is towards describing the image; determining how best its appearance might be characterized. This means, of course, that the reciprocity of part and whole is at the forefront of attention. Indeed, the painterly or gestural aspect of the work offers clues whereby we can read its appearance as something which has been achieved through intelligent bodily activity. In the case of Kandinsky, this emphasis on process is extremely open-ended. His work between 1912 and the early 1930s clearly retains some allusive references to natural forms. Through their active contrast with the world as rendered in conventional representation, they suggest half-remembered scenes; or ones viewed quickly; or vaguely discerned at the periphery of perception. They might suggest dreamscapes, or possible phenomenal worlds other than the one we actually experience. The point is that this multiplicity of possibilities renders the actual reciprocity of part and whole in Kandinsky's work enormously labile. It might have been arrived at from many different directions, and it might be developed in many others. It radiates alternative possibilities. As in perception itself, it is this schema of contingencies, as well as what is literally 'in' the work, which gives the reciprocity of part and whole a distinctive character.

Kandinsky's work, thus, draws on a reciprocal relation which is funda-
mental to any possible visual experience. All pictorial representation
expresses this relation in a way that the ordinary experience of phenomenal
form does not. However, this expression emerges only exceptionally,
usually when a work is of aesthetic merit. In the case of Kandinsky's mode
of painterly and gestural Abstraction, however, the relation forms the
descriptive core of the work. It is represented. Whatever specific icono-
graphic meanings Kandinsky intends are secondary to this structure. They
are its functions, or more specific uses. Of course, in the actual synchronic-
historical process whereby Kandinsky came to create his works, these
iconographic factors may have been paramount. However, the decisive
point is that his embodiments of the part–whole reciprocity are an iterable
surplus. Over and above its immediate conditions of creation and recep-
tion, his work has a more generally legible character. Because of the
precedent of conventional pictorial representation, we expect works of
painting and sculpture to be 'about' something. I have tried to show that
Kandinsky's work is 'about' one aspect of the conditions of any possible
visual experience. It is a visual exemplar of a fundamental element within
the existential subconscious.

I have used Kandinsky as a first example in part because of his impor-
tance as an originator of abstract art. However, whilst Abstraction is a
major twentieth-century innovation, equally important advances were
made through the systematic modification of conventional representation.
To complete the first part of my book, therefore, I now turn to the major
instigators of such modification, Braque and Picasso.

Chapter 2

The Structure of Cubism

There is a large literature on the interpretation of Cubism, much of which invokes philosophers such as Kant, Bergson and Nietzsche.[1] There may be grounds for linking these figures to 'secondary' Cubists such as Gleizes and Metzinger, but the more fundamental instigators of Cubism – Braque and Picasso – are enormously problematic in this respect. They wrote no manifestoes. Indeed, in such comments as are recorded, one senses a radical hostility to the intellectualization of their work, for example, Picasso's remarks from 1923:

> Mathematics, trigonometry, chemistry, psychoanalysis, music and what not, have been related to Cubism to give it an easier interpretation. All this has been pure literature, not to say nonsense, which brought bad results, blinding people with theories.
>
> Cubism has kept within the limits and limitations of painting, never pretending to go beyond it.[2]

And in 1935 he said, 'When we invented Cubism, we had no intention whatever of inventing Cubism. We simply wanted to express what was in us.'[3]

In the previous chapter I showed how pictorial representation has a level of intrinsic philosophical significance, centred on the complex reciprocity between the individual work, the iterable code, and our embodied historical interactions with the world. I also suggested that this dimension has been completely obscured by the notion that pictures are primarily meaningful through direct visual correspondence with some real or imagined state of affairs. In this chapter I contend that in Braque and Picasso's Cubist practice the principle of reciprocity begins to emerge without the influence of overt philosophical ideas. The means involved a subversion of the 'correspondence' relation in favour of a more total expression of both the physicality and aesthetic possibilities of the medium and the substantiality of the represented object. However, this tendency towards (in Kahnweiler's words) 'a complete figuration'[4] also involved a reduction of pictorial representation to a state of – let us term it – restricted iterability. I shall consider some of the ramifications of this at the end of this chapter.

The Development of Cubism

Let us begin by noting that there is no documentary evidence to suggest that the origins of Cubism are anything more than a stylistic phenomenon. André Salmon does mention that before 1907 Picasso had 'meditated upon geometry'[5] but this must be taken as a general interest, rather than the origins of a new theoretical basis to his art. In fact, if we consider Cubism up to 1909, what is fundamentally at issue is an attempt to integrate the two specific stylistic influences of 'primitive' (mainly African) art and Cézanne. Picasso seems to have taken 'primitive' art seriously for the first time in *Les Demoiselles d'Avignon* (1907; pl. 4), but without being able to find an adequate means of assimilating it. The relationship of Picasso to this art is controversial; he even went so far as to deny its influence on his work. However, there is one source that mentions the influence of such art. In the 1930s no less a person than André Malraux visited Picasso's studio. Picasso described to Malraux the impact made on him by a visit to the Trocadero Museum in Paris. What moved Picasso most profoundly were the African masks on display. They struck him as having a 'magical' or 'exorcistic' significance rather than a purely formal one:

> They were weapons. Arms to free people from being the slaves of the spirits; to become independent. They were instruments. If we turn the spirits into material forms we free ourselves of them and gain our independence. The spirits, the unconscious . . . emotion, all mean the same thing. Now I understood why I was a painter. That was probably the moment the *Demoiselles d'Avignon* came to being, but not because of the forms I saw, but because it was my first exorcistic canvas.[6]

According to this, by being represented, the world and our unconscious drives and emotions are, as it were, earthed and thereby brought under control. That which is alien is explicitly stamped with the mark of our own individuality. This comes close to Hegel's remark that 'The universal need for art . . . is man's rational need to lift the inner and outer world into his spiritual consciousness as an object in which he recognizes again his own self.'[7] Picasso, though, falls short of the height of self-reflection to which Hegel brings our understanding of art. On Picasso's terms, painting has only an instrumental significance. The artist absorbs and exorcises the alien aspects of the world through the creation of art-works, and is thence free in everyday life to enjoy a more direct and demystified contact with reality, to appropriate it on his or her own terms. However, this points implicitly to a very unsettling division of labour. The artist's existence as an artist is a mere means (is external) to the end of a closer, more autonomous contact with the

4 Pablo Picasso, *Les Demoiselles d'Avignon*, 1907. The Museum of Modern Art, New York. Acquired through the Lillie P. Bliss Bequest

real world. The problem remains as to how this autonomy, achieved through art, can itself be made integral to actual creative labour and its products. That Picasso could not solve this problem is perhaps illustrated by the fact that the works created immediately after *Les Demoiselles* are, in effect, radically stylized paintings of African sculpture. No substantial break with the basic tradition of Western painting had yet been made.

Just at the time that Picasso abandoned *Les Demoiselles* (probably in early autumn 1907), the major Cézanne retrospective exhibition was held at the Salon d'Automne and Emile Bernard's articles on Cézanne (including the famous exhortation to 'treat nature by means of the cylinder, the sphere, and the cone') appeared in the *Mercure de France*. Now whereas at this point Picasso was trapped at the threshold of a more autonomous mode of painting, it was Braque with his *Gran Nu* (1907–8; pl. 5) who came to

5 Georges Braque, *Gran Nu*, 1907–8. Collection Alex Maguy, Paris

synthesize Picasso's discoveries with those of Cézanne's late style, thus realizing the goal to which Picasso had implicitly been reaching.

We must now pause for a moment and ask why African sculpture and Cézanne's mature style should be so conducive to an art which embodies a more direct and complete appropriation of reality. Salmon records Picasso as regarding 'primitive' art as more 'rational'[8]; and it is precisely this more 'conceptual' approach to representation which has been made so much of by Cubism's subsequent interpreters. But why should we call 'primitive' art 'rational' or 'conceptual'? The fitness of such terminology rests heavily upon the fact that African sculpture was perceived as tending towards formal generalization, that is, towards geometrical shapes. To call this 'conceptual', however, is a glib characterization, which could also be used to characterize the classical or idealizing tendency in Western art. Of course in the first decade of the twentieth century (as is possible now, indeed) the artist would approach African sculpture from the viewpoint of his or her own artistic tradition. In other words, rather than interrogate such works in terms of their own context of meaning, such an interpreter would be more interested in the contrast with, and implications for, his or her own conception of artistic method and values. We would have, to use Gadamer's term, a 'fusion of horizons'.

Two main areas of contrast emerge. First, in its more generalized qualities, African sculpture suggests a different relation between artist and subject matter from that found in Western art. Rather than being the outcome of a 'one-off' relationship between artist and model, it appears – to the Western observer, at least – as a product of working from memory. One might suppose that this in itself means that African sculpture is 'conceptual', but the notions of 'concept' and 'memory-image' are by no means synonymous. Indeed, to work from a memory-image suggests that the artist is not attempting to realize an abstract idea, but rather to reconstitute a subject matter on the basis of intimate contact with it over a period of time. This suggests, in turn, an 'all-over' knowledge of the subject matter, one which is not simply the result of a single visual relation, but of a contact involving all the senses, especially the tactile. Given the elusive nature of memory-images, the outcome of such a work will tend towards the exaggeration of salient formal features of the subject matter. This presents an interesting contrast with the classical tradition in Western art. Classicism aims towards what one might call the 'trans-phenomenal', the extension of forms encountered in the world beyond their perceptible embodiment towards a putatively pure and ideal existence when conceived in abstraction. Put in traditional philosophical language, ideal art is genu-inely conceptual – it aims at the essence of its subject, rather than its

accidental details. The tendency of African sculpture, in contrast, is 'hyper-phenomenal', the intense exaggeration of a subject's perceptible formal qualities.

This leads to the second main area of contrast. Ideal art, in effect, diminishes the tangible material nature of the medium itself. A plastic image is desired, but one which, as it were, hides its physical foundations. African sculpture's generalized tendencies, by contrast, allow the physical properties of the medium to emerge more directly. These contrasts point in directions which might have powerfully affected Picasso and Braque. There is a possibility of expression which is founded upon a more intimate relation between artist and subject, and which alludes to senses and bodily capacities other than sight alone. At the same time, this gives a more overt expression to the nature of the medium itself than is customary in Western sculpture.

How do these considerations relate to Cézanne's work? One might say that Cézanne's mature style (as exemplified in many of the still lives from the 1890s) proceeds in much the same direction as African sculpture. There is that same tendency towards a more sustained and global perceptual acquaintance with the subject matter, which, when carried out pictorially, gives a more substantial form and volume-enchancing appearance to objects. It also, ironically, more tangibly manifested the properties – in this case, planar flatness – of the medium itself. Interestingly, William Rubin has argued that the origins of so-called 'analytic' Cubism are to be found in Braque's development of a Cézannesque style and in Picasso's response to this.[9] Primitive sculpture, in consequence, is assigned a minimal role. However, whilst Rubin convincingly illustrates the continuity of Braque's Cézannesque style up to the sojourn at L'Estaque (from May to autumn 1908), this alone does not, I feel, account for the peculiar stylistic features of such works as Braque's *Gran Nu* (1907–8) and the various L'Estaque landscapes. The predominance and rigid definition of large, irregular, striated and angular facets in such works, for example, is a feature which goes beyond Cézanne's language of closely knit uniform planes, but is nevertheless to be found in both African sculpture and Picasso's *Les Demoiselles*. Indeed, given the fact that Braque had already seen and been disturbed by *Les Demoiselles*, it seems to me that the introduction of such facetting can be attributed to lessons learnt from this work and thence (if indirectly) from African sculpture.

What is fundamentally common to both Cézanne and the Western perception of African sculpture is the use of a phenomenological 'return to the things themselves' and, specifically, the body's encounter with them. In previous art, subject matter tended to be subordinated to narrative func-

tion, or to the technical or aesthetic virtuosity of the artist's handling. Much Impressionist painting made a break with this, but only by asserting the primacy of the artist's vision. The significance of Cézanne and African sculpture lies in the possibility they brought of a new and more sustained relation between artist and world, which brings the physical properties of the subject matter, the artist's handling, and the aesthetics of the medium into a closer and more harmonious reciprocity. For example, in relation to his study for the *Gran Nu* Braque observed in 1908 that

> I . . . create a new sort of beauty that appears to me in terms of volume, of line, of mass of weight, and through that beauty interpret my subjective impression. Nature is the mere pretext for a decorative composition plus sentiment, it suggests emotion and I translate that emotion into art. I want to express the absolute and not merely the factitious woman.[10]

The primacy of mass, line and volume gives the artist a more complete appropriation of both subject and medium in three ways. First, the emphasis on these formal properties implies a more physical and intimate knowledge of the subject than is suggested by conventional styles. Second, this emphasis expresses some aspect of the artist's emotional response to the subject. They are the subject as it is experienced. Third, the tendency to hyperphenomenality leads towards an awareness of the painting as a configuration of forms upon a canvas. There is, of course, a persistent temptation in art criticism to suppose that formal aesthetic values and content are irreconcilable with one another. But already in early Cubism we find so-called 'decorative composition' which actually complements the content of the work.

In sum, the early phase of Cubism, from mid-1908 to Picasso's works at Cadaques in 1910, is to be construed as a search for new and profound artistic expression, rather than for new theoretical or 'conceptual' bases for art. It may seem odd to associate Cubism with expression, since it is frequently remarked how 'austere' or 'dispassionate' it is as a style. We justifiably tie the recurrent 'expressionist' tendency in painting to such things as the use of vivid colouring, loose handling and subject matter where extreme emotions are displayed. However, this description tends to suppose that there is a necessary connection between 'painterliness' or morbid or violent subjects and expressiveness as such. The relations of handling, colour, content and expression, however, are entirely contingent. We can work in a Fauvist style without necessarily palpitating with primeval excitement as we strew paint about the canvas. Similarly, one has only to look at something like David's *Death of Marat* (1793) to see the expressive potential of a more austere handling and organization. The key

question is whether a work gives us reason to believe that the artist is not simply picturing some aspect of the world but expressing a distinctive personal response to it. In Cubism, for example, I have argued that the artist is moving towards closer and more total contact with the subject matter through the medium. Given this move, the stylistic means of Cubism appear as something more than 'dispassionate', in that to achieve this kind of expression involves an emphasis on formal elements and tonal relationship at the expense of colour and traditional perspective. The absence of such emphases would simply imply the conventional and purely visual relation between artist and subject matter. If this reading is correct, the significance of Picasso and Braque's innovations is in preparing a visual basis for the expression of that primordial contact between the body and things which Merleau-Ponty terms a 'practical' as opposed to 'intellectual synthesis'. As Braque himself said about his works of late 1909 (such as *Violin and Palette*), 'I had already adopted the concept of tactile or manual space.'[11]

Let us now turn to the middle and latter phases of Cubism. To make sense of Picasso's introduction of broken facets in 1910 and the consequent fusion of objects with the surrounding space, we must look at a feature which first occurs in *Les Demoiselles d'Avignon* and which is continued in the *Gran Nu* and other pre-Cadaques works by Picasso and Braque. In the right-hand corner of *Les Demoiselles* is a seated figure whose torso is turned away at an angle from the viewer, but whose head is presented frontally. As John Golding puts it, 'It is as if the painter had moved freely around his subject, gathering information from various angles and viewpoints'[12] and hence we find 'the combination of various views of a subject in a single image.'[13] Unfortunately, these two quotations are not synonymous. The first tells of an effect that is a function of any art which stresses mass and volume, and is especially strongly suggested by distended images. But we cannot infer from this that it is the artist's intention to give us a 'combination of various views' of an object, or a simultaneous image. For example, passages in certain Ingres paintings such as the neck of the *Grand Odalisque* (1819) seem to present limbs as grossly distended but we do not think of this as anything other than an expressive effect. Sometimes such distension is used for narrative function. For example, it is not inconceivable that the awkward conjunction of head and torso in the seated figure in *Les Demoiselles* is painted to express sudden and violent surprise. (One is reminded of the cold shock experienced by the voyeur at the keyhole in Sartre's *Being and Nothingness* at the realization that he has been discovered.)

Even more crucial, perhaps, is the fact that artistic style by its very nature tends to distend – to throw the world out of focus – either by accident or

contrivance. Given these points, I argue that the distended image of Picasso
and Braque's Cubism up to mid-1910 is just that – a distended, rather than
a simultaneous image. The only counter to such an interpretation would be
an offering of explicit documentary evidence – of which there is none[14] –
or phenomenological evidence of the most striking kind. Unfortunately,
the pre-Cadaque Cubist works seem without exception to be representa-
tions of a conventional if highly distended sort. Golding looks upon the
simultaneous image as the major innovation of Picasso and Braque, the one
stylistic feature that is not to be explained by Cézanne or 'primitive' art.
However, if this had been the really important breakthrough, surely one
would have expected a much more overt exemplification of it. This is, of
course, what does later occur in Duchamp's *Nude Descending a Staircase*
series (1911–12) and in many Futurist works; but we can find no such clear
statement of a simultaneity effect in any of Picasso and Braque's works.

Indeed, this is not just a case of an interpretation that is wrong; it is one
which arguably leads us in precisely the opposite direction of the real
breakthrough made by Cubism. The simultaneity thesis presupposes that
the pictorial space of Picasso and Braque is pretty much the same as the
traditional notion, with the exception that objects are presented from
different angles in a succession of instants. What Picasso and Braque are
really doing, however, is extending and transforming Cézanne's mature
style, where so much emphasis is given to the volume and substance of
objects that conventional perspective tends to become highly ambiguous.
Instead of pictorial space being construed as a given mathematically struc-
tured absolute in which objects are placed, it is engendered from objects
and their relations with other objects. We should expect inconsistencies in
perspective simply as a result of the artist's method, rather than as a result
of a device which implies objects being viewed simultaneously from
different angles. We have, in other words, a more physical and, as it were,
'existential' treatment of space, rather than the introduction of a new
temporal approach.

Another by-product of this method is that through creating space by
means of the bloating and distension of objects 'in' it, the representation
will have a less accentuated sense of recession. In other words, pictorial
space will tend less to engender an illusion of actual space and more to
affirm its formal status as a configuration of marks upon a canvas. This
carries with it a significant temptation. In a work founded upon illusionistic
perspectivally based space, to amend the appearance of objects in it for the
sake of achieving purely formal and aesthetic harmony seems (although of
course it is inevitably done) to cut against the demands of illusionism. In
the Cézannesque style, however, where the formal structure is accentu-

ated, there is a correspondingly greater temptation to amend the content for aesthetic effect. These points enable us to understand the significance of the broken facets introduced by Picasso at Cadaque and the subsequent systematic and complete fragmentation of the image. Whereas the early phase of Cubism simply extends 'primitive' sculpture through its corollary in Cézanne's painting, the phase from 1910 to 1912 makes a breakthrough which Cézanne could not have attempted. Hence Braque's crucial remark late in life that 'When the fragmentation of objects occurred in my painting around 1910, it was as a technique for getting closer to the object within the limits tolerated by the painting.'[15]

The fragmentation of objects means that pictorial space is constituted exclusively from the distended and rearranged substance of objects. It is replete with them; it is a total encounter. The distension that takes place in more conventional artistic representation (and even the early phase of Cubism) nudges, as it were, objects into an expression of their sensuous and aesthetic potential. But narrative content and illusionism will tend to obtrude upon the encounter with objects themselves. We concentrate instead upon the 'idea' or message and the skill involved in creating the illusion. Even the artist who paints in the style of the most meticulous Dutch still life is paradoxically distanced from the subject. He or she reduces it to a purely visual entity, and thus denies an expression of its total physical substantiality. Indeed, at the same time, the object is reduced to the mere vehicle by which the artist's skill is to be displayed.

The method of Picasso and Braque's Cubism between 1910 and 1912 allows a palpable and more complete expression of the object and its aesthetic possibilities, in a way that shuts out these other elements. It does so by disrupting the spatio-temporal cross-section which is the logical ground of conventional, perspectival representation. To see a represented scene in these conventional terms is to see a two-dimensional projection of a possible instant in the spatio-temporal continuum. To represent a succession of instants, as in Duchamp's *Nude Descending a Staircase*, involves that the image should contain relational criteria whereby we can say that one 'moment' (here, a section of the image) is before or after another moment: that is, as well as having a set of sections which appear different from one another, we must have a syntax whereby we can say that these differences are due to change brought about by the passage of time. The distension of substance which takes place in Picasso and Braque's work between 1910 and 1912, however, admits of no such syntax. The artist expands the object into its sensuous and aesthetic possibilities in a way that radically diminishes those expectations arising from perspectival representation. Although in such Cubist works we can specify that it is a painting 'of' something (even

if sometimes we cannot specify what), the nature of the image is not simply spatially fragmented, it is also fragmented in temporal terms. The introduction of a grid framework, however, transformed mere fragmentation into aesthetic rearrangement.

This negation and aesthetic re-arrangement puts Picasso and Braque's 1910–12 Cubism into a category of its own; it is not systematically illusionistic, yet it has structural affinities with its referent that other modes of reference (such as names or linguistic statements) generally do not. At the heart of this uniqueness is the fact that by creating pictorial space through the distending of objects, the artist is fusing the object of study with the medium of expression. The more the object is distended towards an unfamiliar, re-arranged (and thence illusionistically useless) configuration, the more the object harmonizes with the formal nature of painting itself. Indeed, confronting object and medium in this way means that as the work develops, so many new formal possibilities are opened up that the work takes on a life of its own. This is why John Nash's favouring of the Nietzschean view that Cubism is essentially a case of artists forcing 'preconceived' images upon everyone else seems so unlikely.[16] In the phase of Cubism up to 1912, it is as though the artist brought subject matter and medium together and said 'see what you can learn from one another through me.' The explorative and experimental aspects of hermetic Cubism clearly push in the direction of a wholly abstract or formally autonomous form of art and, if Nash's Nietzschean interpretation were correct, that is exactly where Braque and Picasso should have arrived. However, they did not. Indeed, we find that they stuck to a subject matter of familiar and intimate objects – predominantly still lives, but also some portraits and related subjects.

Their innovations do, however, raise the problem of iterability. The more an artist distends the image, the more unfamiliar the object becomes to observers of the work. There comes a point, indeed, where without the guide of a title or other external evidence, one cannot pick up the thread of the subject matter which has been spatio-temporally re-arranged. The introduction of lettering in works such as Braque's *Candlestick* (1911; pl. 6) go some way towards re-establishing an iterable contact with reality, without disrupting the aesthetic flow of distension. Indeed, since written or printed signs are themselves two-dimensional entities, this develops the already established tendency to emphasize the structural affinity between the pictorial sign and its referent.[17] But all this provides only the most nomimal interpretative aid. Such innovations demand a decision as to whether Cubism should turn back towards more conventional idioms or move into a realm of wholly autonomous creation. The introduction of

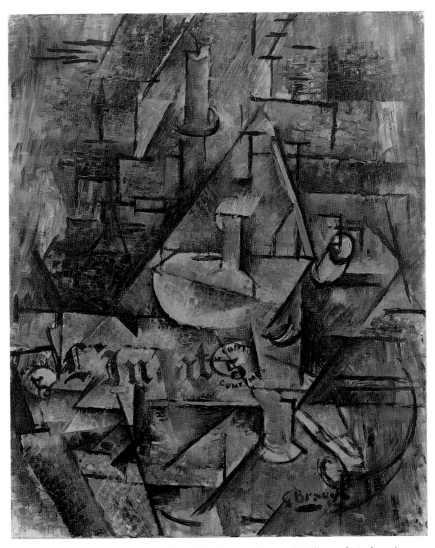

6 Georges Braque, *Candlestick*, 1911. The Scottish National Gallery of Modern Art

papier collé bypassed this dilemma in a brilliant fashion. A clearer reference to subject matter was achieved, but without conceding the re-arranged image of the preceding works. The approach affirmed a distinctive new integrity of subject matter, founded upon a radically new means of exploration. Unfortunately, it is precisely the nature of this means which marks the end of Cubism as an innovatory style of pictorial expression. The outbreak of the First World War marked the end of Picasso and Braque's collaboration, but by this time Cubism in its Synthetic phase had exhausted

its logical possibilities. I use 'logical' here in its most absolute sense, because after *papier collé* and collage, there is no purely pictorial way that a Cubist style can be extended without repetition. The only directions open are towards abstract painting or a distinctive Cubist sculpture. Neither artist chose the former path, and whilst both explored sculpture, it did not figure as the major factor in their subsequent innovations.

The Philosophical Significance of Cubism

In 1917, Braque lucidly summarized his conception of Cubism: 'The subject is not the object, it is a new unity, a lyricism which grows completely from the means.'[18] The 'unity' which Braque posits here is the fusion of subject matter and medium, which is pursued from 1908 to 1910, achieved between 1910 and 1912, and exhausted before 1915. Its effect is not only to negate the distance between subject matter and medium, but also thereby to move the artist into a closer and more intimate relation with both. In more conventional art, objects are distended according to the artist's handling of the medium. In Picasso and Braque's work, objects are, in addition, distended so as to harmonize with the nature of the medium itself. Now, I argued before that our cognitive relation with the world is organized by a principle of reciprocity. How the world appears is a result of its sensible aspects being organized in relation to the scope and achieved co-ordination of the body's sensori-motor capacities. But reciprocally, a given and ever changing spatio-temporal realm is a presupposition of both having a body and of facing physical demands which necessitate its co-ordination. All artistic representation tacitly embodies this general reciprocity. The subject matter is not simply there; it is articulated and characterized through the particular artist's handling of the medium. But this articulation is possible only because a stable spatial medium sustains it, and a changing world provokes it. The reciprocal dependence of these elements is radicalized by Cubism. In describing its basic visual–semantic structure we are simultaneously describing a more general reciprocal structure. One might express this formally: Cubist works manifest an emphatic organization of visual appearance, whose particular character is such as also to emphasize those general characteristics of spatial tangibility and mutability which both enable and prompt the organization of appearance *per se*.

These considerations suggest that Cubism's true intellectual affinities lie not with Kantianism or, as is sometimes remarked, with the pure phenomenology of Husserl, but rather with the existential phenomenology of

Heidegger, Sartre and more particularly Merleau-Ponty. Here is Braque in 1954, talking of his pre-1914 Cubism:

> The traditional concept of perspective failed to satisfy me. Mechanised as it is, this perspective never assures [ensures] the full possession of the object. It procedes from one standpoint and refuses to budge from there. This angle, or viewpoint, is a totally insignificant thing. It is as though one were to draw only profiles all one's life, leading one to believe that man has only one eye.[19]

This dissatisfaction with pictorial space exactly parallels the dissatisfaction felt with traditional philosophy by Merleau-Ponty.[20] He argues that our fundamental contact with objects arises through the body's exploration of them through all its sensory, motor and affective capacities. Traditional philosophy with its 'analytic attitude', in contrast, takes consciousness as its starting point and constructs the 'external' world from sense-data or atoms of sensation presented to the pure perceiving subject. On these terms, Braque and Merleau-Ponty construe the task of art and philosophy, respectively, as a return to a fuller and more basic contact with the world that had been overlooked by traditional perspective or the 'analytic attitude'.

It may seem odd that at this stage I should link Cubism and philosophy, after having so emphatically denied Cubism as a self-consciously philosophical movement. However, Merleau-Ponty (like Heidegger before him) comes more and more in his later philosophy to adopt a quasi-poetic vocabulary. He thereby admits that phenomenological method should become more sensuously evocative in the style of art, rather than remain at a high level of theoretical abstraction. This suggests that we should revise our understanding of Cubism. The link between philosophy and art is frequently seen (by both artists and philosophers) as a one-way relationship – philosophy influences art or provides the justification for specific styles. Indeed, (as we shall see further on in this book) there are some tendencies in Modernism to construe the art object as fundamentally a quasi-philosophical statement about the medium. (This, of course, leads eventually to the conclusion that we can dispense entirely with the art object, as conceptual 'art' strives to do, in favour of the art 'statement'.) It is ironical that in Heidegger and Merleau-Ponty (and, to a lesser extent, Sartre) exactly the opposite impulse is at work. We find philosophy aspiring to become like art, because modern art has already accomplished within its own limits what philosophy tries to do.

This is somewhat more than a mere anticipation or analogy. If we seek a return to a more fundamental mode of being in the world – one which declares its reciprocal structure – the groundwork for this enterprise can

involve a 'making strange' of that which is familiar or taken for granted. In its radical distension and fusion of medium and world, Cubism lays bare both the flesh and substance of objects, and the artist's definitive proximity to them. This profound awareness of and proximity to the substantiality and palpability of objects themselves is the basic characteristic of Sartre and Merleau-Ponty's phenomenology (the one feature, in fact, which is not derivable from their broader philosophical sources), as in this passage from Sartre's *Nausea*:

> the root, the park gates, the bench, the sparse grass on the lawn, all that had vanished; the diversity of things, their individuality, was only an appearance, a veneer. This veneer had melted, leaving soft monstrous masses, in disorder – naked, with a frightening, obscene nakedness.[21]

Or Merleau-Ponty's 'Eye and Mind':

> Visible and mobile, my body is a thing among things; it is caught in the fabric of the world, and its cohesion is that of a thing. But because it moves itself and sees, it holds things in a circle around itself. Things are an annex or prolongation of itself; they are incrusted into its flesh, they are part of its full definition.[22]

These passages evoke well the fundamental mood of French existential phenomenology – a mood that, as I have suggested has antecedents not in philosophy but in art. One might say that Cubism brings a kind of shock of the familiar, thus creating an intellectual context that makes Sartre and Merleu-Ponty's work possible. The gulf between the human subject and the world, in other words, is bridged by Cubist painting in a way that leads on to the thematization of this bridging by philosophy.

Cubism and Iterability

Can Braque and Picasso's works be 'read' in the terms I have described, independently of any knowledge of the context of immediate production and reception, or of the artist's intentions? The answer is yes, but in only a restricted sense. The relation between overt representational elements and the fragmentation and reconfiguration of such elements in a grid structure declares – in comparison with more conventional representational – a more all-embracing relation between artist and subject matter, achieved through the medium. However, it is all too easy to go beyond this strict descriptive level of iterability and read Cubism as a depiction of

actual temporal change. Indeed, as the huge secondary literature itself shows, there are also many other ways in which the descriptive level has been interpreted. At first sight this might seem to make Cubism extremely analogous to pictorial representation, in that individual statements in the code can be invested with different functions according to different contexts of use and interpretation. However, the two cases are not analogous. In pictures, we can read what specific kinds of things (in the most general sense) are being represented and, if the work is perspectival, we shall also be able to recognize the specific nature of the spatial relations between them. Whatever ambiguities of interpretation arise are determined by the relation between the (as it were) grammatically well-formed pictorial statement and its contexts of employment and reception. With Cubism, in contrast, it is our criterion of grammaticality itself that is internally ambiguous. The kind of thing 'going on' in the work is in iterable terms at least as I have described it, but the fact that what has been described is so general leaves open the possibility that other factors may be involved even at this level. Cubism has a definiteness of sense, but unlike that of pictorial representation it is not definite enough to rule out a degree of ambiguity in the iterable dimension. This ambiguity can be barred by relating Cubism to its creators' statements; but the need for such reference counts as a severe restriction of Cubism's iterability.

The interesting question is why Cubism should be thus subject to ambiguity at the iterable level. We recall that picturing has its own indirect intrinsic philosophical significance, through the reciprocity which holds between the individual work, the iterable code and experience. These relations give picturing its communicative potency. But the very fact that it is exceptional for this dimension to figure as an element of overt iterable meaning (in the context of art) is one of the reasons why picturing has so much flexibility. It can be used across a range of contexts, without us having to trouble about the 'whys and wherefores' of the image itself. In artistic representation these issues are central, and in Cubism especially so. Here, interest centres not so much on a visual image itself, but on the conditions of its imaginative and pictorial generation and distribution. Just as it is hard to learn what Cubism is, it is equally hard to apply its 'statements' in any contexts other than artistic and decorative ones.

There is, then, an iterable dimension to Cubism, but it is restricted. In art historical terms this is not decisive. Indeed, it may even be of positive import. Cubism's objective achievement is to offer a mode of representation whose basic structure visually exemplifies the principle of reciprocity in a very general way. It emphasizes the physical presence and mutability of visual appearances and relations – factors which both enable and prompt

the organization of appearance by both art and perception itself. It presents the reciprocal dependence of all these factors in a way that our normal understanding of the world does not. Further, this evocation of the existential subconsciousness is so very general that the attendant ambiguity is, in effect, an open invitation. Other artists can take up the challenge of clarifying the full implications of Cubism, by adapting and developing it for their own theoretical ends. In the coming chapters, I shall consider specific examples of such strategies, beginning with Italian Futurism.

Part II

From Duration to Modernity:
Bergson and Italian Futurism

Few art movements have suffered more from stereotypical presentation than Italian Futurism, and Marinetti's bombastic propaganda has succeeded too well in declaring the Futurist obsessions with speed, violence and Modernity. But, of course, there is much more to the movement than that. The obsession with speed, violence and Modernity is not simply pursued for its own sake. It figures, rather, as a key component in a much more sophisticated discourse, centred on the relations between metaphysics, Modernity and creative practice. At the heart of this discourse is the Futurists' – particularly Boccioni's – engagement with the philosophy of Henri Bergson.

The link between Futurism and Bergson has often been noted and in most accounts a few concepts from the Futurist manifestoes are linked to a few concepts from Bergson.[1] But the linkage is much more profound, for Bergson's philosophy can be shown to permeate Futurism. There is a case to be put for seeing the Futurist obsession with Modernity and its products as a means of responding to problems in Bergson, and thence of going beyond him.

In the next section, therefore, I shall outline the salient aspects of Bergson's philosophy, emphasizing those concepts and problems which are most relevant to Futurist theory and practice and which involve the principle of reciprocity. Under the heading 'Bergson and the Development of Futurism', I shall systematically link Bergson's work to the chronological development of Futurism, noting in particular its response to Cubism and then the sense in which the artists go 'beyond' Cubism. I shall conclude with an assessment of Futurism's failure and success in relation to iterability.

Bergson's Philosophy

For Bergson there is one fundamental cosmological principle, the drive towards generation of life. This *élan vital* is a process of duration – of constant becoming – and is constituted by two opposed currents. In

Bergson's words, 'life is a movement, materiality is the inverse movement of each and each of these two movements is simple, the matter which forms a world being an undivided flux, and undivided also the life that runs through it, cutting out in it living beings all along its track. Of these two currents the second runs counter to the first, but the first obtains all the same something from the second. There results between them a *modus vivendi* which is organization.'[2]

This statement is a perfect encapsulation of Bergson's overall position. Let me now fill in the major details. First, the realm of matter consists of a mode of unfocused, extended and, as it were, low-grade duration founded on elements whose relations are best understood in radically mechanistic terms. The elements of matter 'draw back into themselves, mark as many moments in their existence as science distinguishes in it, and [their] sensible qualities without vanishing, are spread and diluted in an incomparably more divided duration. Matter thus resolves itself into numberless vibrations, all linked together in uninterrupted continuity, all bound up with each other, and travelling in every direction like shivers through an immense body.'[3]

But since the function of matter in the cosmos is to provide material from which life can be generated, it is given organization by the *élan vital*'s constant striving to create. This striving takes the form of a need to maximize the amount of indeterminacy and liberty in the universe, and is realized through the evolution of organic life. Such life forms are separated from the realm of matter by nature itself. Through their mutually dependent relations of parts and whole, they form self-sufficient systems able to act upon and replenish themselves from the surrounding environment. Indeed, it is this capacity for inaugurating activity which enables the organic life form to organize matter. As Bergson illustrates it, 'the separation between a thing and its environment cannot be definite and clear-cut; there is a passage by insensible gradation from the one to the other; the close solidarity which binds all the objects of the material universe, the perpetuity of their actions and reactions, is sufficient to prove that they do not have the precise limits which we attribute to them. Our perception outlines, so to speak, the form of their nucleus; it terminates them at the point where our possible action on them ceases, where, consequently, they cease to interest our needs.'[4]

Whilst Bergson's remarks here refer specifically to human life, they have a general application to the organic world. For it is on the basis of its practical needs and capacities that any life form perceives and thence gives contour and order to the unfocused flow of matter. It carves up matter into an organized world. At the heart of this carving up is the fact that organic

beings are, in varying degrees, free in their response to stimuli. Herein are found the origins of consciousness itself. It is described by Bergson as 'the light that plays around the zone of possible actions or potential activity which surrounds the action really performed by the living being. It signifies hesitation or choice.'[5] Indeed, 'Our representation of things arises from the fact that they are thrown back and reflected by our freedom.'[6] In beings with a nervous system and brain, consciousness is all the more advanced since the interrelated function of these organs is to transmit perceptual data from one to the other to enable complex possibilities of response to stimuli. In human beings, such an advanced mode of consciousness also facilitates the development of intelligence, which Bergson defines as the capacity to fabricate 'instruments' (in the widest possible sense). Chief amongst these instruments are the concepts of language and the ideas of homogeneous space and time. These enable us to immobilize and solidify the flow of reality to render it appropriable for our practical needs. In Bergson's own words, the ideas of homogeneous and divisible space and time 'express, in abstract form, the double work of solidification and of division which we effect on the continuity of the real, in order to obtain there a fulcrum for our action'.[7]

Bergson thus draws an extremely complex distinction. At the most basic level, he is contrasting the duration of space and time as immediately experienced, with space and time as grasped in abstract terms by the intellect. In the former experience, space and time is an indivisible flow of heterogeneous elements in which we are caught up. In the latter experience, thought as it were stands back and articulates the flow in terms of space and time as homogeneous dimensions, divisible into sharply distinct things and states. Thought immobilizes the flux of duration and gives it precise outlines. The complexity resides in the fact that whilst the intellect's notion of space and time is a distortion of reality it is necessary from the viewpoint of the human organism's practical hold on reality.

This distinction is rendered even more difficult in relation to personal identity. On the one hand, according to Bergson, our immediate experience of the self is as an indivisible flow wherein complex sequences of perceptions or states of mind are not clearly demarcated from one another. On the other hand, when we explicitly reflect upon ourselves, we articulate our past and possible future experience in a kind of linear narrative. We view the passage of experience as a clear succession of discrete events and states arranged alongside one another. In this case, in other words, we articulate the self on the distorted model of distinct elements arranged in homogeneous space and time.

The relationship between these various aspects of our immediate experience of duration and the intellect's reflection upon it refers us directly to a key element in Bergson's philosophy, the role of *memory*.[8] It is memory which gives depth and complexity to that mode of duration which is the human reality. Bergson summarizes this depth:

> While external perception provokes on our part movements which retrace its main lines, our memory directs upon the perception received the memory-images which resemble it and which are already sketched out by the movements themselves. Memory thus creates anew the present perception or rather it doubles this perception by reflecting upon it either its own image or some other memory-image of the same kind . . .[9]

We are now at the heart of both the positive and negative claims of Bergson's philosophy. His positive overall position is that the *élan vital* – a constant drive towards creativity – surges through matter, evolving organic life forms in its track. The freer a life form is, the more creative possibilities it can introduce into the universe. At the apex of such forms is the human reality. Our bodies carve out structures in the world of matter, on the basis of their needs and interests. They further articulate matter by solidifying its flow through the exercise of the intellect and memory. This means that each moment of human experience is unique and that the whole of experience is constantly changing – thus embodying the principle of reciprocity. Every perception is built and organized by the ever accumulating moments of the past and the ever opening possibilities of the future which is spreading out before it. Reciprocally, the character of the particular moment influences how this temporal horizon is understood.

The negative obverse of this is that whilst the imput from memory gives the creativity of human perception and action its particular richness, it is also channelled into a degree of misrepresentation. When the intellect directs its operation to the task of theoretical understanding and analysis, it forgets its own foundations in the domain of practical interests. Hence Bergson observes that

> Our intellect, when it follows its natural bent, proceeds on the one hand by solid perceptions, and on the other by stable conceptions. It starts from the immobile, and only conceives and expresses movement as a function of immobility. It takes up its position in ready-made concepts, and endeavours to catch in them, as in a net, something of the reality which passes.[10]

In other words, the intellect fails to recognize that the solidification and division of duration into discrete things and states are effects wrought by it

for practical ends. Instead, it takes these as the starting point or building bricks of reality itself. Hence when it is called upon to offer analyses of the indivisible flow of duration, it does so in an artificial and distorted way. It attempts to explain duration in terms of discrete immobile units set in motion. This leads inevitably to philosophical paradoxes, notably those posited by the philosopher Zeno of Elea.

Is there any way round this barrier to the intellect's articulation of the flow of duration? According to Bergson there is. Here he remarks on our perception of the movement of an object in space:

> My perception of the motion will vary with the point of view, moving or stationary, form which I view the object. My expression of it will vary with the system of axes, or the points of reference to which I relate it. For this double reason I call such motion *relative*: in the one case, as in the other, I am placed outside the object itself. But when I speak of an *absolute* movement, I am attributing to the moving object an interior, and, so to speak, states of mind; I also imply that I am in sympathy with those states, and that I insert myself in them by an effort of imagination.[11]

The 'effort of imagination' to which Bergson alludes is usually termed by him 'intuition'. It is through such acts of intuition that we most adequately express the reality of duration. Let us consider this in the light of the following claims by Bergson. Concepts – grounded on the immobilization of duration – are not adequate to the task of expressing intuition. However,

> the image has . . . this advantage, that it keeps us in the concrete. No image can replace the intuition of duration, but many diverse images, borrowed from many different orders of things, may, by the very convergence of their action, direct consciousness to the precise point where there is a certain intuition to be seized. By choosing images as dissimilar as possible, we shall prevent any one of them from usurping the place of the intuition it is intended to call up . . .[12]

This creates a decisive possibility in relation to images:

> By providing that, in spite of their differences of aspect, they all require from the mind the same kind of attention, and in some sort the same degree of tension, we shall gradually accustom consciousness to a particular and clearly defined disposition – that precisely which it must adopt in order to appear to itself as it is, without any veil.[13]

Throughout his oeuvre, when Bergson wishes to contrast the deepest expression of duration with the distorted reflection of it obtained by analytic thought, he uses art to illustrate the positive expression. Indeed, I

suggest that it is only the production and sustained appreciation of the products of the artistic imagination which would satisfy the cultivation of that 'clearly defined disposition' which Bergson sees as enabling us to achieve intuition. So when Bergson comes to define metaphysics itself as 'the science which claims to dispense with symbols'[14] he is in effect pointing out a necessary link between philosophy and art. We might even read him as actually conceding that some form of rigorous artistic expression should supersede traditional forms of philosophizing. Here is a telling *entreé* into Futurism.

Bergson and the Development of Futurism

Marinetti's *First Futurist Manifesto* of 1909 sets the tone for the whole movement, with its glorification of dynamism, speed and technology and its fanatical rejection of tradition. This in itself gives some indication of a general affinity with Bergson's own view of reality as one of creative and constant Becoming. And there is a similar dimension to the work of Nietzsche, a philosopher much admired by Marinetti and his circle. But there is a further aspect of Bergson's work which marks him out as the decisive overall theoretical influence on Futurism. It centres on his arguments concerning our practical need to articulate the world in terms of frameworks of homogeneous space and time. Such frameworks are in essence artificial contrivances which function by solidifying the indivisible flow into static, measurable units. Both philosophical and common-sense views of the world, however, fail to recognize this artificial character. They mistakenly suppose that the world is naturally an aggregate of distinct and static things which have been set in motion. In other words, the dynamic indivisible motion of reality is understood distortedly in an abstract form. Bergson's critique, therefore, offers a subversion of the claims of rationalist and classical notions of space. The attraction of this for Futurism is obvious, as articulated by Boccioni in 1913:

> It is the static qualities of the old masters which are abstractions, and unnatural abstractions at that – they are an outrage, a violation and a separation, a conception far removed from the law of the unity of universal motion. We are not, therefore, anti-nature, . . . we are ANTI-ART; in other words, we are against the stasis which has reigned for centuries in art . . .[15]

Here Boccioni is ratifying avant-garde art, by criticizing traditional values on precisely the terms in which the traditionalist would reject avant-garde

products, as 'unnatural abstractions'. What enables Boccioni to do this is his Bergsonian linking of what is natural to what is dynamic and in uninterrupted motion.

Articles on Bergson first appeared in Italy in the 1890s and continued throughout the first decades of the twentieth century in a variety of Italian academic journals. In 1909 a selection of Bergson's own writings including the whole of the *Introduction to Metaphysics* was published in Italian. The translator was Giovanni Papini, an art critic. Papini and Ardengo Soffici (another art critic and writer on Bergson) were both in contact with the Milanese Futurists by August 1911, and Soffici, indeed, formed a close working relationship with Boccioni.

The fruits of the availability of Bergsonian ideas are first manifest in detail in the *Futurist Painting: Technical Manifesto* of 1910. This document, from which these passages come, was signed by Boccioni, Carrà, Russolo, Balla and Severini but was probably mostly written by Boccioni:

> All things run, all things are rapidly changing. A profile is never motionless before our eyes, but it constantly appears and disappears. On account of the persistency of an image on the retina, moving objects constantly multiply themselves; their forms change like rapid vibrations, in their mad career. Thus a running horse has not four legs, but twenty, and their movements are triangular. . . . our bodies penetrate the sofas on which we sit, and the sofas penetrate our bodies. The motor bus rushes into the houses which it passes, and in their turn the houses throw themselves on the motor bus and are blended with it. . . . Painters have shown us the objects and the people placed before us. We shall henceforth put the spectator in the centre of the picture.[16]

What makes these passages Bergsonian rather than Nietzschean is their emphasis on the motion and interpretation of phenomena in the process of immediate perception itself. The first, for example, stresses the fluidity of such perception, but at the same time – through its point about the persistence of the image on the retina – also implies that the immediate data of perception are built upon the persistence and continuing influence of data past. The second quotation is even more revealing. We recall Bergson's argument that the distinction between the thing and its environment is one of gradation rather than absolute division. All things profoundly intersect. Since, indeed, the forms of the phenomenal world are 'nuclei' defined on the basis of the observer's practical capacities for action, the division between human subject and the phenomenal world is not a sharp one. Hence the Futurist's desire to place the spectator at the centre of the picture.

7 Umberto Boccioni, *The City Rises*, 1910. The Museum of Modern Art, New York. Mrs. Simon Guggenheim Fund

The Bergsonian themes mentioned here recur with variations and different emphases throughout the whole corpus of Futurist writing upon art. Their immediate significance in the *Technical Manifesto* of 1910 is to legitimize the technique of 'Divisionism', as in Boccioni's *The City Rises* (1910; pl. 7) and Carrà's *Leaving the Theatre* (1909–10). In these and many other contemporaneous Futurist works, forms are given vibrancy and fluidity by means of streaked brushwork, and juxtaposition and harmonies of colour derived from the Italian followers of Post-Impressionism, notably Gaetano Previati. The world is presented as a flowing continuum of interpenetrating elements.

During 1911, this substantially figurative phase of Futurism was subjected to some dramatic transformations. The text which accompanied the major travelling Futurist Exhibition of early 1912 elucidates the theoretical and Bergsonian basis of the crucial changes which had been effected in these works. The following passage is logically central to this.

The simultaneousness of states of mind in the work of art: that is the intoxicating aim of our art. . . .

In painting a person on a balcony, seen from inside the room, we do not limit the scene to what the square frame of the window renders visible; but we try to render the sum total of visual sensations which the

person on the balcony has experienced, the sun-bathed throng in the street, the double row of houses which stretch to right and left, the beflowered balconies, etc. This implies the simultaneousness of the ambient, and, the dislocation and dismemberment of objects, the scattering and fusion of details, freed from accepted logic, and independent of one another.

In order to make the spectator live in the centre of the picture, . . . the picture must be the synthesis of *what one remembers* and of *what one sees*.[17]

This passage is profoundly indebted to Bergson's *Introduction to Metaphysics*, in which he suggests that through intuition we are able to coincide with the inner reality of the object, with its – the phrase is Bergson's – 'state of mind'. In such a relation, the duration of the observer and that of the observed are joined directly and simultaneously. Hence, it would follow (and this seems to be, in effect, the Futurists' point) that if such a relation could be successfully depicted, then the object, the observer of the object, and the observer of the picture of them will all be simultaneously bonded. We will have an intuition wherein the indivisible flow of duration will receive its fullest expression.

Another striking link between the 1912 exhibition text passage and Bergson's *Introduction* is Bergson's claim that in using 'images' to form intuitions, the images chosen must be as disparate as possible to prevent any one of them from 'usurping' the intuition, and to test and condition, and thereby render the mind amenable to further intuition. These points are precisely what the Futurists are responding to in their advocacy of the 'dislocation and dismemberment' of objects, and the need to escape from 'accepted logic'.

The full significance of this becomes clear when we have developed the implication of another passage in the 1912 exhibition text:

All objects . . . tend to the infinite by their *force lines*, the continuity of which is measured by our intuition.

It is these *force lines* that we must draw in order to lead back the work of art to true painting. We interpret nature by rendering these objects on the canvas as the beginning or the prolongation of the rhythms impressed upon our sensibility by these very objects.[18]

The Bergsonian significance of these remarks is profound. As we saw, for Bergson matter is a form of attenuated duration whose vibrating elements interact with each other to infinity, 'travelling in every direction like shivers through an immense body.'[19] The human subject's body in conjunction with consciousness and memory interrupts this flow and concen-

8 Umberto Boccioni, *States of Mind II – They Who Go*, 1911. The Museum of Modern Art, New York. Gift of Nelson A. Rockefeller

trates it into shapes and contours which constitute the phenomenal world. It is this vision of matter in motion, arrested by human embodiment, which is exemplified in the 1912 exhibition text, through the notion of force-lines impinging on sensibility. This strategy is derived from Bergson's *Matter and Memory*, a copy of which Boccioni owned and annotated. In this work Bergson notes that 'lines of force' in the context of scientific knowledge direct us towards a proper understanding of duration. They 'point out a direction in which we may seek for a representation of the real'.[20] More specifically, 'they show us, pervading concrete extensity, modifications, perturbations, changes of tension or of energy, and nothing else. It is by this, above all, that they tend to unite with the purely psychological analysis of motion',[21] that is, the flow of duration.

This sophisticated theoretical position is embodied in numerous Futurist works of late 1911. Boccioni's *States of Mind* series (pl. 8), for example, involves expressionistic articulations of form, but disciplined and reorganized by the imposition of grid-like structures, or other emphatically linear elements. Similar formal features are to be found in Russolo's *Houses + Lights + Sky* (1912–13; pl. 11) and Carrà's 1911 reworking of the *Funeral*

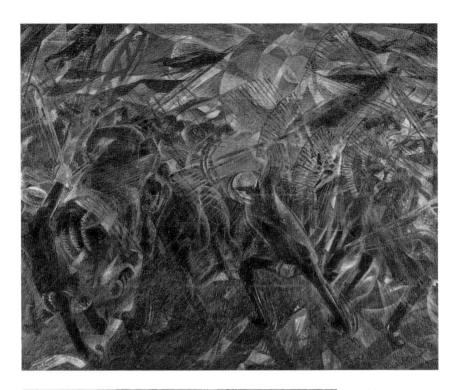

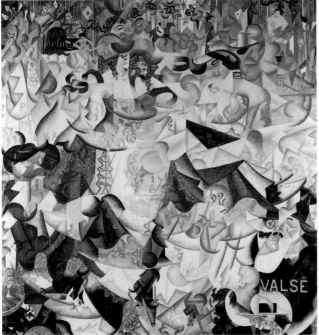

9 (*above*) Carlo Carrà, *Funeral of the Anarchist Galli*, 1911. The Museum of Modern Art, New York. Acquired through the Lillie P. Bliss Bequest

10 Gino Severini, *Dynamic Hieroglyphic of the Bal Tabarin*, 1912. The Museum of Modern Art, New York. Acquired through the Lillie P. Bliss Bequest

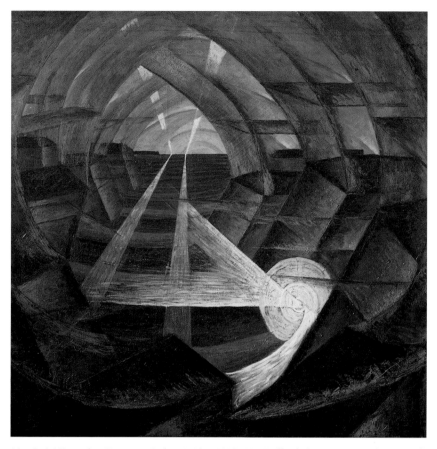

11 Luigi Russolo, *Houses + Lights + Sky*, 1912–13. Oeffentliche Kunstsammlung Basel, Kunstmuseum, Gift of Sonia Delaunay

of the Anarchist Galli (pl. 9). In all these works we find a shift of emphasis from figurative evocations of reality's interpretative flow to more abstract and linear realizations of this.

The immediate impulse for the Futurists' deeper study of Bergson's work may have come from their personal contact with Papini and Soffici in mid-1911. However, the more interesting impulse is probably their acquaintance with Cubism. Their first encounter with it came indirectly, from an article on Picasso and Braque written by Soffici himself. Later that year the Milanese Futurists travelled to Paris and experienced the new innovations first hand. I suggest this led to a more searching study of Bergson because they hoped to find further ideas which would enable them to adopt and modify the radical pictorial innovations of Cubism on their own terms. The Bergsonian themes I have outlined fulfil this expec-

tation to a high degree. They enable Cubist space and grid structures to be transformed into a pictorial discourse of objects in motion, rather than – as in Picasso and Braque's work at least – a discourse of pictorial distension and re-arrangement.

Now after the 1912 exhibition, it is Boccioni's writings which determine the major contours of Futurist theory and practice. It is in his work, indeed, that the engagement with Bergson becomes more complex. In the *Technical Manifesto of Futurist Sculpture* (1912) Boccioni extends his position on painting to sculpture, by proclaiming that the

> systematization of the vibrations of lights and the interpretation of planes will produce a Futurist sculpture, whose basis will be architectural, not only as a construction of masses, but in such a way that the sculptural block itself will contain the architectural elements of the *sculptural environment* in which the object exists.[22]

Hence, 'the cogs of a machine might easily appear out of the armpits of a mechanic . . . or a book with its fanned-out pages could intersect the reader's stomach.'[23]

As well as applying already established ideas to the particular case of sculpture, Boccioni for the first time introduces in this Manifesto the important notion of 'analogy'. This is more fully developed in a major essay of 1913 entitled *The Plastic Foundations of Futurist Sculpture and Painting*. Boccioni usefully situates the notion:

> We must consider works of art (in sculpture or painting) as structures of a new inner reality, which the elements of external reality are helping to build up into a system of plastic analogy, which was almost completely unknown before us. It is through the kind of analogy, which is the very essence of poetry, that we shall achieve the plastic state of mind.[24]

What is at issue here can be illustrated by reference to Boccioni's major work of 1913, *Unique Forms of Continuity in Space* (pl. 12). Here, the striding figure is not – as one might have expected – obviously intersected by forms from the surrounding environment. Rather, it is articulated in such a way that past and possible future dispositions of the limbs are suggested by truncated force lines in the figure's striding gait. It is this fusion which functions as an external complex of form that is analogous to, or suggestive of, the figure's internal power of motion.

Interestingly, the notion of analogy used in a slightly different sense also plays an important role in Marinetti's *Technical Manifesto of Futurist Literature* (1912) and Severini's *The Plastic Analogies of Dynamism – Futurist Manifesto* (1913). Severini remarks, for example, that 'in this epoch of dynamism and

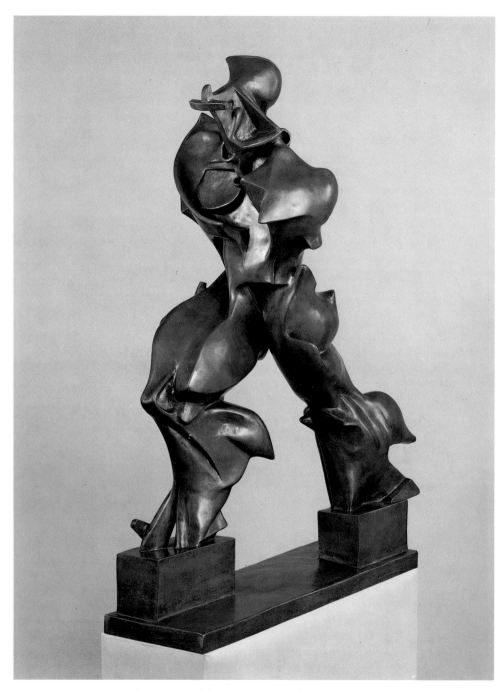

12 Umberto Boccioni, *Unique Forms of Continuity in Space*, 1913. Tate Gallery, London

simultaneity, one cannot separate any event or object from the memories, the plastic preferences or aversions, which its *expansive action* calls up simultaneously in us'.[25] Hence, in Severini's paintings of 1912 and 1913 (pl. 10), some central motif – often that of a dancer – is dissolved into a rhapsodic whirl of form and colour which implies past and future movement and at the same time is patterned by elements with connotative relations, or more subjective associations with the central motif. The notion of analogy (as Boccioni and Severini explicitly acknowledge) came immediately from Marinetti, but had become almost a tradition for avant-garde theories and practices in the arts since at least the time of Rimbaud and Mallarmé. And it took root so deeply in Futurist work only from 1912 onwards through the relationship to Bergson. We recall Bergson's claim that 'memory directs upon perception received the memories which resemble it and which are already sketched out by the movements themselves.'[26]

For Bergson, in other words, present acts of perception are always inscribed with both memory images of analogous or associated acts from the past and with anticipations of analogous ones from the future. Hence, Severini's notion of analogy, with its emphasis on immediate perception being enriched by memory, can be tied directly to Bergson. Indeed, as we have seen, Boccioni's related claim concerning the way in which force-lines expressing sequences of external movement are analogous to the object's inner motion is also paralleled in Bergson.

The depth of these links with Bergson is underlined by the fact that in *The Plastic Foundations* where Boccioni discusses his notion of analogy at length for the first time, he also introduces other Bergsonian themes and, indeed, makes two direct quotations from *Matter and Memory*. Boccioni (following Bergson) draws a contrast between the quantitative (measurable) aspects of objects and their environment, and their qualitative aspect, which is an inner motion graspable by feeling. This qualitative dimension is synonymous with the object's unfolding through time. He then quotes Bergson: '*All division of matter into independent bodies with absolutely determined outlines is an artifical division*'; and, '*Every movement, inasmuch as it is a passage from rest to rest, is absolutely indivisible.*'[27] Boccioni continues by describing the Futurists' experimental search for a 'formula' which would express this indivisible continuity. His descriptions culminate in this crucial passage:

What we want to do is show the living object in its dynamic growth: i.e. provide a synthesis of those transformations undergone by an object due to its twin motions, one relative the other absolute, . . . for us the object has no form in itself; the only definable thing is the line which reveals

the relationship between the object's weight (quantity) and its expansion (quality).

This has suggested to us the notion of force-lines, which characterize the object and enable us to see it as a whole – it is the essential interpretation of the object, the perception of life itself.[28]

Having introduced the notion of external plastic analogy and its capacity to express inner motion earlier on, Boccioni here states this in explicitly Bergsonian terms as the distinction between 'relative' and 'absolute' motion, a distinction which occurs in the *Introduction to Metaphysics* and in *Matter and Memory*.

That Boccioni broadly follows Bergson in his usage of this distinction is manifest in the *Plastic Foundations* and, indeed, through the clarifications of it in his next two major writings. In fact, absolute and relative motion become the key terms in his theoretical vocabulary. They receive their fullest exposition in an essay of 1914 which is actually entitled *Absolute Motion + Relative Motion = Dynamism*. In this decisive text, Boccioni characterizes absolute motion. It is

the plastic power which the object contains within itself, closely bound up with its own organic substance, determined by its particular characteristics: colour, temperature, consistency, form (flat, concave, convex, cubic, conic, spiral, elliptical, spherical etc.).'[29]

To understand this plastic power, the object must be 'conceived according to its living outlines, which reveal how its motion would be broken up according to the tendencies of its forces.'[30] To illustrate this, Boccioni notes that 'if you place next to each other a sphere and a cone, you will find in the former a sensation of dynamic thrust and in the latter one of static indifference. The sphere shows a tendency to move while the cone tends to take root.'[31] Boccioni's point is that absolute motion is the object's inner momentum, that is the different directions in which (if there were no human observer to gather up and solidify them) an object's vibrations might disperse themselves on the basis of its own particular physical characteristics.

Let us now consider relative motion. This is simply a case of an object's movement in relation to those other objects – mobile and immobile – which surround it. In effect, this means the object as it is gathered up and situated in accordance with human perception and action. In the present text, however, Boccioni gives it a rather startling characterization. As one might expect, he begins by observing that it 'is a manner of conceiving the object in motion quite apart from the motion which it contains within

itself.' But he then continues 'That is to say, we must try to find a form which will be able to express a new absolute – *speed*, which any true modern spirit cannot ignore. It is a matter of studying the different aspects assumed by the life of speed and its consequent simultaneousness.'[32]

This remark is crucial, for here Boccioni goes far beyond Bergson's notion of relative motion. The key to this is 'simultaneousness', which came to acquire a specific meaning in addition to its literal one. In his book *Futurist Painting and Sculpture* (1914) Boccioni defines it as 'an effect of that great cause which is *universal dynamism*. It is the lyrical manifestation of modern ways of looking at life, based on speed and contemporaneity in knowledge and communication'.[33] Simultaneousness, then, is the dynamic so-much-happening-at-once ambience and rhythm of modern life itself – and especially of that which is shaped by the products of the techno-scientific spirit.

To grasp the full significance of this we must recall two features of Bergson's philosophy. The first is that through intuition we identify with the duration or absolute motion of the object. The second is the problematic status of analytic thought which immobilizes and distorts reality but which is necessary to our practical existence. Bergson generally (and especially in the *Introduction to Metaphysics*) presents the latter as an obstacle to the former. Our drive to intuit absolute motion is hampered by the analytic concepts – notably those of homogeneous and divisible space and time – with which we take hold of objects and thence locate them in the framework of relative motion. What makes this conflict into something of a tension is that it turns intuition into an attempt to transcend a framework which – whatever its metaphysical limitations – is nevertheless an integral and necessary feature of the human condition, and is perhaps (a point barely dealt with by Bergson) a presupposition of consciousness itself. Boccioni's sustained engagement with Bergson after 1911, I argue, and especially his treatment of absolute and relative motion, registers both an awareness of this conflict and an attempt to resolve it through art. The key to this is 'simultaneity'. For the speed and dymanic ambience of life in a modern age of techno-science means that the realm of relative motion is energized. As Boccioni emphatically states, 'there is no such thing as a non-moving object in our modern perception of life.'[34]

From sentiments such as these, two things can be inferred. First that the Futurists' intoxication with the modern world is such that they would manifestly want to see such a world acknowledged and affirmed, rather than dismissed *tout court* in the baggage of relative motion in general, as a mere barrier to intuition. The second inference is that through 'simultaneousness' this barrier, in fact, disappears. The speed and dymamism of

modern life, the very instruments of science and technology have made the realm of relative motion come alive and vibrate with energy. Imagery derived from modern life, therefore, enables the constant becoming of duration and absolute motion to be expressed analogically within the world of relative motion. Modernity turns the latter realm into an image of the absolute, whereas before it was primarily an impediment to it. This is why Boccioni describes 'speed' as a new 'absolute' and glorifies 'universal dynamism'. The very title *Absolute Motion + Relative Motion = Dynamism* indicates that he regards his work as a creative synthesis which articulates the absoluteness of becoming in a way that improves upon and advances beyond Bergson. It is also instructive in this respect to note an observation made in an article of 1913. Boccioni addresses a claim made by Soffici that Parisian Cubism was incompatible with Bergson's philosophy:

> You said . . . that Bergson distrusts artistic realizations. Very true. Do you not think that we Futurists have gone beyond that point and that sometime soon someone will run along behind us – philosophically speaking – and will discover heaven knows what system in what is our, the only possible, the great *dynamic and evolutionary realization.*[35]

Boccioni here triumphantly affirms that Futurism goes beyond Bergson, through the synthesis of absolute and relative motion in dynamism, whose image is attained through the evolution of Futurist art. As one might expect, the major Futurist works from 1912 transform the Cubist grid and space into combinations of minor figurative elements and force lines which articulate characteristically forceful objects. Boccioni's *Dynamism* series of 1913 is the most emphatic of these. Other artists, lacking perhaps the same degree of theoretical sophistication, give this impulse a more lyrical inflection, as with Severini's various *Dancers* and such works as Balla's *Dynamism of a Dog on a Leash* (1912).

Unfortunately, an art which takes itself to have attained the absolute is always faced with the problem of what to do next. It is tempting to suppose that the advent of the First World War was the major factor in Futurism's decline in significance. Certainly, Boccioni's removal from the scene was a key factor. But it might also be claimed that Futurism had already reached the limits of the theoretical and practical space set out for it by Boccioni. Its major products after 1913 (including much of Boccioni's own work) seem to be retreading paths already trod, most notably the re-appropriation of Cubist methods and motifs.

I have argued that the influence of Bergson upon Futurist theory and practice is rather more profound than is generally acknowledged. His overall philosophical position, with its affirmation of creativity and reser-

vations about common-sense notions of time and space, offers a general basis for the ratification of avant-garde art. It also offers a means flexible enough to enable Futurism to appropriate Cubist innovations on its own terms. More significant still, Bergson's ideas not only indicate the primacy of artistic expression, but also suggest that dislocational multi-image systems have a privileged role in such expression. The most profound influences on a person or practice are usually those which we not only learn from but also improve upon. The tension between absolute and relative motion in Bergson offers just such an opportunity. Indeed, by resolving this tension, the Futurists could claim a positive metaphysical significance not only for art and for modernity as such, but most of all for the art of modernity.

Iterability in Futurist Art

It would be all too easy to say that the links with Bergson are so close that if his philosophy is flawed – as many argue is the case – then so is any art founded upon it. However, the Bergsonian influence on Futurism does not translate completely into the iterable dimension. Suppose, for example, that we encounter Boccioni's *The City Rises* or *Unique Forms of Continuity in Space* or a Severini *Dancer* without knowing anything of the theoretical ideas which informed their production. In such an encounter, we would have no visual grounds whatsoever for reading them in terms of duration, lines of force, absolute and relative motion, and other distinctively Bergsonian concepts. However, through the contrast with more conventional representation, we could at least read the visual cues as forms in motion or as a confluence of present and past appearances. Indeed, it is precisely this Futurist innovation which is the origin of a now established (if not especially common) feature of picturing's iterable dimension, the after-image. This is, of course, most familiar from photography, where frames of the moment of action are juxtaposed with succeeding or preceding ones to depict a sequence of activity in a single image. One might say that this key Futurist 'effect' has succeeded in conventionalizing itself as a new aspect of the iterability of pictorial representation. It has invested picturing with a means to represent overtly temporal processes of becoming. More importantly, in its emphatic relating of present to past and possible future appearances, it indicates the reciprocal basis of becoming. Hence Futurism's inability to iterate Bergson's philosophy in its full depth is actually an advantage. For it means that his more problematic notions are left buried in the relation between the works and the original context of

theoretical production; whilst the reciprocal basis of becoming – which has viability independent of Bergson's specific understanding of it – introduces the iterable dimension.

As with Braque and Picasso's Cubism, Italian Futurism renders explicit factors which are usually implicitly present only in representation. Here memory has the decisive role in defining the presentness of an image. This conjunction of after-imagery with the willingness to organize arrays of sequential appearance in emphatically formalized and decorative ways (notably grid structures), gives a strong sense of the productive imagination.

It is clear that for Futurist artists, the overt embodiment of philosophical ideas in artistic representation offers a mode of understanding which exceeds what philosophy itself can offer. This is a claim to which I shall return as this book progresses.

In the final analysis, then, Futurism is not the revolutionary transformation of art which it takes itself to be. However, it does succeed in transcending its Bergsonian sources, in a way which allows key reciprocal relations to figure as overt factors at the iterable level of pictorial representation. It also continues that thematization of the indirect philosophical significance of representation which was begun by Picasso and Braque.

For a much more radical structure and application, we turn now to the work of Kasimir Malevich.

Malevich, Philosophy and Non-Objectivity

Of all twentieth-century artists' writings on art, those of Malevich are the most difficult to comprehend.[1] Matters are especially complicated by an over-readiness to associate his theories with the mystical philosophy of Ouspensky. The more significant philosophical inspiration for Malevich is Schopenhauer. Indeed, it is by following the general analogies between Malevich's theory and practice and Schopenhauer's world-view, that the iterable surplus in the former's work emerges most clearly.

Let us start by tracing the links with Ouspensky.

Ouspensky and Malevich

In *Tertium Organum* (1912) Ouspensky gives systematic exposition to theories of the fourth dimension which had been in the air for many years:

> Any three-dimensional body, existing, is at the same time moving in time and leaves as a tracing of its movement the temporal, or four-dimensional body. We never see or feel body, because of the limitations of our receptive apparatus . . . we see the *section* of it only, which section we call the three-dimensional body. Therefore we are in error [in] thinking that the three-dimensional body is in itself something real. It is the *projection* of the four-dimensional body – its picture – the image of it *on our plane*.[2]

Ouspensky's point here is that from the viewpoint of four-dimensional reality all the spatial aspects and relations of things are simultaneously present. However, because of the limitations of our cognitive apparatus, we observers have only a three-dimensional, partial grasp of this spatial plenitude. We supplement our immediate awareness of an object's spatial presence with a sense of those aspects of it which we have experienced in the past, or which would unfurl if we changed our position in relation to it. Here, in other words, the simultaneous presence of all an object's aspects can be comprehended only crudely, through the medium of temporal

succession. This temporal dimension, however, is only an illusion. As Ouspensky puts it:

> we are receiving as sensations and projecting into the outside world as phenomena, *the immobile angles and curves of the fourth dimension.*
>
> On this account is it not necessary and possible to realise that the world is immobile and constant, and that it seems to us to be moving and evolving simply because we are looking at it through the narrow slit of our sensuous receptivity.[3]

In contrast to this limited viewpoint, a four-dimensional consciousness 'can see the past and the future lying together and existing simultaneously'.[4] What appears to us as temporal succession is, for such a consciousness, an eternal present – a single, infinitely extended and complex spatial datum. Now whilst human beings do not possess fully realized four-dimensional consciousness, there are certain states of 'intuitive' awareness which take us in such a direction. These are especially to be found in the province of mysticism and art. The latter, for example, combines feeling and thought in a way that evokes a sense of the world's plenitude, including the fact that it exceeds the limits of three-dimensional understanding. In Ouspensky's words, 'in art we have already the first experiments in a *language of the future.* Art anticipates a physic evolution and divines its future forms.'[5] It is almost certain that Malevich had a working knowledge of the text of *Tertium Organum* itself, or at least a very well-developed second-hand knowledge of some of the ideas expressed in it. For example, Ouspensky describes the brain as a 'prism' and suggests that 'it is a mirror reflecting psychic life'.[6] Malevich uses these very metaphors in a number of his own texts, such as the essay 'On New Systems in Art' (1920) where we are told that 'in the world of the mind our brain reflects its real states like a mirror'.[7] Further uses of the brain–prism or mirror metaphor are found in Malevich's two major works, *The World As Non-Objectivity* (written by 1925) and *The Non-Objective World* (1927). Similarly, Ouspensky's use of the term 'intuition' for higher knowledge or functions, and his vision of art as a prophetic language of evolutionary possibility, are shared by Malevich, as in his 'Suprematism: Thirty-Four Drawings' (1920), in which Suprematist form is seen by him as the basis of an advanced future technology. However, the most fundamental point of contact between Ouspensky and Malevich consists in another metaphor, the likening of our limited cognitive apparatus to a slit through which we view a more fundamental reality. Ouspensky's 'narrow slit of our sensuous receptivity', for example, is echoed by Malevich's likening our view of nature to 'looking through the small slit of the kaleidoscope'.[8] This shared metaphor

for the limited nature of human cognition is not just a link between Ouspensky and Malevich, it is one which embodies an idea that is foundational for both their theoretical positions. But Ouspensky and Malevich assign very different meanings to this shared acknowledgement of our cognitive limitations.

There are two different approaches to the fourth dimension. The first of these consists in the fact that we can and do have a direct experience of four dimensionality as spatial through combining different (that is, temporally distinct) three-dimensional views of an object in a single pictorial or photographic plane. However, this literal spatial realization of the fourth dimension is not one which Ouspensky ever remarks upon. For him, the real task of art is to evoke a sense of the fourth dimension by much more complex and indirect associational means. It should intimate that the whole and infinite 'truth' about reality cannot be fully expressed in any straightforward finite terms. Hence, the literal artistic spatialization would probably have struck him as deeply inadequate. This sense of inadequacy, indeed, would have been further amplified by the fact that in such pictorial realization, the image of spatial simultaneity is one which manifestly declares itself as one that is assembled or constructed from materials. Hence, its origins in a temporally successive process might tend to inhibit our reading of the image's spatial simultaneity.

For Ouspensky the fourth dimension must be recognized, instead, as the absolute metaphysical ground of our finite world. This is because the existence of temporal succession itself logically presupposes that of a fully realized four-dimensional realm. His main argument for this is as follows:

> The past and the future cannot *not exist* because if they do not exist then neither does the present exist. Unquestionably they exist *somewhere* together, but we do not see them . . . We are forced to admit that the past, the present and the future do not differ in anything, one from another; there exists just one present – the Eternal Now . . .[9]

We should therefore accept the existence of the fourth dimension in the absolute sense of the single infinitely extended spatial datum, with all its parts simultaneously present. The upshot of this for Ouspensky is that temporal succession is a form of bondage which can and must be transcended through 'intuition' or evolutionary progress. Cosmic consciousness of the fourth dimension is our legitimate goal.

Ouspensky's arguments are, however, deeply flawed. First, far from the existence of the present presupposing the simultaneous existence of the past and the future, it presupposes precisely the opposite. As I argued in Chapter 1, any notion of the present – eternal or finite – is intelligible only

in so far as its existence differs from that of other modes of temporality. To put this point in general terms, we can have no notion of past, present or future except on the basis of the differences which characterize them. It might seem that if four-dimensional cosmic consciousness could be realized, at least for such a consciousness our world would appear as an infinitely extended space with all its parts simultaneously present. Even this, however, is problematic. For any notion of consciousness presupposes that there is some object which one is conscious of. But an object can be present to consciousness only by being distinguished from some item which is *not* simultaneously present. Consciousness, in other words, necessarily involves some awareness of temporal succession, unless it is of the most rudimentary animal form. But cosmic four-dimensional consciousness, of course, could hardly be that.

In utter contrast stands Malevich's theoretical position. In *The World as Non-Objectivity*, for example, Malevich tells us that

> The fourth dimension is a kinetic tape on which the object is unrolled in the fourth state, disclosing its whole in elements.
>
> All the changeability of man's affairs is built on this fourth dimension and the fact that in each place it is measured in a different way in accordance with circumstances which surround it, and they are rich in their multiplicity of points.[10]

This passage suggests that for Malevich, the fourth dimension is seen primarily as temporal, relational and artistic (in the literal sense noted earlier), rather than absolute and metaphysical in the manner of Ouspensky. We 'realize' an object four-dimensionally when we investigate the temporal unfurling of its spatial aspects and, in the creation of art, combine these multiple views of an object, its surroundings and associations on a single plane. Consider, for example, *Lamp (Musical Instrument)* of 1913–14 (pl. 13). The image is constructed from recognizable figurative elements such as the lamp itself and fragments of musical instruments. These are situated in a (collectively) more indeterminate pictorial context which alludes both to internal and external surroundings. (The latter is signified, for example, by the saw-toothed top of a fortress wall towards the centre of the composition.)

It is this artistic sense of a fourth dimension which informs the Cubo-Futuristic phase of Malevich's painterly development. That the spatial realization of the fourth dimension means no more to Malevich than this artistic sense is shown by the fact that (as we shall see) the bulk of his writing is dominated by the theme of the constancy of becoming. He rightly emphasizes, in other words, precisely those temporal issues which

13 Kasimir Malevich, *Lamp (Musical Instrument)*, 1913–14. Stedelijk Museum, Amsterdam

Ouspensky so glaringly misunderstands. Indeed, whereas Ouspensky sees becoming as an illusion to be transcended in the direction of an optimistic and cheerful cosmic consciousness, Malevich sees it more pessimistically as both the essence and inescapable limit of the human condition. It cannot be transcended, whatever is on the 'other side'.

Malevich derives from Ouspensky at best a sense of the limited nature of the human condition, a belief in the destiny of art and a few technical terms. His interest in the fourth dimension as a source for Cubo-Futurism may have been vaguely stimulated by reading Ouspensky. But equally it may have simply arisen from his intercourse with the canvases and ideas of French Cubism and Italian Futurism. Similar considerations apply to Malevich's Suprematist period, for example the '0.10' exhibition of 1915. This included works whose titles refer to forms moving in the fourth dimension. But the key term is 'movement'. Movement entails temporal succession, a process of becoming, and suggests therefore that Malevich's sense of the fourth dimension is finite and temporal rather than absolute and metaphysical in Ouspensky's sense.

The Importance of Schopenhauer

In order to understand Malevich's arrival at the fully-fledged notion of 'non-objectivity' we must follow up the interplay between his pessimistic scepticism concerning cognition and the idea of the constancy of becoming. The source of this latter theme (and the pessimistic intonation of the former) is Schopenhauer's philosophy. For Schopenhauer, the world consists of a will that is engaged in an endless process of becoming. It projects a realm of spatio-temporal phenomena in which different forms – organic and inorganic – are engaged in perpetual strife. As Schopenhauer puts it,

> everywhere in nature we see contest, struggle, and the fluctuation of victory, and later on we shall recognize in this more distinctively the variance with itself essential to the will. Every grade of the will's objectification fights for the matter, the space, and the time of another. Persistent matter must constantly change its form, since, under the guidance of causality, mechanical, physical, chemical, and organic phenomena, eagerly striving to appear, snatch the matter from one another, for each wishes to reveal its own idea. This contest can be followed through the whole of nature; indeed only through it does nature exist.[11]

Human beings are the highest grade of objectified will. But in their struggles for life and meaning, projects are realized, thwarted and sup-

planted by other projects. The strife and becoming of the will find no moment of culmination. The most that can be achieved are certain contemplative states, in philosophy, morality and art, which temporarily lift the individual beyond the strife of the will's becoming.

Malevich put Schopenhauer's philosophy to idiosyncratic use. In 'From Cubism and Futurism to Suprematism and the New Realism in Painting' (1916 version) Malevich informs us that

> Everything runs from the past to the future, but everything should live by the present, for in the future the apple trees will shed their blossom.
> Tomorrow will wipe out the trace of the present, and you will not catch up with the pace of life.
> The mire of the past, like a millstone, will drag you down.[12]

This valorization of the present is the key to Malevich's conception of art. For him the great classical tradition of art is tied to its past, for in essence it simply refines or aestheticizes the achievements of 'primitive naturalism'. It is only with Futurism that art manages to, as it were, catch up with the present. This is because in this movement 'the wholeness of things' is 'violated' in accordance with the dynamic rhythms of modern machinery. Futurism, however, has its drawback: its contemporaneity is still tied to the representation of the products of 'utilitarian reason' (machinery and other functional artefacts). Paradoxically, this is inferior to utilitarian reason itself. As Malevich puts it,

> the forms of utilitarian reason are superior to any images in pictures.
> They are already superior, because they are living and have come from material which has been given a new form for the new life.[13]

What is needed is for art to become a living form of creation analogous to utilitarian reason, but without being tied to utilitarian reason's creation of functional, consciously intended artefacts. In this respect, Malevich suggests that we should 'free our art from vulgar subject matter and teach our consciousness to see everything in nature not as real forms and objects, but as material masses from which forms must be made'.[14] This means that artistic creation must become absolute. That is to say, it must become congruent not with nature or natural form as such, but rather with the unconscious organizational basis from which natural forms are generated. Forms must emerge as independent elements from the mass of the painting, in the same way as, in Schopenhauer's terms, Will projects the teeming forms of the phenomenal world. To carry this analogy further, for Malevich it is the square as the basic painterly mass which functions as a generative matrix analogous to Schopenhauerian will.

I am suggesting, then, that in Malevich's first major essay something analogous to Schopenhauer's world-view is offered as the basis for artistic creativity. In his next major writing, 'On New Systems in Art', Malevich goes much further:

> Intuition is the kernel of infinity. Everything that is visible on our globe disperses itself in it. Forms originated from the intuitive energy which conquers the infinite. Hence arise variants of form as tools of movement.
>
> The globe is simply a lump of intuitive wisdom that must run over the paths of the infinite. Everything has arisen from earth and is running, and every step in an epoch of culture, every step meets the new conquest and must change, with different emphasis; forms of the past disintegrate again into elements, continuing in this way until their energy disappears.[15]

The world is an infinite 'intuitive universal movement of energic forces'. It is one vast reservoir of forms in motion in conflict with one another. Malevich goes on to claim that what governs this strife of becoming is an 'economic' principle 'which affirms that every action is the result of bodily energy, but that all bodies attempt to preserve their energy . . . This is the way in which nature, and bodies, and the whole of man's creation move.'[16] Hence the world forms itself into centralized systems of organisms, each striving to preserve its energy. At the apex of this process is the human being, who strives to conserve energy by organizing the world into ever more simple and economic systems; by constantly changing, the human being thereby evolves. This will lead to a decisive point:

> When humanity achieves unity – it is on the path now – it must unite the new world which has flown out of its skull: with the organisms with which he [that is, humanity] is at present engaged in a bloody struggle . . .
>
> Similarly we strive for unity with the elements: we do not wish to conquer or destroy, but to fuse them into a single organism with ourselves.[17]

This evolutionary possibility will not mean an end to becoming. Rather, it means that we will be congruent with becoming, through having maximally realized the principle which structures it, that of economy. For Malevich the Suprematist square points us towards this congruence: 'Standing on the economic Suprematist surface of the square . . . I leave it to serve as the basis for the economic extension of life's activity.'[18] But why can the Suprematist square serve this function?

Malevich's opaque answers are found in the text 'Non-Objective Creation and Suprematism' (1919) and 'Suprematism – Thirty-Four Drawings'

(1920). In the former (re-iterating his 1916 position) we are told that 'All
that we see has arisen from a colour mass turned into plane and volume,
and any machine, house, man, table, they are all painterly volume sys-
tems.'[19] This would suggest that the Suprematist square is perhaps the most
fundamental articulation of all visual form. It is the site where the amor-
phous colour mass begins to take on specific structures. In the 'Thirty-Four
Drawings' this is elaborated further in relation to his three phases of
Suprematist development up to 1920:

> Their constructions were based upon the chief economic principle of
> conveying the power of statics of apparent rest by the plane alone.
> Hitherto all the forms of whatever it might be have only expressed these
> sensations of touch through a large quantity of interrelated and linked
> forms, creating an organism, but in Suprematism action on one plane or
> in one volume has been achieved by economic geometricism.[20]

The key point is that the Suprematist square is not only the most funda-
mental expression of all form, it is also the most lucid means of expressing
the economic principle which governs the generation and interactions of
such form.

We will recall Malevich's point in the 1916 paper that utilitarian forms
are superior to those in naturalistic representation because they are direct
and 'living'. By adopting an 'economic' method based on geometric form
(with the square as its most basic articulation) Suprematist art becomes
congruent with the dynamics and statics of reality itself. This congruence
is not indirect and second-hand, it is an exemplification of pure becoming.
The reason for this (although Malevich himself does not make it explicit)
is that some kinds of geometric form – notably the square – are actually
two-dimensional entities. Consider *Suprematist Composition: White on White*
(c. 1918). This exemplar of a white square tilted obliquely to the plane is
not a mere representation or illusion of such forms and their relation; it is
a real concrete instance of them. Or, in *Supremus No. 57* (1916; pl. 14), a
triangle tilted obliquely to the plane sets up a basic optical tension which
is amplified by the uneven aggregation of a variety of small geometric
forms around each angle of the triangle. In these cases and, indeed, all
Malevich's Suprematist work, stasis and action are functions of the imme-
diate optical relation between real two-dimensional entities, rather than
relations encountered indirectly, as properties of a represented three-
dimensional world. Malevich's 'economic' geometricism thus expresses
form in motion at a level of reality which is continuous with that of our
active material existence. Indeed, even if – in the case of expressing volume
through cones or cylindrical form – we bring in an element of three-

14 Kasimir Malevich, *Supremus No. 57*, 1916. Tate Gallery, London

dimensional illusion, this is nevertheless overtly recognizable as something generated from more fundamental two-dimensional geometrical forms and relations. Such abstraction, lays claim to a more direct reality than conventional representation, because it does not conceal the means whereby illusion is generated.

Suprematist geometric abstraction – with the square as its purest expression – is an economic way of exemplifying the constancy of becoming. It achieves this by collapsing the division between art and the level of real existence. It is hardly surprising that Malevich further suggests that (once absorbed in material life) Suprematist abstraction can serve as the model for a future technology, wherein machines 'will be one whole without any fastening',[21] as complex in potential but as economical in form as the Suprematist square.

There is no concrete evidence that Malevich had read Schopenhauer before 1920, but Schopenhauer had long been translated into Russian and was widely discussed in avant-garde circles. Indeed, it is clear that Malevich was familiar with and sympathetic to the most fundamental tenets of Schopenhauer's work. For example, Schopenhauer's world-will engaged in perpetual strife and becoming through its objectified forms is parall-eled by Malevich's intuitive energic force (with colour mass as its visual aspect) infinitely generating its conflicting systems and organisms. In Schopenhauer, the organizational principle of the will's becoming is the principle of sufficient reason. In Malevich, we find a broad counterpart to this in the 'economic' principle. In the writings of both, the human being is explicitly identified as the 'perfection' of nature.

Whilst Schopenhauer allows some fragmentary salvation for humankind through contemplative withdrawal from the world in philosophy and art, Malevich, in contrast, sees a more systematic redemption to be had through actual involvement with the world. We cannot escape our natural limita-tions, but we can at least exist in harmony with the principle of economy that shapes becoming and the pattern of nature. This congruence is achieved through the creation of Suprematist, that is, 'non-objective' art. So far from this being an aesthetic withdrawal from the world, it actually sets out a utopian evolutionary possibility for humankind – a total merging with the creative force at the heart of nature. That Malevich sees this utopian potential as opened up – and the very fact that he emphasizes the notions of system, centralization and economy – points to him rethinking Schopenhauer in the light of not only the demands of advanced art, but also the possibilities opened up by early Soviet Communism. Indeed, in his essay 'The Question of Imitative Art' (1921) Malevich passionately (and at some points almost hysterically) links avant-garde art to Communism, and naturalistic academic work to the forces of reaction.

After 1920 Malevich's artistic output seems to diminish and for some years until 1925 he worked on a book entitled *The World as Non-Objectivity*, which in both title and content involves clear references[22] to Schopenhauer's *The World as Will and Representation*. It was not published in Malevich's lifetime and, given the political circumstances, it could not have been. First, Malevich observes that '"The world is the world" and there cannot be various points of view about it. The silence of the world troubles our brain and a wish arises in the brain to pierce this silence and to find in it a tongue and word.'[23] In concrete terms, this means that 'we attempt all the time to define the unknown and to form such a phenom-enon into a "something" comprehensible to us whereas its sense lies in the opposite.'[24] But why does the sense of what is 'comprehensible' lie in its

opposite, incomprehensibility? Malevich's answer to this is that the ground of the world (which at some points he rather misleadingly calls 'matter'; 'energy in motion' would have been a better choice) is wholly and radically non-objective. As Malevich puts it, 'Matter in movement is an unchanging, indestructible "world" situated outside time progress, which represents various conditions of universal nature and a force, which transforms the aspectual forms of phenomena'.[25] What is ultimately real, in other words, is simply the world in its becoming – the irrational brute fact of energy which changes. We beings who are embroiled in becoming, however, can have no perceptual experience of what it is that becomes. It is wholly non-objective and cannot be represented in thought or through any kind of mystical intuition. Given the fact that (like Schopenhauer's world will) what is ultimately real and permanent is beyond the phenomenal world and cannot be directly experienced, all knowledge and belief systems are of purely relative value and significance.

But what of art? In this respect Malevich notes:

> The analysis of Suprematism gave me the idea that colour matter is possibly colourless and assumes colour in accordance with various tensions of movement. Painting as colour matter has arrived at a new condition, it has lost all its colour variations and has become simply colourless, non-objective energy. Does this not embrace the meaning of all meanings, all doctrines about the world . . .[26]

In retrospect, then, Malevich still sees Suprematism as in a sense congruent with the visual world's formative principles, but he now reads this in somewhat more specific terms. The Suprematist work is colourless energy whose very colourlessness is a symbol of what ultimate reality in its non-objectivity must be for us – indeterminate being.

What Malevich is, in effect, doing in these passages is radicalizing the pessimism of Schopenhauer's world view. We who are caught in the world's web of becoming can give no justification for or explication of why this is. For Schopenhauer, the world can at least be explained as 'will objectifying itself' – there is at least some philosophical story to be told about the world. But for Malevich there is no such story. Talk of the economic principle and progress has gone. The real world is simply non-objective and there.

In *The Non-Objective World* (published in 1927 in Germany) Malevich developed these ideas: 'Matter itself is eternal and *immutable*, its *insensibility to life* – its lifelessness – is unshakeable. The changing element of our consciousness and feeling, in the last analysis is illusion'.[27] And, 'For that matter, the truth concerning reality actually doesn't interest us in the least.

What interest us are changes in the manifestation of the perceptible. But these changes . . . are also only changes in the formal point of view – illusions.'[28] Hence, the 'essence and content of consciousness' lies in its 'inability to comprehend reality'.

In these remarks, Malevich is not only radicalizing Schopenhauer's pessimism but also turning it into an existentialist awareness of the absurdity of being. At the heart of all things is a timeless substrate which is indifferent and absolutely unknowable. All that consciousness can have is a perpetual stream of becoming – a welter of appearances, none of which does anything but distort our understanding of the ultimate ground of reality. Malevich then radicalized his theory of art accordingly. For, 'If it is possible to maintain that works of art are creations of our subconscious (or superconscious) mind, we are bound to acknowledge that this subconscious mind is more infallible than the conscious.'[29] This is an important transition. Rather than deriving art's significance from its rational congruence with the constancy of becoming, he is returning to its irrational core – that 'additional element' wherein, through responding to given historical circumstances, individual artistic inspiration can go beyond these and issue in an original work. Something which springs from subconscious inspiration will be closer to the ultimate ground of things than something produced solely on the basis of the normal 'illusions' of our conscious life. That is why, for Malevich, 'Art values – in the present case the aesthetic arrangement of the forms and colours on the picture plane – are essentially imperishable and immeasurable because they are timeless.'[30]

Such values are timeless because they are the expression of 'pure feeling' – the subconscious intuitive urge to create art. In the transition from such feeling to the concrete art object, we find an aesthetic exemplar of the broader philosophical momentum from the timeless irrational · core of being to its phenomenological manifestations. On the basis of this, Malevich reinterprets key phases in his own development, in particular the *Black Square* (1915) – 'The Square – feeling, the white field – the void beyond this feeling'.[31] We are thus led to his major conclusion: 'And so there the new non-objective art stands – the expression of pure feeling, seeking no practical values, no ideas, no "promised land" . . . art values alone are absolute and endure forever.'[32]

A mediating factor in the trajectory of Malevich's later thought was his disillusionment with the authoritarian decay of Soviet Communism. But, as we have seen, issues of process and temporality are decisively bound up with the rise of Modernism in the visual arts. And if – as in the case of Italian Futurism and Malevich – becoming is seen as fundamental, attention must be paid to the structure of that which becomes. With the discourse

of the subconscious and 'pure feeling', Malevich looks in this direction and anticipates strategies which are also found in Surrealism and Mondrian's Neo-Plasticism. He is, therefore, a major transitional figure.

Furthermore, Malevich's linking of the subconscious and 'pure feeling' is a way – albeit a philosophically clumsy one – of affirming the importance of contingency (elements of chance, the inexplicable and choice between alternatives) in human experience. In a finished work of art, those contingent moments of inspiration and creativity are now condensed into necessity. They make the work what it is. Remove any aspect of them and the work would turn out differently. The aesthetic configuration is one which brings that which is temporal and transient and that which is timeless into a harmonious reciprocity. It gathers up the ephemerality of creative moments and preserves them in an enduring form. Now this is true of all art, but whereas in many artists it is only one aspect of the total creative project, in those with an existential orientation it is much more central. A philosophical viewpoint which emphasizes the principle of reciprocity tends to assign a privileged role to art in articulating the human experience of the world. Malevich, in his radicalizing of Schopenhauer's pessimism, brings us to this position. Art shows truths which cannot adequately be spoken. For Schopenhauer, philosophical and aesthetic contemplation offer some respite from the bondage of becoming. For Malevich, this is true of the aesthetic experience of art alone. The central limitation of his view is his apparent desire to link this redemptive function specifically to non-objective art. This, like most things pertaining to Malevich's theories, is an ambiguous issue.

Malevich and Iterability

The real importance of Malevich in relation to iterability lies not so much in his early or later figurative pieces, or the Cubo-Futurist canvases, but in his Suprematist works. For in these, Malevich is not 'abstracting' from a world of given phenomenological items (as in the cases of Kandinsky, Cubism and Futurism); rather, he constructs the pictorial manifold from 'real' two-dimensional entities, notably the square. Representation is thus achieved primarily on the basis of optical illusionism, rather than the conventional pictorial mode.

To see what is at issue here, we turn to some remarks from Merleau-Ponty:

> Let us imagine a white patch on a homogeneous background. All the
> points in the patch have a certain 'function' in common, that of forming

themselves into a 'shape'. The colour of the shape is more resistant [sic] than that of the background; the edges of the white patch 'belong' to it, and are not part of the background although they adjoin it: the patch appears to be placed on the background and does not break it up. Each part arouses the expectation of more than it contains, and this elementary perception is therefore already charged with a *meaning*.[33]

What Merleau-Ponty is describing is the way in which a simple optical relation of, let us call it, figure and ground can disclose that fundamental principle of reciprocity, which is the structural basis of both the perceptual field and the life of self-consciousness itself. As Merleau-Ponty goes on to say, this figure–ground relation is 'the very definition of perception, that without which a phenomenon cannot be said to be a perception.'[34]

The relation of figure to ground is a dynamic and mutable one. It is an active reciprocity wherein an element which functions as a figure singled out for attention in one context can, with a change of context, function as part of a broader ground defining a different figure. This space of reciprocal transformation is the optical substance of Malevich's Suprematism. Of special significance here is the square. In the *Black Square* and *Suprematist Composition: White on White*, it functions as both figure and ground (since in both works the internal square is defined in relation to a white plane). In other works, we find the square elongated into a rectangle or tilted obliquely. In other works still, it functions solely as a ground for individual forms or constellations.

Even to describe Malevich's Suprematist work is to discern reciprocal relations, movement, resistance, conflict, displacement and possibilities of transformation in the figure–ground structure. It might be said that such works function as abstract optical metaphors for the relational dynamics of perception itself. They re-present variations on a basic philosophical structure. However, whilst we might say this, is there any compelling reason why we must say it? The answer is yes. For Malevich does not create entirely *ex nihilo*. By using the technical formats of pictorial representation (placing marks on a single delimited plane), he locates his Suprematist works within a convention of expectation. This convention holds that the relations of marks to one another and to the plane are to be taken as signifying something other than just that. As we have seen, this 'something other' is a broader, quasi-Schopenhauerian notion of reality. But (as we also found in the relation of Bergson to Futurism) this specific philosophical dimension does not iterate adequately. To discern it requires that we relate Malevich's work to its immediate context of production and to a body of complex theoretical texts. But there is an aspect of this position

which is iterable. For embedded in Malevich's quasi-Schopenhauerisn code is the primacy of the square and forms in reciprocal movement. I have shown how this both relates to the foundational principle of perception itself and is the optical basis of Malevich's Suprematism. Indeed, apart from aesthetic characterizations of particular works in terms of 'harmony', 'balance' or 'elegance', this approach is the only one available for reading Malevich beyond his immediate historical context.

In fact, this is an important breakthrough. For Malevich's discourse of reciprocal relations at the level of optical illusion is highly iterable. Irrespective of an artist's specific intentions, if he or she is creating a purely abstract work, then the dimension of optical illusion will always be both paramount and (as we have seen) describable as forms reciprocally related in a field of potential movement. Indeed, this virtual schema of perceptual relations it translates into many stylistic idioms apart from Malevich's relatively austere geometricism. Before considering these, we must first address the important issues arising from the figuratively orientated art of Surrealism.

Dialectic and Surrealism: From Breton to Pollock

Surrealism grew as a systematic response to the moral and social disasters of the First World War, and to the lack of positive social change after these disasters. It had one immediate cultural precedent, namely those complex tendencies focused in the Dadaist movement between 1916 and 1920. This movement is usually characterized in terms of its critical, destructive and anarchic orientation. Richard Huelsenbeck sums this aspect up well:

> Because Dada is the most direct and vivid expression of its time, it turns against everything that strikes it as obsolete, mummified, ingrained. It claims a certain radicalism; it beats a drum, wails, sneers and lashes out; it crystallizes into a single point yet extends over the endless plain; it resembles the mayfly and yet is kin to the eternal colossi of the Nile Valley. Whoever lives for the day, lives for ever.[1] . . .
>
> The Dadaist is the freest man on earth. Human beings are simply ideologues if they fall for the swindle perpetrated by their own intellects; that an idea, symbol or a momentarily perceived fact, has an absolute reality. Concepts can be handled like a collection of dominoes.[2]

In these remarks we can find loose elements of those more negative themes which occur to some degree in Nietzsche and Bergson. However, whereas in Expressionist and Futurist art the tension between process and 'objective order' is resolved through specific forms of artistic creativity, in Dada it is left open. Dadaist creative activity is characterized by a wholehearted willingness not only to embrace contradiction but also to see this in the most positive terms. Again in Huelsenbeck's words:

> Since Dada is the movement, experience and naiveté, that sets great value on its common sense – deeming a table a table and a plum a plum – and since Dada is unconnected to anything and so has the capacity to make connections with all things, it opposes every kind of ideology, i.e. every combative stance, against every inhibition or barrier. Dada is elasticity itself . . .[3]

All these remarks from Huelsenbeck embody a yearning for freedom, but one which is realized through the nominal contradiction of being, as

it were, simultaneously inside and outside the 'common sense' world. This immanence in, and transcendence of, the given order of material things is a theme which proves decisive for the Surrealists.

There are other points of contact: for example, the Zurich Dadaists – notably Arp – experimented with the aesthetic possibilities presented by random creation and chance associations; the Berlin group professed concrete utopian aspirations linked to far-left politics and the possibilities of sexual liberation implied by the radical psychoanalysis of Otto Gross.

In rehearsing this Dadaist background to Surrealism, we can put its Freudian dimension in a proper perspective. Hal Foster's book *Compulsive Beauty*, for example, interrogates Breton's work as if the psychoanalytic and political were the only dimensions to Surrealism.[4] Of course, Breton was familiar with Freud's work, and it undoubtedley proved a vital catalyst in the emergence of Surrealism from Paris Dadaist activity after 1920. However, an undue emphasis on the Freudian elements in Surrealism's history and interpretation brings only distortion. It prevents a full understanding of the totality and depth of the project.

As an indicator of this depth, one might briefly consider the work of Salvador Dalí in the late 1920s and 1930s. In many paintings from this time, such as *The Persistence of Memory* (1931; pl. 15), Dalí uses complex obsessive symbolism deriving from both childhood memories and psychoanalytic writing. He also exploits morphological analogies wherein the specific shape of one thing recalls or suggests that of an entirely different thing. (This strategy is a kind of visual analogue to the psychoanalytic technique of free association.) One might think that Dalí's work at this time simply illustrates the kind of factors and explorative techniques which Freud relates to neuroses and psychological 'complexes', which would make Dalí's Surrealism little more than pictorial representation with Freudian syntax and iconography.

Interestingly, however, Dalí's writings of the time suggest a much more radical agenda, in which his notion of 'paranoiac-critical' activity is of central importance:

> Paranoiac-critical activity no longer deals with surrealist phenomena and images in isolation, but rather considers them in a coherent unity of systematic and significant relationship. In contrast to the passive disinterested, contemplative and aesthetic attitude to irrational phenomena, there is the active, systematic, organizational, cognizant attitude to irrational phenomena considered as associative, partial and significant events in the authentic domain of our immediate and practical experience of life.[5]

15 Salvador Dalí, *The Persistence of Memory*, 1931. The Museum of Modern Art, New York. Given Anonymously

Dalí's point here is that paranoid delirium (wherein chance associations of objects or events are seen as having a systematic 'meaning') can also have a critical significance. This is realized through systematically bringing about arbitrary conjunctions of incongruous but associationally potent items. This 'irrational' conjunction illuminates or develops a dimension of meaning which is latent in normal experience – namely that irrational periphery of fleeting memories, fantasies, daydreams and chance or unexpected happenings, which influence or determine the direction and substance of particular moments of conscious life. As Dalí remarks. 'Paranoiac-critical activity is an organizational and productive force of objective chance.'[6] Hence the Freudian aspect is not the *raison d'être* of Dalí's Surrealism, it is just one aspect of a much broader project, which seeks to express the depth and complexity of our reciprocity with the world. Similar considerations also hold in relation to other Surrealists, most notably to Breton's theories.

To do justice to the deeper significance of Surrealism, therefore, it is necessary to engage with an influence which (though it has scarcely – if at

all – been recognized) is much more decisive than Freud. I am referring to Hegel.[7] Breton himself said:

> I hardly need stress the 'Hegelian' aspect of the idea of surpassing all antinomies. It was undeniable Hegel – and no one else – who put me in the condition necessary to perceive this point, to strain toward it with all my might, and to make this very tension my life's goal . . . To my mind his method has bankrupted all others. When Hegelian dialectic ceases to function, for me there is no thought, no hope of truth.[8]

The further advantage of engaging with Hegel is that it leads fairly directly to the other major philosophical influence on Surrealism, Marxism. More than this, indeed, it requires that we attend to the specific aspect of Marxism which was most fruitful to the movement, the notion of dialectic. To establish the discussion on a firm footing, I shall first outline the general philosophical positions of Hegel and Engels.

Dialectic in Hegel and Engels

At the heart of Hegel's philosophy is a sense of the limitations of the finite mind. Truths concerning the human condition and its place in the broader scheme of things do not come 'ready-made' in discrete moments of illumination. They are to be found in the systematic unfolding and progression of thought, and the specific forms of cultural existence in which thought finds expression.

The key to this progression lies in Hegel's notion of logic.[9] It has three aspects. The first is that of 'understanding'. By this Hegel means a primarily analytic mode of thought which resolves and separates its object into parts, or clearly distinguishable components, each of which it regards as self-subsistent. This analytic mode of thought is very much the province of scientific rationalism and other influential traditions in philosophy. It is, however, beset by problems: if we seek to explain the world as a system of physical laws or of self-subsistent entities, paradox is the inevitable result. Familiar examples are those of the world's 'beginning' and the 'infinite divisibility' of matter. On the one hand, physicists search for the ultimate origin of the universe, and ultimate irreducible particles (for the universe, it seems, must 'stop' somewhere); yet on the other hand, any specific finite event or item is by its very nature dependent for its occurrence on some preceeding event or item. Understanding, in other words, is led into paradox when it seeks to explain ultimate truths in analytic terms of distinguishable components.

The second aspect of logic, for Hegel, is the 'dialectical' or, rather, negatively dialectical mode. This is used when the analytic approach of understanding is shown to entail contradictions. It is the cognitive strategy which is especially manifest in forms of philosophical scepticism – notably that of Hume – and marks an advance on the 'truths' of understanding, but in its negative character remains essentially incomplete. For truth to be articulated in its fullest sense, dialectic must advance to a third stage, that of 'speculative reason'. In this mode, reason comprehends the passage from understanding's distorted truths to dialectical contradictions, as not just a fact, but rather a necessary progression. Truth is seen as a pattern of immanent development wherein partial truths are shown as necessarily contradictory. This showing embodies a wholeness of comprehension which both contains and goes beyond the steps which lead up to it.

For Hegel, if the task of speculative reason is carried through, the world stands revealed as a network of relations with a logical principle of organization, wherein the existence of individual parts is dependent on the principle's immanence and unifying function within the whole. The universe in its entirety – the 'Absolute' – is a system of progressing thought whose completeness is not determined by questions of spatio-temporal extent but by its immanent logic. It has no inside or outside. It simply is, and is so necessarily. In principle, one might begin by thinking of any significant item or event and through speculative reason, trace the contradictions inherent in it, arriving eventually at a proper comprehension of the truth of the Absolute.

This position is, of course, completely at odds with a common-sense understanding of reality. From that point of view things are just things, events are just events: all in all, everything is either one thing or another. For Hegel, however,

> Neither in heaven nor in earth, neither in the world of mind nor of nature, is there anywhere such an abstract 'either-or' as the understanding maintains. Whatever exists is concrete, with difference and opposition in itself. The finitude of things will then lie in the want of correspondence between their immediate being, and what they essentially are. Thus, in inorganic nature, the acid is implicitly at the same time the base: in other words, its only being consists in its relation to its other. Hence also the acid is not something that persists quietly in the contrast: it is always in effort to realize what it potentially is. Contradiction is the very moving principle of the world.[10]

This passage points to the heart of Hegel's philosophical position. The positing of any finite item or relation in thought or perception is always

contradictory when it is 'one-sided' or incomplete. Consider the statement 'The rose is a rose'. In common sense terms this is a mere tautology. For Hegel, however, it entails contradiction. The rose for example, is only a rose in so far as it is not a daffodil, a dahlia, a lump of sugar or whatever. It has a determinate character only by negating or being 'other than' an infinite number of other items or relations. Again, to affirm the universal character 'is a rose', one is simultaneously relating it to and distinguishing it from other individual roses. There is an ontological problem in that the statement seems to affirm the fact that we are dealing with a relation between self-subsistent particulars. But a rose can be a rose only in so far as one day it will cease to be a rose: finite items can exist only if they come into being and eventually pass out of existence. These negative possibilities are entailed by any affirmation of 'isness'.

Hegel's theory, then, is that whilst the positing of any finite fact necessarily entails massively complex relations between universals and particulars, and existence *per se*, its simple affirmatory character excludes explicit reference to such relations. It is in this sense of excluding the total logical context which makes them possible that our customary finite thoughts about the world and, indeed, finite things themselves, are self-contradictory. All that is finite is defined and made possible by its dependence on other finite things and relations. This dependency can be resolved only as thought posits an object and reveals implicit contradictions, thus passing on to a 'higher' stage of awareness, which preserves and transcends the previous stages. That stage must then be shown to embody contradiction and thence lead to a still higher, more logically complete stage.

This progression (often characterized as thesis–antithesis–synthesis) permeates the whole of reality. In Hegel's system, all life forms come into being and conflict with other life forms and forces in order to attain higher modes of existence. However, it is in the sphere of human activities and institutions that dialectical progression finds its decisive realization. For Hegel, the thesis–antithesis–synthesis structure informs all human agency and its products, that is the expressions of ideas, the products of rational agents. In everything human beings do and create, the Absolute is striving to comprehend itself in progressively more complete ways. This is especially the case in patterns of social organization, such as the state, and even more so in questions of art, religion and philosophy. In Hegel's terms these activities are privileged, in that by means of them, humankind is able to reflect and express its general relation to the world. As different art forms and religious and philosophical doctrines emerge in history and are superseded by others, the nature of what is ultimate – Absolute Spirit – is

gradually made manifest by this progression. In the most general terms, according to Hegel, religion (in the form of Christianity) is a more complex manifestation of the Absolute than is art; and philosophy is more complete than is Christianity. But it is only with Hegel's own philosophy that the Absolute comprehends itself with final unconditional necessity and completeness. From the vantage point of his system, the world appears not as a contradictory aggregate of self-subsistent material things, but as a system wherein all parts are dependent on the unfolding immanent logic of the whole; and the human reality is decisive through comprehending and thence completing this logic.

At first sight Hegel's philosophy seems massively authoritarian: every item in the universe has a determined place. But this doctrine also offers a kind of redemption of the commonplace and incongruous precisely because everything has its role to play in the whole. It also has a kind of epistemological principle of toleration, since it holds that competing ideas and world views are never absolutely false. They all have something of the truth within them, as long as they are viewed in relation to the immanent logic of the whole.

Hegel's approach has the attraction of showing the limits of common sense and scientific rationalism. A finite mind cannot comprehend truth in the fullest sense by simply dividing the world in a framework of self-subsistent categories and entities. It must take account of the fact that thought and perception has a kind of epistemological and ontological subconscious: our specific thoughts and perceptions emerge from and are defined against a fabric of broader relations which is suppressed or overlooked by immediate consciousness. (This fabric parallels my notion of the existential subconscious.)

Now, of course, Hegel's system raises many acute philosophical problems. I shall explore one which in a number of different forms is central to this study. The immanent logic which governs the unfolding system is deductive. It is not simply a case of advancing temporally from one stage to another. As noted earlier, *qua* Absolute Spirit the world has no beginning or end, no inside or outside. Rather it is a self-contained and self-determining whole. Much of the circular progression of this logic is presented by Hegel temporally, in terms of broad historical evolution. For example, Hegel's own system is seen as the culmination of a process of philosophical advance and is the point where the Absolute achieves self-congruence. But what happens after that? Is the rest of the history of the universe merely a logical superfluity? Indeed, whilst the system is self-contained, there is surely some question of origin to be explained.

This leads us to the closely related question of why the Absolute should exist. Given that there is a world, then Hegel can argue that it must form the system described by his philosophy. But this leaves open the question of why anything at all should be. This problem is especially serious since the whole dynamic of the Absolute is to find repose in unconditional necessity. But if we cannot explain the *raison d'être* of the Absolute itself, this dynamic remains incomplete.[11]

The existence of the world is a mysterious contingency – something which is, but did not have to be, and which is unamenable to further rational explanation. The question of contingency forms a major fault-line throughout Hegel's philosophy. His official position on this topic is as follows. Contingent facts or entities are ones which are actual but could have been otherwise. As Hegel puts it, 'Accordingly we consider the contingent to be what may or may not be, what may be in one way or in another, whose being or not-being, and whose being on this wise or otherwise, depends, not on itself but on something else.'[12] Hegel goes on to place this in a positive light against mechanistic and determinist views of reality:

> On the surface of Nature, so to speak, Chance reigns unchecked, and that contingency must simply be recognized, without the pretension sometimes erroneously ascribed to philosophy, of seeking to find in it a could-only-be-so-and-not-otherwise. Nor is contingency less visible in the world of Mind . . . Thus in language (although it be, as it were, the body of thought) Chance still unquestionably plays a decided part; and the same is true of the creations of law, of art, *etc.* The problem of science, and especially of philosophy, undoubtedly consists in eliciting the necessity concealed under the semblance of contingency. That, however, is far from meaning that the contingent belongs to our subjective conception alone, and must therefore be simply set aside, if we wish to get at the truth.'[13]

Whilst philosophy strives to recognize the immanent logic which organizes reality, it must allow a role for contingent events within the structure of the system as a whole. From the viewpoint of Hegelian speculative reason, in other words, the contingency of certain events has a necessary function in the broader scheme of things. Unfortunately, this is somewhat at odds with Hegel's absolute idealism. For if reality as a whole forms a self-contained, logically connected system of thought, it should be possible to deduce the existence of every item within the whole. All contingency will be mere 'semblance'.

The seriousness of this problem consists in the more general issue which it points towards: if there really is an element of contingency in the way the mind organizes its objects, then this suggests that there is something about the object which is other than mind.

This is a problem for Hegel but not an immediate one for those, such as Engels, who wish to appropriate dialectic on grounds less absolute than Hegel's idealism. Engels remarked that:

> the metaphysical mode of outlook, justifiable and even necessary as it is in a domain whose extent varies according to the nature of the object under investigation, nevertheless sooner or later always reaches a limit beyond which it becomes one-sided, limited, abstract, and loses its way in insoluable contradictions. And this is so because in considering individual things it loses sight of their connections; in contemplating their existence it forgets their coming into being and passing away; in looking at them at rest it leaves their motion out of account . . .[14]

Engels is here objecting to what Hegel calls 'understanding' and on broadly the same grounds. Against this, Engels advocates dialectical thinking 'which grasps things and their images, ideas, essentially in their interconnections, in their sequence, their movement, their birth and death'.[15] Like Hegel, Engels sees contradiction and negation as the very heart of dialectical movement, and again on similar grounds. In his words:

> Negation and dialectic does not mean simply saying no, or declaring that some thing does not exist, or destroying it in any way one likes . . . negation is determined . . . in the first place by the general, and secondly by the particular nature of the process. I must not only negate, but also in turn sublate the negation. I must therefore so construct the first negation that the second remains or becomes possible . . . Each class of things . . . has its appropriate form of being negated in such a way that it gives rise to development, and it is just the same with each class of conceptions and ideas.[16]

So Engels substantially reaffirms the major dynamic of Hegel's thought. The first key respect in which he differs from Hegel centres on the problem between the congruence of temporal and logical progression. For Engels this constitutes an insoluble contradiction within the Hegelian system, of which he says:

> On the one hand, its basic assumption was the historical outlook that human history is a process of evolution, which by its very nature cannot

find intellectual finality in the discovery of any so called absolute truth; but on the other hand, it laid claim to being the very sum total of precisely this absolute truth. A system of natural and historical knowledge which is all embracing and final for all time is in contradiction to the fundamental laws of dialectical thinking.[17]

The Hegelian system, Engels proposed, must be superseded by a materialism which, in its dialectical character, also overcomes the inert mechanistic and metaphysical materialism of the eighteenth century. A dialectical materialism will be one which grasps the immanent laws of logic that determine the continuing evolution of humanity. Engels's articulation is lucidly summarized:

> The materialist conception of history starts from the principle that production, and with production the exchange of its products, is the basis of social order; that in every society which has appeared in history the distribution of the products, and with it the division of society into classes or estates, is determined by what is produced and how it is produced, and how the product is exchanged.[18]

In due course, antagonistic and contradictory relationships develop between the modes of production and exchange and the patterns of social organization founded upon them. It is this contradiction which generates far-reaching historical change, in the form of struggle between classes. The most developed stage of this comes with the disintegration of the feudal system, and the growth of the capitalist mode of production, founded on the division of stages of production and labour in factories. Here

> The separation between the means of production concentrated in the hands of the capitalists, on the one side, and the producers now possessing nothing but their labour power, on the other, was made complete. *The contradiction between social production and capitalist appropriation became manifest as the antagonism between proletariat and bourgeoisie.*[19]

At the heart of this contradiction is the fact that whilst the capitalist economy is founded on a co-operative social mode of production (involving factories and the division of labour), the form in which the products of this mode are appropriated and exchanged remains that of an individualist market economy. This latter structure is an anarchic struggle for survival between individual capitalists. In order to survive in the market the capitalist must increasingly impoverish the workforce and improve the techniques of production. But this anarchy cannot prevail. In due course the impoverished proletariat, who form the social core of capitalist produc-

tion, will revolt against its rulers and inaugurate a socialist, and ultimately Communist, order of production. In this order the anarchy of market competition will be replaced by a planned economy geared to the needs and interests of all. In such a society, the planned and social nature of the means of production will be matched by similar characteristics in the patterns of appropriation and exchange. Class antagonism will thereby be abolished.

In addition, class antagonism in society is concealed by ideology. In Marx's and Engels's terms, ideology is a systematic framework of ideas, beliefs and institutions which conceal the true social basis of production in capitalist society. Such a framework, in essence, reflects and consolidates the interests of the ruling classes. Ideology, however, does not usually adopt a strategy of conscious deception. Rather, it is a self-deceptive body of false rationalizations, which is then systematically transmitted to the broader population. It is thus able temporarily to justify the existing order and reconcile the oppressed with their lot.

Ideology characteristically presents reality in terms of stable and enduring facts, relations and values – a 'natural' order of things and institutions. This apparent order is, at crucial periods, disrupted by social change consequent upon economic crisis. However, as we have seen, Engels follows Hegel in asserting that, ultimately, reality can be understood only as the progressive unfolding of an immanent logic. From this vantage point Engels holds that the apparent chaos and contingency of a society based on capitalist production can be seen to follow inexorable laws. The anarchy of the market economy is not simply an anarchy. The rise and fall of particular capitalists, politicians or institutions are individually contingent episodes but, viewed in a dialectical context, the tendencies in society which they instantiate are necessary ones. Chaos and anarchy play a necessary role in the unfolding of history. Indeed, from the dialectical materialist viewpoint, chance and necessity are identical.

As both Hegel and Engels thought, naive deterministic scientific viewpoints explain order in the world, but in a way which makes the existence of human freedom seem problematic. Expositions based on a dialectical logic of immanence, in contrast, establish freedom on a proper rational basis. The individual achieves freedom when he or she is able to recognize and act in harmony with the unfolding logic, rather than simply be carried along by the contingent succession of events or be deceived by the false rationalizations of ideology. But, whereas for Hegel the only unconditional truth or ultimate principle is that of the Absolute's self-comprehension – the logic of the system as a whole – Engels cannot accept this. For him, the zone of truth *vis-à-vis* human historical evolution is rooted firmly in

economic structures. Now, given Engels's affirmation of the pervasiveness of dialectical relationship in human affairs and nature itself, this move is contradictory in a bad sense. Engels is unwarrantably favouring one element within a reciprocally developing totality. In effect, he is superimposing a causal model – economic determinism – on an otherwise dialectical system. To be fair, his model is not simply deterministic in that he allows that elements in the broader socio-cultural superstructure can affect the economic infrastructure. Even so, such contingencies themselves have a necessary function. They are absorbed back into the grand narrative of the primacy of the economic. Engels, in other words, offers us a kind of sawn-off dialectic, where the immanent dialectical logic of historical development is always coerced by the causal effects of economic transformations.

This general problem finds a potent exemplar in the case of the negation of capitalism. According to Engels, as soon as capitalism is abolished, the source of social conflict is removed:

> The interference of the state power in social relations becomes superfluous in one sphere after another, and then ceases of itself. The government of persons is replaced by the administration of things and the direction of the processes of production. The state is not 'abolished', *it withers away*.[20]

With the abolition of the division of labour and class society, therefore, the state will cease to be of use. Engels imagines that in a classless society 'administration' and 'direction' will be a function of free co-operation between individuals and communities. Planning, 'administration' and 'direction', unfortunately, require specialization, and with specialization appear social difference and, in principle, the possibility of new antagonisms. So, the negation of capitalism does not entail the advent of a classless society or the withering away of the state. There are many terms in which capitalism's contradictions might find a resolution.

Engels's problem here is not simply lack of foresight, it is dialectical incompetence, in a literal sense. He follows Hegel too closely in seeking some fundamental principle of immanent logic (economic determinism, in his case) and some ultimate stage of realization. Whilst Hegel's system has its flaws, it is at least profoundly consistent: if reality is dialectically organized, then it is so through and through. The only resolution is that of the system as a whole. Engels, however, wants a historical materialist truth that is at odds with dialectical logic. In privileging economic structures, he narrows the scope of dialectic in a way that also narrows our comprehension of what it is to be human in the fullest sense. Economic structures

do not simply transform one another with consequent social upheavals. Rather, they are an important element within the totality of relations which characterize human existence in different historical epochs. As such, their significance is variable.

To summarize: Hegel's philosophy holds that truth consists in the progressive unfolding of claims to knowledge whose contradictions emerge and are transcended in higher truth claims which are themselves superseded. This progression is a logic immanent to the way humans think about and organize their world. It is brought to completion in Hegel's philosophy when the world comprehends itself as a logically unfolded system of thoughts and relations – an Absolute mind. Hegel, unfortunately, does not offer a satisfactory account of the relation between historical development and logical progression in his system. Neither can he account for the world existing at all. Indeed, the relation between contingency and necessity is ambiguous even in the internal details of his system.

Engels follows in his affirmation of the dialectical structure of reality, but rejects its idealist claim to have arrived at a final state of ultimate knowledge. Instead, he proposes a dialectical materialism which seeks to explain a logic which is immanent in the unfolding of human history. He locates this in the economic sphere. This in dialectical terms is an error, since it construes the function of economics in a fundamentally deterministic or causal mode, rather than a dialectical one. In so doing it impoverishes our understanding of the complexity of human forms of engagement with the world.

Breton's Use of Dialectic

Breton's writings show some general familiarity with Hegel's philosophy and a quite detailed knowledged of his monumental *Aesthetics*.[21] The influence of Engels is even more manifest, particularly his *Anti-Dühring* and *Ludwig Feuerbach and the End of German Classical Philosophy*. It is the full theoretical articulation of dialectical materialism in these works that orientated Breton more towards Engels than Marx. In 1934, Breton distinguished between two phases of Surrealism.

> The first can summarily be characterized by the belief . . . in the omnipotence of thought, considered capable of freeing itself by its own resources. This belief witnesses to a prevailing view that I look on today as extremely mistaken, the view that *thought is supreme over matter.*[22]

The outbreak of the Moroccan war in 1925 had stimulated Breton and his circle into a thorough reappraisal of their position. Surrealist activity 'Suddenly experienced the necessity of crossing over the gap that separates absolute idealism from dialectical materialism.'[23] Surrealism entered – to use Breton's term – its 'reasoning' phase. At first sight, this move from a neo-Hegelian to a dialectical materialist position seems readily explicable. The radical world view expounded in the *First Surrealist Manifesto* (1924) is not simply a pose or a theory which leaves one's everyday existence untouched. It has far-reaching socio-political implications and it is, therefore, hardly surprising that the impact of a war of imperialist aggression should act as a catalyst in moving the First Manifesto position towards a more concrete and even more radical socio-political standpoint.

There were also theoretical issues involved in the transition from 'intuitive' to 'reasoning' Surrealism. In the *First Manifesto* Breton declares:

We are still living under the reign of logic . . . But in this day and age logical methods are applicable only to solving problems of secondary interest. The absolute rationalism that is still in vogue allows us to consider only facts relating directly to our experience. Logical ends, on the contrary escape us . . . experience itself has found itself increasingly circumscribed. It paces back and forth in a cage from which it is more and more difficult to make it emerge.[24]

The decisive figure in the uncaging of experience is, according to Breton, Sigmund Freud. For it is he who overcomes the rigid division drawn between our rational modes of ordering the world and those modes – notably dreaming – which are customarily dismissed as irrational. Interestingly, much of the argument in the remainder of the *Manifesto* offers an approach to the dream which is not specifically Freudian (decoding dreams in terms of the specific subject's libidinal drives). Rather, Breton seeks to identify patterns of overlap between dreaming and 'normal' mental functioning such as memory. Indeed, it becomes clear that the resolution of the putative contradiction between waking and dreaming states has a much broader significance. On the basis of Freud's 'discoveries', Breton suggests that

The imagination is perhaps on the point of reasserting itself, of reclaiming its rights. If the depths of our mind contain within it strange forces capable of augmenting those on the surface, or of waging a victorious battle against them, there is every reason to seize them – first to seize them, then, if need be, to submit them to the control of our reason.[25]

Breton outlines the outcome of this seizure:

> From the moment when it is subjected to a methodical examination, when by means yet to be described, we succeed in recording the contents of dreams in their entirety . . . we may hope that the mysteries which really are not will give way to the great Mystery. I believe in the future resolution of these two states, dream and reality, which are seemingly so contradictory, into a kind of absolute reality, a surreality . . .[26]

Hence we arrive at Breton's formal definition:

> Surrealism. n. Psychic automatism in its pure state, by which one proposes to express – verbally, by means of the written word, or in any other manner – the actual functioning of thought. Directed by thought, in the absence of any control exercised by reason, exempt from any aesthetic or moral concern.[27]

In all these remarks, the Hegelian quest for absolute knowledge is both recast and subverted by the consequences which flow from overcoming the specific contradiction between waking and dreaming states. Through 'automatism' and 'Mystery', Breton indirectly focuses on precisely those areas which I identified as weaknesses in Hegel's philosophy. Automatism is a process of free association (analogous to dreaming) which introduces into conscious life – or makes explicit – those reserves of meaning which always subtend such life. Breton thus finds a strategy roughly analogous to Hegel's 'speculative reason' which gives expression to what I termed the epistemological and ontological subconscious. However, whereas Hegel stresses specific lines of necessity in the link between consciousness and subconsciousness, Breton gives this an existential emphasis by focusing on contingency. He affirms the element of arbitrariness in the way individuals arrive at, focus and develop their patterns of thought. In the artefact, such as a poem or 'writing', which reflects this, contingent facts and associations now have the character of necessity. We are shown the 'truth' which informs and makes possible the ordinary narrow functioning of thought.

Breton expects that the overcoming of the contradiction between waking and dreaming – achievable through the study and recollection of dreams, and automatism – will lead to a higher form of knowledge where putative mysteries are resolved. But he sees this as leading to the 'great Mystery'. Breton does not specify what it consists of. However, given his positive affirmation of it, and questions of the 'marvellous' in general, he is clearly thinking in terms of the ultimate ineffability and contingency of being, the question of why things are at all. He countenances something like the issue which Hegel himself is unable to face.

Breton's turning away from Hegelian idealism is not just a response to a crisis inaugurated by contemporary political events. Rather, he is intuitively concentrating on and developing areas which are problematic in Hegel. The *First Manifesto* itself, in other words, already counts as a revision and going beyond Hegel.

In the *Second Surrealist Manifesto* (1930) Breton makes an explicit transition from Hegelianism to dialectical materialism. After having affirmed his acceptance of the Hegelian view that freedom is a function of the interplay between individual and social being, Breton suggests that dialectic in the Hegelian sense is inappropriate. Indeed, he quotes Engels's *Anti-Dühring* in order to affirm that absolute idealism is superseded by materialism.[28] Breton then interprets materialist dialectics:

> There was, for us too, the necessity to put an end to idealism properly speaking, the creation of the word 'Surrealism' would testify to this, and to quote Engels's classic example once again, the necessity not to limit ourselves to the childish: 'The rose is a rose. The rose is not a rose. And yet the rose is a rose,' ...[29]

The quotation to which Breton is alluding is one where Engels shows how conventional understanding trivializes dialectical relations. We recall that Hegel holds that all finite utterances – even assertions of self-identity – are contradictory, to the degree that they are only true by virtue of what they negate. For Engels this dimension of negation is constituted by the fact that all finite items are in process. They are linked and limited by complex causal relations of growth and decay in concert with other things. Such relations form part of any item's full definition, but common sense or metaphysical thinking one-sidedly exclude these.

Breton develops Engels's example:

> to lure 'the rose' into a movement where it is pregnant with less benign contradictions, where it is successively, the rose that comes from the garden, the one that has an unusual place in a dream, the one impossible to move from the 'optical bouquet', the one that can completely change its properties by passing into automatic writing, the one that retains only those qualities that the painter has deigned to keep in a surrealist painting, and finally, the one completely different from itself, which returns to the garden.[30]

Here Breton affirms contingency and negation. The rose is inscribed and defined within a shifting network of possibilities, a function not simply of what the rose is in itself, but also of how it is posited within the experience of the one who experiences it. The objective skin of consciousness, as it

were, is mediated and given its specific character by a flesh of subjective associations.

This extends the logic of the *First Manifesto* towards what I have termed the existential subconscious (a background field of reciprocal relations which sustains any present moment of consciousness). The full ramifications of this are spelt out in Breton's *Surrealism and Painting* (1929):

> Everything I love, everything I think and feel, predisposes me towards a particular philosophy of immanence according to which surreality would be embodied in reality itself and would be neither superior nor exterior to it. And reciprocally, too, because the container would also be the contents. What I envisage is almost a communicating vessel between the contained and the container. Which means, of course, that I reject categorically all initiatives in the field of painting, as in that of literature, that would inevitably lead to the narrow isolation of thought from life, or alternatively the strict domination of life by thought.[31]

This turn away from the omnipotence of thought to the integration of thought and life seems to be the outcome of embracing dialectical materialism, but whilst Breton takes overt cues from Engels, his position actually subverts dialectical materialism, through his notion of immanence. There is an immanent logic to the world which consists of the reciprocity of subject and object in human experience. Each element in the pairing mediates and is a part of the full definition of the other (precisely what is illustrated in Breton's treatment of the rose example in the *Second Manifesto*). Engels's dialectical materialism, in contrast, sees the world of ideas as a reflection of the material world. Such a strategy exemplifies his tendency to impose a causal framework on dialectical relations. Breton's position, in other words, is more consistently dialectical and, indeed, begins to appear as a step towards the historical and conceptual overcoming of the contradiction between idealist and materialist philosophies. In this sense, it is a crude precursor of existential philosophy, particularly in its emphasis on contingency.

In the crucial essay 'The Crisis of the Object' (1936), Breton suggests:

> Our primary objective must be to oppose by all possible means the invasion of the world of the senses by things which mankind makes use of more from habit than necessity . . . with this new focus . . . the same object, however complete it may seem, reverts to an infinite series of *latent possibilities* which are not peculiar to it and therefore entail its transformation.[32]

Instrumental reason – the logic of technology and commodity production

– stultifies our proper understanding of the world. Reality appears as fixed and static, and adopted for exclusively functional ends. That dimension of subjective association which always situates objects of thought and perception is systematically suppressed. The function of surrealist activity is to restore and develop it. Possibility, as well as crude one-sided functional actuality, must be given voice. Breton explicitly identifies this as a recurrent theme in his thought – for example, in his 1924 suggestion that objects seen in dreams should be manufactured:

> I certainly hoped that the multiplication of such objects would entail the depreciation of those objects of often dubiously accepted *usefulness* which clutter up the so-called real world . . . But the aim I was pursuing went far beyond the mere creation of such objects: it entailed nothing less than the objectification of the very act of dreaming, its transformation into reality.[33]

The significance of this 'objectification' links with Breton's aspiration to create a 'communicating vessel' which expresses the reciprocity of the container and the contained, the interpenetration and interdependence of subject and object of experience. It is the core of Breton's theory of artistic creation, which I shall address in the next section.

It is clear that the 'intuitive' phase of Surrealism is not a case of Hegelian absolute idealism over and above Breton's adoption of a strategy analogous to Hegelian 'speculative reason'. Indeed, whilst Breton's strategy is dialectical, his specific employment of it (in relation to the contradiction of dreaming and waking) is one which has the effect of emphasizing the importance of contingency – an area which is problematic for Hegel. It is the radicalization and existentialization of this which leads to the 'reasoning' phase of Surrealism, where Breton embraces dialectical materialism.

However, the structure of Breton's general theory is actually at odds with this doctrine, since it affirms the reciprocity of subject and object of perception, and a radical notion of contingency. In affirming the 'is-but-could-be-otherwise' dimension of things Breton undermines the rigid structure of functional thinking. These structures characterize much of Engels's thought, particularly the primacy which he assigns to matter over thought and the economic over other spheres. Breton tacitly stands in an antagonistic relation to Marxist thought in general. That philosophy aspires to a society which is planned and administered without the oppressive mediation of the state, but the Surrealist strategy is one which calls into question the whole rationale of planning and administration in any central-

ized sense. In Breton's writing, his general quarrel is ostensibly with the Communist Party and Stalinism. I suggest that (despite his avowal of Trotskyism), his real quarrel is with Marxism.

Whatever the broader ramifications, it can be said that Engels provides a catalyst for Breton to bring dialectical strategy 'down to earth', even if this does not end up as dialectical materialism properly speaking. Engels's catalytic function is also important in relation to Breton's approach to artistic creation, to which I turn now.

Breton's Refinement of Dialectic

The key to understanding Breton's theory of art in the 1930s consists in his relation to Hegel's aesthetic theory. In his essay 'The Surrealist Situation of the Object' (1935), for example, Breton disparages Marxist theses on poetry and art in favour of Hegel's:

> I say even today it is Hegel whom we must question about how well-founded or ill-founded Surrealist activity in the arts is. He alone can say whatever this activity was predetermined in time; he alone can teach us whether its future duration is likely to be measured in days or centuries.[34]

In Hegel the historical unfolding of all forms of human expression articulates – with varying degrees of clarity – humankind's comprehension of the Absolute. Art is a crucial manifestation of this. Hegel analyses art through the overlapping vectors of the ontological and the historical. Ontologically, the artwork has a dialectical foundation in its ability to reconcile the sensible and the rational. It involves sensible and imaginative material for its embodiment; and it gives form to this material through subjective intelligent activity. Hegel again: 'The beauty of art is beauty born of spirit and born again, and the higher the spirit and its production stands above nature and its phenomena, the higher too is the beauty of art above nature.'[35] In creating art, humankind externalizes or objectifies its spiritual life, and is thus able to 'find itself' in the alien world of material objects. That which is other is here appropriated by spirit and, in being appropriated – made into an artwork – is invested with a 'higher' mode of being. The reason for this higher status is that in artistic creation, the artist transforms the world, not simply through forming material, but rather by investing that material with a symbolic content. Mere material objects are simply there. Artworks, however, show how human beings interpret, inhabit and evaluate their world. Hence, Hegel wrote,

Art liberates the true content of phenomena from the pure appearance and deception of the bad, transitory world, and gives them a higher actuality, born of the spirit. Thus, far from being mere pure appearance, a higher reality and true existence is to be ascribed to the phenomena of art in comparison with [those of] ordinary reality.[36]

For Hegel, the art-work reflects our mode of inherence in the world, but as a dialectical phenomenon rather than as a mere mirror. In the art-work, the world is clarified; we comprehend ourselves in fuller terms.

This dialectical function of art is also linked by Hegel to specific media. Broadly speaking, architecture and monumental sculpture are the crudest art-forms. Freestanding sculpture (exemplified by that of the ancient Greeks) is 'higher', whilst painting, music and poetry, are higher still. There is a transition from forms where the emphasis is primarily on physical material, to media where the physical base is secondary to the complex semantic meanings which are projected from it. Hegel, indeed, sees this transition as the key to the history of art itself. 'Symbolic' art (primarily architecture) is the earliest widespread form, but is superseded by the 'Classical' art of the Greeks, notably their statuary. It is at this point that art reaches its highest phase.[37] However, classical art is superseded by 'Romantic' art , primarily in painting, music and poetry. (It should be pointed out that whilst Hegel's use of the term 'Romantic' encompasses our usual historical employment of it, it also has for him a much broader application.) The reason why classical art is thus dialectically superseded, is because, with the advent of Christianity, humankind's spiritual needs and understanding of its relation to the world became much more complex. Media such as painting, music and poetry have a much greater depth of symbolic meaning and associations, according to Hegel. They are thus better fitted as expressions of humankind's spiritual complexity. Despite this, even they are superseded by religion in the form of Christianity and then philosophy itself. For Hegel, humanity's progress towards its self-comprehension as the voice of the Absolute means that art can no longer satisfy our deepest spiritual needs. In logical terms it comes to an end, in the sense that no advance can be made on 'Romantic' art.

In the 1930s Breton drew on all the major aspects of Hegel's theory: in the 'Crisis of the Object', he talks of his desire to 'objectify' dreams, and to create a 'communicating vessel' between that which contains and that which is contained in experience. In this, and other essays, it becomes clear that for Breton art is the 'communicating vessel' through its objectification of inner life (both dreams and the arbitrary associations of psychic automa-tism). As with Hegel, the art object has a dialectical function wherein truths

about humanity's relation to the world find concrete expression and thence transform our self-understanding. Breton also follows Hegel in his broad analysis of the way in which this definitive function has been mediated in different historical circumstances.

The most important element in the historical cues which Breton takes from Hegel is the notion of 'Romantic' art. As we saw earlier, in this mode of creation art has ceased to satisfy the deepest needs of the spirit and, in logical terms, comes to an end through the splitting apart of its constituent elements. In Hegel's words,

> On the one hand, art passes over to the presentation of common reality as such, to the presentation of objects as they exist in their contingent individuality . . . and it now has the interest of transforming this existence into a show by means of artistic skill; on the other hand, it turns vice versa into a mode of conception and portrayal completely contingent on the artist, i.e. into humour as the perversion and derangement of everything objective and real by means of wit and the play of a subjective outlook, and it ends with the artist's personal productive mastery over every content and form.[38]

There is an important ambiguity in Hegel's position. For whilst he describes art as coming to an 'end', he also seems to allow that works which are orientated towards the mere imitation of given realities and works where the artist's imagination is dominant still warrant the term art. Indeed, Hegel further allows that

> if this satisfaction in externality or the subjective portrayal is intensified, according to the principle of romantic art, into the heart's deeper immersion in the object, and if, on the other hand, what matters to humour is the object, then we acquire thereby a growing intimacy with the object, as sort of *objective* humour.[39]

Hegel is uncharacteristically cautious about the scope of this, claiming that, subjectively speaking, such activity is 'a fugitive notion, but one which is not purely accidental and capricious but an inner movement of the spirit devoted entirely to its object and retaining it as its content and interest'.[40] What Hegel is, in effect, saying is that whilst art in its deepest spiritual sense has come to an end, finite spirits still need to externalize themselves, to see material things imprinted with spirit through artistic creation. However, although the Absolute has attained self-comprehension, human beings continue to do such things as art and philosophy whose ontological and historical structure Hegel has woven together and presented exclusively as aspects of this achieved self-comprehension. After Hegel, therefore, are these activities mere contingencies

with no forward pattern of dialectical advance? Surely not; for if the world is a dialectical system, then contingency on this scale has to be accommodated. But Hegel, as we saw, has problems even with the concept of contingency.

It is precisely these areas of weakness on which Breton focuses and deals with effectively. In 'The Poverty of Poetry: The Aragon Affair' (1932) Breton deploys Hegel first to distinguish poetry from the prosaic, and then to affirm the relative autonomy of poetry and art. More specifically, he identifies the 'tremendous prophetic value' of Hegel's treatment of 'Romantic' art. Indeed, Breton sees this treatment as a key to understanding the structure of artistic modernism as such. Having indicated generally why this is so in his main text, Breton makes it more specific still in this footnote:

> I regret being unable to insist further here on the very remarkable oscillation between these two poles: (1) imitation of the accidental external aspect; (2) humour, which characterizes all artistic activity for over a century. On the one hand the imitation of the most deliberately 'earthy' aspects of life (naturalism), the most fugitive aspects of nature (impressionism), of the object considered as volume and substance (cubism), of the object in movement (futurism); on the other hand, humour, particularly striking in disturbed periods and testifying in the artist to the imperious need to dominate the accidental, when the latter tends to prevail objectively. First, symbolism, with Lautréamont, Rimbaud, corresponding to the Franco-Prussian war; pre-dadaism (Roussel, Duchamp, Cravan) and dadaism (Vaché, Tzara) corresponding to that of 1914.[41]

In this passage, Breton is at least reading post-Hegelian artistic Modernism in terms of the Hegelian bifurcation noted earlier, and in his main text he does much more than this. He sees 'objective humour' as a decisive resolution of the conflict between the imitation of the accidental and the artist's imperious mastery of forms through humour. By so doing, Breton revises Hegel's position:

> The truth is that romantic art in its broadest sense as Hegel understood it is far from having reached the end of its days and that, the general forms of art's development not permitting a given individual any appreciable licence, we are probably in art, whether we choose it or not, in the phase of objective humour.[42]

What Breton does here is to continue the dialectical momentum suggested by Hegel, in such a way as to break out of the Hegelian system. Objective

humour is not the end of art, but a new stage, which in its most developed form Breton goes on to identify specifically with Surrealism. Firstly, he wishes to justify Surrealism as a tendency in accord with the dominant trajectory of artistic change. But objective humour has a much deeper significance, both in terms of its own dialectical content and the dialectical transition towards which it points.

Objective humour has both its objective and subjective dimensions. The objective aspect shows most clearly when Breton relates it to 'extreme' forms of poetic activity. For example, we are told that

> 'Evil' for Lautréamont (as for Hegel) being the form under which the motive force of historical development presents itself, it is important to fortify it in its *raison d'être*, which cannot be done better than by establishing it on prohibited desires, inherent in such primitive sexual activity as is manifested in particular by Sadism.[43]

The strategic significance which Breton is assigning to evil and black humour here again draws its inspiration not directly from Hegel but Hegel as interpreted by Engels. Breton is in fact alluding to a specific passage from *Ludwig Feuerbach and the End of Classical German Philosophy*, which makes the significance of Breton's own points somewhat clearer:

> With Hegel evil is the form in which the motive force of historical development presents itself. This contains the twofold meaning that, on the one hand, each new advance necessarily appears as a sacrilege against things hallowed, as a rebellion against conditions, though old and moribund, yet sanctioned by tradition; and that, on the other hand, it is precisely the wicked passions of man – greed and lust for power – which, since the emergence of class antagonism serve as levers of historical development.[44]

On these terms the embrace of evil – especially in relation to the humourous affirmation of prohibited desires and social taboos (in Lautréamont and others) – sets an artwork at odds with the rigid values of the society which surrounds it. At the same time such a work expresses the deeper, unadmitted regions of desire which drive such a society. By drawing on these resources, humour in its blacker modes offers, therefore, an idiom which is sacrilegious in both its form and content. It exists in an antagonistic relation to bourgeois society that is far sharper and more thoroughgoing than mere critique or satire.

The subjective aspect of this leads Breton in a rather different direction. In this respect he quotes Freud on humour:

Like jokes and the comic, humour has something liberating about it, but it also has something of grandeur and elevation . . . The grandeur in it clearly lies in the triumph of narcissism, the victorious assertion of the ego's vulnerability. The ego refuses to be distressed by the provocation of reality. . . . It insists that it cannot be affected by the traumas of the external world; it shows in fact, that such traumas are no more than occasions for it to gain pleasure.[45]

The starting point of objective humour is the world posited in terms of mere contingencies, accidents, and incongruous juxtapositions. Hence the triumph of the ego is all the more thoroughgoing since it is an overcoming of conditions which normally engender passivity and resignation in relation to the real.

Objective humour, then, is both a historically and subjectively empowering artistic strategy. With it, any putative antagonism between registering reality's mere contingencies and accidents, and the artistic urge to master forms is overcome. For Breton, this is not simply a higher stage of 'Romantic' art, it also implies a dialectical transition to a further level of understanding. He calls this 'objective chance', and defines it as 'that sort of chance that shows man, in a way that is still very mysterious, a necessity that escapes him, even though he experiences it as a vital necessity'.[46] What Breton probably has in mind here are those ultimate meanings whose presence is embodied in automatic creation, and which are recognized as being there, even though we are unable to give unambiguous voice to them. Freud's psychoanalytic method is the obvious general inspiration for this, but again it is Engels who provides a more direct cue.

Breton refers to Engels in a second elucidation of objective chance in the essay 'Limits Not Frontiers of Surrealism' (1937):

[It] resides in the necessity of passionately interrogating certain situations in life characterized by the fact that they appear to belong *at the same time* to the real series and to the ideal series of events, so that they constitute the only vantage point offered us inside the prodigious mental 'Domain of Arnheim' which is objective chance and which Engels defined as the 'form of the manifestation of necessity'.[47]

In speaking of 'real' and 'ideal' series of events, Breton obviously means works which juxtapose items from the material world in such a way as to manifest mental functions, for example in dreams or fantastic imagery. But there is a further criterion of simultaneous reality and ideality, which is clear in the passage from Engels to which Breton alludes, from his *Ludwig Feuerbach and the End of Classical German Philosophy*. Here Engels describes how he and Marx restated Hegelian dialectic in materialist terms:

Thus dialectics reduces itself to the science of the general laws of motion, both of the external world and human thought – two sets of laws which are identical in substance, but differ in their expression in so far as the human mind can apply them consciously, while in nature and also up to now for the most part in human history, these laws assert themselves unconsciously in the form of external necessity, in the midst of an endless series of seeming accidents.[48]

What this passage focuses upon is the idea of a logic – immanent both in the world and thoughts about it – wherein seemingly chance facts can be recognized as the expression of deeper dialectical laws, common to both subject and object of experience. For Breton, the simultaneous inhabiting of the real and ideal series can express an immanent dialectical logic analogous to the one outlined by Engels. But the question is, how analogous?

This brings us to a further level of ambiguity. Breton intends that the immanent logic revealed by objective chance concerns historically specific relations. For example, in distinguishing Surrealist work from 'socialist realism', he asserts that no useful purpose is served by a work expressing the '*manifest content* of an age'. The surrealist project is rather 'to express its *latent content*'.[49] A work shows this character best between the lines, as it were, and especially when it is oriented towards objective humour. This approach is quite consistent with Engels's position (and Breton, indeed, quotes the well-known letter to Mary Harkness to prove the point). However, Breton also holds that the level of objective meaning revealed by chance elements within a work far exceeds the mere reflection of specific historical relations. This leads him to one of the most decisive statements in the whole literature of Surrealism:

An appeal to autonomism in all its forms is our only chance of resolving, outside the economic plane, all the antinomies which, since they existed before our present social regime was formed, are not likely to disappear with it. These contradictions cry out for attention, since they make themselves cruelly felt and since they imply too a servitude even more profound and final than temporal servitude . . . They are the contradictions of being awake and sleeping (of reality and dream), of reason and madness, of objectivity and subjectivity, of perception and representation, of past and future, of the collective sense and individual love; even of life and death.[50]

In this passage the tension and the scope of Breton's dialectic find a telling expression. After the ritual genuflection to dialectical materialism's primacy

of the 'economic plane', Breton suggests that only Surrealist work can resolve fundamental contradictions. But what contradictions! Breton presents them as universals which transcend specific historical conditions, and of a scope which far exceeds the world view of dialectical materialism. On these terms, the Surrealist art-work is of fundamental philosophical significance. With automatism, it breaks through the ossified canons of conventional reason and artifice. In its elements of chance we discern something of the complex structural reciprocity of subject and object of experience.

In effect, Breton is displacing the entire function of art within the Hegelian dialectic. Rather than being one aspect of the Absolute's logical passage to self-comprehension, art is its higher stage. And it is not the metaphysical Absolute of Hegel's system; it is the structure of finite self-consciousness itself that is comprehended. The Surrealist work shows something of this structure, but does not spell it out in direct reasoning. There is illumination but with an aura of the inexplicable and the mysterious. In this position, Breton is, dialectically speaking, entirely consistent. For a finite being cannot state the ultimate structure of things in any exhaustive sense; by definition, something must exceed its cognitive grasp; there must always be an element of uncertainty and contingency which cannot be explained. This means that dialectical movement does not find any absolute stage of realization, unless the human being can itself evolve to a higher stage of existence. It is clear that Breton sees the Surrealist project as pointing in this direction, in so far as through automatism it incorporates putatively irrational random elements into rational comprehension. Reason, in other words, undergoes structural alteration.

Breton's theory of art, then, is thought through with a dialectical competence which overcomes the problematics of Hegel and the narrowness of Engels. Engels serves as a catalyst for Breton to interpret Hegel in more material terms, but what results is not so much a dialectical materialism as an evolutionary existential phenomenology with art rather than philosophy to the fore.

Magritte and Pollock: The Dialectic of Automatism

In the 1920s and early 1930s, Breton worked closely with artists such as Ernst, Dalí, Tanguy, Masson, Matta and Man Ray; and it is likely that Breton's theory formed an important element within these artists' general theoretical orientation. Breton himself at many points specifically relates his theory to the practice and writings of these and other artists.[51] In order to

fully appreciate Breton's position, I shall relate it to a Surrealist who is slightly problematic – René Magritte – and to another painter – Jackson Pollock – who was not part of the initial Surrealist movement.

My justification for this choice also hinges on the key notion of automatism. As adumbrated by Breton, it has two directions. The first of these is the associational: the automatist image results from chance associations between one object and another. This initial moment of inspiration may come from a dream or a random thought process; once made, it forms the basis for more conscious artistic development. Many works by Dalí, Masson and Ernst are of this sort. Chance occurs at the level of choosing images or the preparation of material, which are then incorporated in the 'finished' work. The other mode of automatism – process – is much more radical: it consists of writing or making subject to a minimum of rational control. Much Surrealist poetry is of this kind, but whilst some elements of it are found to a greater of lesser degree in most Surrealist paintings, it is decisive in relation to Pollock's work after 1946.

Magritte's work is the exemplar of associational automatism. After an initial close association with Breton he followed an independent course and late on in life, indeed, was inclined to view Breton's work with some disparagement. This notwithstanding, there are sustained and profound areas of intellectual affinity between the two. Magritte remarked as late as 1965:

> Surrealism is the direct knowledge of reality; reality is absolute, and unrelated to the various ways of 'interpreting' it. Breton says that Surrealism is the point at which the mind ceases to imagine nothingness, not the contrary.
>
> That is fine. But if I repeat this definition I am no more than a parrot. One must come up with an equivalent such as: Surrealism is the knowledge of absolute thought.[52]

He professes some affinity with Breton but characteristically wishes to articulate the Surrealist project in his own terms. They are strongly reminiscent of Hegelian idealism, notably 'absolute thought', but his relation to Hegel is a profoundly revisionary one:

> Hegel, for one, experienced . . . presence of mind. But, in his old age, when he found the sight of the starry sky banal (which is true along with the sight of a locomotive), he overlooked as a philosopher the fact that the starry sky imitated in an image would no longer be banal if this image were to evoke mystery, thanks to the lucidity of a painter . . .[53]

The key notions in this passage (which recur in Magritte's writings) are

'presence of mind' and 'mystery'. He links them: 'The basic thing, whether in art or in life, is "presence of mind". Presence of mind is unpredictable. Our so-called will does not control it. We are controlled by "presence of mind" which reveals reality as an absolute mystery.'[54] Broadly, for Magritte presence of mind is thought's capacity to relate to objects in a way which illuminates the ultimate inexplicability of both this relation and the very fact of existence itself. Mystery is a paramount condition of all things. As Magritte puts it:

> Mystery – without which no world, no thought, would be possible – corresponds to no doctrine, and does not deal with possibilities. Thus, a question such as 'How is mystery possible?' is meaningless because mystery can be evoked only if we know that any possible question is relative only to what is possible.[55]

In these cryptic remarks, Magritte is indicating that the congruence between thought and its objects is a function of coherent contexts, but that the possibility of this relation and indeed the questioning of mystery itself are beyond the range of any answer. In its most ultimate and absolute character, reality itself is without *raison d'être*. It exceeds all logic and strategies of comprehension. It has the character of absolute contingency.

Magritte, then, like Breton, focuses intuitively on precisely those areas which are problematic in the Hegelian system. And like Breton, he assigns a special significance to art in this respect. In *Time Transfixed* (1938; pl. 16). Magritte begins from the simple contingent desire to paint a locomotive:

> Starting from the possibility, the problem presented itself as follows: how to paint this image so that it would evoke mystery – that is, the mystery to which we are forbidden to give a meaning, lest we utter naive or scientific absurdities . . .[56]

The image of a locomotive is immediately familiar, so in order to achieve his desired end Magritte was led arbitrarily to juxtapose it with another familiar image – that of a dining room fireplace. For him 'there are neither *mysterious* nor unmysterious creatures. The power of thought is demonstrating by unveiling or evoking the mystery in creatures that seem familiar to us (out of error and habit)'.[57] The unexpectedness and inspired character of the conjunction places the two familiar objects in a dialectical relation (though Magritte does not remark upon it). In dialectical terms, the two objects limit and exclude one another and are, in that sense, opposites. This formal opposition is made into an active antagonistic one, because in this specific conjunction the two objects contradict normal patterns of empirical possibility (locomotives do not normally emerge from dining room

16 René Magritte, *Time Transfixed*, 1938. The Art Institute of Chicago, Joseph Winterbotham Collection

fireplaces). It is this very antagonism which arrests our attention and leads us into a higher state of awareness. For, as Magritte in effect notes, the objects appear strange and mysterious in themselves; and their conjunction manifests the power of the unpredictable scope of thought. The synthesis of this dialectical sequence is the sense of the impenetrable mystery of being.

If *Time Transfixed* offers a dialectical route to mystery at an objective level, *The Human Condition* (1933; pl. 17) follows a similar direction at the subjective level. Of this work, Magritte observed:

> The tree in the picture hid the tree behind it, outside the room. For the spectator, it was both inside the room within the painting and outside the real landscape. This is how we see the world. We see it outside ourselves, and at the same time we only have a representation of it in ourselves. In the same way, we sometimes situate in the past that which is happening in the present. Time and space thus lose the vulgar meaning that only daily experience takes into account.[58]

In this work the simple dualities of internal and external, past and present, are brought into a relation that is, in dialectical terms, antagonistic (in the sense noted earlier). The pictured landscape is relatively unremarkable, as is the one 'behind', with which it is exactly isomorphic; but their exact conjunction renders both of them strange. Inner and outer are both identical with, yet distinct from, one another. Likewise, whilst it is the pictured landscape which occupies present awareness by concealing the background, yet (viewing the work as though it were a real scene) it is the concealed background which is, as it were, the real space of the present. The pictured landscape is simply a product of the past. In other words, a putative opposition – of past and present – is rendered in a way that affirms simultaneous identity and difference. We are thence led, once more, to that higher state of awareness wherein the mystery of being is declared.

At the heart of Magritte's implicit but clearly defined dialectical strategy is his making objects exist in a fuller, more 'sensational' way through being represented in antagonistic relations. These paintings exemplify the simplest means of this. Magritte set out other strategies for achieving such ends:

> The creation of new objects, the transformation of known objects; the alteration of certain objects' substance – a wooden sky, for example; the use of words associated with images; the false labelling of an image; the realization of ideas suggested by friends; the representation of certain day-dreaming visions – all these, in sum, were ways of forcing objects finally to become sensational.[59]

17 René Magritte, *The Human Condition*, 1933. National Gallery of Art, Washington. Gift of the Collectors Committee

What makes this passage so interesting is that Magritte outlines a strategy which in its various components encompasses all those Surrealists whose automatism is fundamentally associational (it would fit, in particular, Ernst, Dalí, Tanguy, Man Ray and Meret Oppenheim). Dialectical antagonisms (or 'delirium' in Dalí's sense) serve to raise understanding to a higher level which articulates truths which are unamenable to common-sense reason. Magritte's characterization of this truth as a mystery-without-meaning is not a relapse into mysticism (there is no ineffable spiritual unity or 'one-ness' involved); rather, it is a reconciliation with the limits of finite being. Thought set loose, as it were, acknowledges the fact that it can reach out to an object, only because some aspect of the object always exceeds it. Things can only be if it is possible for them to be otherwise, but the grounding of this and our general cognitive hold of the world cannot themselves be explained.

We are thus led back to Breton. Magritte's strategy is in perfect accord with Breton's programme; the only difference is in emphasis. Indeed, whilst Magritte does not use the specific concepts of 'objective humour' and 'objective chance' in his writings, his practice is a perfect exemple of them. Putatively incongruous or bizarre chance associations lead dialecti-cally to an awareness of the ultimate contingency of all things. Art has a privileged role in this. Again like Breton, whilst professing Marxist politics Magritte sees art's political significance as residing not in a politically correct 'message' but in a dialectical tension with capitalism. As he put it, 'The only way poets and painters have of struggling against the bourgeois economic system is to give their works a content that rejects the bourgeois ideological value that underlies the bourgeois economic system.'[60]

One presumes that what Magritte has in mind here is the kind of strategic uselessness adumbrated by Breton. Representations which derive from chance associations are, *vis-à-vis* the usual communicative function of pictures, useless. They do not convey information in harmony with the functional significance of the capitalist 'object'. Instead, they demand a mode of reception which, as dialectical consciousness, subverts bourgeois patterns of thought and value. Again, however, the radical implications of this are such as to fit very uneasily with Magritte's sympathies with Marxism and its ideology of planning and production. Magritte outreaches the philosophical matrix which he professes.

In discussing Magritte's work I raised no questions of technique: this is because in associational Surrealism, dialectical content is delivered by the finished product. The act of creation disappears, as it were, into the presentation of what is created. In process automatism, matters are much more complex.

18 Jackson Pollock, *The Moon Woman Cuts the Circle*, c. 1943. Centre Georges Pompidou, Paris

Pollock, though not a formal part of the Surrealist movement, was deeply familiar with Surrealist art and strategy by the 1940s. In a work such as *The Moon Woman Cuts the Circle* (c. 1943; pl. 18) the closed off quasi-Cubist character of the picture plane serves to declare a narrative. But the narrative consists not simply of the image itself (derived from a Jungian text) but of the complex tension between the image and the insistent physicality of paint, gesture and, indeed, colour. A tension of this sort indicates an antagonism between Pollock's free utilization of existing pictorial sources and his desire to find a distinctive personal mode of expression. The following remark from 1943 indicates the direction in which Pollock was looking for a resolution of this conflict:

The fact that good European moderns are now here [in America] is very important, for they bring with them an understanding of the problems of modern painting. I am particularly impressed with their concept of the source of art being the unconscious. This idea interests me more than these specific painters do . . .[61]

Pollock's interest in the unconscious dates from before 1943, and at various times in the late 1930s and early 1940s he underwent Jungian analysis. However, his ability to link this to his art, at that time, seems to have been subject to the tension between image and formal means.

The accident as an element in the creative process was familiar to Pollock (he and Siqueiros experimented with it in 1936 and Janet Sobel and Hans Hofmann used it in the early 1940s). The use of accident proved decisive in reconciling Pollock's conflict from around late 1946. In a work such as *Summertime* (1948; pl. 19) the formal configuration is achieved by various means such as dripping and pouring paint, with the canvas on the floor rather than on an easel. From 1947 to his death in 1956 (despite modifications in both content and technique) this approach remained basic to Pollock. Could it be that through these means he was able to express the unconscious and, if so, in what sense?

In 1947 Pollock wrote:

When I am in my painting, I am not aware of what I am doing. It is only after a sort of 'get acquainted' period that I see what I have been about. I have no fears about making changes, destroying the image, etc., because the painting has a life of its own. It is only when I lose contact with the painting that the result is a mess. Otherwise there is a pure harmony, an easy give and take, and the painting comes out well.[62]

This passage emphasizes the contingency of the creative process. But in an interview from 1950, Pollock gives the opposite emphasis: 'it seems to be possible to control the flow of paint, to a great extent, and I don't use the accident – 'cause I deny the accident.'[63] Pollock goes on to agree tentatively with his interviewer that the denial of accident here parallels a similar denial in Freud. The putative contradiction between contingency and the denial of accident is one which can be reconciled dialectically. From a conscious viewpoint, the artist is immersed in the creative process. Using Pollock's technical means, a formal configuration is generated, rather than deliberately plotted and executed. It is a complex give-and-take between artist and medium, full of modifications, erasures, and new beginnings – all mediated by the nature of the evolving compositional totality. However, this contingent process is not simply a series of happy accidents; it has an

19 Jackson Pollock, *Summertime*, 1948. Tate Gallery, London

immanent logic of necessity to it. Whilst Pollock clearly wants to see the elements in his work as non-accidental in the sense of being guided by the unconscious in a Freudian sense, the logic of immanence to which I am referring reaches much deeper, in a philosophical rather than psychological sense.

Pollock himself points us towards it in another remark from his 1950 interview:

> The modern artist is living in a mechanical age and we have a mechanical means of representing objects in nature such as the camera and photograph. The modern artist, it seems to me, is working an inner world – in other words – expressing the energy, the motion, and other inner forces.[64]

Pollock is clearly referring here to volition and feeling, but these are only part of the broader discourse of gesture. Much has been made of the drama of 'action painting', but its real significance is dialectical.

In externalizing inner states (a function which Breton also saw as fundamental to advanced art), Pollock's action painting gives the specific inflection that the configuration is generated with minimum preconception. The 'action' character of the configuration is one which declares itself as an embodiment of contingency – something which could have turned out otherwise, which could have evolved in different directions. Now, in all art which is made, rather than mechanically reproduced, this contingent element is what is conquered and transcended in the finished object. Viewed retrospectively, all the choices and strategies which are contingent elements in the evolving process are now invested with the character of necessity – there are no 'accidents'. For this specific work to be what it is now, it had to be created on exactly the causal basis which did, in fact, constitute the process of its making. This is the complex reciprocity between contingency and necessity which is implicit in all artifice. It is the immanent logic of making per se. Pollock's action paintings thematize this, precisely because the particular character of their configuration is one which emphatically reflects back the contingent dimension in their making, through the internal and necessary cohesion of the final product.

The question of finality offers us another dialectical cue. It is customary to separate products of artifice from those of nature on the basis of the rational free choice involved in the former. But freely to configure material on the basis of a rational sense of order is to import a dimension of organic unity into the process of creation. Parts are defined and co-exist in relation to the evolving and final whole. Indeed, rational artifice at its most rational strives to invest its products with a cohesion that reflects the structure of natural organisms. This continuity of reason and nature is something which informs all artifice – and perhaps even all 'organization'. But it is customarily obscured. The clarity and unity of reason is seen as antagonistic to the spontaneity and overwhelming diversity of nature. In Pollock's action paintings the one-sidedness of this antagonism is overcome. For even whilst such works are not 'set out' in advance, their origination and generation require continuous sequences of complex rational choice and decision, determined by the evolving organic cohesion of the whole. Pollock's specific technical means, in other words, end in works which thematize that complex and continuing reciprocity of reason and nature which is usually left implicit in products of artifice.

Whilst Pollock sees his own work as an expression of the unconscious in a Freudian sense (overlooking the fact that there is no such thing as the Freudian unconscious in reality), the real significance of Pollock's work is that it expresses a key aspect of what I termed the existential subconscious. The space of these works is not 'optical' in the sense of Greenberg and Fried; it is organized around the generally unnoticed dialectical interdependence of contingency and necessity, reason and nature. If associational automatism returns us to an awareness of contingency through specific dialectical antagonism, process automatism declares the operations and ramifications of this for artifice itself.

Theoretical Considerations

To sum up so far, Breton's greatest theoretical debt was to Hegel and Engels, and he implicitly responded to the question which was problematic for both thinkers, the primacy of contingency. Neither thought or planning can be fully congruent with their objects; there is an excess of the uncertain and the accidental, which means that dialectical transformation cannot be articulated in an 'absolute' or 'scientific' system. Breton, in other words, grasped dialectic in fundamentally existential terms by taking the finite status of consciousness seriously. This means that what is ultimate about our reciprocity with the world can be shown indirectly only as a

ceaseless immanent logic at work in those fusions of contrivance and chance which are the epitome of Surrealist automatism in both its associational and process modes. The Surrealist work thematizes the broader network of epistemological and ontological relations which inform and make possible thought's immediate relation to the object, but which are customarily repressed or overlooked. It is the art of the existential subconscious.

It is interesting to speculate how Engels and Hegel might have responded to this. Engels would perhaps have protested that the systematic character of his and Marx's theory is much more open-minded than I have presented it, and that Surrealism can be assimilated as a socially progressive movement within the framework. In particular, the charge of 'economic determinism' would be vehemently rejected. However, despite Breton's avowed profession of dialectical materialism, the fundamental impulse of Surrealism in theory and practice is one which disrupts any theory of what might be called centralization. Indeed, Breton thought through dialectical relations more throughly than Engels. For the idea of 'production' as fundamental is a one-sided distortion if it is understood as the primacy of the economic plane. Needs over and above the production of the means of subsistence and reproduction inform all dimensions of artifice and sociality, and amongst the biggest need of all is that to articulate the very fact and wonder of being.

Hegel's response to Surrealism would be much more interesting. He conceived the world as a free, self-determining totality, thus avoiding the problem pervading all philosophies which fall short of this absoluteness, that of 'bad infinity'. The bad infinite is one which is understood as the mere endless repetition of finite elements and which leads to irresolvable paradoxes concerning ultimate beginnings. In Hegel's terms, any framework of dialectical relations that does not close in on itself through some internal logical resolution will be a case of bad infinity. With Surrealist strategies, however, this objection does not hold. For, as we have seen, contingency is decisive in our reciprocity with the world; as finite beings, something always eludes us, there is always more than we can ever comprehend. This other side of thought and perception is something which for Breton (but not for Magritte) can be progressively transformed. Those key antagonisms pinpointed in the *Manifestoes* – reason/madness, waking/dreaming, perception and representation – are the ones that could be surmounted in evolutionary terms. Surrealist art is an element in this more total strategy of transformation. It points towards a mode of being wherein those dialectical and reciprocal couplings which define our present state of finite existence will be changed into something higher. And this

means something different from *homo sapiens*; it means a being with a radically different structure of finitude. Of course, one cannot say what such a creature would be like; but Surrealist art can at least, however opaquely, posit its possibility.

It remains to relate associational and process automatism to iterability. The associational mode, as we have seen, hinges upon incongruous and unexpected juxtapositions of represented objects, events or qualities. The linkage of such items is determined not by correspondence with the empirical world but on the basis of avenues of association opened up by subjective desire and fantasy. In the work of Breton and artists such as Dalí (before the mid-1930s) and Magritte, this associational strategy is a function of much broader political and epistemological ends. A wholescale transformation of reason and the revaluation of all values is the desired aim. However, what is striking is the way in which associational Surrealism floated free of these subversive intentions. Indeed, it took on the very opposite significance: it has since become conventionalized as a specific and highly readable syntax for linking pictorial images, used most notably by the advertising industry. Representations of products are linked to incongruous situations or invested with fantastic properties, in order to declare them as objects worthy of consumer desire. Apart from the dubious politics of this, it is clear that associational Surrealism has established itself in the iterable dimension. It has a logic which allows it to be learned and applied across a wide range of contexts beyond those of its origins. This does not, of course, preclude its being used for new subversive or artistic purposes, but such a project becomes more and more difficult to realize with the accelerating globalization of advertising imagery, made possible by new mass-media technologies.

One way in which this conventionalization can be partially resisted is through a kind of hybrid associationism, which utilizes recognizable or partially recognizable representational forms in abstract or indeterminate contexts. An example of this is Joan Miró's *Person Throwing a Stone at a Bird* (1926). Miró's biomorphic images suggest the forms of a human being and a bird; but the allusiveness of these images sits in delicious incongruity with the trajectory of the stone itself. Its motion and axis are shown as they might be in a quasi-scientific illustration. But both allusive and quasi-scientific elements are rendered in a highly linear style, which allows them to be decoratively absorbed in the complex and fundamentally flat ground. They thus function in effect as abstract elements. Similar considerations hold in relation to much of Yves Tanguy's work, which consists of strongly recessional but indeterminate 'landscapes', populated by humanoid, biomorphic or quasi-mechanical forms.

One might say, then, that when representational images are set in a less figuratively legible context, or when this context (as in the Miró example) serves to absorb such images, then the work becomes correspondingly more abstract and less available to conventionalization.

This leads us directly to the iterable significance of process automatism, which (especially in the work of Masson and Pollock) often involves a figurative or quasi-figurative element that is totally woven into a more abstract setting. We recall that in Malevich the optical reciprocity of figure and ground represents an iterable exemplar of possible dynamics in the perceptual field. This iteration of perceptual dynamics can also be linked to the process automatism of Masson and Pollock, to the degree that the distribution of forms in their work is organized in a definite visual rhythm, as in Pollock's *Summertime*. There is further important dimension to process automatism, which links it to the dynamics of the productive imagination, as well as of the immediate perceptual field.

In Pollock's *Full Fathom Five* (1947; pl. 20), the distribution of forms over the canvas is fairly even except for the border area. And this exception is a decisive factor in the bulk of his post-1946 'all over' paintings. For by leaving the border areas open, the forms enclosed within them are defined and activated in relation to a plane other than that of the physical flatness of the support. The colours and forms do not 'sit' on a surface. They are animated within an optical, illusionistic space, which accentuates the gestural dimension of process automatism. A gestural emphasis can, of course, in itself convey a sense of the work having resulted from processes of artifice (as we saw in relation to Kandinsky in Chapter 1). This temporal impulse is radicalized by Pollock's particular style: it invests the formal configuration with mutability and transformatory potential. *Full Fathom Five*, for example, has an organic momentum which indicates possibilities of continuation beyond that which is given. One might imagine tracing the configuration back to previous stages in its generation, or projecting future ones. Or one might imagine the visual complex growing out towards the viewer, or weaving roots deep into the plane, thus piercing its shallowness. The gestural textures of this and other works by Pollock are, in other words, readily describable in terms of the generation of appearance. We have already encountered aspects of this in a number of contexts, notably that of the existential subconscious. It means that the way in which any item given to the senses exists not as a mere datum, but is fully definable only in its reciprocal relation with a complex schema of past and future possibilities which are (at least tacitly) projected around it. Now whilst this is true of any sensory item – be it directly perceived or represented in a picture – we do not usually attend to it. Indeed, we could

20 Jackson Pollock, *Full Fathom Five*, 1947. The Museum of Modern Art, New York. Gift of Peggy Guggenheim

not other than in exceptional circumstances, since our cognitive capacities would then be overwhelmed by a plethora of information. These exceptional circumstances arise when an item engages our aesthetic interest. In the case of Pollock and other process automatists merely describing their work involves consideration of this reciprocal dimension. The gestural and 'spontaneous' character of the work's appearance predisposes us towards such a dimension irrespective of any more specific 'intentions'. The stylistic format demands that we attend to the sensory fabric of this particular appearance and the imaginative dimension which generates it. This is not to suggest that such works will necessarily succeed in totally engrossing us in these ways; neither does it mean that they are superior to more conventional modes of representation. It is all a question of emphasis and quality.

Thus, associational Surrealism is readily codified in iterable terms. However, its very ease of use in this respect has rendered it highly susceptible to non-artistic functions. Process automatism fares better. It introduces an awareness of the iterable generation of appearance. Whereas in an artist such as Malevich the dynamics of potential perceptual relations are invoked, process automatism gives more emphasis to the dynamics of the productive imagination. In this it shares some ground with both Cubism and Futurism. For the pivotal emphasis of Braque and Picasso's work is on the nature of the artistic image itself – specifically the intimate reciprocal relations which hold among subject matter, medium and the artist's imaginative organization of these. In the case of Futurism, the connective temporal activity of the imagination is to the fore. And this yields the decisive point of the importance of the existential subconscious. Breton and the Surrealist painters drew on that complex network of broader reciprocal relations and subjective associations which defines the fabric of immediately given empirical appearances. In particular, they focused on elements of chance and contingency in the function of the imagination. That achievement was the result of an enormously sophisticated theoretical project, but a Surrealist work does not presuppose a detailed familiarity with that project in order to be 'read'. Breton's work clarifies the depth and artistic potential of the existential subconsciousness but, once established, the notion can be applied and read in many other visual contexts. Indeed, for the purposes of this book, the existential subconsciousness is of much broader significance. The Surrealist artists emphasized specific aspects of it, but Cubism, Futurism and Malevich were also orientated towards expressing those relations which condition the possibility of empirical appearance, but which do not usually figure explicitly at the level of recognizable appearance. They were all orientated towards different dimensions of the

existential subconsciousness. Whatever the complex relation of philo-
sophical ideas and practice in the artists so far considered, their common
core is the existential subconscious. It is organized by the productive
imagination and, more fundamentally, the principle of reciprocity. The
various different relations which form this principle are the iterable basis of
all the art that I have considered.

Chapter 6

The Dialectic of Abstract–Real in Mondrian

Of all twentieth-century art, Mondrian's work appears to be the most amenable to description in terms of purely formal transformation. After early figurative phases, familiarity with Cubism leads to gradual abstraction away from natural form. The major transition points are the pieces of 1913 and 1914 (with titles centring on 'Composition'), the 'plus and minus' works from around 1914 to 1917, the square and rectangular emphases of 1917–18 and finally works whose structure is based on relations between perpendiculars and regular colour planes from 1918 onwards. This final structure informs all Mondrian's work thereafter, although its formulations are complex and diverse in both richness of formal organization and the relation between this and the edge or shape of the canvas.

At first sight, this progression fits in very neatly with the familiar interpretation of Modernist art as striving for a purer, more autonomous kind of painting. There is, indeed, this aspect to Mondrian. However, his own vindications of the move to abstraction reach beyond the confines of art itself. Looking back on this move, Mondrian in 1942 spelt out what was at issue for him in the encounter with Cubism: 'I became aware that Cubism did not accept the logical consequences of its own discoveries; it was not developing abstraction towards its ultimate goal, the expression of pure reality.'[1]

In his figurative work, Mondrian found some inspiration from Theosophy, an eclectic religious doctrine which emphasizes reincarnation and spiritual progression towards universal enlightenment.[2] Whilst the universalist impulse and interest in dualities (which partly characterize this doctrine) remained with Mondrian throughout his career, they were transformed and redirected by other influences. This is fortunate, because from the iterable viewpoint they present the same problems of ill-defined criteria which we encountered in relation to Kandinsky at the end of Chapter 1. The point of transition to a more fruitful theoretical framework can be found in some of Mondrian's aphorisms of 1913–14: 'Every human being, every object, everything in the world has a reason to exist . . . Everything is necessary – all things and all men in their relative value of existence.'[3] More specifically:

The conflict between Matter and Force in everything; between the male and the female principle. Balance between the two means happiness. This is difficult to achieve, partly because the one is abstract and the other real. Through conflict comes life; change is necessary.[4]

In these remarks, we find Mondrian turning towards a systematic and more philosophical conception of reality, which centres on duality and, in particular, the dialectic of 'abstract–real'.[5] Mondrian does not use the term 'dialectic' but since his theory gravitates around the conflict and harmonizing of opposites, its basic momentum is dialectical.

The origins of this dialectical turn probably lie in Mondrian's acquaintance with the work of the Dutch neo-Hegelian G. P. Bolland, particularly *The Reality of Pure Reason* (which Mondrian read in its 1912 reprint). Once this infusion of Hegelian concepts established itself in Mondrian's thought, it provided a framework which was repeated and refined throughout his large corpus of theoretical writings from 1917 to the 1940s.

Mondrian's General Position

Let us begin with Mondrian's conception of 'pure reality'. It consists of an 'original unity': 'Pure vision shows us this original unity as the *enduring force in all things*, as the *universally shared force common to all things*.'[6] Mondrian identifies this force with Aristotle's notion of that formless unifying 'substance' which is at the heart of all things. For Mondrian, its manifestation in space and time is in the guise of dualities, of which, throughout his writings, the most important are inward/outward, spirit/ nature, mind/matter, abstract/real, universal/individual, expansion/limitation, joy/suffering, male/female. In each of these pairings the first and second elements are correlated with the first and second elements in all other pairings. Thus 'inwardness', 'spirit' and 'universality' are all different aspects of the same, as it were positive pole of duality.

This dialectic of oppositions means that relationship is a fundamental feature in our cognitive hold upon the world. This is not only because the notion of duality logically entails a relation between two elements but also because in specific historical epochs there are imbalances between them. Indeed, this is the source of all that is tragic about existence. As Mondrian puts it,

> *The union of the universal (as far as it has developed in man) with the individual (as far as it has developed in man) gives rise to the tragic*, the struggle of one against the other forms the tragedy of life. Tragedy arises from *inequality*

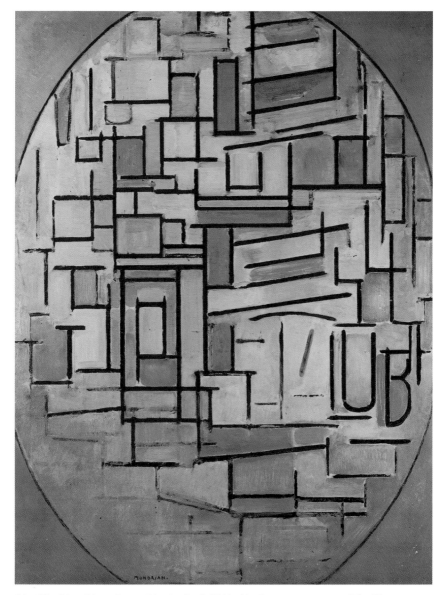

21 Piet Mondrian, *Composition in Oval*, 1913–14. Gemeentemuseum, The Hague

*in the appearance of the duality by which unity manifests itself – within space and
time.*[7]

The heart of this tragic inequality is that the dual and dialectical unity of
truth is always veiled by nature. In the 'trialogue' *Natural Reality and
Abstract Reality* (1919–20), the character speaking for Mondrian says:

We must not see beyond nature: rather we must, so to speak, see *through* nature. We must see deeper, see *abstractly* and above all universally. *Then we can perceive nature as pure relationship.* Then we can see the external for what it really is: a reflection of truth. For this we must free ourselves from *attachment* to the external, only then we can rise above the tragic . . .[8]

Here he is loosely Schopenhauerian. As creatures of nature we are be-witched by its capricious surface order and unities, which are part of the flux and perishing of all phenomenal things. To go beyond this we need to grasp those relations which are the truer, universal and immutable basis of the superficial unity of natural form. Mondrian gives this somewhat Schopenhauerian standpoint a specifically dialectical slant. He requires that natural relations should be internalized and abstracted into wholeness, precision and exactness. Our subsequent actions and artefacts then exter-nalize this knowledge, so that our relation to nature is more balanced. When externalized in this way, dialectical oppositions are purified and presented in their true character as a unity of opposites. The two antago-nistic elements, in other words, are 'equilibrated' and harmonized, through being recognized and affirmed as reciprocally dependent. Abstraction thus enables duality to be expressed 'determinately'.

This process of abstracting from the real, to reveal and equilibrate dualities, is not purely introspective; it permeates all aspects of life. Each historical epoch is characterized by a specific kind of relation between the most fundamental dualities. Sometimes the universal will preponderate, at other times there will be a regression towards the individual and superficial. But, generally, Mondrian sees human evolution as having an overriding trajectory. Our drive to alleviate tragedy through finding truth and repose in the equilibration of opposites drives us increasingly towards the univer-sal. In this respect, modernity has a privileged status. More than at any other time, the outward natural world has been internalized and under-stood in terms of duality: 'In all fields, life grows increasingly abstract while remaining real. More and more the *machine* displaces natural power. In fashion we see a characteristic tensing of form and intensification of colour, which signifies the departure from the natural.'[9] Indeed, 'Although the man of truly modern culture lives within concrete reality, his mind trans-forms this reality into abstractions, and he extends his real life into the abstract – so that he once again realizes this abstraction.'[10] The dialectic of abstract–real involves a progression from outward nature to inward abstrac-tion, and thence outwards once more, enabling us to enjoy a fuller, more determinate sense of what is real. In modern times, real life is determined by the fruits of abstraction.

In the 'Aphorisms' of 1913–14 (and elsewhere),[11] Mondrian seems to be committed to a tightly knit Hegelian system in which whole every part has a necessary place, but his theory is actually much looser than this. For one thing, unlike Hegel, Mondrian sees ultimate unity as residing in a formless core of being – the Aristotelian 'substance' alluded to earlier. His dialectic is metaphysically grounded, rather than interpreted only as an immanent logic inexorably binding the whole of reality. That being said, there is an immanent logic of sorts at work in Mondrian's scheme of things, and it involves dialectical progression. But whereas Hegel knits all things together in a dialectical framework – a closed system – Mondrian sees evolution as a gradual advance focusing on ever more general dualities. Indeed, most important of all, for Mondrian the motive force of dialectical change in human consciousness and situations is not simply (as in Hegel) the drive to ultimate self-comprehension, it is also (as in Schopenhauer) the alleviation of the tragedy of finitude and the attainment of existential equilibrium.

The crucial idea of Mondrian's which is similar to Hegel's is of the formal structure of dialectical progression. This involves a transition from a given one-sided state of affairs (thesis) to a new conception which challenges that state of affairs (antithesis) and resolves in a state wherein thesis and antithesis are recognized in their opposition as mutually defining elements in a higher dialectical unity (synthesis). And like Hegel, Mondrian sees this as characteristically involving a move from the 'capricious' apparent unity of naturally given forms, through inward abstraction or generalization to an eventual externalization when truth shall appear in a higher and more determinate (that is, explicit) form. We must now address Mondrian's own theory of art.

Abstract–Real

In 'The New Plastic in Painting' (1917), Mondrian quotes the following from Bolland: 'The beautiful is the true in the perceptual mode. And truth is a multiple unity of opposites; if we can find the beautiful in the true, then it must be found as a unity-in-diversity of opposites'.[12] As we have already seen, for Mondrian, the universal dialectical unity of things is 'veiled' by the superficial unity of natural appearances. Hence, Mondrian says, 'The evolution of consciousness causes *beauty to evolve* into truth. We can say that beauty is truth aesthetically subjectively perceived.'[13] The relation between beauty and truth, then, is an evolving one. As humankind's general level of consciousness progresses towards the universal, so too will the beauty of its art be elevated into a more explicitly dialectical form. The aesthetic

emotion will be purified, to the degree that the art which occasions it is oriented towards purely 'plastic' considerations.

For Mondrian the term 'plastic' is of vital significance.[14] In his idiosyncratic usage it means the power to create or take on spatial form and relations. The 'pure plastic' is this power understood in its universal sense of dialectical relations, those which ultimately determine natural appearance but which are also 'veiled' by it.

In Mondrian's theory beauty is the sensible or perceptual expression of this universal 'plastic' power, and all art aspires to deepen its expression by making it more explicit: 'That style in which individuality best serves the universal will be the greatest: the style in which universal content appears *most determinately plastic* will be the purest.'[15] As one might expect, given Mondrian's general valorization of modernity, it is Modernist art, particularly Cubism, which accelerates the progression towards more 'plastic' expression: '*In Cubism the work of art . . . actually becomes a manifestation that has grown out of the human spirit and is thus integral with man.*'[16] Mondrian then spells out the limits of this:

> Cubism broke the closed line, the contour that delimits individual form; but because it also represents this *breaking*, it falls short of pure unity. While it achieves greater unity than the old art because its composition has strong plastic expression. Cubism loses unity due to the fragmented character of the natural appearance of things. For objects remain objects despite their fragmentation.[17]

So Mondrian thought that Cubism brought art to a threshold but could not cross it itself. This threshold is not that of natural appearance, but rather what such appearance existentially implies. Again:

> The natural, the visible in general, expresses the tragic to the extent that it has not been transformed (to universality) by the human spirit. The tragic *in nature is manifest as corporeality* – and this is expressed plastically as form and natural colour, as roundness, naturalistic plastic, the curvilinear, and capriciousness and irregularity of surfaces.[18]

If painting is to achieve pure plastic expression, therefore, its pictorial means must be abstracted beyond those achieved by Cubism. Only in this way will art be infused with the universal so that we can find repose from the tragedy of the corporeal finite world.

Mondrian offered a useful overview of his position in 'The New Plastic':

> Abstract–Real painting reveals the *abstract vitality of full and complete life, by deepening the naturalism of its plastic to the realy abstract, that is, by making*

it determinate and by establishing equilibrated composition (or proportion); it realizes this vitality through the rhythm of the composition and through the relativity in which the abstract appears . . .[19]

The main element in this passage involves abstracting from nature towards the universal, and making this determinate through equilibrated relations. At its heart is a transition 'from (outward) impure nature to pure inward nature, and from impure spirit to pure spirit (the universal)'.[20] The intricacy of the reciprocity is a perfect exemple of Hegelianism in Mondrian's thought. We might make sense of it as follows. To abstract from nature is to form a conception of it which is more ordered, more whole and more precise than nature itself. This means that we grasp it in its purity, in terms of those more fundamental dialectical oppositions which structure its surface unity. In doing this, at the same time we elevate our spiritual awareness towards the universal, by virtue of moving from impure notions of unity (derived, of course, from natural appearance) to pure ones based on recognized relations of opposition and duality. Our spiritual abstraction from nature, in other words, results in a more determinate understanding of the universal structure of both elements in the nature and spirit duality. We grasp the truth in its fullest sense.

Mondrian now makes his decisive move by affirming the 'plastic' means which allow the visual realization of this: 'For in the duality of position of the right angle we see exact opposition; in the duality of perpendicular opposition, we see the most extreme opposites: the natural (female) element and the spiritual (male) element.'[21]

Much hangs here on the meanings which we give to 'perpendicular opposition'. In strictly spatial terms, the two angles formed by a perpendicular with its base are literally opposite one another. Their opposition is, as Mondrian rightly says, 'exact'. But what is our criterion of the 'extreme opposites' which are involved in the perpendicular? One presumes that this (again) accrues to the relationship between the perpendicular and its base. The vertical axis connotes maleness, spirit, activity, while the horizontal connotes the female, nature, passivity. However, to understand the broader significance of the perpendicular's extreme oppositionality, we must first see how Mondrian relates it to colour and planarity.

For him, colour must be 'determined'. As he puts it in 'to determine colour involves, first, *the reduction of naturalistic colour to primary colour;* second, *the reduction of colour to plane*; third, *the delimitation of colour so that it appears as a unity of rectangular planes.*'[22] The abstraction to primary colour involves interiorizing, purifying and thence universalizing natural appearance. But why should colour then be reduced to planar form? Mondrian's

answer is that '*Actually* things take their visual shape from a complex of planes that expresses plasticity through *angularity*; form always appears more or less as a confluent angularity.'[23] The plane in other words, is a fundamental form – or, rather, angular relation between lines – which underlies natural appearance. It is also (as Mondrian goes on to note) the basic structural format of painting itself.[24] Hence if painting is to express a more universal 'plastic' it will do so by reducing the corporeality of natural form to a unified composition of planes which gives the illusion of lying in one plane – which encompasses the third stage in 'determining' colour.

For Mondrian (as noted before), corporeal form is fundamentally curvilinear. Abstracting from it, therefore, means that contour (or 'closed line') must be 'tensed' into straightness – the essence of the perpendicular. By this means colour can be organized in Mondrian's three stages:

> Of the three determinations of colour, perpendicular delimitation expresses the *most precise* relationship. It also involves the other determinations of colour; *planarity* results directly from delimitation; the *primary colours* can be thought of as reducible to the colorless (white).[25]

As well as unifying the composition of colour planes, the perpendicular also allows it to embody a further, absolutely fundamental duality, according to Mondrian:

> Expansion – the externalization of active primal force – creates corporeal form by growth, addition, construction, etc. Form results when expansion is limited. If expansion is fundamental (because action arises from it), it must also be fundamental to artistic expression. If it is to be recognized consciously as fundamental, it must be represented clearly and directly.[26]

Here, the dialectic of expansion and limitation is a complex one. Broadly speaking, in the corporeal world of closed natural form, limitation is the overriding factor. It does not simply define expansion, it dominates it. What is needed, therefore, is a mode of expression where expansion is made determinate but not through 'particular limitation', that is, not through a form recognizably derived from natural appearance. It is in this respect that the perpendicular relationship proves crucial: 'Thus expansion is realized *without particular limitation*, purely through difference in the colour of the planes and the perpendicular relationship of lines or colour planes. Perpendicularity delimits color without closing it.'[27]

Mondrian's account of the result of perpendicularity's relation to colour planes involves the 'equilibrating' or harmonizing of opposites – the presentation of unified duality. Nature is governed by the logic of extreme

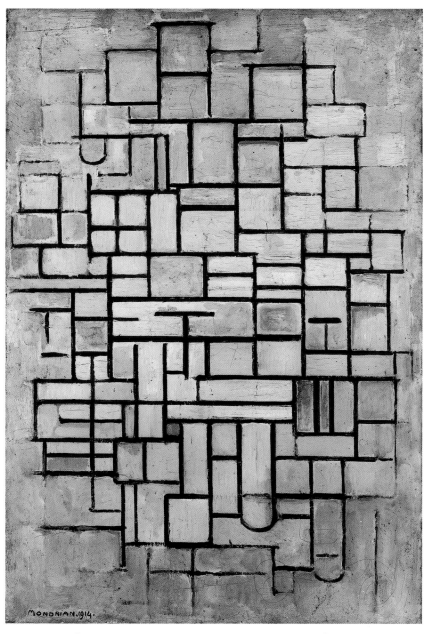

22 Piet Mondrian, *Composition No. 6*, 1914. Gemeentemuseum, The Hague

opposites but these are veiled through imbalances in their particular occurrences. Of the duality of angle in the perpendicular, Mondrian observes that 'because the duality contains *two distinct elements*, their unity can come into being through their equal manifestation, that is, the degree of equal purity in which the two elements are opposed.'[28] Equilibration, in other words, involves expressing the elements in a duality with equal clarity, so that they exactly balance one another. In this way, their relation can be recognized as a unity. For Mondrian, the perpendicular involves the purest and most extreme 'plastic' manifestation of such unity-in-opposition. It is, in effect, the essence of plastic oppositionality. Indeed (as we have seen), both in itself and in its relation to colour, it is able to express both that planarity which (according to Mondrian) is the foundation of natural form, and the dialectic of expansion and limitation – and all this in determinate terms, ones which are exact and explicit but which do not involve the use of particular natural forms.

The dialectic of pure 'plastic' creation then moves from the thesis of outward nature to its antithesis in the inwardness of the artist's abstraction, and to its synthesis in the equilibrated universal embodiment of perpendicularity. In this final stage – the Hegelian *aufheben* or 'preservatory surpassing' – we recognize the truth of duality at the level of the visual.

On the basis of all the preceding points, one could be forgiven for thinking that Mondrian operated at such a level of theoretical generality as to turn the individual work into a mere statement of the formulae of visual truth. He was, however, keenly aware of this problem:

> If the new plastic is dualistic through its composition . . . *the composition is also dualistic.* The composition expresses the subjective, the individual, through rhythm – which is formed by the relationship of colour and dimensions, even though these are mutually opposed and neutralized. At the same time it expresses the universal through the proportions of dimensions and colour value and through *continuous opposition of the plastic means themselves.* It is precisely this *duality* of composition that makes abstract–real painting possible.[29]

Mondrian's point is that composition not only involves abstracting towards the universal, but also an element of personal choice in the way this is 'plastically' articulated. This element of choice, however, does not degenerate into the merely individual, because its rhythm follows a code of purified, universally significant oppositional relations. The subjective element is not an adornment – something which the truth is merely 'dressed up' in. For, as Mondrian then says, 'The universal plastic means would itself reappear as *particularity* if it were abolished by composition itself; otherwise,

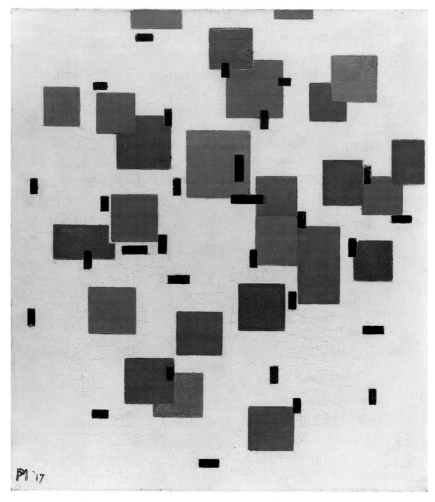

23 Piet Mondrian, *Composition with Colour Planes on White Ground*, 1917. Rijksmuseum
Kröller-Müller, Otterlo

being individuals ourselves, we would tend to see individuality again in the
universal plastic means.'[30] The artist's individual mode of articulating the
universal 'plastic' means, therefore, is a kind of negation. Simple formulaic
expressions of universal truth degenerate into mere particular instances of
the truth. However, if the universal pictorial means are rendered in an
original, inventive way, the work becomes more than a particular, it makes
the oppositionality of the universal–particular duality into a determinate
relation. It presents them in extreme and thence equilibrated opposition.

 Similar considerations apply more generally. The individuality of a style
of painting is not some superfluity which masks the universal or absolute

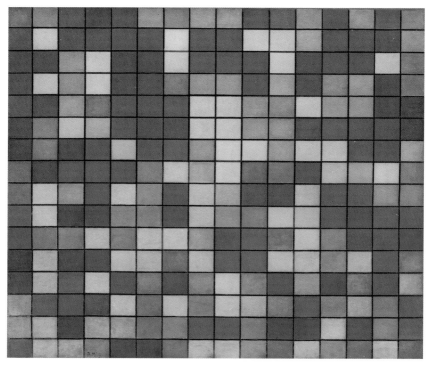

24 Piet Mondrian, *Draughts Board Composition, light colours*, 1919. Gemeentemuseum, The Hague

truth of duality: 'Because individuality of style provides the mode and the degree in which the absolute is made visible, it shows the spiritual outlook of the time and is precisely what makes a style appropriate to its period and constitutes its vitality.'[31]

Given all these points, it is clear that for Mondrian all art involves dialectical complexity and that Neo-Plasticism embodies it to the highest degree. For the relation of perpendicular and colour planes simultaneously exemplifies dualities of inward/outward, spirit/nature, male/female, expansion/limitation, universal/particular, and universal/historical particular (amongst others). I linked the term 'abstract–real' to the general progression from outward nature to inwardness and abstraction, and to the final expression of equilibriated opposition. Abstract–real, in other words, signals the two poles and relationality of dialectic. In the final phase of synthesis, abstract–real also takes on a higher meaning. When the pure 'plastic' means achieve equilibration, we are no longer dealing with, as it were, mere ingredients and a dialectical momentum. We are dealing with a work wherein the abstract has become real through being expressed in its

true guise as duality; and where the real has become abstract through its adoption of pure 'plastic' means (rather than particular natural forms). Abstract–real, in other words, also signifies the ultimate reciprocal identity of opposites.

The further importance of this higher meaning consists in the special significance which Mondrian assigns to art. For him, the whole point of dialectical progression towards the equilibration of opposites is to eliminate those imbalances in dualities which tie us to nature. When these are balanced, we commune with immutable dialectical structure, and are elevated above the finite flux of nature's superficial 'capricious' appearance, We find some existential 'repose'. Mondrian does not claim that art alone brings us to this state, but he does incline towards its having a privileged status. This is because – as both spiritual and outward object – it engages the 'totality of our being', our rational and our animal nature. Whilst, say, philosophical or religious contemplation might provide some relief from the tragic bondage of becoming, it is not complete, for we can never

25 Piet Mondrian, *Composition with Red, Yellow and Blue*, 1920. Stedelijk Museum, Amsterdam

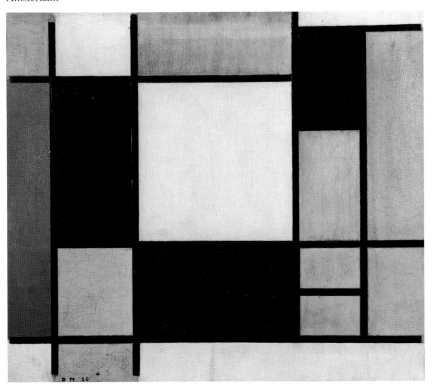

wholly transcend the limits of space and time. Nature is always in us. But in art, limit is acknowledged precisely because the fundamental duality of universal and individual can only be made determinate in so far as their oppositional relation is made explicit and thence equilibrated. This means that the pole of particularity must actively affirm its particularity, rather than be dominated by the universal. Whilst, however, such activities as philosophy, science and religion may strive to stress the truth of duality, this is embodied in their content rather than through their means, in what is said or discovered, rather than the individual style or context in which it is said or discovered. Here, in other words, the universal preponderates. This preponderance may push us further along the road to universal consciousness but not in a way which actively harmonizes our spiritual and natural being.

Art (or at least Neo-Plastic painting), in contrast, internalizes, declares and thence equilibrates such opposition through the relation betwen its universal content and an element of individuality in the style of its expression. Here, the limits of our finite nature are made into an integral part of the truth expressed. On these terms, art in its most fully developed form is true to the essence of being human. The abstract–real in art therefore has a third aspect as that which authentically expresses the fundamental duality of the human condition. Such art is able to release us from the tragedy of becoming, by negating it both at the level of spirit and the abstract and at the level of the outward or real.[32]

Let us relate Mondrian's theory of abstract–real painting to Hegel, and assess its broad ramifications.

Hegel and Mondrian's Problems

Towards the beginning of his *Aesthetics* Hegel observes that 'The beauty of art is higher than nature. The beauty of art is beauty *born of the spirit and born again*'.[33] For Hegel, this general movement from nature to the inwardness of spirit and subsequent externalization in the art-work is part of a much broader dialectical progression wherein all being strives to attain ultimate universal comprehension. All apparent unity in the world – including that of natural forms and appearances – is one-sided and incomplete, unless it is understood within the immanent dialectical logic that guides the unfolding of the whole. Truth becomes determinate only when it is understood in terms of such dialectical opposition and synthesis.

Like Hegel, Mondrian sees art as part of a greater whole – an immanent

logic of duality and opposition, where oppositions are gradually refined, made explicit and thence brought into a state of higher dialectical unity. The outcome of this total logic is the realization of universal unity. But there are important differences between the two. Hegel's philosophy has a primarily ontological foundation, which attempts to comprehend the world as a complete and enclosed systematic whole. Mondrian also hints at such a system, but the foundation of his theory is metaphysical and existential. The metaphysical aspect consists in his positing a universal formless unity at the heart of nature, with fundamental dualities as its mode of manifestation in space and time. The clarifying, and making determinate, of these dualities is the essence of the human evolutionary process, although it must be admitted that Mondrian does not offer much clarification of the specific linkages between the stages in this process.

Given the affinities between Mondrian and Hegel, it is worth probing Mondrian about two related areas of difficulty in Hegel. These are, first, the nature of the congruence between chronological and dialectical evolution towards the Absolute. For given that Hegel sees his own system as the culmination of the dialectical progression, this leaves the world after Hegel with nowhere to go, dialectically speaking. The future *vis-à-vis* the Absolute's already attained self-comprehension is a mere superfluity, an utter contingency. This leads directly to the second problem, the general function of contingency within a closed system that aspires to absolute necessity.

I shall now consider Mondrian in relation to the first of these problems. Because of the metaphysical dimension of his thought – wherein the world progresses from unified substance to spatio-temporal diversity and back again, dialectical progression can be identified broadly with humanity's evolution towards a state of final unity, which has not yet been attained. He thus bypasses Hegel's problem (albeit in a way whose intelligibility Hegel would have bitterly contested). Interestingly, there are some striking parallels between Mondrian's strategy and that of Surrealism. The Surrealists dealt with the progression and evolution problem by radicalizing the concept of art and drawing the appropriate conclusions. For them, the incorporation of arbitrary contingencies in relation to associational and process automatism indicated not only a stage of art beyond the Hegelian Romantic, but also pointed towards an ultimate dialectical transformation of the structures of reason and of finitude itself. The progression of the world does not close in on itself ontologically, rather it begins to mutate into something different with a new principle of unfolding. On these terms, modernity – with the Surrealists in its vanguard – marks a stage of evolutionary transition.

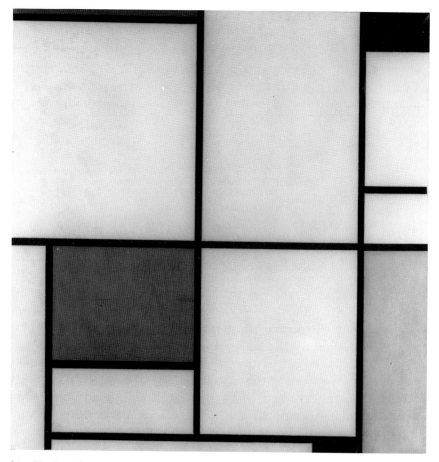

26 Piet Mondrian, *Composition with Red, Yellow and Blue*, 1921. Gemeentemuseum, The Hague

Mondrian offers a similar analysis, though through radically different pictorial means. He reads modernity itself as a rapid acceleration towards the universal, and traces its course in the momentum of art and the tenor of modern life itself. Abstract–real painting forms a decisive stage of further transformation, for it is as important for what it points towards as for what it achieves. In many of his texts on Neo-Plasticism Mondrian develops the implications of abstract–real painting for architecture, interior design and urban planning. Various early hints of its political significance are much expanded in his writings of the 1930s in direct response to the rise of Nazism and Soviet Communism. He evolves, indeed, a schematic but insistent politics of utopian neo-socialism on the basis of abstract–real universalism. The point is that, for Mondrian, evolution continues beyond

Mondrian. In effect, he offers an image of that which Hegel should have countenanced in order to avoid the problems of the 'end' of the system. The image is that of a culture whose whole form of life gravitates around its own explicit recognition of duality, opposition and the advance of the universal. It is the dialectic of abstract–real carried further by becoming the principle of all social and individual praxis. Mondrian remarks that:

> A great *heightening* of subjectivity is taking place in man (evolution) – in other words a *growing, expanding consciousness*. Subjectivity remains subjective, but it diminishes in the measure that objectivity (the universal) grows in the individual. Subjectivity ceases to exist only when the mutationlike *leap* is made from subjectivity to objectivity, from individual existence to universal existence.[34]

Until this transformation of reason and finitude is attained abstract–real art will continue to play a vital mediating role. In its equilibration of fundamental dualities, it embraces the totality of person's spiritual and natural being, and alleviates the tragedy of becoming. However, when the 'mutationlike *leap*' occurs, 'Then what today we call art vanishes too – precisely because subjectivization ceases. Then a new sphere comes into being – a new life arises.'[35] Unlike Hegel, Mondrian rightly sees that the end of dialectical progression can be satisfied only by mutation into a different mode of finite consciousness. This is why – again unlike Hegel – art continues to meet our highest needs. It continually points towards change and advance, precisely through being rooted in that which is fundamental, our status as universal–individual, or abstract–real, beings.

So it seems that Mondrian would not need to explain contingency, for his system is not closed, and – in the dialectic of universal and individual in artistic composition – the element of contingency or 'rhythm' plays a vital role. But contingency does raise fundamental problems for Mondrian. For it is quite clear that he takes himself to have established an iterable code which expresses fundamental philosophical truths. However, the connection between code and idea is in some respects highly contingent, which severely restricts its iterability. For example, whilst one might admit the importance of dualities such as spirit/nature in human experience, the form in which these dualities are expressed is extremely ambiguous. Mondrian's linkage of the perpendicular and colour plane to such dualities is especially so. It may be, for example, that on the basis of loose cultural convention one might read vertical lines as connoting spirit, or maleness, or whatever, but one does not have to. Indeed, it is entirely possible to construct alternative sets of 'associations' which have equally viable application to the perpendicular. Mondrian sees the straight line as a spiritualization of corpo-

real contour – a tensing of it into purity. But one could equally well see it as dividing or declaring a particular space, or as joining such spaces (interpreting 'space' here as the site of the corporeal). Problems also arise with other claims by Mondrian, notably the expansion/limitation duality. One would have thought that the proper dialectical linkage here would be between expansion and contraction, but even if we overlook this, it might equally well be claimed that the circle is fundamental and that it embodies expansion and limitation in extreme opposition through the relation be-tween the space which it includes within its circumference and that which it excludes.

Mondrian wants to treat the perpendicular and colour plane as though these are the natural embodiment of a range of broader dualistic relations. In this, he is probably looking back to Theosophy. However, by so doing he faces those sorts of difficulties which we noted in relation to Kandinsky in Chapter 1. There can be no purely intuitive criteria for positing associations between forms and 'spiritual' states. Whatever associations we make with specific forms require complex cultural mediation. Indeed, the same forms can be read in entirely different ways, or other forms can be claimed to be even more fundamental in the desired dualistic respect. There is, in other words, an important contra-iterable dimension involved throughout.

Mondrian also sees his Neo-Plasticism not only as an affirmation of universal truth, but one which is exactly congruent with the nature of modern consciousness and society. It is an art of the Absolute – one which will be superseded only when the rational structure of the human reality undergoes 'mutation'. However (even overlooking the considerable prob-lems of this notion), there is a more direct difficulty. For one characteristic of modernity is its ever-accelerating demand for the new. Mondrian clearly takes his art to have answered such a demand, but given its absolutist stylistic rigidity, it cannot continue to do so. As in the case of Italian Futurism, Mondrian's Neo-Plasticism is theoretically overdetermined. An art which takes itself to have embodied the Absolute in its formal means cannot then be transformed in significant new stylistic directions on the basis of changing historical circumstances.

Mondrian's Neo-Plasticism, then, cannot of itself form the sufficient basis of a definitive new iterable pictorial code. However, we may recall that in the cases of Futurism and Malevich, there are at least aspects of the relation between their theory and practice which do translate into iterable terms. In Futurism's case, it involves the reciprocity between present appearance and its past configurations and, in the case of Malevich, the reciprocal dynamics of figure and ground in the perceptual field. These and

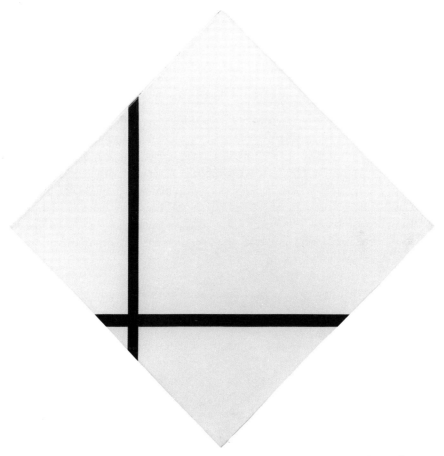

27 Piet Mondrian, *Composition with Two Lines*, 1931. Stedelijk Museum, Amsterdam

the theory and practice of Surrealism express visually what I have called the existential subconscious, those reciprocally based relations which define the structure of the perceptual field and self-consciousness itself. Now, the general thrust of Mondrian's work also relates to the existential subconscious. At its heart is the dialectic of abstract–real, stripped of those contingent associations noted earlier. The core of iterable meaning here can be understood as follows.

As embodied subjects, we are immersed in a spatio-temporal flux of phenomena which we cannot understand as a 'world' without the use of abstract concepts. This suggests an opposition between a flow of empirically given particulars and an ideal order of organizing concepts, but such an opposition is a purely logical one. In concrete experience, the two levels

are mutually dependent. What is paramount is the reciprocity between them. This makes possible a continuum of changing, yet determinate phenomenal relations. But the level of reciprocity is, in existential terms, only subconsciously present. It does not figure in our everyday cognitive life, except in so far as we think about that life philosophically.

To contemplate in this way would be to remain primarily at the level of thought, so to articulate reciprocity in a fuller way – one that engages our existence as both rational and sensible beings – demands an artistic mode of expression. And if it is the reciprocal relation itself which is to be focused on (rather than the phenomena which it serves to organize), then a correspondingly more focused formal vocabulary is demanded. This is precisely what Mondrian provides. His Neo-Plasticist works are sensible items whose internal structure is constituted by reciprocally significant relations. Furthermore, these take the specific form of equilibrated oppositions. The various compositions of the 1920s, for example, are generated exclusively from planes of white and primary colours, organized by a strict regime of perpendiculars. As Mondrian observed, 'Perpendicularity delimits colour without closing it.' This means that whilst line constrains – and thence is in 'opposition' to colour – it also serves to define and declare colour, rather than allow it to be absorbed by forms which are dominated by naturalistic associations. Mondrian, in other words, radicalizes real spatial and colour relations in an ideal pictorial opposition, but through this very oppositionality is able to emphasize their reciprocal dependence.

I am arguing, then, that in optical terms Mondrian's Neo-Plasticist work has an iterable significance in two respects *vis-à-vis* the existential subconscious. First, it visually exemplifies that general reciprocity of the abstract and the empirically real which is a necessary condition of all experience; and second, it exemplifies that reciprocity of line and colour which is fundamental to pictorial and visual reality in general. These two factors constitute an iterable surplus in Mondrian's work which can be discerned without reference to his theoretical writing, but which are, to some degree, contained within it.

Most of the artists considered so far in this book sought to link their work to ultimate philosophical truths. I now turn to Barnett Newman, the artist who did this with arguably the most insistence.

Chapter 7

Barnett Newman and the Sublime

The story of modern painting is always told as a struggle for and against space . . . What is all the clamour over space? It is all too esoteric for me . . .[1]

<div align="right">Barnett Newman</div>

Barnett Newman's work – with its superficial affirmation of the two-dimensionality of pictorial space – is so often taken as an exemplar of the formalist tendency in art that one wonders what other aspects to his work there could possibly be. That there are other aspects is shown by his frequent comments concerning the sublime and by his observation that 'the self, terrible and constant is for me the subject-matter of painting'.[2] Unfortunately, no one has yet shown (with the partial exception of Yve-Alain Bois) how the sublime and the self are linked in Newman's work, and this is true even of his two most assiduous commentators, namely Thomas Hess and Harold Rosenberg. In their texts, Newman's esoteric theory and practice become enshrouded in an aura of eulogistic mysticism that altogether hides those aspects of his praxis which make him so susceptible to formalist interpretations.

In this chapter, therefore, I propose to analyse in depth the relation between sublimity and the self in Newman's theory, and the demands which this makes on his artistic production.

The Sublime

Although the sublime is an aesthetic concept of ancient lineage, the modern sensibility associates it most closely with the late eighteenth and early nineteenth century. Robert Rosenblum suggests, for example, that in Burke, Reynolds, Kant, Diderot, Delacroix and their contemporaries, 'the sublime provided a flexible semantic container for the murky new Romantic experiences of awe, terror, boundlessness and divinity that began to rupture the decorous confines of earlier aesthetic systems.'[3]

In very general terms, Rosenblum's remarks are apt. However, Burke and Kant require more detailed consideration, not only because their theories are highly systematic but also because they hinge upon two phenomenologically distinct extremes of human experience. Burke articulates the first of these in his claim that terrible or overwhelming phenomena when experienced from a position of safety can give rise to 'a sort of delightful horror, a sort of tranquillity tinged with terror; which, as it belongs to self-preservation, is one of the strongest of all the passions.'[4] Here, the experience of the sublime is defined by its indirect allusion to the fact of human mortality. One might say, therefore, that for Burke the sublime is to be understood in an 'existential' sense.

Kant chooses a rather different approach: 'the sublime is to be found in an object even devoid of form, so far as it immediately involves, or else by its presence provokes a representation of limitlessness, yet with a super-added thought of its totality.'[5] The last clause of this statement is crucial. As with Burke, an emphasis is placed on objects of an overwhelming or terrifying nature giving rise to experiences of the sublime. But for Kant the underlying structure of this experience is determined not just by implicit reference to the fact of human mortality, but also by the finite human subject's capacity rationally to affirm itself in the face of such overwhelming and terrifying phenomena – hence the 'super-added thought of its totality'. Our rational faculties are able to comprehend and thereby challenge that which from the viewpoint of 'sensibility' (that realm of sensation, perception and affect where the human self connects with nature's causal chain) seems beyond all comprehension. Indeed, it is the employment of this rational capacity rather than the overwhelming phenomena themselves which Kant finds sublime. Through it we experience our freedom to transcend behaviour and phenomena that are merely causally determined. As Kant puts it: 'the feeling of the sublime in nature is respect for our own vocation . . . this feeling renders as it were intuitable the supremacy of our cognitive faculties on the rational side over the greatest faculty of sensibility.'[6] I shall call this Kantian sense of the sublime 'transcendent'.

Newman's Understanding of the Sublime

In his well-known paper 'The Sublime is Now' Newman dismisses Kant summarily and suggests that it was Burke alone who articulated some essentials of the sublime.[7] A complete picture of Newman's own theory and its true affinities can be gained by a consideration of several of his early

writings, notably 'The First Man was an Artist' and 'The Ideographic Picture' (both 1947).[8] In both these pieces we find the single premise that human beings' first attempts to rise above nature through speech are basically poetic outcries rather than acts of communication. In polemic mood Newman asks and answers:

> Are we to say that the first man called the sun and the stars God as an act of communication and only after he had finished his day's labour? The myth came before the hunt. The purpose of man's first speech was an address to the unknowable. His behaviour had its origins in his artistic nature.[9]

The key passage here is the final sentence – humankind's 'artistic nature' or, as Newman goes on to say, 'The artistic act is man's personal birthright'.[10] Newman is in effect making the claim that the artistic act in confrontation with the unknowable is what marks us out as authentically human and that, reciprocally, the artistic act as the bearer of 'pure ideas' about death, tragedy and other aspects of the unknown, finds its *raison d'être*. Hence Newman is led to say of the Kwakiutl American artist:

> The abstract shape he used, his entire plastic language was directed by a ritual will towards metaphysical understanding . . . To him a shape was a living thing, a vehicle for an abstract thought complex, a carrier of the awesome feelings he felt before the unknowable.[11]

In this passage Newman does not simply see the art-work as arousing (as Burke puts it) 'a sort of delightful horror', but rather stresses its embodiment of the artist's transcending of mundane reality and of the pleasures of sense towards self-understanding acquired in the face of the unknown. This is why Newman uses the terms 'abstract thought complex' and 'pure idea'[12] rather than 'feeling' and 'emotion' alone. The former serve to bring out the element of rational self-comprehension inherent in the artist's 'awesome feelings'. Newman also suggests that non-geometric abstraction alone can act as the bearer of such 'pure ideas'. His overt justification for this lies in the negatives that representational work simply depicts natural form or social realities, and that geometric abstraction simply transforms nature into a sensuously pleasing surface.

But what is it about non-geometrical abstraction that makes it so suitable a bearer of 'pure ideas'? Newman does not answer this question explicitly but it is reasonable to assume that he sees non-geometrical abstraction as having greater connotative power. It hovers, as it were, in the potently ambiguous space between conventional representational art and pure geometrical abstraction. Characteristically, the exploitation of this space takes

the form of a combination of loosely biomorphic and geometric elements that transcend mere aesthetic value without relapsing into the mundane narratives of conventional representation. Newman uses the term 'ideograph' to pick out symbols of this sort, and defines it specifically as 'A character, symbol, or figure which suggests the idea without expressing its name.'[13] It is unfortunate that Newman's use of the term has not received wider currency since it fairly accurately summarizes the semantic foundation of the early phase of Abstract Expressionism in general as well as his own work of 1945–47, where elements of biomorphic abstraction are dominant.

If matters had been left here, Newman's work would probably have remained very much within the mainstream of Abstract Expressionism. But there is a strong tension between Newman's theory and his practice. Theoretically, he is concerned only with a specific range of 'pure ideas' – those rooted in the self-comprehension of the artist before the unknown: in practice, his ideographic means of evoking this through organic or biomorphic abstraction leads to broader naturalistic associations that tend to mask or distract us from the underlying 'pure idea'. Newman came to terms with this problem in 'The Sublime is Now' of 1948.

The basis of Newman's discussion is broadly historical and (as might be expected) his view of art history is very much that of a fall from the metaphysical grace attained by primitive art: 'Man's natural desire in the arts to express his relation to the Absolute became identified and confused with the absolutism of perfect creations – with the fetish of quality'.[14] For Newman, this 'fetish of quality' is synonymous with the classical tradition of ideal beauty. With Gothic art, in contrast, an authentic state of sublime exaltation is attained through the artist's desire to destroy form; where, indeed, 'form can be formless'. The liberating momentum of Gothic art is, however, checked by the Renaissance's restatement of classical ideas. It 'set the artists the task of rephrasing an accepted christ legend in terms of absolute beauty as against the original Gothic ecstasy over the legend's evocation of the absolute.'[15]

Michelangelo's sculpture (for reasons not explained) alone transcends the classical ideal which, for Newman, remained dominant until 'in modern times, the Impressionists . . . began the movement to destroy the established rhetoric of beauty by the . . . insistence on a surface of ugly strokes.'[16] This tendency, whilst it was a determining factor in the rise of modern art, stamped that rise with a negative significance – a mere embodiment of the rhetorical exaltation that arises from the destruction of the accepted conventions of artistic style and practice. As Newman puts it, 'the elements of sublimity in the revolution we know as modern art, exist

in its effort and energy to escape the pattern rather than in the realisation of a new experience.'[17] Whereas, for example, the exaltation of Picasso's work may be rhetorically sublime in its overthrow of convention, it leads ultimately to a canvas that simply re-interprets the world in terms of highly structured ideal pictorial form. Similarly in Mondrian, nature is transformed into 'an absolute of perfect sensations' through canvases that exist as pure aesthetic surfaces within the real world. Indeed, even Cubist and Dadaist collage (despite their wild inspiration) succeed only in 'elevating the sheet of paper'. Hence

> The failure of European art to achieve the sublime is due to this blind desire to exist inside the reality of sensation (the objective world, whether distorted or pure) and to build an art within a framework of pure plasticity (the Greek ideal of beauty, whether that plasticity be a romantic active surface, or a classic stable one).[18]

Newman's grumble is that modern art is sublime only in the external or rhetorical senses of perfect aesthetic form and revolutionary exaltation. The task is to find a more authentic and positive sublimity grounded in 'man's' spiritual transcendence towards the unknown. This means the creation of art-works with a sublime content. This brings Newman to the statement of his own (and perhaps Rothko's) position:

> We are reasserting man's natural desire for the exalted, for a concern with our relationship to the absolute emotions. We do not need the obsolete props of an outmoded and antiquated legend [i.e., of Christ]. We are creating images whose reality is self-evident . . . We are freeing ourselves of the impediments of memory, association, nostalgia, legend, myth . . . that have been the devices of European painting. Instead of making cathedrals out of Christ, man, or 'life', we are making it out of ourselves, out of our own feelings.[19]

In this passage Newman comes to terms with the inconsistency between his desire for a sublime art embodying 'pure ideas' and the ideographic associational means whereby he had previously attempted to realize it. Even allowing for the level of generality at which Newman in a short paper necessarily operates, it might be thought that his theory glosses over inconvenient facts. For example, the equating of the Greek ideal of beauty and the romantic 'active surface' seems especially incongruous since much Romantic art is essentially concerned with the sublime rather than the beautiful. Newman's retort might have been that the Romantic's articulation of the sublime is too dependent on subject matter, with distracting naturalistic associations that mask the 'pure idea'. But is this not also true

of Baroque painting, Gothic architecture, and Michelangelo's sculpture – all of which Newman cites as sublime? Clearly, in this case, Newman's metaphysical taste gets the better of his historical judgement. This, however, suggests only that there is rather more sublime art than Newman is prepared to admit; it does not affect the overall thrust of his argument since it may well be that a mode of abstraction free of overt natural associations is sublime in a more profound sense.

This leads me to ask with which other theory Newman has most affinity. He tells us that Kant (along with Hegel) confuses the sublime with the beautiful, and that it is Burke alone who achieves a separation.[20] But, despite his philosophical training, Newman is wrong on this point. Kant emphatically distinguishes the sublime from the beautiful, and does so in a way that has strong affinities with Newman's own theory. Both, for example, see the sublime as residing not simply in the evocation of emotion by overwhelming phenomena, but rather in the sense of rational self-comprehension that arises from such a confrontation. Indeed, this transcendent species of the sublime is further seen as at least partially definitive of the human condition. For Kant it is testimony to our ultimate 'vocation'; for Newman the sublimity of the pure artistic act is the authentic 'birthright' of our 'artistic nature'. Kant and Newman do diverge, however, in at least one highly illuminating respect. Kant suggests that the sublime is not a proper content for art because the art-work is necessarily restricted by 'the conditions of an agreement with nature'.[21] To some degree (allowing for the inconsistencies noted above) this parallels Newman's own worries about the effect of naturalistic associations upon sublime art. What is more striking about Newman's position is that he provides a way of overcoming Kant's restriction by linking the purest expression of the sublime to non-geometric abstraction. The assumption is that work founded on such forms would clearly not be restricted by having to 'agree with nature'.

We find, then, that the basic practical problem which arises from Newman's theoretical position is to come up with a mode of abstraction that will transcend mundane associations and geometric beauty, to embody the sublime in its purest form. Let us now consider how successful Newman was.

Newman's Sublime in Practice

'The Sublime is Now' was published in late 1948, and its exultant final passage in the present tense about making cathedrals 'out of ourselves'

suggests that Newman had already achieved the breakthrough to a non-ideographic sublime art. The key work of this time is *Onement 1* (pl. 28), a painting which Newman began in 1947 and 'lived with' for a year before its completion. Of this work Newman said in 1962, 'I realized that I'd made a statement that was affecting me and that was, I suppose the beginning of my present life.'[22]

Onement 1 is a canvas of some 27 by 16 inches consisting of an upright rectangle of differentiated brownish red, bisected by a narrow band of pinkish red. The reason why this simple format proved so enormously significant for Newman is that it occupies the semantic space between representation and geometric abstraction, without falling into the merely hybrid mode of biomorphic abstraction. The basic colour field is not so differentiated as to set up naturalistic associations but exists primarily as a coloured space. However, the fact that this space is pictorial − is defined and accentuated by the limits of the canvas − means that we approach it with a different set of expectations from those we would bring if, say, it were continuous with or integrated within the surrounding environment, in the way that a painted wall or brownish red wallpaper might be. If that were all, our expectations would probably be of two loosely self-referential sorts. On the one hand we might look upon it as an aesthetically pleasing (or more likely displeasing) surface; on the other hand, we might open ourselves to the canvas's brute physiognomic properties and describe it as 'sad', 'melancholy' or whatever. But Newman's great discovery is that the simple addition of the vertical band serves to activate semantically the colour field. This is why, looking back on his oeuvre in 1962, Newman emphasized the sense of design or 'drawing' that arose from his placement of the bands:

> I am always referred to in relation to my colour. Yet I know that if I have made a contribution, it is primarily through my drawing . . . Instead of using outlines, instead of making shapes or setting off spaces, my drawings declare the space. Instead of working with the remnants of space, I work with the whole space.[23]

The significance of Newman's narrow band, or to use his own term, 'zip', of colour is that it achieves self-definition within the 'whole space' by its accentuation of the colour field − thence intimating a transcendent rather than purely aesthetic or physiognomic level of meaning. The implied analogy is that just as the zip is properly defined and comprehensible only through its relation to the colour field, so humankind can define and express its own finite rational nature only by reference to the infinite and unknown. Reciprocally, just as without its relation to the zip the colour-

28 Barnett Newman, *Onement 1*, 1948. Collection Mrs. Annalee Newman, New York

field remains undeclared, so too are the infinite and unknown established as such only by virtue of their relation to humankind's finite rationality. Reading *Onement 1* in this was explains why Newman was so excited by it. He could express humanity's reciprocity with the unknown not simply by destroying form in the standard manner of sublime art, but by creating an artefact that embodies this relation through a subtle kind of non-representational symbolism.

It will be recalled that in 'The Sublime is Now' Newman claims that 'we are creating images whose reality is self-evident'. Yet it is precisely the transcendent reality of *Onement 1* and Newman's subsequent work which has proved elusive to so many observers. Apart from resorting to Newman's background theory, one superficially viable route to gain access to his transcendent meaning is by referring to the titles of the works themselves – *The Beginning*, *The Command*, *Abraham*, *Horizon Light*. However, there are problems here. These titles may function superficially as denotative expressions, naming events, concepts, individuals and phenomena, but whilst this might seem to import a purely personal or anecdotal significance to the paintings, Newman himself was later at pains to deny this:

> My subject is anti-anecdotal. An anecdote can be subjective and internal as well as of the external world so that the expression of the biography of self or the intoxicated moment of glowing ecstasy must in the end also become anecdotal. All such painting is essentially episodic which means it calls for a sequel. This must happen if a painting does not give a sensation of wholeness or fulfillment.[24]

For Newman this wholeness and fulfilment is clearly rooted in bringing the ultimate confrontation between the artist and the unknown to expression. In this light, we must understand his titles not as terms which denote a particular subject matter or even the artist's personal experiences, but which connote the ultimate and universal experience of the sublime (from which all other 'glowing ecstasy' flows). However, the very fact that Newman's titles have to be analysed in this way rather vitiates their status as interpretative aids; and one suspects, indeed, that any resort to extraneous elements of this sort means that the content of such works is far from 'self-evident'. We have not established them in the iterable dimension.

This problem was dealt with by Newman in another way. After a number of experiments with scale he arrived, by 1950, at a characteristic canvas size in excess of about 8 by 7 feet. A colour field on this scale, of course, is liable to swamp the viewer with the physiognomic emotional qualities intrinsic to it; and, in a work as large as *Vir Heroicus Sublimis*

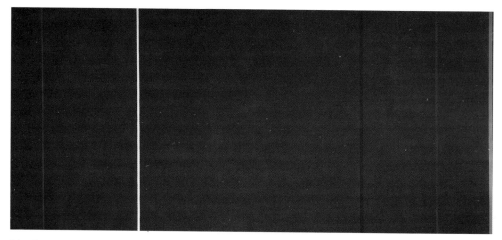

29 Barnett Newman, *Vir Heroicus Sublimis*, 1950–51. The Museum of Modern Art, New York. Gift of Mr. and Mrs. Ben Heller

(1950–51; pl. 29), these qualities – as set off by the zips – do tend to instil experiences of awe and great emotional intensity in the observer. But we must remember at this point that Newman is seeking to express rather more than a Burkean sense of 'delightful horror': he seeks an art that embodies self-understanding in the face of the unknown. However, it again seems clear that the increase in the scale of his works does not of itself make such transcendent sublimity self-evident. Rather we require in addition a thoroughgoing knowledge of Newman's theoretical presuppositions. This is why Newman's much quoted remark that 'Aesthetics is for the artist as ornithology is for the birds' turns out to be so ironic. Newman's work (as much if not more so than any other twentieth-century artist) depends on a matrix of aesthetic theory in order to be read authentically. Unfortunately, the practical application of Newman's theory is beset by other problems, which I shall now consider.

Newman's obsessive pursuit of the transcendent sublime leads him to develop the colour-field and zip format, and so differentiate himself from mainstream Abstract Expressionism. The problem is that whilst this enables Newman to find his own distinct style, it ends by being self-defeating. If, as Newman holds, transcendent sublimity (with its affirmation of the self) is the only authentic subject matter for painting, and if, as Newman also holds, this subject matter can be expressed only in a certain mode of non-geometric abstraction, then the artist is committed to a style which by its very nature admits of no significant development beyond its root format. The colour field and zip cannot be articulated other than in basic monochromes, for to introduce polychromatic elements would be to invite

naturalistic associations that obscure the 'pure idea'. Again, to introduce more overtly painterly and gestural elements would be to over-emphasize the artist's personality, thus inaugurating a regress into the personal and merely anecdotal. All that remains, therefore (if the purity of the 'idea' and the 'wholeness' of the image are to be maintained) is to make endless variations on the colour-field and zip format. And this is exactly what Newman does in almost all his work after *Onement 1*. The zips are sometimes narrow, sometimes broad; sometimes vertical, sometimes horizontal; but zips they remain. Similarly, the colour field is sometimes slightly differentiated, sometimes pure; sometimes one colour, sometimes another; but always fundamentally a colour field. The only alternatives (in his painting, at least) which Newman seems to have entertained can be seen in works such as the gentle self-parody of the *Who is Afraid of Red, Yellow, and Blue?* series of the mid-sixties and the triangular-shaped *Jericho* and *Chartres* of 1969. But the actual internal structure of these works turns out to be, once more, a variation on the colour-field and zip format.

It might be claimed that even though Newman derives his art from a theoretically determined basic format, the variations he makes on this (such as the breadth, number and positioning of zips) give adequate grounds for talking of his style 'developing'.[25] But all that these criteria really establish is the truism that each of his works look different from one another in some specifiable respect. Whilst such perceptible difference may reasonably be said to be a necessary condition of stylistic development, it is by no means a sufficient one. We surely demand in addition that such differences provide both visual evidence of radical self-reappraisals on the artist's part and bespeak a sense of progression and advancement. For example, in Jackson Pollock's painting after 1946, although the artist is still (as in his earlier work) concerned with the problem of expressing the existential subconscious, Pollock's artistic means of realization take on a radically new aspect with the introduction of the drip technique. Indeed, between 1946 and his death, Pollock adapted and extended this mode of self-expression through a number of phases that are not only visually different but also give a clear sense of progression – of problems encountered and solved. With Newman, in contrast, we find that almost all his works after *Onement 1* are visually different in a way that does not radicalize the paradigm structure of the colour field and zip. Indeed, there is not even any real sense of progressive and explorative elaboration of this structure; rather, we find switches and swaps and a multitude of repetitions.

This lack of stylistic development is, I think, one reason why Newman has been such easy prey for formalist interpretations of his work. His theoretically over-determined repetition of a minimal visual format is easily

misread as an insistence on the two-dimensionality of the canvas for its own sake, and thence as an attempt to reduce painting to its pure essence. But what of the theory of the sublime? Why have the formalist interpreters been able to shunt this aside so easily?

In arriving at the paradigm structure of *Onement 1* and exploiting it so extensively, Newman effectively reduced the expression of the transcendent sublime to a formula. His theory, indeed, demands this in order that the authentic subject matter, the 'pure idea', should be absolutely paramount. However, by finding a formula for sublimity Newman tends to inhibit the possibility of a complete experience of it. For even if we have totally grounded ourselves in the background theory, its constant repetition in an impersonal mode of abstraction deadens all but our intellectual sensitivity. We lose interest in the emotional possibilities of the sublime and see it instead as a merely causally significant idea which led Newman to produce works whose real and abiding interest lies not in their subject matter but rather in their status as painted surface. This attitude is entirely characteristic of the way Newman's work has been received, by both critics (such as Greenberg)[26] and artists (such as Don Judd).[27]

Achieving the Sublime in Art

The self-defeating consequences of the application of Newman's theory stem not just from Newman's obsessive pursuit of the sublime but also from a deeply mistaken theoretical articulation of it. We apply the term 'sublime' to art in two logically different senses – descriptively and evaluatively.[28] The descriptive sense is the one employed by Newman, which holds sublime art to consist of certain characteristic phenomenal features – formlessness, form in the act of dissolution, all-encompassing voids and the like. Such properties are, indeed, the basis of a useful category for describing a certain kind of art-work, and such works may evoke sublime emotions in us, but the former is by no means either a necessary or sufficient condition of the latter. For example, James Ward's *Gordale Scar* (or almost the entire oeuvre of John Martin) can justly be described as 'sublime' and possesses all the appropriate characteristics. However, its capacity actually to evoke sublime emotions in the modern sensibility is not certain. One feels that such works are simply trying too hard, and then this sense of obvious human artifice inhibits any profounder sense of revelation. The very fact that the work is characteristically 'sublime' conspires against it producing a sublime effect. And Newman is a case in point.

The fact that the possession of descriptively sublime properties is not even a necessary condition of sublime experience in art is brought out more clearly by the evaluative use of the term. By this, I mean our tendency to call 'sublime' those works which do succeed in evoking that profound self-understanding which arises from the confrontation between the artist and the ultimate powers of life, death and the unknown. In this category we would place the works of artists as stylistically disparate as Watteau and van Gogh. Indeed, the very fact that such works do not have a descriptively sublime content makes them all the more effective. Our experience and awe are all the more intense because the sublimity has arisen from a format where we do not expect to find it – in a *fête galante* or in a still life of a pair of peasant boots. The superficially anecdotal or mundane elements act as the positive backcloth against which the artist's transcendence emerges into clearer view. If Newman had realized this he might have taken up the challenge of producing an art that achieved the sublime through its stylistic quality rather than through its possession of characteristically sublime 'subject matter'.

30　Barnett Newman, *The Moment I*, 1962. Kunsthaus, Zurich

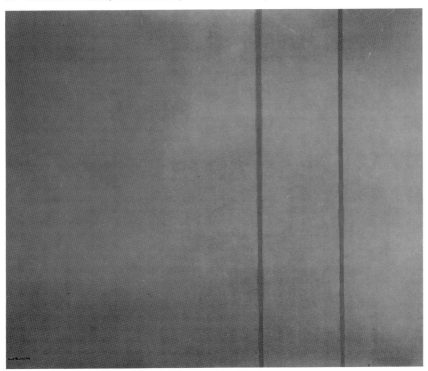

Where are we left *vis-à-vis* iterability? A useful clue is provided by Yve-Alain Bois, in his invocation of Merleau-Ponty, in relation to a number of Newman's paintings after *Onement 1*:

> Newman's move seems to have gone this way . . . if the pictorial field is prevented from functioning as a permanent ground, if the canvas is divided in such a way that in looking at a zip we are solicited by another one further away, hence are constantly in the process of adjusting and readjusting the fundamental figure/ground opposition, never finding a moment of repose when this structure could coalesce, then the only factual certitude that we will be able to grasp will be the lateral expanse of the canvas, the pictorial field as such.[29]

What constitutes the figure/ground relation is always changing – transformed by the body's continuous realignment of position in relation to the overall perceptual field. As Bois claims,

> Newman's stroke of genius is to have understood that perception is made of a constant synthesis of different levels, and that to prevent [the] annihilation of the pictorial field as background, he would have to set some of those levels in irreconcilable opposition to one another.[30]

In these terms, Newman's post-*Onement 1* paintings involve specific responses to a structure which is basic to our embodied inherence in the world. I argued that Newman's approach to the relation of zip and field had a metaphysical significance. It exemplified the reciprocity between finite human reality and the unknown. However, Bois's overall perceptual approach has greater potential in relation to iterability. For whatever specific metaphysical meanings Newman may have intended, these are specific uses of something like the structure which Bois describes.

But we need to clarify this structure since Bois actually misunderstands it in important respects. He does not take the figure/ground approach to *Onement 1*, preferring instead to analyse it in terms of 'bilateral symmetry'. This 'symmetry' arises from the way in which the zip divides the canvas into perceptually equal portions on either side – an effect which, according to Bois, affirms the inseparable co-existence of zip and field. Bois further describes this as 'something like an "originary perception" – the very constitution of a perceptual field via the declaration of its bilateral symmetry – something that only our own embodiment gives us access to'.[31] Why 'bilateral symmetry' should have this special status is something which Bois does not justify beyond a cursory reference to Merleau-Ponty, which seems to have no direct bearing on the issue. In fact, the root structure of *Onement 1* is much better understood on the basis of the figure/ground

relation. That Bois does not realize this is due to his supposing that the figure/ground relation and, indeed, the 'synthesis of different levels of perception' hinge fundamentally on oppositions. But this is to read the perceptual field as though it were a derivation of the field of signification; whereas – as I showed in Chapter 1 – it is the former which is paramount and which serves to stabilize putative oppositions within relations of reciprocal dependence. The decisive feature of such relations is their reversibility. What is, for example, figure in one viewing context can be ground (or an element of ground) in another context. This is the functional reciprocity which defines perception *per se*, and which is exemplified in the most emphatic terms in Newman's *Onement 1*. The zip can be seen as dividing the field – either through being superimposed or through acting as a vertical gap; alternatively, it can be seen as an element within a complex, more total field. The zip and field relation here, in other words, is a matrix of specific visual possibilities of reciprocity. It is in this sense that it signifies an 'originary perception'.

Reading *Onement 1* in this way allows us to see the rest of Newman's oeuvre as a series of more complex variations on the theme of the reversibility of figure and ground. The figure and ground relation is closely tied to optical illusions of presence and absence. Generally speaking, the figure is present to, whilst the ground is absent or distant from, the viewer. Newman's mature works are highly charged in this respect. The colour fields – some in their sheer scale, others in their opacity or lack of differentiation – render the ground as a void or unfathomable distance. But, of course, that which declares them in these terms (and is itself made possible by them) is the presence of the zip. This means that the reciprocity of the figure–ground relation is presented as fundamental and furthermore invokes a similar reciprocity of presence and absence. We cannot on this basis alone make the leap to those metaphysical confrontations indicated in Newman's writings, but we are at least pointed in the right general direction.

I am arguing, then, that (despite my many critical points about his theory and practice) there is an iterable core to Newman's work arising from his theoretical preoccupations. It is based on the reciprocity of figure and ground, and the associated illusion of presence and absence.

Chapter 8

Aesthetic Ideas versus Conceptual Art

In this book so far I have examined the interchange between philosophical ideas and the theory and practice of specific art movements and artists. I have also isolated the iterable surpluses which arise from this interchange. It is now time to gather together the salient points of the discussion. I shall also determine the exact sense in which the art discussed can be said to be iterable. To clarify this notion further and to determine the limits of art, I shall go on to consider some of the philosophical issues raised by Conceptual Art, particularly Joseph Kosuth's attempts to ratify it.

The Major Argument So Far

The pivotal thesis concerns the iterability of pictorial codes. A pictorial code is iterable if, once learnt, it allows the formulation of individual works which can be recognized as images of specific kinds of item, states of affairs or relations without recourse to any information other than that contained in the pictorial work itself. The work should have a sense which can be recognized independently of any knowledge of the creator's specific intentions, or the immediate presence of any state of affairs corresponding to that which the work posits. In the case of conventional picturing the foundation of this is resemblance – understood not as correspondence, but rather as visual consistency between configurations in a plane, and qualities which individuate a specific kind or kinds of item or relation given in three-dimensional space. Once this convention has been learned, its specific instances can be put to more exact denotative uses in specific contexts: we can read, say, this picture of a man as also being of the Emperor Charles V.

I also showed how iterability is a function of the reciprocity between body and world, which is mediated by the productive imagination. Guided by linguistic description, this allows us to realize memory – and to project future or counterfactual possibilities – so as to define the present. Picturing externalizes this function of the productive imagination. The virtue of this externalization is the way it discloses the significance of style. Whatever the factual core of imaginative activity, it is creative and interpretative and its

exercise involves a complex reciprocity among present, past and future, and between the individual and his or her social setting. The style of picturing expresses these relations, in that it centres on the reciprocity between the individual work and the traditions surrounding its specific medium.

Reciprocal relations begin to figure directly in our engagement with the picture only when the work becomes an object of aesthetic interest. This involves much more than simply looking. For whilst such interest centres on patterns of cohesion in the fabric of sensory appearance, our reading of such patterns is always situated in a historical horizon and – in the case of artistic representation – emphatically so. The locus of this horizon is diachronic rather than synchronic. An art historian is mainly interested in the latter when thinking about the immediate empirical condition of a work's production and reception. Aesthetic appreciation focuses on the former, since recognition of a particular work's phenomenal distinctiveness presupposes a comparative context – patterns of sameness and difference, repetition and innovation, in relation to other works. We are dealing, in other words, with historical stylistic variations in the development of pictorial representation as an iterable code.

These variations would be of no interest (indeed, aesthetic responses would have no rationale) if they did not have some intrinsic and far-reaching significance. This significance flows from the fact that the reciprocal relation between a specific work and its comparative (diachronic) historical context is just one aspect of a much broader principle of reciprocity. Nothing in experience is simply an isolated datum. Its specific identity or character is defined through its relation to a background field of meaning. For example, we have already seen the importance of the figure –ground relation; in introspective life we have noted the relation between the present moment of consciousness and an enveloping horizon of past, future and counterfactual possibility. The particular cannot be identified independently of the background field, but the background field is itself composed in part of such particulars. What is encountered as a particular in one perceptual context can, with a change of position, become merely a part of the background field (and vice-versa). Both elements in a reciprocal relation mutually determine one another.

This framework of relations and, indeed, the cognitive capacity which they draw upon (namely, the productive imagination) are not usually noticed in our everyday life. They function as an existential subconscious organized by that general principle of reciprocity which originates in the body's most basic exchanges with the world. This principle determines the contours of all conscious life and is the basis of iterability.

Whereas in conventional representation, the iterable dimension is only explicitly explored in aesthetic appreciation, in the twentieth-century movements I have considered it is rather different. Our intercourse with conventional representation establishes a set of expectations whereby we regard works which follow certain formats (such as being a series of marks on a canvas, or a free-standing configuration of material on a plinth) as being 'about' something. The works which I have considered sometimes use figurative elements – hence the notional resemblance – but these elements function differently from the way they do in conventional representation. In describing such works, including wholly abstract pieces, we have to relate the dominant pictorial elements to a space of reciprocal relations. The principle of reciprocity enables us to read these works in terms other than that of dry formalist description. Through iterability we can say that the work exemplifies such and such an aspect of the existential subconscious. Whatever else the creator intends, the work is at least 'of' one or more of the existential subconscious's reciprocal relations. The usual temptation is to suppose that the 'of-ness' in question here is simply an iconographical matter determined by a work's relation to its immediate context of production and reception. I have tried to show, however, that what is fundamental is rather more than this external relation. The artists engage with or anticipate philosophical standpoints which – whatever their limitations – allow the generation of iterable visual outcomes which transcend the historically specific circumstances of production. This suggests that there is more continuity than is customarily allowed between both disparate twentieth-century tendencies and more traditional art.

Thus, Braque and Picasso's Cubism serves to adapt and reconfigure the plastic substance of the represented subject matter in such a way as to affirm the two-dimensionality of the plane. Instead of the relationship between artistic image and represented reality being fixed in correspondence, it is presented as much more labile and reciprocal. Indeed, in Cubism's insistence on the grid as a means of manifest configuration, the active involvement of the productive imagination in artistic creativity is given overt expression. This being said, Cubism is only partially iterable, leaving open large spaces of interpretative ambiguity. In this respect, Italian Futurism fares rather better. For here the active role of the productive imagination in perception is given clear expression. The present visual appearance is presented as a complex function of temporal processes, most notably that of memory. The further reciprocity between this and artistic creativity is expressed in the use of highly stylized grid structures and 'lines of force' to organize the flow of represented appearances. Cubism and Futurism embody, in effect, a rethinking of conventional representation in accord-

ance with the demands of the existential subconscious. Malevich's Suprematist work, in contrast, is much more radical. It adapts a pictorial space based on optical illusion involving (mainly) geometrical forms in relation to the plane. This is used to conduct explorations of the figure–ground relation which is the structural basis of perception itself. Through the creation of schematic visual possibilities of conflict, resistance, displacement and reconstruction, the reciprocity of figure and ground is evoked in the contingency and mutability of its specific configurations.

All these art movements have one major point in common – the view that what is fundamental in our perceptual relation with the world consists not of correspondence between perception and object, but rather a shifting and unstable reciprocity between the two, which is informed by the existential subconscious. The Surrealists found a discourse of theory and practice which explored the reciprocal structures of this dimension in even greater depth. Breton, indeed, could claim to be the first theorist to do full justice to the existential subconscious. The success of the entire Surrealist enterprise, however, is acutely ambiguous. For whilst it has established itself as a highly iterable modification of picturing, its very use-value in this respect has subverted those subversive intentions which were so much a part of its original agenda.

The pervasive emphasis on contingency and temporal change, as well as an emphasis on dialectic, also informs Mondrian's Neo-Plasticism. It is clear that in the theory and practice of his art, he takes himself to have attained an iterable dimension. Neo-Plasticism is presented as an authentic pictorial language of modern life. Now whilst there are difficulties with this view, there is an element which is iterable in relation to the existential subconscious. Mondrian's work is a highly legible expression of that reciprocity which holds between real empirically given appearances and those abstract principles which we use in organizing them. In his radicalization of line and colour relationship in terms of perpendiculars, the mutual dependency of line and colour in visual life is exemplified in the most uncompromising way.

Before summarizing the work of Barnett Newman, it is worth gathering together some major points. Almost all the artists whom I have considered take themselves to have established new and philosophically decisive pictorial codes. However, none of them is in itself compelling. What we find is that each presents (on the basis of optical or modified pictorial illusion) visual instances of different reciprocal relations which are essential to perception and self-consciousness. They embody different aspects of the existential subconscious. This gives their work an iterable structure. In generating these different aspects, the artists – as I have shown – are guided

by (or anticipate) specific philosophical ideas. But the works can be read in the terms I have described without reference to these more specific ideas. What has been lacking hitherto in art history is a descriptive approach to the visual appearance of twentieth-century work which goes beyond mere aesthetic formalism. I am attempting to provide this. If – as is entirely possible – we can learn to read works in terms of the kinds of reciprocal relations which I have outlined, then such works are invested with an enduring cultural significance rather than a narrowly art-historical one. We find the basis of an iterable visual discourse, of which the works I have considered can be considered as individual 'utterances'.

Yet, in stressing a work's capacity to embody basic perceptual and cognitive relations, am I not effectively de-historicizing it? The answer is no. If a communicative code is to be effective it must consist of iterable elements which can be used across different contexts to clarify patterns of sameness and difference in our changing experience of the world. Hence, in enjoying, say, the subtleties of Malevich's treatment of figure and ground, we are not only dealing with a distinctive illumination of a structure common to all perception; we are also invited to consider questions such as why this particular way of treating this particular relation comes to be formulated and to exert such an influence in this particular historical context. What broader social or intellectual forces does it exemplify; what forces does it reject? Can, indeed, a similar visual and stylistic strategy be successfully adopted in relation to other historical contexts? To ask such questions is to ask about the significance of specific historical instances of more universal structures.

There is another more ambiguous dimension of meaning which must also be considered. Earlier, I analysed the iterable core of Barnett Newman's work in terms of the figure–ground relation. I also noted how the relation of zip and field might be read as a reciprocity of presence and absence (or void). This relation opens the possibility of broader associations with exalted emotions and mortality. In an artist such as Kandinsky, particular colours and forms are invested with specific emotional associations, on the basis of mystical and religious theory. If this body of theory is not accepted, then the emotional associations of colour and form posited by Kandinsky are of a purely iconographic significance. They have no validity beyond the work of him and other artists who subscribe to similar theories. But that is not the end of the matter. For within each society there exists a common cultural stock of such associations which all art draws upon. These are loose and the product of convention much more than nature, but they play an important role. We learn, for example, to see landscapes on a stormy day as gloomy and foreboding, we learn to read

certain kinds of gesture and shape as violent or angry; others still are learned as metaphors of repose or tranquillity. The metaphorical status of these associations is itself significant. For the associated qualities are suggested or alluded to, rather than directly possessed. Indeed, whilst not being wholly determined by personal experience, to recognize and respond to them involves a much more active participation by subjective experience than is demanded by the recognition of ordinary material objects. This gives such associations their particular power. For in their indirectness, they have the fascination of the oracular and the mysterious, yet in engaging with them we draw upon both a common cultural stock and, more significantly, idiosyncratic patterns of personal experience. The result is a mode of indirect communication which, in its very avoidance of the prosaic, carries a potentially deeper affective resonance for the viewer.

My fundamental thesis is that the existential subconscious – composed of various capacities and relations embodying the principle of reciprocity – is the precondition of all iterable codes. In conventional pictorial representation different aspects of this principle emerge primarily through our aesthetic engagement with pictures. In the major twentieth-century tendencies which I have considered they form the descriptive core of representation itself. On the basis of modifications of pictorial illusion, or through optical illusion, they present visual configurations which are consistent with the individuation of specific kinds of reciprocal relation. Just as conventional representation is iterable through codified resemblance, existential representation is iterable through its codified presentation of visual aspects of the principle of reciprocity. On the basis of individual artistic treatments of these, a second wave of associations are set up – associations which are at least partially iterable, to the degree that they draw upon a common cultural stock.

These arguments raise at least one question. Given that conventional pictorial representation implicitly embodies reciprocal relations, and given that much twentieth-century work does so more explicitly, why should this at all matter to us? A philosophical analysis such as this can adequately explain the significance of the existential subconscious, so why should we be interested in its artistic embodiments? A partial answer has already been provided. To express general relations in such sensibly specific media as the visual arts means that they are shown rather than said. A general truth is exemplified in the concrete particular, rather than abstracted from it as in philosophical analysis. This makes the recognition of such truth rather more elusive, in a positive sense. To discern it involves a degree of sensitivity to sensory appearance, informed by comparative historical awareness. Indeed, whereas in forms of knowledge conventionally under-

stood, cognition and understanding operate at an abstract level, in art they are restored to their origins. As I argued in Chapter 1 (and, indeed, in both previous volumes in this series), cognition is achieved gradually through the progressive unification of the body's sensory and motor capacities, in reciprocity with the realm of other spatio-temporal items. That mutual dependence of particular and general, which is the basis of any cognitive act, is ultimately a function of the body's own achieved unity. In art, meaning emerges through the reciprocity between whole and parts in the sensible manifold, and in the reciprocity between the particular work and other works. Here, in other words, the origins of perception are continually repeated and reaffirmed, at the actual level of their origination. The enjoyment of this is not some mere ontological nostalgia. For the mature embodied subject is fully defined and at home with the world only in so far as both its sensible and rational aspects are harmoniously integrated. The art-work's embodiment of ideas is a perfect expression of this. In art, the rational semantic and sensible dimensions are reciprocally related.

Conventional representation, and all the art considered so far in this book, involves the making of iterable meanings. This 'making' needs to be remarked upon. In normal uses of iterable codes, that which is communicated is consumed in the act of communication and its reception: the communicator articulates a fact and the recipient recognizes what that fact is. Only exceptionally do we attend to how the communication is articulated. But in the case of art, this exception is the rule. We are concerned not only with what is represented, but also with how it is represented. We are engaged by the particular way the individual work is articulated in relation to other instances of the same iterable code. This is important not only because the work's individual style clarifies its iterable content in a way which returns us to the origins of perception, but also because it has been achieved by a fellow human being. The iterable content gives a shared reference point in relation to which we can discern sameness and difference. This affords an opportunity for identifying with the artist's way of seeing, and thence the enrichment of our own existential perspectives. In everyday life we can, of course, identify with or be alienated by the way others inhabit the world; we can also learn from the ways in which they describe their experience. But we cannot inhabit the other person. Here art offers a decisive mediating term, for the artist does not simply describe or present ideas through his or her work: the ideas are embodied in a publicly accessible sensible medium. The artist's style or way of seeing is thus manifest, but in a way which is no longer physically tied to the existence of its creator. Through articulation in a codified medium, the artist's view

of things is transformed into a possibility of viewing – a way of seeing or interpreting the world that others can inhabit. Art thus acts as a vital middle term between personal experience of specific ideas and factual presentations of them.

Over these pages, I have gradually moved from talking about specifically twentieth-century tendencies to a consideration of art in general. This is because the iterable status of twentieth-century art (even its 'abstract' modes) allows us to establish a principle of continuity. All art involves the aesthetic embodiment of ideas concerning the existential subconscious and twentieth-century art especially so. However, for many commentators there is a tendency that seems to refute this continuity – Conceptual Art.

Duchamp, Kosuth and the Problems of Conceptual Art

The impulse to Conceptual Art originates most clearly in the work of Marcel Duchamp. In 1946 he wrote:

> The basis of my own work during the years just before coming to America in 1915 was a desire to break up forms – to 'decompose' them much along the lines the cubists had. But I wanted to go further – much further – in fact in quite another direction altogether. This was what resulted in *Nude Descending a Staircase*, and eventually led to my large glass, *The Bride Stripped Bare By Her Bachelors, Even.*[1]

What was at stake in this major transition was then clarified by Duchamp:

> I wanted to go away from the physical aspect of painting. I was much more interested in recreating ideas in painting. . . . For me Courbet had introduced the physical emphasis in the XIXth century. I was interested in ideas – not merely in visual products. I wanted to put painting once again at the service of the mind.[2]

The interesting thing about these remarks is their conservatism. For Duchamp – albeit through Modernist technical means – is clearly seeking to return painting to the same level of intellectual respectability which figures such as Reynolds had claimed for it in previous centuries. Of course, the ideas of interest to Duchamp would be anathema to his predecessors, but the point is that his emphasis on ideas is not one which necessarily regards the visual product as a mere contingency. Neither is there any hostility shown to traditional notions that the work of art is something made by the artist. At most we find a broadening of the significance and scope of the 'made' aspect. Even the 'found' element in

Duchamp's work (that is, elements not physically made by him) is some-
times substantially modified by the artist – as is the case, for example, in
some of the 'assisted' Ready-mades.

Given this, it is clear that the term 'conceptual' when applied to
Duchamp's art signifies a point of emphasis rather than some radical break
which demands a total revision of what counts as art. But why, then, has
Duchamp been consistently treated in these more radical terms?

The answer to this lies in his 'unassisted' Ready-mades. In a work such
as *Fountain* (1917), for example, a porcelain urinal signed 'R. Mutt' is
offered complete, as if it were a work of art. Throughout Duchamp's
career there was a negative Dadaist streak which allowed the artist to
indulge himself through mocking or affirming indifference to the preten-
sions of the art establishment in ironic terms. *Fountain* is a perfect example
of this. Of such works Duchamp declared in 1961:

A POINT I WANT VERY MUCH TO ESTABLISH IS THAT THE CHOICE OF THESE
'READYMADES' WAS NEVER DICTATED BY AESTHETIC DELECTATION. THIS
CHOICE WAS BASED ON REACTION OF VISUAL INDIFFERENCE WITH AT THE
SAME TIME A TOTAL ABSENCE OF GOOD OR BAD TASTE . . . IN FACT A COM-
PLETE ANESTHESIA.[3]

Duchamp's successors (notably the Conceptual artists of the 1960s) how-
ever, have taken the anti-art irony of the Ready-mades as a literal gesture
– one which shows that what defines art is not the making of an object, but
the context of art theory in which some object or idea is located. If there
is no justification for such a view in the major trajectory of Duchamp's
own art practice, why has it become so well established?

The answer to this is simply the bad effects of formalism. Formalism as
a critical doctrine in art arose as a means of legitimizing certain formal
innovations, notably lack of both 'finish' and conventional narrative struc-
ture. The adverse consequence of this was to establish a rigid dichotomy
between formal values and elements of 'idea' or content, with distinctively
artistic significance located firmly in the realm of the former. Given this, it
is easy to understand why artists should seize upon the conceptual emphasis
in Duchamp's work and see it as a new beginning or new foundation for
art practice. For it seems to go beyond the facile anti-intellectualism of
formalism, without merely reverting to the idioms of conventional art.

There is an unfortunate irony here. Another of the adverse effects of
formalism on the definition of art is the view that whereas formalist
approaches can encompass such things as abstract art, representational
theories cannot. Actually they can. This is why I have emphasized the
iterable dimension of abstract and non-conventional representational

works. All art represents in the sense of aesthetically embodying ideas concerning the existential subconscious.[4] Indeed, the art-work in general can be defined as an original symbolically significant manifold, whose meaning can be gathered only by direct acquaintance, and whose originality is internally related to the existence of its specific creator (or ensemble or creators).[5] When an idea or symbolic content is made into an original sensible or imaginatively intended artefact, it exists in a new and distinctive way. As we saw in this chapter, the artist's style of presenting an iterable content is of decisive significance. For when style is articulated in a sensible medium, it becomes more than mere personal style. The artist's approach to an idea is both clarified and made publicly accessible. It becomes a way of seeing rather than something which is simply seen. This vision is, in causal terms, unique – only that one individual or creative ensemble could have made it. But once the work is complete, it offers a general possibility of viewing.

If this approach is correct, then art's sensuous embodiment of ideas reaches deep into the structure of self-consciousness itself, in the aesthetic responses which it generates. There is, in other words, an alternative to formalism, which fully encompasses the 'idea' dimension of art – without reducing 'idea' to merely that of the artist's intentions or theories.

What must be addressed, then, are the nature and claims of Conceptual Art, bearing in mind that there is an alternative to both formalism and the narrow traditionalist view. To execute this task I shall now consider the arguments broached in Part One of Joseph Kosuth's 1969 paper 'Art After Philosophy'. This is by far the most cogent and influential attempt by an artist to ratify the practice of Conceptual Art.

Kosuth's critical strategy focuses on his approach to 'formalism' (meaning both art practice and criticism). At the heart of his approach is a scepticism concerning the necessary relation of aesthetic judgement and the art-work. The aesthetic (as a category) has a global function which far exceeds any link with art alone. Indeed, Kosuth claims that 'Aesthetic considerations are . . . always extraneous to an object's function or "reason to be". Unless of course, that object's reason to be is strictly aesthetic.'[6] Decoration is the exemplar of such aesthetic function. Hence Kosuth goes on to declare that 'Formalist art (painting and sculpture) is the vanguard of decoration, and, strictly speaking, one could reasonably assert that its art condition is so minimal that for all functional purposes it is not art at all, but pure exercises in aesthetics.'[7]

The reason why the link between art and the aesthetic has become well established is historical. Aesthetics originally addressed itself to the question of beauty, which is indirectly related to art by virtue of decoration. As

Kosuth wrote: 'So any branch of philosophy that dealt with "beauty" and thus taste, was inevitably duty bound to discuss art as well. Out of this "habit" grew the notion that [there] was a conceptual connection between art and aesthetics, which is not true.'[8] Kosuth turns out to be particularly hostile to artists such as Olitski, Morris Louis, Caro and Hoyland. He is also equally hostile to Greenberg's formalist critical practice, arguing that it reduces, in effect, to Greenberg's own personal taste (which is itself a reflection of 1950s sensibility).

Given this scepticism and hostility concerning formalism, Kosuth offers one major argument to show (rather than simply assert) its falsity. It holds that formalist approaches to art define it on fundamentally 'morphological' grounds, that is, on the basis of similarities of visual features or the way in which works are 'read' or appreciated. However, Kosuth argues that even in the face of such similarities 'one cannot claim from this an artistic or conceptual relationship.'[9] Indeed, 'Formalist criticism is no more than an analysis of the physical attributes of particular objects that happen to exist in a morphological context. But this doesn't add any knowledge (or facts) to our understanding of the nature of art.'[10]

The real significance of this is not simply that it is a kind of intellectual sin of omission; it also distorts the creative foundations of art itself. As Kosuth goes on to say:

> The strongest objection one can raise against a morphological justifi- cation for traditional art is that morphological notions of art embody an implied a priori concept of art's possibilities. And such an a priori concept of the nature of art . . . makes it, indeed, a priori impossible to question the nature of art.[11]

The fundamental problem of formalism, then, is that it embodies an inherent restriction of art's creative possibilities.

Kosuth's own view of how art is to be defined in positive terms takes its cue from Duchamp's innovations. Duchamp raised the problem of the 'function' of art in a way that goes far beyond the anticipations of such questioning found in the likes of Manet, Cézanne and the Cubists. Indeed, as Kosuth puts it:

> With the unassisted Ready-made, art changed its focus from the form of language to what was being said. Which means that it changed the nature of art from a question of morphology to a question of function. This change – one from 'appearance' to 'conception' – was the begin- ning of 'modern art' and the beginning of conceptual art. All art (after Duchamp) is conceptual because art only exists conceptually.[12]

The scope of the claim 'art only exists conceptually' is unclear. Kosuth's point as I read him is that all art is, by definition, concerned with the presentation of ideas about art (rather than aesthetically appealing surfaces or whatever) and that, after Duchamp, this authentic essence of art is explicitly declared.

Now in shifting the emphasis from the mode of saying to that of what is said, Kosuth is assigning a primacy to the artist's intentions or conceptions concerning the nature of art. Kosuth's notion of the artist holds that 'He is concerned only with the way (1) in which art is capable of conceptual growth and (2) how his propositions are capable of logically following that growth. In other words, the propositions of art are not factual, but linguistic in character'.[13] This is also supposed to imply that

> Works of art are analytic propositions. That is, if viewed with their context – as art – they provide no information whatsoever about any matter of fact. A work of art is a tautology in that it is a presentation of the artist's intention, that is, he is saying that the particular work of art *is* art, which means, is a definition of art.[14]

According to Kosuth, the essence of art is to be self-referential. Art becomes art, through an artist affirming that his or her particular work is a work of art.

Let me now review Kosuth's claims and their ramifications. First, his assertion concerning the relation between aesthetics and art is both philosophically dubious and historically ill-informed. Aesthetic experience – in all its varieties – is, indeed, a global term whose domain is the relation between cognition and phenomenal objects. Art is only one element within this domain. To this degree Kosuth is right. He is wrong, however, to identify art's aesthetic function only with decoration. Since Kant it has been customary to distinguish between decorative art and fine art. In formalist aesthetics, such as the writings of Whistler and Bell, an emphasis is placed on formal qualities which is so rigid that it excludes the formal aestheticized function of elements of content. In the best philosophies of art, however, this dimension is taken account of. In the writings of Kant, Schiller, Hegel, Schopenhauer, Adorno, Merleau-Ponty and others, fine art is seen as the embodiment of aesthetic ideas. This means that, when presented in sensible or imaginative terms, the conceptual content of an art-work has levels of significance which linguistic articulations of that content do not. It is this distinctive mode of embodying ideas (as we have seen) which is art's *raison d'être*. But Kosuth continued:

If Pollock is important it is because he painted on loose canvas horizontally to the floor. What *isn't* important is that he later put those drippings over stretchers and hung them parallel to the wall. (In other words what is important in art is what one brings to it, not one's adoption of what was previously existing.) What is even less important to art is Pollock's notions of 'self-expression' because those kinds of subjective meanings are useless to anyone other than those involved with him personally.[15]

Kosuth dismisses 'self-expression', seeming to regard expression and modes of response to it as absolutely subjective and private. They are not. For the ability to have an 'inner' life is logically parasitic on initiation into publicly accessible embodiments of those states – notably iterable codes and patterns of sameness and difference in their articulation. From earliest childhood, gestures, shapes and colours are learned in terms of affective states or emotions with which they are associated. These form a cultural stock – a loosely iterable vocabulary of forms – in terms of which we respond affectively to the world. Hence Pollock's expressions of such things as smooth and violent rhythms, chaotic impastoes and patterns of stress and release are ones which have an intersubjective significance. And this is why – *contra* Kosuth – the morphological dimension of presentness to sense is of decisive significance in art. For when form or content is sensibly embodied in a work, it is not simply 'about' or an exemplification of 'subjective meanings'. Rather, it presents these in a way which is, at least to some degree, accessible to the viewer on his or her own terms.

This aestheticization, however, is not comprehended by Kosuth. In the remark quoted above, importance is assigned to what the artist 'brings' to art, over and above the adoption of previously existing formats. This relates to the point, noted earlier, that to define art in morphological terms restricts the creative possibilities of art and inhibits, '*a priori*', any fundamental questioning of art's nature. Of course, it actually does none of these things. What Kosuth assumes is that, at its most authentic, artistic creativity is absolute and negative in character. The artist proposes an entirely new definition about what can count as art – hence the real significance of, for example, Pollock's technical innovations. However, for us to read something as an innovation presupposes that we are at least implicitly contrasting it with that which is traditional. Art does not indeed create *ex-nihilo* by simply forgetting all that has gone before. Tradition plays a positive role by providing a wealth of frameworks and interests *vis-à-vis* media and their interpretations which the artist can deploy, refine, react against or develop in wholly new ways. Even if the possibility of artistic creation *ex nihilo* did exist, it would at best count as original nonsense – for there would be no context in which it would be legible as a continuation of art.

This brings us to Kosuth's claim that the art-work is an analytic proposition concerning the nature of art. According to him, it is tautologous in the sense that its *raison d'être* is to affirm that the particular work is art. For this to count as a tautology, it assumes that simply calling something art is enough to constitute it as art. But if this is the case, why bother? If we know in advance that anything can be art, what is the point of continuing the practice? But innovations in art are that, they are not mere tautologies; rather they expand our awareness of the scope and continuing significance of art. Kosuth, in other words, conflates 'tautology' with the more global and, in art's case, more relevant notion of self-referentiality.

Even the notion of self-referentiality raises considerable problems for Kosuth. For let us suppose with him that in its authentic mode, art is profoundly self-referential, that in creating a work, the artistic essence consists not in any material object created by the artist, but in the new idea about art to which the act of making or designating refers. Again, we must ask why art expressing ideas about art in this way should matter in the slightest to us? Kosuth himself says that 'whereas other endeavours are useful, art is not. Art indeed exists for its own sake'.[16] But what is the foundation of this non-utilitarian exploration for its own sake? Let us consider an example from someone other than Kosuth. In 1966, David Bainbridge created a work called *Crane* at the St Martin's School of Art in London. To all intents and purposes the work was indistinguishable from an industrial crane. Its function as 'art object' or crane, in other words, was determined by the ambience in which it was located. Alluding to this work, Terry Atkinson speculated:

> If a bottle rack [that 'by' Duchamp] could be asserted as a member of the class 'art object', and a crane can be asserted as a member of the class 'crane and art object' and then can be asserted to lose its 'art object' status (and so on), all these changes being dependent on changes of ambience perhaps a further development can be constructed through applying such an assertion of declaration to ambience rather than objects. Hence if a bottle rack can be asserted as a member of the class 'art object' then why not the department store that the bottle rack was displayed in, and if the department store why not the town in which the department store is situated, and if the town then why not the country . . . (and further if you like).[17]

These remarks illustrate the passage from alpha to omega in Conceptual Art. For, once the Duchamp Ready-made is allowed as art, literally, everything else can be allowed as art. The result of the experiment is knowable in advance if, that is, we take the experiment as concerning the

limits of art, as a theoretical investigation. However, the Atkinson quota-
tion also evidences a pleasure in exploration for its own sake – a playing
with possibilities. All forms of discourse have their own intrinsic pleasures:
as well as the excitement of anticipation and the satisfaction of success,
there is a pleasure to be had in simply organizing physical material or
theoretical structures – in making them fit, or account for, how the world
is or in simply getting them into some kind of order. In the case of a wholly
non-utilitarian activity, this dimension is paramount. The activity's ratifi-
cation consists not in conceptual results or practical consequences but in
the pleasure of playing with possibilities of relation among ideas, events and
objects – getting things into some kind of order. This means that if – as
Kosuth asserts – art is purely self-referential with no instrumental signifi-
cance, its ultimate rationale is aesthetic. Conceptual 'art' involves sets of
exercises in applied aesthetics. It is experiment, play, the following up of
imaginary truths and systems, or the creation of objects, ideas and systems,
purely for their own sake. These do not expand our understanding of what
art is, neither do they shift its limits; rather, they illuminate a little the scope
of the aesthetic drive in human beings as an impulse to create and enjoy
order for its own sake.

The real significance of Kosuth's position, then, is an unrecognized
affirmation of an extreme subjective version of aesthetic formalism.
Whereas the objective mode of this (in Bell, Fry and others) focuses on the
audience's response to formal qualities in the object, the subjective for-
malism of Conceptual Art is an unrecognized affirmation of the shallowest
aesthetics of genius. It holds the artist's 'intentions' and creative wit to be
paramount, allowing extremes of self-indulgence. To discern the real
'meaning' of the work, one must make obeisance to the supreme authority
of the artist. Art has absolute autonomy.

Where does this leave the status of Conceptual Art? It all depends on
which artist or group one is dealing with. Much Conceptual Art has turned
out to be of the original nonsense sort and, as such, has had no substantial
effects. Other works, however, have had more complex influences.

Let us explore Conceptual Art's artistic status. Earlier on I argued that
the proper definition of art sees the work as an original, symbolically
significant, sensible (or imaginatively intended) formation whose existence
is internally related to the existence of its creator. Such a work does not
admit of paraphrase. Many works of Conceptual Art, however, do admit of
this or its equivalent. Consider, for example, the Atkinson–Baldwin *Air
Show* of 1967, of which Atkinson said:

> The basic tenet of the 'Air Show' was a series of assertions concerning
> the theoretical usage of a column of air comprising a base of one square

mile and of unspecified distance in the vertical dimension. No particular square mile of the earth's surface was specified. The concept did not entail such particularized location.[18]

This and other works by Atkinson and Baldwin in the late 1960s offer an interesting set of exercises to test the conceptual and imaginative sensibility of viewers. However, the duo could have made the same point by using different articulations of language from the ones actually chosen. One can 'get the point' even from a secondary description of what the *Air Show* involved. Moreover, it is possible that someone else – entirely independently of Atkinson and Baldwin – could have arrived at a 'work' embodying exactly the same idea.

The point of substance, then, is this. Conceptual Art seems to restore the autonomy of the artist (instead of the critic) but it does so only in an external sense. For in existing as idea rather than idea completed only by its embodiment in a specific sensible formation, it has no necessary relation to the specific individual creator or creative ensemble who brought it into being. Similar considerations always hold, to the degree that a work is only contingently related to the mode in which it is expressed. If the work's idea can be sufficiently grasped by second-hand description rather than direct perceptual intercourse or could have been sufficiently expressed in different terms, then the relation between idea and embodiment is a contingent one. We are dealing with a loose exercise in aesthetics.

It might seem that the contingency of this relation between idea and embodiment is exactly what is of worth in Conceptual Art. It defetishizes the art object (and overturns its commodity status), and it democratizes art by freeing the creator from having to learn specialized, craft-like skills. But to affirm the defetishization is, in effect, to throw out the baby with the bathwater. For unless a work involves the affirmation of its own particularity as particular or token of a type, there is simply no reason for regarding it as art. Those such as Kosuth fail to understand that art's foundation in the realm of sensible or imaginative particularity can be fetishized in specific historical circumstances, but is not so in itself.[19] Hence, whilst Conceptual Art may play a momentarily healthy strategic role (historically speaking) by breaking the stranglehold of objective formalism, it does not offer anything much of positive value. As for questioning art's commodity status again, this is of only momentary significance and, if anything, has issued in defeat. For the market will have its objects – even if only notes and documents or original photographic records tracing how such and such a Conceptual work or event came to be or was enacted. (It is instructive that the Conceptual artist Christo earns a living and finances his projects for wrapping buildings and landscapes largely by marketing such ephemera.)

In the mid-1970s Kosuth and many other Conceptual artists (such as members of the Art & Language group) became profoundly aware of this problem. Kosuth accordingly revised his position, observing in 1977 that

> A radical conceptual art, as critical practice, would need to realize a program *from* its understanding of the meaning of our meaning systems. The 'demystification' of early conceptualism collapsed into style because of the naivete of its scientistic, *instrumental* tools. Located in the trajectory of an architectonic mode, it couldn't *see itself*.[20]

He continued:

> For these reasons, 'consciousness' in the function of self-reflexivity should be operating within the elements of the work (propositions) of art itself. In this way the *subject* of the maker is present and 'humanifies' the work. The proposal is for work which understands itself as a context which mediates (as it is mediated and is part of) the social context.[21]

Kosuth's point is that whilst what defines art is still the artist's intention or 'proposition', this needs to embody some critical awareness of the conditions under which it operates and is socially constructed. But what scope should we ascribe to 'embody' in this context?

This leads us directly to the complex point concerning Conceptual Art's democratizing function. For if we read 'embody' in a very loose sense (as a contingent relation) this has some unfortunate results. Kosuth's point about the necessity of critique is found in one of these. It consists in the sensibility of 'political correctness'. Barbara Kruger, for example, around 1981 used patriarchally significant images overlaid by comments in Letraset (pl. 31). In relation to such work Whitney Chadwick has observed that

> Barbara Kruger's blown-up, severely cropped photographs of women, and their short accompanying texts, subvert the meanings of both image and text in order to destabilize the positioning of woman as object. She emphasizes the ways in which language manipulates and [she] undermines the assumption of masculine control over language and viewing, by refusing to complete the cycle of meaning, and by shifting pronouns in order to expose the positioning of women as 'other'.[22]

The meaning of Kruger's work can be characterized as a dogmatic statement of a specific position concerning the construction of woman as 'other'. There is noting more to it than that – no positive ambiguity, no space for imaginative associations and fantasy. We have an image with critical but not aesthetic significance. Kruger's weakness in this respect can be contrasted with Mona Hatoum's *Corps d'Etranger* (1995). This work

31 Barbara Kruger, *Untitled* (*Your gaze hits the side of my face*), 1981. Mary Boone Gallery, New York

involves electronically transmitted imagery generated from exploratory devices inserted by the artist into her own body. There are many possible feminist readings of such imagery, which has a primal beauty of its own. Most important, however, is the element of risk which is involved. By this I mean that, in a sense, Hatoum's project embraces the possibility of a purely voyeuristic gaze. Even whilst appropriating her own internal body, its external means – the transmitted image – makes it simultaneously vulnerable. There are many complex levels of meaning involved.

And this is the point. An 'art' which is fundamentally concept or idea-based is one which exists only to illustrate a specific theoretical viewpoint. An effective object-based art is one which opens out avenues of (sometimes risky) imaginative exploration which cannot be reduced to a specific conception (even though the artist may have been guided by such a conception in coming to create the work). The idea-based approach, unfortunately, has been enormously influential in recent times. It found its apotheosis in the 1993 Biennial Exhibition at the Whitney Museum in New York, which regaled its viewers with images and edicts on how to think about women, AIDS, minorities and other social matters. The ration-

ale for this type of propaganda (sometimes crude, sometimes subtle) being shown in such a context was its putative status as critical Conceptual Art. But the concepts in question had little to do with art. Conceptual Art in its very conceptuality, in other words, lends itself to colonization by special interest groups, for whom art is another front for more general political action.

Against this argument the artist's intentions might be evoked. The artists in the Whitney Biennial, for example, care passionately about their causes. Who, then, is to deny their work? Indeed, does not such a denial affirm precisely the white, male, middle-class, Eurocentric and heterosexist attitudes which have regulated and constrained traditional art?

The specificity and sensible particularity of art may well have reinforced dominant interests of various sorts, but it did not have to. Understood critically, it can be changed, without recourse to authoritarian strictures of political correctness. Furthermore, the willingness to claim that what counts as art is determined by context, and ultimately the artist's intentions, is itself an unrecognized internalization (that is to say, a dialectical image in a bad sense) of the attitudes which political correctness is nominally opposing. Whilst it is in some ways traditional to regard art as a reflection of dominant social attitudes, less attention has been paid to art's capacity to anticipate such attitudes before they become dominant. In the present case, the idea that what counts as art is determined fundamentally by the artists, intentions is an anticipation of the facile individualism of the Thatcher–Reagan years. Here what counts is not a responsibility for medium and skills or a dialogue with tradition, but 'Me! Me! Me!' and the absoluteness of 'my desires'; 'if I want it to be art, then it necessarily is.'

If Conceptual Art in many of its manifestations rejects the object-as-commodity, it nevertheless covertly embodies the mediocre anti-ethical standpoint which sustains that attitude. Indeed, by stripping away the overt instrumentalist rational which sustains that anti-ethic, or by filling it out with politically correct critique, the authoritarian self of Thatcher–Reagan petty mercantilism comes to exist in its purest and most ugly state. Such works do not invite a dialogue, they embody a simple imperative – 'believe as I do'. Artistic and political critique are essential to any culture, but presented as art statements (rather than as art theory or politics) they exist in supreme bad faith. For as art-works they cannot simply be judged by standards of theoretical rigour in aesthetics and politics; yet as statements we cannot judge them by criteria of artistic excellence. They occupy a space of ambiguity, which negates dialogue by affirming the absoluteness of the artist-as-self. There is a further irony here, in that the artistic self is never more secure in its majesty and audacity than when proclaiming its own death or impossibility through idioms of 'deconstruction'.

There are, however, some positive ramifications of Conceptual Art. As noted earlier, some works are indeed of genuine interest as aesthetic exercises or experiments, and others are of yet more positive import. For example, though many of Kosuth's installations or other manifestations simply illustrate and are intelligible only in relation to accompanying texts, others – such as the *Modus Operandi* works of the 1980s – might be seen as having a genuine visual interest in their own right. Similar considerations hold in the crossover from Minimal to Conceptual Art as exemplified in the works of Morris, Judd, LeWitt and Reinhardt. These artists designed or produced objects on the basis of complex theories concerning space, object, viewer and producer.[23] Many – if not all – of their works since the early 1960s could have in principle been constructed by someone else, and in many cases they were. Pieces by Judd and Morris, for example, were produced by foundries according to the artists' specifications.

The objects produced by these artists, therefore, in most cases fail to meet the strict demands of true art, since the relation between idea and object is a contingent one. However, some of these works are so aesthetically interesting in their exploration of order's intrinsic qualities and their relation to traditional notions of sculpture or object, that it seems churlish not to regard them as art. This fact is by no means problematic. For art's boundaries have some flexibility. These works, for example, are so significant as aesthetic exercises as to be far more worthwhile than most traditional art produced contemporaneously with them. The field of fine art has always, and will always, overlap with cognate areas – such as the decorative arts and those products of mass culture where aesthetic considerations are a relevant factor in their creation and consumption. We will find a realm of neo-art where the prefix does not have a negative connotation, but signifies rather both overlap with and difference from the emphases of art proper.

In some cases, the point of transition from neo-art to art proper will be almost impossible to locate. Even in traditional art, for example, there are works produced in workshops where the dominant creator will affirm authorship of a work, whereas it was made by both him or her and studio assistants. In the field of Conceptual Art and its legacy, this area of ambiguity is most tellingly found in the work of Ian Hamilton Finlay, which involves craftpersons producing objects to Finlay's specifications.

Finlay's oeuvre in some respects is the most extraordinary and fruitful product of Conceptual Art's democratization.[24] Here the appearance of his written text-objects is an integral part of the works' meaning, even though they are not physically made by the artist himself (pls 32–34). Finlay's work addresses ideas, particularly those associated with the tradition of Neo-

classicism and its ethical and aesthetic ramifications. Ideas of revolutionary purity and terror, of humankind's philosophical status in the world and so forth are not simply presented through an inference from object to the artist's intentions. Their specific modes of embodiment place them in an interpretative no-man's-land. An idea is made clearly discernible, but its ultimate meaning and significance are rendered contestable. This is why Finlay's work has aroused such controversy. For those who are historically, ethically and aesthetically simplistic in their outlook, any addressing of themes where some claim to virtue announces itself in authoritarian and violent terms must also involve a politically correct condemnation of them. Yet the entire creative tradition of Neo-classicism has absorbed and trans-formed such themes, and has endured (however sinister some of its specific historical instances may be). Finlay's work – precisely because it omits simplistic *pro* or *con* attitudes – shows something of the pervasive structure and scope of the aesthetic will-to-form which drives this Neo-classical tradition and enables it to recur. It is an aesthetic clarification, rather than a political exhortation. One might say, therefore, that in relation to Finlay's work, the term 'Conceptual Art' involves no contradiction in so far as it clarifies concepts in a way which eludes conventional modes of theoretical analysis. In the broadest sense, it engages with philosophically significant ideas in a distinctively artistic way.

32 Ian Hamilton Finlay, *Utterances of Louis-Antoine Saint-Just*, five inscribed plaster busts, after the original by D'Angers, presented to Ian Hamilton Finlay by the French Communist Party. 1991/94

33 Ian Hamilton Finlay, *Corday, Lux*, stone, 1995. With Andrew Whittle. This work refers to Charlotte Corday, guillotined for the murder of Marat, and to Adam Lux who fell in love with her following her arrest, and was also guillotined.

34 Ian Hamilton Finlay, *All Greatness Stands Firm In The Storm*, one of two stone piers so inscribed. River Clyde, Glasgow, 1990. With Annet Stirling

I have argued, then, that much Conceptual Art is not art at all but at best a set of exercises in applied aesthetics. It is a subjective counterpart to objective formalism. There are, however, cases which transcend this. What is decisive is the artists' capacity to design or produce aesthetic objects which can achieve to greater or lesser degree the same aesthetic effects as art proper.

In the final analysis the issue of Conceptual Art must be determined by the historical and logical rationale of the very term 'art'. For if there is a distinctive form of meaning in human experience, wherein ideas are sensibly or imaginatively embodied in such a way that their embodiment is an inseparable part of their meaning, then we need a special term for it. The term 'art' has evolved and established itself for just this purpose. By attempting to reduce art to a mere exemplar of ideas about art and politics, Conceptualists once more enact the supreme art form of the Left – political suicide. Rather than contest art as a mode of embodiment on its own terms they give up the field and relegate its sensible idioms to the status of bourgeois fetishism. In so doing, they marginalize themselves from the real artistic life-world on the basis of the obscurity and authoritarian superiority of their mistaken theories and practices. The most secure and tested form of political suicide in art is the demand for overtly political art.[25] This is what much Conceptual Art has tended to become and may continue to be.

So far in the book I have argued that in its modifications or abandonment of conventional pictorial representation twentieth-century art has adopted a new iterable code. Those reciprocal relations which are implicit in any iterable code become the content of representation. In these cases, we have a direct aesthetic embodiment of the existential subconscious. Of course, to understand this as a basis for representation is not as easy as grasping the foundation of conventional representation (codification of visual resemblance between kinds of item or relations given in three-dimensional space). This is why I have traced the interaction between this art and philosophical ideas. These ideas provide a vital clue to the new preoccupations of the artists, though it is only a clue – a point of orientation. For in all the work I have considered there is an iterable surplus. The particular philosophical ideas are, through visual expression, refined in a way that extracts and aesthetically embodies various kinds of reciprocal relation which are fundamental to self-consciousness. This means that once we have learnt to see the new modes of art on the basis of such a code, the artists' more specific intentions and theories assume a wholly secondary significance. The art has outgrown them. This involves no loss to the artist. For his or her work is now invested with an enduring human significance, rather than one defined by art historians alone.

Part III

Simulation and Postmodern Representation

In the first two parts of this book, I have argued that conventional representation and twentieth-century art constitute iterable visual codes. The former is latently informed by those reciprocal relations and capacities which constitute the existential subconscious, whilst the latter posits these more directly. Since at least the late 1960s, both codes have co-existed with broadly equal effect in the art world (even if the structure of the new mode of representation has not been fully understood). Twentieth-century representation is indeed founded on significant iterable structures, but these are exemplified in different ways under different historical and personal circumstances, and hence the significance of stylistic variation. For example, in Malevich's and Newman's different treatments of the figure–ground relation, the same reciprocal relation is embodied with different intentions and has different consequences – both artistic and more general. And, as well as such historical mediation, much more general factors can come into play. Consider the following remarks by J.-F. Lyotard:

> Eclecticism is the degree zero of contemporary general culture: one listens to reggae, watches a western, eats McDonald's food for lunch and local cuisine for dinner, wears Paris perfume in Tokyo and 'retro' clothes in Hong Kong; knowledge is a matter for TV games. It is easy to find a public for eclectic works. By becoming kitsch, art panders to the confusion which reigns in the 'taste' of the patrons. Artists, gallery owners, critics, and the public wallow together in the 'anything goes', and the epoch is one of slackening.[1]

Lyotard's characterization of the eclecticism of postmodern culture and his scepticism as to the worth of much postmodern art have been enormously influential. Jean Baudrillard likewise has influenced much contemporary thought in his claim that sign systems derived from technological models are so pervasive as to obliterate the distinction between reality and representation. The postmodern world is that of the eclectic sign consumer alone.

If these sceptical viewpoints were valid, they would have severe implications for the main argument of this book. It could be claimed that

contemporary historical conditions neutralize the aesthetic effectiveness of the existential subconscious in both its indirect and direct modes of expression. *Qua* iterable, twentieth-century art may have the structures which I have assigned to it, but these structures have now become inert. We seek mere entertainment or decorative functions from art, rather than its humanizing depths. Indeed, the powerful and continuing influence of imagery derived from mass culture on art since about 1960 might be taken as a powerful indicator of this. In this chapter I shall refute this sceptical approach, and then, in my final two chapters will elucidate some of the main achievements of postmodern art *vis-à-vis* the continuing significance of the existential subconscious. For the refutation, I have already dealt at length with Lyotard's approach in *Critical Aesthetics and Postmodernism*. Baudrillard's strategy, however, involves somewhat different issues and accordingly needs a different critique.

Baudrillard's Position

Baudrillard is a difficult writer. His basic strategy is one of rhetorical overload. The reasons for this strategy are complex and I shall consider them later. First I shall negotiate an expository path through the maze of his theory of simulacra.

Signs are not just the province of language and intellectual discourse: all appearance (that is, material present to the senses) is encoded. Baudrillard's theory of simulacra (artefacts whose function is to present and encode appearance) focuses on just this fact. It seeks to describe dominant tendencies in the way appearance historically has been encoded in artefacts. He summarizes his position:

> Three orders of appearance, parallel to the mutations of the law of value, have followed one another since the Renaissance.
> – *Counterfeit* is the dominant scheme of the 'classical' period, from the Renaissance to the industrial revolution.
> – *Production* is the dominant scheme of the industrial era;
> – *Simulation* is the reigning scheme of the current phase that is controlled by the code.
>
> The first order of simulacrum is based on the natural law of value, the second order on the commercial law of value, that of the third on the structural law of value.[2]

Baudrillard's claims here are obscure but can perhaps be explained as follows. In feudal societies, appearances are encoded with a fixity that

parallels the rigidity of the social order itself. Signs have definite and stable reference. However, with the rise of the mercantile and socially mobile societies of the Renaissance, signifying practices are accordingly transformed. They become more shifting and diverse. Literally, more ways of seeing and understanding reality become possible; perspectives multiply. The reason why Baudrillard describes this as the 'counterfeit' order of simulacra is that it aspires to the kind of fixity of meaning upon which feudal signifying practices were founded. It sees its own encoding of appearance as founded on some unproblematic 'natural' correspondence between the sign and its referent. For Baudrillard, however, the relation between sign and referent is never 'natural'; it is a function primarily of social convention. Hence the simulacra of 'classical' society in its yearning for fixity are merely counterfeits of the fixed social convention that lies at the heart of feudal signifying practices. The yearning is itself transformed by the onset of the Industrial Revolution.

In the Industrial Revolution, the encoding of appearance is determined by production and commercial value rather than some supposed natural relation. As Baudrillard puts it, the signs in such a society have no need of counterfeit, 'since they are going to be produced all at once on a gigantic scale. The problem of their uniqueness, or their origin is no longer a matter of concern'.[3] Indeed, the processes of mass production in such a society mean that 'In a series, objects become undefined simulacra, one of the other. And so along with the objects, do the men that produce them.'[4] In these remarks, Baudrillard is following Walter Benjamin's well-known claim that techniques of reproduction radically alter the status of producer. The transition from this second order of simulacra to that third order (of 'simulation') which characterizes our present age is a heightening of this tendency to an extreme degree. In Baudrillard's words, 'all the forms change once they are not so much mechanically reproduced but even *conceived from the point of view of their reproducibility*, diffracted from a generating nucleus we call the mode.'[5] We thus find a transition from simulacra determined by capitalist production to simulacra which reflect techniques of operational efficiency determined by cybernetic models.

According to Baudrillard, in processes of simulation generated by models, the distinction between the simulacrum and the putative 'reality' of which it is a simulacrum is collapsed. We find a society of the 'hyperreal', as he calls it, where

> The real is produced from miniaturized units, from matrices, memory banks and command models – and with these it can be reproduced an indefinite number of times. It no longer has to be rational, since it is no

longer measured against some ideal or negative instances. It is nothing more than operational. In fact, since it no longer is enveloped by an imaginary, it is no longer real at all.[6]

Baudrillard is claiming that third-order simulacra simulate reality with such operational efficiency as to become substitues for the real. But what does this rhetoric amount to? Baudrillard's point is (at least) that our criterion of the real has been transformed by techniques for controlling it. Our sense of what is physically and biologically ultimate, for example, consists of the formulae or computer-based models in which we simulate microscopic quanta and relations, and from which our putative macroscopic 'reality' is thence seen as 'generated'. Similar considerations govern behavioural issues. Increasingly, our experiences are organized around statistical norms and stereotypical roles determined by mass media such as television, tabloid newspapers and the constant pressure exerted through these by the advertising industry. As Baudrillard notes,

> all holds ups, hijacks and the like are now as it were simulation holds-ups, in the sense that they are inscribed in advance in the decoding and orchestration rituals of the media, anticipated in their mode of presentation and possible consequences. In brief, where they function as a set of signs dedicated exclusively to their recurrence as signs and no longer to their 'real' goal at all.[7]

Human behaviour – both the needs and desires which occasion it, and the pattern of unfolding – is increasingly encoded in order to match up with simulation. This is not just a case of adapting to media formats; rather, presentation in such formats becomes a need and a goal of behaviour itself:

> The medium itself is no longer identifiable as such, and the merging of the medium and the message . . . is the first great formula of this new age. There is no longer any medium in the literal sense; it is now intangible, diffuse and diffracted in the real, and it can no longer be said that the latter is distorted by it.[8]

The upshot of all this for Baudrillard is that we live in a hyperreal epoch, where techniques of simulation are so effective and pervasive as to be inseparable from our criterion of reality itself. The drive to encode has become fundamental. Those real oppositions which used to determine our sense of reality – such as the conflict between good and evil – have been replaced by the cyberneticized coding of similarities and dissimilarities. In this epoch, 'Every image, every media message, but also any functional environmental object, is a test – that is to say, in the full rigour of the term, liberating response mechanisms according to stereotypes and analytic models.'[9] Indeed,

All is presented today in a spread-out series, or a part of a line of products, and this fact alone tests you, because you are obliged to make decisions. This approximates our general attitude to the world around us to that of a *reading*, and to a selective deciphering. We live less like users than readers and selectors, reading cells.[10]

Hence, 'The entire system of human communication has passed from that of a syntactically complex language structure to a binary sign–system of question/answer – of perpetual test.'[11] This is why Baudrillard sees the present epoch as organized on the basis of a structural law of value. The value or significance of an item is not determined by its relation to a reality but by its relation to other items in a code of simulation. The distinction between reality and simulacra is collapsed.

Simulacra and Art

As one might expect, Baudrillard has many observations to make about the relation between art and simulation. According to him, art once had 'critical transcendence' in that representation was not confused with that of which it was a representation.[12] In the current epoch of simulation, however, this has changed. Traces of the change are already apparent in the various tendencies to artistic Realism. In their rhetorical insistence on a 'reality effect', such movements manifest a deep-seated insecurity about the status of the real itself. This insecurity is, of course, made explicit by the advent of hyperreal tendencies in art. Baudrillard describes this advent:

> To exist from the crisis of representation, you have to lock the real up in pure repetition. Before emerging in Pop Art and pictorial neo-realism, this tendency is already at work in the new novel [the works of Robbe-Grillet *et al*]. The project is already there to empty out the real, extirpate all psychology, all subjectivity, to move the real back to pure objectivity. In fact this objectivity is only that of the pure look – objectivity at last liberated from the object, that is nothing more than the blind relay station of the look which sweeps over it . . . it is the entire optic, the view has become operational on the surface of things.[13]

Baudrillard further suggests that there are several varieties of this realistic simulation. He is not, however (with one major exception), specific about which artist and movements in which media fit his description of these. I shall, therefore, outline his descriptions and indicate a number of practitioners of twentieth-century art whose works seem to satisfy them quite well.

Baudrillard's first variety of hyperrealistic art is defined as 'The deconstruction of the real into details: closed paradigmatic declension of the object – flattening, linearity and seriality of the partial objects.'[14] This description quite clearly fits most aspects of Cubism and related tendencies, down to David Hockney's assemblages of photographs in the early 1980s.

Elements of Cubism and Futurism would also satisfy Baudrillard's second variety of hyperreal art, 'The endlessly reflected vision; all the games of duplication and reduplication of the object in detail . . . [Here] the real is no longer reflected, instead it feeds off itself till the point of emaciation.'[15]

The most obvious works at all related to this, however, are certain tendencies in Super Realism. In Richard Estes' shop fronts, for example, we find an endless play of empty reflections. In other works, such as those by Don Eddy, this play of reflections is carried through to even more spectacular consummation.

Baudrillard's third variety is the one that he links to a specified artist: 'The properly serial form (Andy Warhol). Here not only the syntagmatic dimension is abolished, but the paradigmatic as well.'[16] The kind of works which Baudrillard has in mind here are the *Marilyn* and *Liz Taylor* lithographs. However, he would doubtless cite the entirety of Warhol's *oeuvre*, in so far as the original which is represented is generally in itself banal, for example, Campbell's Soup tins (pl. 35) or Brillo boxes.

The final variety of hyperreal art which Baudrillard cites is the decisive one:

> the true generating formula, that which englobes all the others, and which is somehow the stabilized form of the code is that of binarity, of digitality. Not pure repetition, but the minimal separation, the least amount of inflection between the two terms . . .[17]

There are a number of tendencies in contemporary art which would well satisfy this description. The first is Super Realism in both painting and sculpture. The works by Estes and Eddy, for example, not only derive from photographs but are almost indistinguishable from blown-up cibachromes. Here the distance between simulation and simulated is minimal. Such images harbour all sorts of resonances concerning that implosion of reality and its simulacra which are the basis of Baudrillard's notion of the hyperreal. Similar considerations apply to the Neo-Geo tendency in New York art. Jeff Koons's *Rabbit* (1986), for example, is simply a banal child's toy rendered and bloated in stainless steel. Other works by him – such as *New Hoover Celebrity IV* (1985) – involve 'sculpture' made from real consumer goods, whose identity is transformed only when they are located in a non-functional context, usually an art gallery. Peter Halley claims to

35 Andy Warhol, *Campbell's Soup Can*, 1964. Leo Castelli Gallery, New York

have been profoundly influenced by the work of Baudrillard, for which evidence can be found in both the 'imagery' of Halley's Neo-Geo abstract paintings and his style of handling. In works such as *Yellow Prison with Orange Background* (1986) and *Two Cells with Circulating Conduit* (1985), Halley evokes electrical and prison cells and computer conduits, in monotonously applied Day-Glo paint. He is concerned to affirm the inter-penetration of architectural, electrical and informational space (or, the pervasiveness of encoding) that is Baudrillard's central theme.

These pieces of Neo-Geo art perfectly exemplify the conclusion of Baudrillard's account of simulation, in which he states that 'hyperrealism is the limit of art, and of the real, by respective exchange, on the level of the simulacrum, of the privileges and prejudices which are their basis.'[18] Just as art is now determined by the encoding procedures of cybernetic organi-zation, so too production in an advanced consumer society 'becomes somewhat abstract and non-figurative. It expresses . . . the pure form of production, it takes upon itself, as art, the value of a finality without purpose. Art and industry can then exchange their signs.'[19] What we find, according to Baudrillard, is that art and consumer production are both permeated and encoded by a drive to reproduce and encode for its own sake. Hence, he maintains, 'art is everywhere, since artifice is at the very heart of reality. And so art is dead, not only because its critical transcend-ence is gone but because reality itself . . . has been confused with its own image.'[20]

A Critical Review

Baudrillard's whole theory is a gross over-simplification and exaggeration of the problems which it addresses. However, there is a strategy at work: it stems from his scepticism about scientific and even metaphysical truth, as in this passage:

> If the complexity of the universe were only hidden to our knowledge, it would end up by being resolved. However, if the universe is a challenge to the successive solutions offered, even the most subtle of hypotheses have no chance. Because it refines itself to infinity, the universe is reversed in accord with science. Adapting itself through a superior ruse, it reacts like a virus to antibodies, all the while retaining its virulence.[21]

On these terms, any attempts to articulate ultimate truths are condemned to failure. The universe is an infinite, contingent, seething, malevolent vat

36 Peter Halley, *Two Cells with Circulating Conduit*, 1985. Courtesy of the artist

of appearances. As one set is encoded, another set appears, calling even the
most subtle hypothesis into question. There can be no ultimate explana-
tions. The universe is seductive and deceptive. This scepticism leads
Baudrillard to say:

> If the world is hardly compatible with the concept of the real which we
> impose upon it, the function of theory is certainly not to reconcile it, but
> on the contrary to seduce, to wrest things from their condition, to force
> them into an over-existence which is compatible with the real.[22]

Such theory must adopt the following strategy:

> It must become simulation if it speaks about simulation, and deploy the
> same strategy as its object. If it speaks about seduction, theory must
> become seducer, and employ the same stratagems. If it no longer aspires
> to a discourse of truth, theory must assume the form of a world from
> which truth has withdrawn . And thus it becomes its very object.[23]

Baudrillard's own theory is, of course, of this kind. It is not just discourse
about copying, it actually copies the accelerating logic of simulation and
the engulfing rhythm of the universe itself. Having located a tendency, it
serves through exaggeration and over-simplification to make that tendency
seem more global and pervasive than it is. This game of encoding, how-
ever, also presents a vision of what that tendency is on the way to

becoming. It embodies a passage from appearance to disappearance which is the very pulse of the universe.

Theoretical discourse tends either towards the descriptive or the explanatory. Baudrillard is profoundly sceptical about the latter, and rightly so, at least *vis-à-vis* the scope of scientific and metaphysical explanation. There can be no verifiable ground which will explain the ultimate nature of all things. All we are left with is the description of patterns of contingency. But this does not necessarily lead in the direction of Baudrillard's strategy of wilful exaggeration. For we must ask why it is that the structure of the world is shifting – a seething vat of appearances, a welter of different perspectives. The answer is that the universe is not unfathomable in itself, but only in relation to the cognitive capacities of finite beings. At the root of finitude is the fact that we are individually embodied subjects. The very fact that there can be different perspectives on the world (true, false, indifferent, seductive or whatever) is a function of the fact that as embodied subjects we can never have a complete hold on the world. There is always more to be perceived and more to be done that can be contained in any one moment or sequence of perceptions and actions. However, that there can be any perspectives at all, let alone characterizations of them as shifting or transient, presupposes a basic definiteness of sense in our use of signs. This is what I have termed the 'iterable'. Baudrillard makes no attempt to deal with this, which is a fatal flaw. For the dimension which comprises the condition of the possibility of signs and their uses is a stable one, determined by the reciprocity of body and world. How the world is, is a function of how our body orientates us towards it.

To assert the primacy of embodiment is to hold out the promise of a foundational philosophy – not a scientific or metaphysical explanation, but an ontological description. Such a philosophy will seek to elaborate those structures and relations which are constant in our body's hold on things. It will seek to articulate those structures which not only underlie historical transformations of self-consciousness, but which are its necessary presuppositions and needs. To describe such structures offers the basis of a discourse of truth – contra Baudrillard – and also questions important elements in his prophecies concerning the ubiquity and pervasiveness of simulation and the hyperreal.

Reinterpreting 'Baudrillard-friendly' Artists

Let us begin with Warhol, one of the artists whose work seems most amenable to Baudrillard's theory. Baudrillard addresses Warhol's work as

though what is of primary significance is the thematization of reproducibility. There are some works, notably the *Brillo Boxes*, where this may be the main focus of meaning, but much and perhaps most of Warhol's *oeuvre* admits of an alternative primary interpretation. In the *Liz* and *Marilyn* lithographs, the images reproduced are not the same, visually, as the image of which they are reproductions. There are patterns of deviation organized around the slippage of colour over linear boudaries. Interestingly, these look very similar to technical mistakes which occur in mass lithographic production. The significance of this visual strategy lies in its subversion of the principle of reproducibility. The copies err; they mutate; they decay or at least deviate through transmission. Indeed, the profusion of copies is itself a powerful testimony to the enduring significance of Elizabeth Taylor and Marilyn Monroe as icons of popular sensibility.

That the relation between copy and original is more complex than Baudrillard realizes can also be shown by the celebrated *Campbell's Soup Can*. Here there is an obvious distance between the original and its reappearance in an art medium. Indeed, the whole point is that there is a distance. The colours are sour and understated; the size of the image and the fact that its central object is defined without reference to a functional context make it seem uncanny. There is enough for the viewer to achieve orientation, but there is a strangeness which at the same time disorientates – as though indicating an indifference, an induced facticity, an impersonality at the core of mass production and its artefacts.

The point of this thematization in an art-work such as Warhol's is that it is not delivered as a verdict which the viewer is coerced into accepting through rhetoric. Rather, through its contrast with other works, Warhol's cool and putatively passive style internalizes the theme. He realizes alienation. By 'realize' I mean that this theme is made existent at the level of embodiment, that is, perceptually as well as intellectually. The meaning emerges aesthetically in a way that is consistent with the way in which meaning emerges in our most fundamental embodied reciprocal interaction with the world. This involves the cognitive capacities and the senses operating as a unified field. And the fact that the represented object is present only as symbol means that we can engage with it in personal and interpretative rather than functional terms. Realization in this context, therefore, means brought to a higher stage of reflection through aesthetic articulation.

There is another dimension which must be considered as well. Baudrillard's vision of artistic change amounts to little more than ever-accelerating chronological succession. But the embodied subject's relation to time is much more complex. It involves all those complex reciprocal

relations described in Chapter 1, most notably the way in which the present creatively interprets the past and anticipates the future. Art reflects this. Indeed, Warhol's work is not simply something which came 'after' Abstract Expressionism under the pressure of social change. His innovations expand both the scope of art and our experience of the world. To innovate is to take up a position in relation to a present mode of inhabiting the world – a tradition – and to transform that tradition by opening up new ways of doing things. Chronological succession is here made meaningful through reciprocal relations. It is time energized by possibility. It is a general strengthening of our hold on the world – a flexing and testing of perspectives.

These points apply to the significance of creative art in general (as well as to Warhol). I shall now consider them in relation to Super Realism and Neo-Geo art. It is possible to read Super Realism as being centrally addressed to the question of reproducibility. There is, as Baudrillard might put it, 'minimal' separation, the least amount of 'inflection' between the finished painting and the photographic image which is its starting point. However, this minimal optical separation can amount to an interpretative chasm. In Malcolm Morley's Super Realist work, for example, the artist paints in not only a central photographic image, but also the margin which defines that image in the original postcard or book illustration from which the painting is derived. The meaning and significance of originality is thematized not in rhetorical or purely analytical terms, but at the level of perception itself. (His achievement in this respect parallels that of Warhol.) Even those less critically orientated Super Realists – such as Estes and Eddy – can also be read as going far beyond the issue of reproducibility, by as it were re-embodying photography. For to take a good photograph does not simply involve the instantaneous click of a shutter. The photograph does not passively register what is there. Just as the present object of consciousness is given its distinctive character through its reciprocal relation with 'background' fields of meaning, so too is the photograph. It draws on its own aspects of the existential subconscious. A good photographic image must be composed: it is a complete dialectic between visual presence, depth and touch, and the necessary flatness and edge of the photograph. Reality is interpreted by the medium. Because, however, the final step is the relatively instantaneous push of a button, it is easy to overlook the photographer's educated gaze and positioning, and all those moments of reciprocity with the world which make this achievement possible. If such factors are overlooked, the photograph is reduced to the status of mere mechanical reproduction. Super Realist painting goes some way towards restoring those aspects of the existential subconscious which sustain pho-

tography. For, by copying the photographic image in paint – by the bodily act of judging and applying paint to a surface – the artist symbolically restores – at the level of perception – a sense of photography's origins in educated bodily exploration of the world. It declares foundations which are implied but not visible in the photographic image itself.

Whatever iconographical context (derived from Baudrillard or others) Halley assigns to his work, there is a more pressing interpretation which arises from its relation to tradition. As we saw in the discussion of Barnett Newman, that artist's colour-field abstraction hinges on the reversibility of figure/ground, presence/absence, and the wave of mortal associations which these reciprocal relations set up (even if not quite as explicitly as Newman himself intended). In comparison with these (and, indeed, the post-1945 work of Rothko and Still), the banality of colour and composition in Halley's Neo-Geo work is extremely telling. His *Prison* and *Conduit* works present the decisive figure–ground relation as that which has been colonized by the ubiquity of techno-scientific sensibility. The figure–ground relation may be the basis of our transcendence towards the world, but it is no pure transcendence. Under specific historical conditions it is mediated in such a way as to appear primarily as mundane or confining or both. The explicit banality of Halley's pictorial means, in its relation to preceding art, declares this with the utmost directness. It articulates a further dimension of one of these relations which are fundamental to the existential subconscious. This aspect may be somewhat negative, but at least it has been brought to a point of reflection. More than this, indeed, it has been achieved on the basis of an iterable structure, the insistent figure–ground relations. Halley has his own quite detailed theoretical programme, but we do not need to know it in order to read his work in the way described.[24] At the descriptive and diachronic historical level, there is a fruitful emotional tension between what the figure–ground relation has been and what it has now become. The fallibility of human aspiration and insight as finite embodied subject is starkly and ironically manifest.

Even those artists who might seem most amenable to Baudrillard's theory can be interpreted in terms which reach far beyond the issue of reproducibility. But it might be objected that the points I am presenting are in a sense irrelevant, since what Baudrillard is explicitly doing is high-lighting a dominant tendency in contemporary existence and exaggerating its significance to make us aware of how pervasive it might one day become. Baudrillard, in other words, is not trying to encompass all inter-pretations. Against this, it must be said that the significance of the artists whose work I have discussed is one which actively counters the tendency to simulation and the hyperreal. For such works evoke a clear reality

principle – namely the embodied subject's reciprocity with the world. All creative art (however manic the technological and historical transformations which a society undergoes), returns to a primordial ground – the existential subconscious – from which all orientations towards the world ultimately spring. Simulation and hyperreality is an accelerating tendency; but in the view of this critique, no more than a tendency. To privilege it in the way that Baudrillard does is, in effect, to construe human consciousness as though its relation to embodiment were a contingent one. It is not. Contingency informs our embodied orientation towards the world, but as a function of necessity – the inescapable limits of being finite. The artwork as aesthetic object draws on both these dimensions of existence in their reciprocity.

Baudrillard's theory of simulacra, then, is a kind of deconstructive philosophy which falsely absolutizes contingency. In particular, the artists to whom his theory is most applicable actually resist it in their work. The indirect or direct expression of the existential subconscious continues to have validity.

The Postmodern Iterable:
Installation and Assemblage Art

Many post-modern artists have utilized particular philosophical ideas, but as in all times and places, contemporary artists also exist in a climate of ideas. Often a body of creative work will be shaped – consciously or not – by patterns of theory or a general sensibility that characterizes an epoch or society as a whole. There is a strong case for linking the post-modern era to a widespread tendency to 'deconstruction'. Further, this tendency has important links with the prevalence of installation and assemblage works in contemporary art.

Deconstruction and Postmodern Sensibility

Whether or not they have exceeded their high point of influence, deconstructive strategies of one sort or another have recently dominated innovatory thought in the humanities and social sciences. At the heart of all these strategies is one major insight – that the meaningfulness of an item is not determined by direct unmediated correspondence between concept and object (in the very broadest terms). Rather, the relation between these elements is unstable and determined by their position within an overall field of signification. This field itself, however, is not an enclosed totality. It is open and subject to constant reconfiguration.

In Lacan's work this general position is expressed in the way that language's differential structure is seen as embodying – and indeed perpetuating – a lack of congruence between thought or desire and its objects.[1] In Derrida's writing it is argued that Western thought is dominated by 'logocentric' prejudice, wherein the field of lingustic meaning is unwarrantably assimilated to the supposedly direct relation which holds between the individual speech act and the 'presence' of its semantic content.[2] And in Foucault the notion of 'discourse' is fundamental.[3] A 'discourse' is not a once-and-for-all given body of universal truths; it is a specific (historically transformable) field wherein meaning is produced solely in a context determined by relations of power organized on the basis of class, gender, race, religion and the like.

If (as in all these views) meaning is producible only within an unstable field, then the relation of the self to the world and of the self to its own self-understanding are both, at best, provisional. Their 'essence' is to be constantly re-made, as the overall field of meaning itself undergoes reconfiguration. The self and its position in the world have no fixed centre; they are 'ex-centric'.

This deconstructive impulse has a broader significance. At the heart of Jean-François Lyotard's exhibition 'Les Immatériaux', held at the Centre Georges Pompidou in 1985, was a thesis concerning technology and humanity.[4] It is well summarized in Walter Benjamin's observation that, in the era of mass-reproduction of images, 'technology has subjected the human sensorium to a complex kind of training'.[5] Lyotard's exhibition went a good way towards clarifying some of the many aspects of this training. Specifically, it evoked the way in which the availability of information and the complex new modes of obtaining and transmitting it transform both human understanding and the object of such understanding. The exhibition consisted of thirty-one zones (some subdivided) yielding a total of more than sixty 'sites'. The viewer was free to wander through this labyrinth according to his or her own order of priorities, accompanied only by a set of headphones. On entering each zone, the headphones would pick up a 'commentary' for that zone, consisting of music or readings from poetry, philosophy or other kinds of text.

The overall organizational principle of the exhibition centred on the notion of the 'message'. This involved the interplay of five factors – the origin of the message, its medium, the code of articulation, the 'content' of the message and, of course, its ultimate destination. These factors were explored in relation to computer and media technology, art, ideas of gender and many other aspects of post-modern life. The upshot was a sense that, in present times, the everyday surface of life is dematerialized. That which once was simply present to consciousness is, in the context of information deriving from new technologies, now seen to be a function of more complex relations. The material world is, as it were, a projection from this domain of 'immaterials'. Its meaning is no longer perceived but has to be deciphered in relation to the broader network of relations which subtend it.

There are a number of points to gather from this. It is clear that the deconstructive impulse is part of a broad transformation intimately connected with social and technological change. This connection should not be construed in a simple causal sense: the deconstructive impulse is not just a 'reflection' of deeper transformations of socio-economic factors. Something of its complexity can be understood through the theory of Jean

Baudrillard. As we saw, his ideas are philosophically flawed, but in broad empirical terms he does accurately describe a dominant trajectory in contemporary existence – the tendency to erase the distinction between reality and representations of it. On these terms, there is no more nature, no more reality as such. How we represent the world and, in particular, how we represent it through media-messages has totally colonized any sense of what the world is, in itself. We are now in the realm of the 'hyperreal'. Baudrillard indicates some of the factors involved in a passage which is well worth repeating:

> all hold-ups, hijacks and the like are now as it were simulation hold-ups, in the sense that they are inscribed advance in the decoding and orchestration rituals of the media, anticipated in their mode of presentation and possible consequences. In brief, where they function as a set of signs dedicated exclusively to their recurrence as signs and no longer to their 'real' goal at all.[6]

These points can be illuminated by an example. In early 1994 a South African far-right Afrikaner group the AWB organized a terror-convoy of cars, which drove through a black township, firing indiscriminately. This in itself is a prime example of the action-as-media-spectacle just described by Baudrillard. The tail end of the convoy, however, was hit by return gunfire from black policemen. Two wounded Afrikaners – despite their pleas for mercy – were then shot dead by one of the policemen, quite cold-bloodedly, in front of television cameras and photographers. In effect, this was a murder done for the purpose of media transmission. When the reporting of this event was considered by a panel of critics on a BBC television talk show, the shocking aspect of the event was accounted for purely on the basis of the racial insecurity of whites encountering a show of newly attained black power. Rather than address the question of murder for media transmission, in other words, the critics assimilated the event only in terms of the fashionable codes of political correctness.

Lyotard's 'Les Immatériaux' and Baudrillard's hyperreality show how the deconstructive tendencies look in relation to a broad play of constantly changing codes and signifying practices. We live in a culture which is obsessively concerned with the distribution and consumption of signs, rather than realities. In this context, familiar categories and traditions are constantly subverted. The media are the message.

In this and previous works, I have argued that whilst the deconstructive sensibility is widespread, it is not philosophically sound. The relation between signs and the shifting field of their deployment is stabilized and partially 'centred' by their reciprocal dependence. Without being posi-

tioned in a field of relations, no identifiable individual sign would be possible; but, reciprocally, without individual signs having some stable identity and definiteness of sense – all in all, iterability – no systematic networks of signification would be possible. Likewise, the self (as I argued in Chapter 1) is not some simple essence, but neither is it a mere play of the signifiers through which it is articulated. The self is a reciprocity between the present and conceptions of past and future, and the productive imagination, organized by both language and, more fundamentally, the principle of reciprocity as a decisive mediating element.

The deconstructive theories do, however, contain one element of truth. They rightly focus on the fact that meaning – in the most general sense – is not some relation of correspondence but is a complex relation among signs, the world and broader fields of signification. To get the picture exactly right, we need to reinterpret this as a reciprocity of containment and excess. No matter how unstable and shifting or excessive fields of signification may be, they are contained by the iterability of signs and their successful applications.

Throughout this book I have described the way in which twentieth-century artists utilize specific philosophical or philosophically significant ideas, and succeed in extracting an iterable visual content from these – a content which involves the presentation of some reciprocal relation or relations which figure in the existential subconsciousness. Postmodern art has made its own distinctive contribution to this. The deconstructive sensibility is very much the character of the times. One important artistic manifestation of this is the prevalence of Installation and site-specific Assemblage Art. For the very essence of these formats is to create a configuration whose meaning is manifestly emergent from a field of rela-tions. The conventional art object is also determined in these terms; but in Installation and Assemblage it is made much more overt. The work comes to us in a context where the transience of the specific configuration is known in advance. We know that the present work could cease to be, or will cease to be, and that something else will come to occupy its space. Unlike the present object of consciousness, its reciprocal relation with a broader field of meaning is made absolutely manifest by virtue of being an installation or assemblage. We discern the provisional and unstable nature of the immediate configuration. This potentially excessive dimension of meaning, however, is contained by the fact that it emerges from a quite specific, as it were, 'achieved' configuration of sensory material. Indeed, there is no excess, no overwhelming flow of time, situations or events, except in so far as there is some vantage point, measure or, more signifi-cantly, individual, in relation to which the overwhelming character of

these factors can be determined. In reciprocal terms, there is no excess without the possibility of containment, and vice versa. This is the structural pivot of the best post-modern Installation and Assemblage Art.

Deconstructive Art

Lyotard's 'Les Immatériaux' exhibition presented contemporary culture as a spectacle; and whilst it could be criticized, it invited a questioning of that culture through the overt excessiveness of the whole spectacle. Indeed, even as one was overwhelmed by the labyrinth of images and information, one knew that it had been brought forth – like all the products of culture – by human powers of rational ingenuity.

This possibility of critical reflection and containment within the aesthetic can also be discerned on a much less extravagant scale. For example, David Mach's work throughout the 1980s and 90s has centred on site-specific assemblages where an overriding image is composed from ready-made units. He has used tyres, toys, magazines, bottles, kitchen and household utensils, footwear and so on. Whereas Jeff Koons exploits such banal items for weak theoretical ends, Mach does not. The emphasis in his work is on the fragile relation between the constituent units and the image which, in concert, they represent. There is much irony and humour in many of these conjunctions, but this aspect is of wide significance. For it is achieved through the manipulation of an excess of ready-made signs. It contains and controls these signs. Humour and irony in this context, in other words, are a vivid exemplar of the triumph of reason over the excess of banality. We have a kind of critical–comical version of the sublime.

The Slovenian duo vssd (the acronym means 'Painter, do you know your duty?') produced some of the most impressive Installation Art of the 1990s. For *(About) The Soul* – an installation at the Equrna Gallery, Ljubljana, in early 1994 (pls 37–38) – selected areas of the gallery walls were painted blue and hung with numerous small paintings of flames and fractal patterns. In the centre of the main space, a small group of glasses was assembled; each glass was partially broken and painted in black. In an antechamber tables and chairs were placed together, with copies of earlier drawings on the tables. The title of the work alludes to Aristotle's *De Anima* (On the Soul); and the nature of the self and identity formed the real substance of this installation. The term 'substance' is pertinent in this context. Traditional notions of the self or soul construe it as a simple individual substance. But, as we have seen, the self in contemporary times is seen in much more complex 'ex-centric' terms and this is exactly how

37 VSSD, *(About) The Soul*, 1994. Equrna Gallery, Ljubljana, Slovenia. Courtesy of the artist

it is treated in *(About) The Soul*. The self is de-substantialized through resolution into an ill-defined field of constituent elements, whose individual significance is also ambiguous. The small paintings, for example, are like particular memories. They are different from one another, but they have strong stylistic affinities. Indeed, since the self is not just the sum of its memory-parts, how we read these parts individually and in concert is determined by their reciprocal relation to a whole, which encompasses, of course, factors beyond the individual self. The ambiguity of this wholeness – this enmeshing of inside and outside – was brought out by the overall physical layout of the installation, which took different formats in different rooms with no linear narrative to connect our traversals of them.

Interestingly, as well as thematizing the complexity of the self, *(About) The Soul* also declares the problems of VSSD's own identity. The particular configuration of the whole installation was new, but it did not come to be *ex-nihilo*. This was shown, in part, by the inclusion of the earlier drawings as an integral element in the installation; but more significantly it was a function of the small memory-analogue paintings just mentioned. The flames and fractals were disposed in a new way, but they are important and familiar VSSD motifs from previous installations. They therefore exemplified the continuity and difference which characterizes both individual and group identity. .

In one sense, a work such as *(About) The Soul* overwhelms with its many-layered complexity. At the same time, however, it is both a containment

38 VSSD, *(About) The Soul*, 1994. Equrna Gallery, Ljubljana, Slovenia. Courtesy of the artist

and elucidation of that complexity. Again, it makes vivid the scope of reason itself.

All the factors which I have been considering in relation to installation and assemblage meet in the work of Cornelia Parker. The bulk of her installations involve items suspended – visibly and palpably – by wires from the ceilings of gallery spaces. The objects she uses are ready-made – coins, household appliances, toys, trophies, silver-plate tableware – very much the kind of bric-à-brac one might encounter in junk shops and car-boot sales. This detritus of consumer society, however, is subjected by her to decisive transformation. As she has said:

> I am concerned with ambivalence, with opposites, with inhaling and exhaling, things falling apart and things rising, things disintegrating and coming back together . . . with killing things off, as if they existed in cartoon comics and then resurrecting them, so that one set of references is negated as a new one takes its place . . .[7]

In an installation created in 1989 entitled *Matter and What It Means* (pl. 39), Parker had five thousand coins flattened into slivers by a steamroller. The slivers were then suspended by wire a short distance above the ground so as to give the impression of two human forms hovering in space. Here several avenues of association converge. All matter can be resolved into simpler elements; these are gathered together when making a form and disperse when the form ceases to be. But Parker's installation locates the

39 Cornelia Parker, *Matter and What It Means*, 1989. Chisenhale Gallery, London

spectator in a space between the two factors of cohesion and dispersal. The installation constitutes a set of relationships which define life and death themselves. Another aspect of this is illumined in the relation of the suspended figures and the shadows they cast upon the ground. We see the figures as simultaneously inhabiting an overt present and an obscure or hidden past. Indeed, the way the figures hover over the ground conveys a sense of the individual, the species and of life itself as having emerged from an anonymous matrix.

The more cosmological implications of these themes are well brought out in Parker's spectacular installation *Cold Dark Matter – An Exploded View* (1991; pl. 40). The first stage of the installation in the gallery consisted of a garden shed lit from the inside which occupied an otherwise empty floor. In this context, the object was endowed with an eerie sense of something about to happen. And it did. Parker had the shed and its contents (diverse bric-à-brac) transported to an outdoor location for the second stage. It was then blown up by army explosives experts, with the explosion captured on film. Parker collected the debris, which, suspended from wires, came to

form the final stage of the gallery installation. The hanging of the damaged material and debris was guided by photographs of the explosion, with a 200-watt light bulb at the heart of the suspended assemblage. The result was both a constellation of material and an extraordinary play of shadows about the gallery walls and floor.

The cosmological symbolism of *Cold Dark Matter* again involves a convergence of kindred associations. There is an obvious allusion to the Big Bang and, in the fact that the suspended material has undergone a form of destruction (so is now useless), to an ultimate disintegration. What is of more interest is the universal constant which this specific cosmological pairing involves. Parker professes an interest in opposites and links *Cold Dark Matter* to inhaling and exhaling. But this opposition is a particular manifestation of a more universal reciprocal relation of convergence and divergence, centripetal and centrifugal motion. This rhythm of opposition is at the heart of all being. Indeed, its recurrent character is suggested by the play of shadows from the assemblage. The forces which sustain its configuration have operated before, and will operate again. The shadows are hence the latent forms of past actualities and future possibilities.

One further universal factor in Parker's work must now be considered. The reciprocal relation between contingency and necessity is one of the

40 Cornelia Parker, *Cold Dark Matter – An Exploded View*, 1991. Installation view, Chisenhale Gallery, London

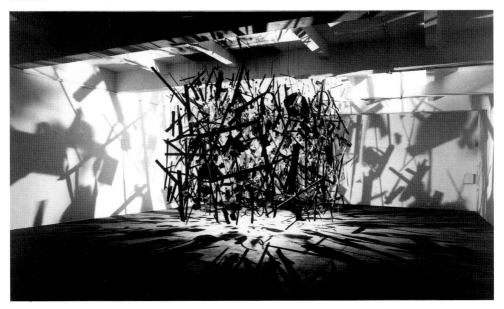

most fundamental of all the oppositions which inform human experience. *Cold Dark Matter* explores this in interesting ways. At first sight it is mere chaos. Then we see the strings and recognize the imposition of order. All art (except the most vacuous experiments with pure chance) involves giving some form to material, but the process of making or arranging involves contingent elements of choice. In the present case, even if Parker had arranged the debris so as to reconfigure exactly a specific moment in the explosive dispersal, there would still be some ambiguity – some contingent element of choice involved. However, in the final product all is necessity. The many different possible routes to the made object or installation end here. From the viewpoint of the end product, the contingencies of the process of creation now appear inexorable. This fact is true of all art, but in the work of an artist such as Parker, it is brought out from the realm of the unrecognized or intuitive to become an overt and iterable element in the work itself. What is especially subtle is the particular means whereby Parker achieves this. For the contingent material she is dealing with is manifestly – through the marks of damage and destruction – shaped by the blind causal forces of natural necessity. And whilst the final assemblage is necessary (in the sense just noted) it has the appearance of being a merely chaotic configuration. Here, in other words, contingency and necessity do not occur in some neat well-defined opposition, but, as in lived experience itself, they weave imperceptibly in and out of one another.

Parker is fascinated by children's encyclopaedias, especially those images and diagrams which 'unpack' an object or phenomenon, showing all the many different elements which it contains. Similarly, she is fascinated by those processes of change and destruction in cartoons whereby Tom is battered out of shape by Jerry, only to reassume his original form a few moments later. Parker's creative impulse is one which radiates outwards from these simulacra and caricatures of objects and events. She takes simple (sometimes banal) structures and 'resurrects' them in a way which brings out deep levels of significance. To engage with her work in aesthetic terms is at the same time to be brought to a point of critical reflection. The reciprocity of containment and excess illuminates both the post-modern multitude of signs in rapid transformation and the deeper relations which sustain this.

Problems with Installation and Assemblage Art

Installation and Assemblage Art is clearly much more akin to aspects of Duchamp and Conceptual Art than it is to representations which are

'made' (in the customary sense of that term). However, in both this and the two previous volumes I have affirmed the importance of art proper. That is, works which are made, and whose originality as art-works is internally related to the existence of the specific creator or creative ensemble. No one else could have created them.

In Chapter 8, I argued that whilst there is a central definable core to art proper, its boundaries are not at all rigid. In this respect, the works which I have considered in this chapter are enormously instructive. VSSD's and Parker's works contain made elements, but on nothing like the scale of more conventional painting or sculpture. (In contrast, artists such as Jeff Koons and Christian Boltanski produce works that consist of simple ideas whose realization adds little to the original ideas, and demands less in terms of insight and imagination on the creator's part.) With VSSD and Parker, the basic ideas are of considerable intricacy. Their realization involves complex approaches to materials, techniques and procedures. The personal involvement in the process of realization is such that it is inconceivable to imagine the works having been made by anyone other than the specific ensemble or artist in question. They are at the very least on the border zone of art proper, and with more analysis and argument, it might be possible to identify them with art proper in a fuller sense.

David Mach is more complex. As with all Installation and Assemblage Art (indeed, Conceptual tendencies in general), more depends on the specific work than on the artist's whole *oeuvre*. Mach's celebrated *Polaris* (1983; pl. 41) consisted of a giant submarine assembled from car tyres. In principle, anyone could have had an idea of this sort, and realized it in just about the same way as Mach did. Other works, however, such as the *101 Dalmations* (1985), involve personal intervention much more akin to that found in the works of VSSD or Parker. Whilst it is important to have a central conception of what art is, being a boundary or marginal case is not the decisive factor. What is of more significance is the way a work's aesthetic properties (made or not) engender critical reflection, on the basis of their relation to other works, to their contemporary context and beyond.

Throughout this work I have argued that a distinctive feature of non-conventional twentieth-century representation is its overt embodiment of specific reciprocal relations. The artists rework philosophical ideas into an iterable visual discourse of the existential subconscious. Installation and Assemblage Art add to this in their own special way. Existing in a cultural context dominated by the deconstructive ideas described earlier, they extract (intentionally or not) what is of most validity in them, and express this in visually iterable terms. At their heart is the specific reciprocal relation of containment and excess, which characterizes much contempo-

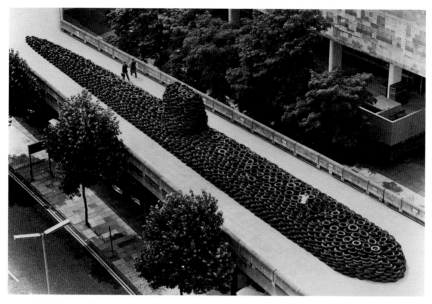

41 David Mach, *Polaris*, 1983. Hayward Gallery, London (now destroyed). Courtesy of the artist

rary work. But what matters finally is how an idea is embodied in a particular sensible configuration. Through its reciprocity with a comparative context of other works, the particular stands out and engages with contemporary interests. It mediates (and is mediated by) a sense of what is important, problematic or even dangerous in our broad scheme of interests. This is why in this chapter I have addressed artists whose work invites critical reflection. Their particular modes of installing and assembling are ones where the kinds of excess and complexity which are contained, and, more significantly, the strategies of containment themselves, are ones which matter to us now. In a culture which constantly fantasizes the 'loss of self', the critical reflections of Mach, vssd and Parker each give us (in different ways) a position from which the self's relation to the world can be understood and thence stabilized.

In this and the previous chapter I have described ways in which art is able critically to channel the deconstructive impulses of contemporary culture. But can there ever be radically new art again? Can there ever again be significant artistic paradigm shifts? Installation and Assemblage Art of the sort addressed do have a loosely prophetic character: in such works the systematic reciprocal dependence of part and whole, and the mutability of its specific configurations, is made manifest. I shall develop some of the implications of this in my final chapter.

Leaving the Twentieth Century: A Future for Art

As we have seen throughout this book, what is semantically fundamental to radical twentieth-century tendencies is consistency between the art-work and the existential subconscious. This subconscious is organized by a principle of reciprocity which continues the basic interaction of body and world. The principle of reciprocity plays a role which parallels that of resemblance in conventional representation. It enables the works to be read independently of the artists' specific intentions. It is the iterable basis of such art. But this has not been explicitly recognized. The innovatory tendencies have instead been interpreted as a case of correspondence with the artists' intentions or an actual, imagined or 'spiritual' reality; or formal-istically, as a case of pure aesthetic surface. These two mistaken approaches can reasonably be described as the two dominant paradigms of twentieth-century art.

Since the 1960s both paradigms have exerted equal influence in the art-world – a peaceful co-existence which to some degree has cancelled out art's creative vitality. In this stasis, we can see the emergence of Conceptual Art as a pseudo-paradigm. I say 'pseudo' because Conceptual tendencies involve a privileging of the ideas, contexts and intentions which bring a work into being. The work is significant in so far as it refers to these factors. It is therefore another version of the correspondence paradigm. More-over, it is one that serves as a gigantic locking mechanism. For if, in principle, any object can be counted as art, then the possibility of large-scale innovation – the development of new paradigms – is heavily restricted.

In this gridlock of paradigms, it is all too easy to believe that art has come to an end. But there is a way forward. What if consistency with the principle of reciprocity itself were explicitly adopted as the basis of a new paradigm? Interestingly, some tendencies of this kind are now being engendered in the art world itself – through a complex confluence of specific historical and artistic circumstances.

★　　★　　★

Breaking the Gridlock of False Paradigms

We might expect the break in the gridlock to occur most emphatically through developments in cultures which have not been entirely synchronous with the intellectual and commodity cultures of Western art, such as those of the former Communist Eastern European Bloc.

In countries such as the old Soviet Union, East Germany and Czechoslovakia, the relation between the correspondence and pure art paradigms was almost always an antagonistic one. The correspondence mode (in the form of Realism) was officially sanctioned, whilst Modernist tendencies were seen as subversive and could be pursued systematically only in secret from the authorities. In other countries – notably Poland and Yugoslavia – this antagonism did not hold to the same degree. This, in turn, created an ambiguous situation. On the one hand, Modernist tendencies were attractive through their embodiment of the glamour and freedom of Western culture, but on the other hand embracing this glamour meant accommodation and adaptation to it. In these more culturally open countries, therefore, the conditions for creating distinctive local Modernist idioms were largely undeveloped.

Matters began to change substantially in the early 1980s. Of decisive significance here is the phenomenon of Neue Slowenische Kunst (NSK) in the former Yugoslavia.[1] The emergence of this movement is enormously complex and bound up with questions of politics and national identity in Yugoslavia's constituent republics, but artistically it is unmistakable and absolute. It maintains an aesthetic of order, system and excessive spectacle and complexity. NSK conceive themselves as an all-encompassing state. Their political metaphor is reinforced by the production of NSK passports and the despatch of NSK 'embassies' to different countries. Such a totalizing strategy enables NSK groups such as 'Irwin' to absorb the symbols and trappings of other systems – both political and artistic – which had traditionally colonized Slovenia (pl. 42). We find, for example, motifs taken from Nazi and Soviet culture, from Malevich and other key Modernists and, of course, from important imagery in Slovenia's own visual culture.

Rather than creating a Slovene Modernism, NSK leapt a generation and situated themselves in that context of excess and eclecticism which is so characteristic of Post-modernism world wide. The significance of this leap lies in its affirmation of system in a post-modern context that otherwise denies system and embraces difference and deconstruction. The conflict involved generates the possibility of an extraordinary progression. NSK's affirmation of system is one which systematically deconstructs those codes which it is drawing upon, to reveal the transience of their authority and, by implication, the transience of its own. Systems are devised so as to nego-

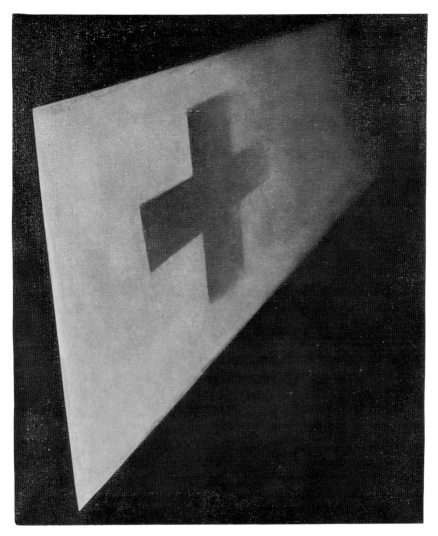

42 Irwin, $L\overset{z}{\underset{s}{+}}D$, 1990. Private Collection. Courtesy of the artists

tiate the changing circumstances of the human condition. Systematicity is necessary, but its historically specific forms cannot be. They must change and transform through interaction with other systems. They necessarily exist in a space of reciprocal exchange and transformation.

It could be said, therefore, that NSK embodies in latent form the reciprocity of systems. Such an embodiment demands an idiom of expression which is complex, contrived and manifestly artificial. NSK's strategy might best be described as an advanced variety of mannerism. It is, of course, important to distinguish between mannerism and mere eclecticism. An

eclectic art – like much of Julian Schnabel's work during the 1980s – draws on a wide variety of sources and materials. A mannerist work can also have this character, but its distinctive trait is to lay out a definite direction of stylistic development and to pursue it obsessively. A given idiom is taken up, refined and elaborated so systematically that the process of elaboration becomes almost an end in itself. A loosely mannerist trait also characterizes the work of other Slovenian artists besides NSK in the 1980s and 90s. Tadei Pogačar's installation work, in its systematic appropriation of given objects, is a kind of conceptual mannerism. In a more complex way, this is also true of the VSSD duo. Marko Jakse appropriates material from Surrealism and the pre-Raphaelites, amongst many other sources, and obsessively reconfigures it in the form of hugely convoluted and highly individual fantasies. Marjetica Potrč's three-dimensional work appropriates Minimalist idioms and elaborates them in intricate, almost decorative, structures including significant figural elements (pl. 43).[2]

A mannerist tendency exists in other parts of recent Slovenian culture, notably in the large amount of writing inspired by Lacan. Lacan as a theorist is elusive and complex, which is also characteristic of the work of the Slovenian Lacanians, especially Slavoj Žižek, but they appropriate and elaborate his work on a systematic and specific basis. It could be said, indeed, that the analysis of system in all its cultural aspects is the unifying theme of Žižek's *œuvre*.

In the interplay between Slovenian art and culture, and the specific historical circumstances of the 1980s and 90s, a distinctive national artistic tendency has emerged. It is a mannerism – not just in a stylistic sense but as a creative disposition. It loves to elaborate, complicate and reconfigure the immediately given. In some cases this involves playing with system and with possibilities of systematicity, but none of the artists I have mentioned so far pursue this as an explicit end in itself. What links them is a shared cultural context – the fact that they inhabit a historical intersection between relatively centralized social structures and the possibility of more open systems. There is nothing inevitable about the genesis of Slovenian mannerism but, given the intersection and the complex cultural influences arising from Slovenia's geographical position, such a development is an eminently logical one.

Slovenian mannerism is of considerable art historical interest. It is a living exemplar of that unity of artistic and broader cultural factors which Panofsky describes as 'iconology'. However, its significance goes beyond this. In its insistent emphasis on system it presents (in a highly focused form) a tendency which is also developing elsewhere. One important manifestation of this is in the work of the Russian artists George Pusenkoff

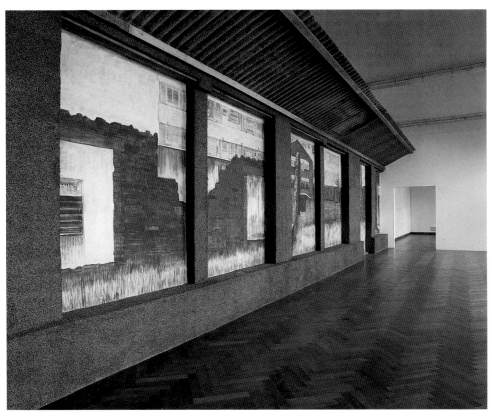

43 Marjetica Potrč, *Kampala*, 1996. Installation view, Gallery of Modern Art, Ljubljana (fresco by Taylor Spence). Courtesy of the artist

and Eric Bulatov. Their installations are not simply site specific but have internal structures which systematically appropriate, complicate and reconfigure other styles and systems from the history of Western visual culture. In their work, as in Slovenian mannerism, the empty stylistic eclecticism of much Post-modern art is transformed into an obsessive play of systematicity. One can also see other loose signs of this in Western European and American art. Anthony Gormley's sculpture, for example, takes castings of the human body and obsessively elaborates the visual and philosophical possibilities which they present, through an enormous diversity of sculptural and installation contexts. Similar points might be made in relation to Cornelia Parker, David Mach, Ian Hamilton Finlay and Cindy Sherman. In each there is a fundamental 'premise' (for Parker and Mach it is the mutability of representational material; for Finlay it is the relation of nature, culture and the classical tradition; for Sherman, it is the artist's own

image). Each of these individuals does more than simply refine their visual premises; they elaborate and play with them systematically and sometimes even fantastically. In any good artist, of course, one expects to see signs of stylistic development. These artists make development itself systematic and extravagant but without relapsing into mere repetition.

Perhaps the most interesting artist of all in this context is John Latham. Latham has long been a respected figure, but without his work attaining a major level of influence. One reason for this is his commitment to system. This extends not only to the development of his work, but also to the premises themselves. These encompass a somewhat arcane scientific-philosophical system which his practical works creatively exemplify. The real – perhaps prophetic – significance of Latham's achievement is to point us towards a new artistic paradigm.

This leads directly to the major point concerning the broader significance of Slovenian mannerism. An art which is orientated towards system offers the basis of a semantic paradigm other than the distorted correspondence and pure-art paradigms. Whilst artists whom I have just discussed are moving in this direction, they have not made the significance of system itself explicit. System in their work is usually a vehicle for broad philosophical and cultural ideas and personal associations. There is nothing wrong with this, quite the opposite. For system amounts to little unless its intrinsic power can illuminate specific historical and personal situations. But the nature and scope of that intrinsic power needs to be stated in the most emphatic terms, otherwise it will remain locked on the periphery of the two dominant mistaken paradigms. One way of making such a statement is through a theoretical analysis of the present kind. A more searching approach is to integrate artistic practice and theory in such a way that each element acts as much more than a mere illustration of the other. This strategy is now under way in Mojca Oblak's *Transcendental Mannerism*. Oblak is a Slovenian artist who, as a student, was involved in the same cultural milieu as NSK but was never a member of that movement. It is perhaps her philosophical training which has enabled her to articulate explicitly the more universal significance of system and mannerism, in an independent artistic way.

Transcendental Mannerism

Oblak's theoretical position is set out in her major text: 'My system is not an alternative system, for it explores the possibilities of systematization as such. Systematization is the form and *subject-matter* of the system.'[3] The

artist was led to this strategy by worries about not only art's loss of vitality, commodification and the limits of Conceptualism, but also about the nature of human freedom itself. Through addressing this latter problem, she is able to resolve the former ones.

It is Kant who provides the vital clue for Oblak. In his critical philosophy, freedom has two components – its spontaneity (the capacity to inaugurate action) and its rational basis, which consists in our capacity to act in conscious accordance with rules or laws. Whether or not the spontaneity is anything more than illusion is not something we can know theoretically, but we must act as if it is real. If, indeed, we did not act on this assumption, we would not be able to form a coherent world picture of human values and moral responsibilities.

There are many more concepts which Kant treats in this 'as if' way. He calls them 'Transcendental Ideas'. Put in more familiar terms, they are principles whose truth or falsity cannot be absolutely determined but which – if we treat them as rules or methodological principles – enable us systematically to advance and articulate specific areas of knowledge.

Oblak's decisive theoretical step consists in seeking a visual realization of the 'Transcendental Idea' of freedom in its fullest sense. This realization has to be one which integrates both the spontaneity of freedom and the systematic and conscious following of rules which gives freedom its direction and meaning. Spontaneity and system must be presented as if each were the cause of the other. What this demands, in effect, is a self-determining, self-sufficient system of reciprocally dependent forms, relations and rules where the rules are such that, through their operation, new possibilities – even unpredictable ones – are both constantly generated and constantly understood. Each stage in the system's unfolding must preserve and transcend those which went before, yet without issuing in a definitive stage of resolution.

Oblak expresses the significance of this as follows:

> My thesis is that only on the basis of the laws of the system i.e. the sustained and effective employment of reason and its capacity for spontaneity, can we resist the restrictions of 'natural', 'habitual', 'institutional', 'pre-disposed' patterns (of thinking, understanding, and imagination) and thus create the possibility of 'original breaks'.[4]

Systematicity in Oblak's sense is thus a power of positive resistance to the encroachment of the commonplace and the mediocre. It consists not in the conquest of contingency by necessity (as in Hegel) but in the creating of an explicit reciprocity between the two. But what kind of formation can exemplify such authentic systematicity? Oblak's answer – following Kant

and Adorno – is the aesthetic formation. Any aesthetic unity involves not only a discernible and harmonious interplay of whole and parts, it also engages those specific capacities for imagination and understanding which are essential to any rational experience. In our aesthetic responses, imagination and understanding mutually enhance one another. The aesthetic thus provides a key example of authentic free systematicity.

Oblak's next move is to utilize the forces inherent in this systematicity, by finding a highly self-conscious mode of expression for them. Art is usually limited in this respect by being a 'painting' or a 'sculpture' or an 'installation' or whatever. For Oblak, these descriptive characteristics are at best secondary to the logic which organizes their creation and arrangement. Her works are in specific media, but their identities in this respect – and, indeed, the character of the art-work as artwork – are suspended within the system. It is as if, in her and Kant's terms, they existed only as elements within this self-determining structure.

The matrix of Oblak's system consists of a lengthy text and forty-two triangles (ostensibly in the form of painted clouds; pl. 44). These triangles were painted originally in hexagonal groups. In the first of these groups, three of the triangles exemplified three kinds of fundamental visual relation: one of them declared figure and ground, another declared the relation of light and dark and the other exemplified colour). Between each of these fundamental elements was a mediating triangle which synthesized the visual qualities of the triangles immediately adjoining it. In the next hexagonal sequence of triangles, this order of relations was repeated, but the individual triangles were rendered in a different way. And in the next sequence, the repetition was rendered with even more variations on the visual relation between specific triangles and their positional counterparts in the previous sequences. And so on and so on.

In devising this specific matrix, Oblak's premises were substantially *ex nihilo* and arbitrary. There is, for example, no intrinsic reason for choosing a triangular format or for developing it through forty-two instances. This contingent character is maintained (as the system 'unfolds') through the introduction of the unpredictable formal variations on the complex visual oppositions which hold among the three fundamental triangles and those which serve a mediating role. Opposition is usually understood in dualistic terms, but by basing it on threefold criteria, Oblak introduced a chaotic reciprocal dimension into her system.

This is augmented by the fact that the original seven hexagonal groups (although not the individual triangles within them) can be rearranged into a different order. Indeed, it is also possible to see new gestalt hexagons where the physically distinct groups overlap. This allows Oblak to develop

44 Mojca Oblak, *Matrix of the System*, 1994. Mala Galerija, Ljubljana. Courtesy of the artist

the system. On the basis of a group of triangles, common to two such gestalt hexagons, she composes a single image which synthesizes the group's visual qualities. These oval 'pictures' are both complemented and disturbed by an extraneous element (pl. 45). It consists of a glued on fragment of a reproduction of a Renaissance painting, each of which is

45 Mojca Oblak, Oval Painting, 1995. Mala Galerija, Ljubljana. Courtesy of the artist

46 Mojca Oblak,
Jewellery, 1995.
Private Collection.
Courtesy of the artist

formally harmonious with a specific oval picture. The fragment is simulta-
neously declared and hidden by extravagant black leather strings composed
in the same whirling manner as the 'cloud' content of the triangles. The
fragment thus gives the impression that it can be peeled off and become
independent.

At the time of 'deducing' the oval paintings Oblak was also making
experimental jewellery from leather strings, children's toys and semi-
precious stones (pl. 46). In the jewellery, however, the forms overwhelm
and suspend any ostensible practical decorative function. They are, in fact,
the logical seeds of the system. As Oblak puts it, 'in jewellery the System
returns to itself and recognizes itself in the original simplicity of its basic
idea. The jewellery – as beautiful, self-sufficient and arbitrary – shows the
"truth" of the System'.[5]

Oblak plans to undertake a constant exploration of all the possibilities
opened up in the logical space between the original matrix of triangles and
the jewellery's microcosmic summation of the system. It will be a rule-
governed elaboration and articulation of contingency such that, at any one
stage, all the preceding stages will appear as necessarily leading up to this
one. Such a transformation of contingency into necessity is implicit in all
artistic making, but in Oblak's system it is pursued self-consciously, and the
reciprocal dependence of contingency and necessity is made manifest. All
worthwhile art also strives for originality but does not necessarily negotiate
the negative and positive significance of originality. The negative sense is
that of merely doing something different, which may lead only to 'original
nonsense' (as we saw in Chapter 8). The positive sense of originality
recognizes that difference is not enough. It must involve the power both
to assimilate and to develop its material in a rule-governed but experi-
mental way. This explicit goal is the force which drives Oblak's system in
its text and objects. She takes the theoretical orientation of Conceptual Art
to and beyond its extreme. Her system brings art and philosophy into a

mutually illuminating relation. It is obvious that the system is massively contrived, difficult and complex: it has many of the stylistic features associated with mannerism, but her mannerism is stylistic only in a secondary sense. Its origins lie in those powers of freedom, rule and contingency that are the precondition not only of art but also of living and dynamic systematicity as such. This obsessive pursuit of the complex transcendental conditions of art and experience necessitates a mannerist idiom of exemplification. Like everything else in Oblak's system, 'Transcendental' and 'Mannerism' are reciprocally correlated terms.

The Significance of Transcendental Mannerism

The importance of this mode of system consists in the paradigm shift which it makes possible. What Oblak does is to redevelop and extend those notions of systematicity and reciprocal structure which (contrary to Greenberg) were driving forces in Suprematism, Surrealism and other 'difficult' movements. This does not involve a return to Modernism or a 'Neo-modernism'. Neither, indeed, can Oblak's strategy be assimilated at all easily under Post-modernism. Her art becomes significant as project rather than mere idea or eclectic expression. And the possibilities are endless.

Oblak herself notes that even someone taking her own matrix of forty-two triangles as a starting point would quickly develop something radically different. It follows that an artist who devised his or her own explicit system would immediately be launched into a wholly different creative space from that which Oblak occupies. There is also striking potential for developing such systems on the basis of the new computer technology, and whilst Oblak's system looks 'abstract' it would also be possible to develop similar strategies on the basis of exclusively figurative imagery.

Transcendental Mannerism is thus the starting point for a new mode of visual legibility. Attention is focused not on correspondence or on the immediately given aesthetic object, but on the object's explicit relation to a reciprocally structured logical space of both previous actualities and future possibilities. This entails a paradigm shift in the social and institutional nature of art, as well as its semantic structure. Previously, significant change in art has come from the invention and development of new individual styles and on conflict between these. An art which is orientated towards system, however, can – even within one 'personal' system – accommodate many different visual styles. Systems can, of course, compete with one another, but in an artistic context, system offers the opportunity for an unprecedented degree of co-operation between artists. The possibility

arises, indeed, for complex research and development programmes of an interdisciplinary nature (as we have already seen, Oblak's own system involves consistent co-operation between art and philosophy).

Whilst much recent Conceptualism has linked object and ideas in only an external way, Oblak-type systematicity functions in an integrated manner. It demands much more than the three-minute attention span of contemporary consciousness; it negates contemporary shallowness. Oblak's and other art systems could be looked at and walked round in a gallery, but they would always exceed such a space. Even when inhabiting the gallery, they are already elsewhere – in the developments which have taken place since their 'acquisition'. This has remarkable implications for art collecting. For, as well as acquiring the specific work, the collector or institution would also 'buy into' the system. Hence, as the system develops, the significance of the acquired work also changes in a reciprocal way. This makes it incumbent on the artist to ensure that documentary illustration of such developments are always available to the system's 'stakeholders'. The relation between artist and audience is not, therefore, simply that of producer to consumer or critic. Rather, the system mediates between the two as an intellectual and aesthetic institution. This opens the possibility of a new notion of artistic belonging and community.

Oblak's Transcendental Mannerism, then, presents an artistic realization of that reciprocal dependence of individual element and developing whole that is the basis of any notion of a field of signification and which, as I have shown throughout this book, is the organizational basis of the existential subconscious. Oblak's own system will always have a largely transitional significance. This is because its purpose is to integrate visual work and theoretical text in such a way as to be mutually illuminatory and recipro-cally dependent. The theoretical content here means, in effect, that hers is a kind of meta-system – one which continuously explores and declares the logical core of a new paradigm based on systematicity and thence explicit reciprocity. Now others can expand this in different empirical directions. What one might hope to see are other systems whose textual bases could easily be transcended: once we had grasped the basic 'grammar' of the system, we could follow its development without having constantly to refer back to the originating text and premises. The more explicitly system is pursued as a goal, indeed, the more the possibility of such autonomous visual systems will emerge. When this happens, the paradigm shift will be complete. Instead of looking to art for correspondence or aesthetic purity, we will be concerned instead with how the consistency of the individual work and its system can illuminate the scope or restrictiveness of the realities which surround it.

Conclusion

In this book I have argued for the iterability of art, founded on a reciprocity between body and world. The thesis has been explored in relation to specific twentieth-century movements and artists and their philosophies. A brief restatement of my theme now will allow us to conclude with a consideration of some of its broader ramifications.

Conventional pictorial representation is iterable: once the convention of picturing (founded on resemblance) has been learned, one can recognize what basic kind of item or set of relations is being depicted, without recourse to iconographic or empirical evidence. Fundamentally, a picture is a collection of marks on a plane which is consistent with the individuation of possible kinds of three-dimensional visual entity or relations between such entities. This mode of visual reference is possible only in so far as it embodies aspects of a general reciprocity between body and world. Normally, reciprocity itself does not figure in our reading of pictures but it is invoked when we address them aesthetically as art – works – when we are concerned with those features that define the appearance of the particular picture or sculpture.

In twentieth-century works which involve a radical modification of pictorial representation or a move towards abstraction, reciprocity is involved in any description of them other than merely physical terms. To the degree that they follow the customary presentational formats of picturing or sculpture, this establishes the convention that they project a semantic space – they involve reference to things other than themselves. This space is defined by consistency between the appearance of the particular work, and the individuation of visual exemplars of that principle of reciprocity which is the organizational basis of the existential subconscious. Such exemplars include the reciprocity of part–whole, present–past–future appearance, figure–ground, presence–absence, actual–possible, real–ideal and containment–excess. If a work has any iterable semantic aspect, it must be describable in terms of one or more of these or similar relations. Throughout this work, I have traced the way in which specific historical, theoretical or practical interests led artists to the generation of iterable visual outcomes – they can be read in terms of one or more aspects of the

principle of reciprocity. What these twentieth-century art movements have done, in effect, is to move through theory and practice to the revelation of that dimension which makes systematic visual reference possible. The conditions of iterability are themselves made visually iterable.

Let me now consider some queries and objections concerning this thesis. If twentieth-century work is significant in the sense described, this involves the claim that in reading such works we follow a convention – namely, that they present exemplars of the principle of reciprocity. But if this is so, why has the convention not been more explicitly formulated? In many respects it has: Merleau-Ponty's philosophical work points us in this direction, but even in the formalist analyses of art critics the relations which I have described are always used in a barely descriptive sense. The problem is the bareness of the description. In Greenberg, for example, the figure–ground relation is often described but only in the context of a story affirming the picture plane. The relation's centrality in human perception and its overlap with other aspects of the principle of reciprocity (such as presence-absence and actuality-possibility) are never even countenanced. We are left in the 'intuitive' zone of a purely formalist conception of the aesthetic. In the history of pictorial representation, the right concepts have been analysed in an almost universally misleading way. Picturing's foundation in resemblance, for example, has almost always been misunderstood as a case of correspondence of picture and reality, rather than a consistency between picture and kinds of visual entity or relation. The convention is employed, but its logical structure is systematically misunderstood. This, I argue, has also been the case with the principle of reciprocity's relation to twentieth-century art. It has been used, but without its structure or significance being fully comprehended.

As for the principle of reciprocity itself, the various relations which I have described are its specific aspects (elements of the existential subconscious). The principle is a functional unity whose exemplars are provided by the different spatio-temporal contexts of its employment. These employments are by no means exclusive, which means in the case of art, that more than one aspect of the principle can appear in the same work. For example, in Mark Rothko's *Untitled* (1954; pl. 47), an upright rectangle, a loosely differentiated field of orange-yellow is almost entirely covered by a red-orange horizontal band in the lower third of the painting. The band is lightly painted over with white-edged layers of lilac and violet so that its horizontal edges are given a clear definition at the top and a more hazy definition at the bottom. The orange-yellow field is concentrated in a horizontal zone of more emphatic yellow immediately above the band. Reciprocal relations emerge from this optico-physical matrix. The

complex lower band appears to hover in front of the broader field. And this is not just a figure–ground relation. The mode of its realization – in the optical illusion of hovering – is one which implies a series of other reciprocal relations. For one thing, the white and purple of the horizontal band allows the red-orange below to show through. The hovering effect is one of optical precariousness and transience; even of potential fluidity. This means that the presentness of the work's appearance – its actuality – is visually charged by the suggestion of possible dissolution, absence and the mutability and contingency of appearance. Indeed, the fact that in this and many other works Rothko achieves these effects by an emphatically horizontal composition tends to declare a somewhat unexpected reciprocal element. For the usual formal effect of insistent horizontal and vertical structures is to convey stability, to idealize the more enduring characteristics of the spatial manifold. In Rothko, however, the suggestion of ideal, enduring, horizontal and vertical structures both sustains and is sustained by the fraying and fragile mode of its actual visual realization. We find a reciprocity of ideal and real.

In Rothko's work, then, simple reciprocal relations of a spatial kind (figure–ground, part–whole) are realized in such a way as to provide optical exemplars of other temporal or modal reciprocal relations. As soon as one moves beyond the work's optical and physical structures to a description of its semantic space, one is led to several different visual exemplars of the principle of reciprocity. Formalist analyses, by contrast, freeze matters between the two levels. Form is assessed in terms of harmony, balance, 'presentness', 'quality', but without any attempt to investigate the deeper factors which make these both possible and humanly significant. The principle of reciprocity is the ground of these factors. It is a fundamental unity whose different employments are the very basis of embodied self-consciousness – of objective perception and inner 'spiritual' experience. The particular relations which I have described all exemplify it, and there may be other such relations. The task of describing and applying them to art is not easy. Throughout this book I have linked specific artists to specific relations, but, as the example of Rothko shows, individual works or groups of works can disclose many aspects of reciprocal meaning. In a sense, therefore, the fundamental meaning of much twentieth-century art has still to be brought out into the open. What is needed here is not more empirical art history and empty theory, but an informed looking which addresses the structure of the visual particular and its diachronic and dialogical relations with other such particulars.

The philosopher and literary theorist Charles Altieri has described this approach as 'idealist', specifically suggesting that, in my treatment of art,

47 Mark Rothko, *Untitled*, 1954. Yale University Art Gallery, New Haven, The Katharine Ordway Collection

the historical agent behind the text is 'contingent' – only the agency
rendered by the work matters. But then the self we get is only a
projection imposed upon the actual empirical states of desire and need
and oppression which must be the basis for any historical empathy.
Historically the agency which Crowther locates is at best an aesthetic
construction out of history rather than a direct reflection of the needs
and desires and evasions embodied within it.[1]

The 'agency rendered by the work' is indeed fundamental, rather than the
empirical historical circumstances of its production. It is vital to stress,
however, that this does not involve some ideal, underlying ahistorical
'essence'. The principle of reciprocity is not an idealist notion at all. Its
origins are in the nature of embodiment and its reality consists in the way
it is exemplified in concrete circumstances.

What is decisive here is not some mental construct, but rather our
general human capacity to follow and apply rules. If there is to be any
historically specific sense of agency, any sense of agency *per se* or, indeed,
any personal identity whatsoever, this presupposes that our cognitive
capacities find expression in iterable sign systems. The learning and use of
such rules is not a wholly private or historically specific matter. Whatever
specific meaning is intended by a sign user, this is a function of the relation
between the context of use and the iterable status of the particular configu-
ration of signs. While Altieri wishes to privilege the former element, I wish
to emphasize that the latter has its own intrinsic significance, which
endures and illuminates historically specific points of reception over and
above those of its original context of use. Human beings share similar
cognitive capacities and similar kinds of existential problems by virtue of
being embodied. If they can read the iterable content of a work – if they
know (however vaguely) the basic semantic convention – they can be
struck by patterns of similarity and difference with their own personal or
cultural ways of articulating such content. These patterns can illuminate
one's present situation, sometimes with dramatic effect. This is because –
as I have shown throughout this work – they involve the reciprocal
dimension, that is, all those structures of perception and self-consciousness
which originate in embodiment and are the basis of our rational finite
existence.

In sum, historically specific acts and states presuppose a more general and
iterable vehicle of articulation. In the course of time, particular circum-
stances of use pass away, but individual articulations of an iterable code can
remain – in the form of art and other artefacts. Altieri's critique, in time-
honoured but mistaken fashion, presupposes that such articulations are

mere mirrors: their authentic function should be the 'direct reflection of the needs and desires and evasions' embodied in their original contexts of historical production. But, to continue the metaphor, once the original context has gone, what is it that remains to be 'reflected'? Only the historian's own imaginative construction of that which was. But art does not reflect, it realizes. When an artist submits him or herself to the demands of an iterable code, the nexus of private meanings which surrounds the work is transformed − the more so as the code's specific articulations involve a process of making. This 'agency rendered within the work' − the artist's stylistic presentation of an iterable content − is not some idealist 'aesthetic construction out of history'. No specific historical experience is possible at all unless it constellates around a concrete trans-historical semantic vehicle.[2] In this work I have tried to give the trans-historical its due. The irony is that if one does not do this, the consequent privileging of 'actual empirical states of desire' and so on leads to a kind of ahistoricality. Such states are stripped of that core of generality whose instantiation helps define the nature of their particularity. We are left with a kind of abstract-materialist conception of agency. This, of course, is one where reality is replaced by the rhetoric of 'reality'.

Left to conventional art history and theory, much twentieth-century art would remain locked in its own time of origination. Its meaning would emerge only through a priestly class of professional mediators and managers. The works would become significant only via accompanying texts of an appropriate kind. I have shown how the principle of reciprocity informs such art. It enables us to discern a meaning which transcends any original context of production. Whatever else the artists might intend, by adopting the presentational formats of painting and sculpture they necessarily create visual exemplars of different aspects of the principle of reciprocity. The fact that this conceptual content is embodied in a sensible configuration is of the most decisive significance. For it means that it is mediated by another individual human being. In this respect, it is instructive finally to consider a passage from Gilles Deleuze and Félix Guattari:

The concept of the Other Person as expression of a possible world in a perceptual field leads us to consider the components of this field for itself in a new way. No longer being either subject of the field or object in the field, the Other Person will become the condition under which not only subject and object are redistributed but also figure and ground, margins and center, moving object and reference point, transitive and substantial, length and depth.[3]

Here Deleuze and Guattari emphasize the full ramifications of a basic truth – that we are only conscious of self in so far as we can define it in a shared logical and social context. This context is provided by the concept of the Other Person. The full ramifications of this notion are hard to grasp in purely intellectual terms. It requires that we see ourselves and the other in a continuous horizon of shared and divergent existential possibilities. What is important here is not simply the specification of the reciprocal concepts involved, but a full invocation of the nature of their reciprocity. This is a living relation, charged with profound affective and instinctual power. To express it in living form demands accordingly an idiom that fully integrates the sensible and conceptual, but without falling into the realm of purely private meaning.

Art – particularly the tendencies considered in this book – provides such an idiom. In the art-work, conceptual content is rendered from the inside and outside simultaneously and equally. It is embodied in a symbolic object which is indelibly the product of an individual creator or ensemble. But as object the work is destined for contexts beyond that of its origination. In this shedding of origins, the work's conceptual content is not simply that which was posited by such and such a person at such and such a time, but is one generated by the Other Person, in Deleuze and Guattari's sense. The work presents a possible viewing position in the world we share. The viewer engages with factors which are the very basis of intersubjective experience at the level of their emergence. Each work has the potential to re-enact different aspects of the origins of perception and self-conscious-ness itself. It affirms, thereby, that enduring trajectory towards life which is both the origin and limit of human experience.

Notes and Sources

Preface

1 The other works are my *Critical Aesthetics and Postmodernism*, and *Art and Embodiment: From Aesthetics to Self-Consciousness*, both Clarendon Press, Oxford, 1993. The present work was previously conjectured as *Philosophy in Art*. There will be another entitled *Defining Experience Defining Art*.

2 Maurice Merleau-Ponty, *The Prose of the World*, trans. John O'Neil, Heinemann, London, 1974, p. 83.

3 Theodor Adorno, *Aesthetic Theory*, trans. C. Lenhardt, Routledge and Kegan Paul, London, 1984, p. 165.

Introduction

1 Jonathan Crary, *Techniques of the Observer: On Vision and Modernity in the Nineteenth Century*, M.I.T. Press, Cambridge, Mass., and London, 1992, p. 6.

2 See, for example, Norman Bryson, *Vision and Painting: The Logic of the Gaze*, Cambridge University Press, 1983; Griselda Pollock, *Vision and Difference*, Routledge, London, 1988; Victor Burgin, *The End of Art Theory: Criticism and Postmodernity*, Macmillan, London, 1986; Rosalind Krauss, *The Originality of the Avant-Garde and Other Modernist Myths*, M.I.T. Press, Cambridge, Mass., and London, 1986. It is important to emphasize that the problem with these semiotic idealist approaches is not their commitment to theory – theory is indispensable – but that they use mainly bad theory. Some of this can be salvaged and put to use. For an example of this in relation to Lacan see my 'More than Ornament: The Significance of Riegl', *Art History*, 17: 3, 1994, pp. 482–94; and the papers 'Lacan and Žižek: An Introduction' and 'Leaving the Twentieth Century: Lacan, Žižek: and the Sinthome', *Art and Design* (Profile no. 35), April 1994, pp. 76–9 and 88–95, respectively. Discussions of Derrida and Barthes can be found in Chapters 1 and 11 of my *Critical Aesthetics and Postmodernism*, Clarendon Press, Oxford, 1993.

3 See, for example, Arthur C. Danto, *The Transfiguration of the Commonplace*, Harvard University Press, 1981, and George Dickie, *Art and the Aesthetic*, Cornell University Press, Ithaca, 1974.

4 I am indebted to Geoff Teasdale of Leeds Metropolitan University for this phrase.

5 See, for example, Clement Greenberg, *Art and Culture: Critical Essays*, Beacon Press, New York, 1961; and Michael Fried, 'Art and Objecthoood' in *Minimal Art: A Critical Anthology*, ed. Gregory Battcock, Dutton, New York, 1968, pp. 116–47.

6 Ellen Dissanayake, *What Art is For*, University of Washington, Seattle and London, 1988; and *Homo Aestheticus: Where Art Comes From and Why*, Free Press, New York, 1992.

7 Yve-Alain Bois, *Painting As Model*, M.I.T. Press, Cambridge, Mass., and London, 1993; Thierry de Duve, *Kant after Duchamp*, M.I.T. Press, Cambridge, Mass., and London, 1996, offers an apotheosis of Duchamp, which fails to do justice to the ironic

and 'anti-art' dimension of his practice. But de Duve does attempt to find something like a trans-historical and transcultural dimension in modern and post-modern art, through an ingenious application of Kant's moral and aesthetic theory, however flawed the application: see my review of *Kant after Duchamp* in the *British Journal of Aesthetics*, 1997 (forthcoming).

8 *Critical Aesthetics and Postmodernism* and *Art and Embodiment: From Aesthetics to Self-Consciousness*, both Clarendon Press, Oxford, 1993.

9 The relevant works are Maurice Merleau-Ponty, *Phenomenology of Perception*, trans. C. Smith with revisions by Forrest Williams, Routledge and Kegan Paul, London, 1974; and Ernst Cassirer, *Philosophy of Symbolic Forms*, notably vol. 1, *Language* and vol. 3, *The Phenomenology of Knowledge*, Yale University Press, New Haven, 1966. Merleau-Ponty's work is sometimes cited in relation to specific artists and problems. (See, for example the Introduction, and 'Richard Serra: A Translation' in Krauss, *Originality*, and Richard Shiff, 'Cézanne's Physicality: The Politics of Touch' in *The Language of Art History*, ed. S. Kemal and I. Gaskell, Cambridge University Press, 1991, pp. 129–80.) My use of Merleau-Ponty and Cassirer, however, will be based on the philosophical significance of their work for art and experience *per se*.

10 An exception to this is Mark Cheetham's *The Rhetoric of Purity: Essentialist Theory and the Advent of Abstract Painting*, Cambridge University Press, Cambridge, 1994. Andrew Benjamin's *Object-Painting: Philosophical Essays*, Academy Editions, London, 1994, is also extremely insightful, especially in relation to post-modern art.

Chapter 1

1 I have criticized this scepticism in Chapter 1 of *Critical Aesthetics and Postmodernism*, Clarendon Press, Oxford, 1993.

2 Jacques Derrida, 'Signature Event Context', *Margins of Philosophy*, trans. Alan Bass, Harvester, Brighton, 1982, p. 315.

3 *Ibid.*, p. 318.

4 An extremely full (if somewhat scattered) exposition of reciprocity can be found in: Ernst Cassirer, *The Philosophy of Symbolic Forms*; vol. 1: *Language*, trans. R. Manheim, Yale University Press, New Haven, 1966, see esp. pp. 85–114. Cassirer himself rarely uses the term 'reciprocity', and the connections which I go on to make with embodiment are made by him only in the most schematic terms.

5 The position which I am describing here is most fully developed in Maurice Merleau-Ponty's *Phenomenology of Perception*, trans. C. Smith with revisions by Forrest Williams, Routledge and Kegan Paul, London, 1974.

6 Some recent treatments of imagination included Wolfgang Iser, 'The Aesthetic and the Imaginary' in *The States of Theory: History, Art and Critical Discourse*, ed. David Carrol, Stanford University Press, Stanford, 1990, pp. 201–20; Kendal Walton, *Mimesis and Make-Believe: On the Foundation of the Representational Arts*, Harvard University Press, Cambridge, Mass., and London, 1993. Both these discussions are useful but fail to make any significant connections between the imagination and self-consciousness itself. Some important steps in this direction can be found in P. F. Strawson, 'Imagination and Perception' in *Kant on Pure Reason*, ed. R. C. S. Walker, Oxford University Press, 1982, pp. 82–99.

7 This approach is developed in my paper 'The Logical Structure of Pictorial Representation', *Acta Philosophica*, XV, 1994, pp. 199–210. In this essay I refute the scepticism concerning the role of resemblance which Nelson Goodman rehearses in his *Languages of Art*, Hackett, Indianapolis, 1976. Extremely useful approaches with some kinship to my own can be found in Flint Schier, *Deeper into Pictures*, Cambridge University Press, 1989, and Andrew Harrison, 'A Minimal Syntax for the Pictorial and

Linguistic – Analogies and Disanalogies' in *The Language of Art History*, ed. I. Gaskell and S. Kemal, Cambridge University Press, 1993, pp. 213–39.

8 See the 'Schematism' section of Kant, *The Critique of Pure Reason*, trans. N. Kemp-Smith, Macmillan, London, 1973, p. 183. The article by Strawson, 'Imagination and Perception', is also useful here.

9 Clement Greenberg, 'Problems in Criticism II: Complaints of a Critic', *Art Forum*, October 1967, p. 38.

10 It is important to clarify this term. A rule, relation, or phenomenon is transcendental to the degree that it is logically presupposed in order for human experience to be possible. In particular, it is important to demarcate this philosophical usage from its more popular ones e.g. in 'transcendental meditation' where transcendental is synonymous with transcending given reality (i.e. going 'beyond' it).

11 I have argued this in Chs 1–3 of *Art and Embodiment: From Aesthetics to Self-Consciousness*, Clarendon Press, Oxford, 1993.

12 Wassily Kandinsky, *Concerning the Spiritual in Art*, trans. M. Sadler, Dover, New York, 1977, p. 56. I am indebted to Professor Christina Lodder for her comments on this section.

13 *Ibid.*, pp. 30–31.

14 Merleau-Ponty, *Phenomenology*, p. 323.

15 *Ibid.*, p. 335.

16 *Ibid.*, p. 333.

Chapter 2

1 I have explored this literature in 'Cubism, Kant, and Ideology', *Word and Image*, 2: 3, 1987, pp. 195–201. See also Lynn Gamwell, *Cubist Criticism*, U. M. I. Research Press, Michigan, 1980. Recent approaches such as Yve-Alain Bois's 'Kahnweiler's Lesson', *Painting As Model*, M.I.T. Press, Cambridge, Mass., and London, 1994, pp. 65–97, tend to overemphasize the post-structuralist notion of the field in relation to Cubism's philosophical context. The iconographical dimension of Cubism is well treated in Jeffrey Weiss, *The Popular Culture of Modern Art: Picasso, Duchamp and Avant Gardism c. 1909–1917*, Yale University Press, New Haven and London, 1994.

2 Pablo Picasso, 'Statement' (1923), reproduced in Herschel B. Chipp, *Theories of Modern Art*, University of California Press, Berkeley and Los Angeles, 1968, p. 210.

3 Picasso, 'Conversation' (1935), in Chipp, *ibid.*, p. 271.

4 D. H. Kahnweiler, *My Galleries and Painters*, trans. Helen Weaver, Thames and Hudson, London, 1971, p. 138.

5 André Salmon, 'An Anecdotal History of Cubism', in *Cubism*, ed. and trans. Edward Fry, McGraw Hill, New York, 1966, p. 83.

6 Picasso quoted by André Malraux in *La Tête obsidienne*, Gallimard, Paris, 1974. A convenient English translation of the relevant passages can be found in Irina Fortunescu, *Braque*, trans. R. Hillard, Abbey Library, London, 1977, pp. 20–21.

7 G. W. F. Hegel, *Aesthetics*, vol. 1, trans, T. M. Knox, Clarendon Press, Oxford, 1975, p. 31.

8 Salmon in *Cubism*, p. 82.

9 William Rubin, 'Cézannisme and the Beginnings of Cubism', in *Cézanne: The Late Works*, ed. William Rubin, Thames and Hudson, London, 1978.

10 Braque, 'Personal Statement' (1908–9), reprinted in Chipp, *Theories of Modern Art*, pp. 259–60.

11 Quoted in an interview with Doré Vallier. For an English translation see Fortunescu, *Braque*, p. 12.

12 John Golding, *Cubism: A History and Analysis 1907–14*, Faber and Faber, London, 1967, p. 58.
13 *Ibid.*, p. 57.
14 There is some evidence for Gleizes and Metzinger holding such a view. See, for example, Metzinger, 'Cubism and Tradition', in *Cubism*, pp. 66–7.
15 Quoted in an interview with Dora Vallier, trans. Fortunescu, *Braque*, p. 12. I have slightly modified the translation.
16 See John Nash, 'The Nature of Cubism: A Study of Conflicting Interpretations', *Art History*, 3: 4, 1980, pp. 435–47.
17 For a detailed discussion of this issue in relation to collage and its iconographical ramifications see Christine Poggi, *In Defiance of Painting*, Yale University Press, New Haven and London, 1993.
18 Braque, 'Personal Statement', reproduced in *Cubism*, p. 53.
19 Quoted in an interview with Dora Vallier, trans. Fortunescu, *Braque*, p. 12.
20 See, for example, Merleau-Ponty, *The Visible and the Invisible*, ed. Claude Lefort, trans. Alphonse Lingis, Northwestern University Press, Evanston, Iu., 1968 esp. Ch. 4.
21 J. P. Sartre, *Nausea*, trans. Robert Baldick, Penguin, Harmondsworth, 1971, p. 183.
22 Merleau-Ponty, 'Eye and Mind', trans. Carleton Dallery, in *The Primacy of Perception*, ed. James Edie, Northwestern University Press, Evanston, Ill., 1976, p. 163.

Chapter 3

1 The literature on Bergson and Futurism is astonishingly limited. Marianne Taylor, *Futurist Art and Theory 1909–1915*, Oxford University Press, 1968, provides a basic introduction.
2 Henri Bergson, *Creative Evolution*, trans. A. Mitchell, Macmillan, London, 1912, p. 263.
3 Henri Bergson, *Matter and Memory*, trans. Nancy Paul and W. Scott Palmer, Allen and Unwin, London, 1978, p. 276.
4 *Ibid.*, p. 278.
5 Bergson, *Creative Evolution*, p. 152.
6 Bergson, *Matter and Memory*, p. 29.
7 *Ibid.*, p. 280.
8 *Ibid.*, p. 195.
9 *Ibid.*, pp. 122–3.
10 Bergson, *Introduction to Metaphysics*, trans. T. E. Hulme, Macmillan, London, 1913, p. 56.
11 *Ibid.*, pp. 1–2.
12 *Ibid.*, p. 14.
13 *Ibid.*
14 *Ibid.*, p. 8.
15 Umberto Boccioni, cited in *Futurist Manifestoes*, ed. Umbro Apollonio, Thames and Hudson, London, 1973, p. 94.
16 *Ibid.*, pp. 27 and 27–8.
17 *Ibid.*, p. 47.
18 *Ibid.*, p. 48.
19 Bergson, *Matter and Memory*, p. 276.
20 *Ibid.*, p. 266.
21 *Ibid.*
22 Boccioni, *Technical Manifesto of Futurist Sculpture*, cited in *Futurist Manifestoes*, p. 62.
23 *Ibid.*, p. 63.
24 Boccioni, *The Plastic Foundations of Futurist Sculpture and Painting*, cited in *ibid.*, p. 88.

25 Gino Severini, *The Plastic Analogies of Dynamism*, cited in *ibid.*, p. 120.

26 Bergson, *Matter and Memory*, pp. 122–3.

27 Boccioni, *Plastic Foundations*, cited in *Futurist Manifestoes*, p. 89. The Bergson he was quoting comes from *Matter and Memory*, pp. 259 and 246.

28 Boccioni in *Futurist Manifestoes*, p. 90.

29 *Ibid.*, p. 150.

30 *Ibid.*, pp. 150–51.

31 *Ibid.*, p. 151.

32 *Ibid.*, p. 152.

33 Boccioni, *Futurist Painting and Sculpture*, cited in *Futurist Manifestoes*, p. 178.

34 Boccioni, *Plastic Foundations*, cited in *Futurist Manifestoes*, p. 152.

35 Boccioni, 'Futurist Dynamism and French Painting 1913', cited in *Futurist Manifestoes*, p. 110.

Chapter 4

1 The most easily accessible authoritative work is Charlotte Douglas, *Malevich*, Thames and Hudson, London, 1994. Someting of the diversity of interpretative approaches can be gleaned from the special Malevich issue of *Art and Design*, September 1989. One of the most probing interpretations of the philosophical import of Malevich's theory is Mojca Oblak, 'Kant and Malevich: The Possibility of the Sublime', *Art and Design*, Profile no. 40, 9: 3/4, 1995, pp. 34–41.

2 P. D. Ouspensky, *Tertium Organum*, trans. C. Bradgon, Kegan Paul, London, 1934, p. 52.

3 *Ibid.*, p. 115.

4 *Ibid.*, p. 42.

5 *Ibid.*, p. 83.

6 *Ibid.*, p. 183.

7 All the essays by Malevich cited here are to be found in his *Essays on Art*, trans. A. B. McMillin, X. Glawacki-Prus and David Miller, Borgen, Copenhagen, 1968, vol. 1. This reference p. 114.

8 Kasimir Malevich, *The World as Non-Objectivity*, trans. X. Glawacki-Prus and Edmund T. Little, Borgen, Copenhagen, 1975, p. 19.

9 Ouspensky, *Tertium Organum*, pp. 42–3.

10 Malevich, *The World*, pp. 55–6.

11 Arthur Schopenhauer, *The World As Will and Representation*, trans. E. J. Payne, Dover, New York, 1969, vol. 1, pp. 146–7.

12 Malevich, 'From Cubism and Futurism to Suprematism and the New Realism in Painting' (1916), *Essays*, p. 39.

13 *Ibid.*, p. 32.

14 *Ibid.*, p. 25.

15 Malevich, 'On New Systems in Art', *Essays*, p. 104.

16 *Ibid.*, p. 84.

17 *Ibid.*, p. 107.

18 *Ibid.*, p. 85.

19 Malevich, 'Non-Objective Creation and Suprematism', *Essays*, p. 121.

20 Malevich, 'Suprematism-Thirty-Four Drawings', *Essays*, p. 123.

21 *Ibid.*, pp. 124–5.

22 These are discussed in Troels Anderson's introduction to Malevich, *The World*.

23 *Ibid.*, p. 57.

24 *Ibid.*, p. 215.

25 *Ibid.*, pp. 57–8.

26 *Ibid.*, p. 112.

27 Malevich, *The Non-Objective World*, trans. H. Dearstyne, Paul Theobald and Co., New York, 1959, p. 18.
28 *Ibid.*, p. 20.
29 *Ibid.*, p. 36.
30 *Ibid.*, p. 38.
31 *Ibid.*, p. 76.
32 *Ibid.*, p. 78.
33 Maurice Merleau-Ponty, *Phenomenology of Perception*, trans. C. Smith with revisions by Forrest Williams, Routledge and Kegan Paul, London, 1974, pp. 3–4.
34 *Ibid.*, p. 4.

Chapter 5

1 Richard Huelsenbeck (ed.), *The Dada Almanac*, trans. Malcolm Green and others, Atlas Press, London, 1993, p. 10. This collection, dating from 1920, is the single most insightful document in relation to the entire Dadaist movement. Green's introduction and editorial contributions are excellent.
2 *Ibid.*, p. 11.
3 *Ibid.*
4 Hal Foster, *Compulsive Beauty*, M.I.T. Press, Cambridge, Mass., and London, 1993. Foster's analysis is very acute in relation to Surrealism's pattern of reception. However, the pivot of his own interpretation is a deployment of Freud's notion of the 'uncanny'. Overlooking the considerable problems of Freudian mythology and the difficulties of linking the uncanny to art, Foster's analysis offers a one-sided view of Surrealism. Instead of addressing Breton's theoretical project in detail, he offers psychoanalytic readings of selections drawn primarily from Breton's creative writings. The result is an unwarranted privileging of the death instinct, and a neglect of the considerable philosophical significance of the Surrealist project. In particular, Foster fails to grasp how the Surrealist notion of objective humour embraces the dimensions of death and perversity as means to an end.
5 Quoted in Patrick Waldberg, *Surrealism*, Thames and Hudson, London, 1978, pp. 91–2.
6 *Ibid.*, p. 91.
7 Hegel scarcely rates a passing mention in Foster, *Compulsive Beauty*. On p. 16 he quotes Breton's remark that 'Freud is Hegelian in me', but does not develop the implications of this. The neglect of Hegel also holds true of J. H. Mathews, *The Surrealist Mind*, Associated University Press, London, 1991. Even in Maurice Nadeau, *The History of Surrealism*, trans. R. Howard, Plantin, London, 1987, the only Hegel citations are in the texts by Breton himself. One exception to the trend is Anna Balakian, *Surrealism: The Road to the Absolute*, Dutton, New York, 1970. Balakian, however, does little justice to the systematic significance of Hegel for Surrealism. Bernard-Paul Robert, 'Breton, Hegel, et le surreal', *Revue de l'Université d'Ottawa*, 44, 1974, pp. 44–8, addresses the relation primarily between Hegel's *Phenomenology of Spirit* and the Surrealist Manifestoes, but in only a piecemeal way.
8 André Breton, *Conversations: The Autobiography of Surrealism*, trans. and introduced by Mark Polizzoti, Paragon House, New York, 1993, p. 118.
9 The most accessible discussion of this is to be found in Hegel's so-called 'lesser' *Logic*, trans. W. Wallace, Clarendon Press, Oxford, 1972, esp. pp. 113–22, Wallace's edition incorporates useful elucidatory material derived from Hegel's lecture notes (Zusätze).
10 *Ibid.*, p. 174.
11 Hegel is committed to a version of the ontological argument for the existence of God, if the dynamic is to be carried through to completion. This would hold, in the

broadest terms, that the structure of the world is one that entails the world's necessary existence as well. Everything hangs here on the meaning one gives to 'entails'.

12 *Ibid.*, p. 205. In one sense, the problems which I shall raise for Hegel in relation to contingency are the animating factors in Theodore Adorno's appropriation of dialectical thought. For a useful exposition of his relation to Hegel see Adorno, *Hegel: Three Studies*, trans. Sherry Weber Nicholson, M.I.T. Press, Cambridge, Mass., and London, 1993, esp. 'The Experiental Content of Hegel's Philosophy', pp. 53–88.

13 Hegel, *Logic*, p. 206.

14 Friedrich Engels, *Anti-Dühring*, trans. E. Burns, Lawrence and Wishart, London, 1948, p. 28.

15 *Ibid.*, p. 29.

16 *Ibid.*, p. 158.

17 *Ibid.*, pp. 30–31.

18 *Ibid.*, p. 294.

19 *Ibid.*, p. 299.

20 *Ibid.*, p. 309.

21 Amongst the works cited by Breton are Hegel's *Aesthetics, Philosophy of Nature, Philosophy of Right*, and *Phenomenology of Spirit*.

22 André Breton, 'What is Surrealism' in *What is Surrealism? Selected Writings*, ed. Franklin Rosemont, Pluto Press, London, 1978, p. 116.

23 *Ibid.*, p. 117.

24 Breton, *The First Surrealist Manifesto, Manifestoes of Surrealism*, trans. Richard Seaver and Helen Lane, University of Michigan Press, Ann Arbor, 1969, p. 9.

25 *Ibid.*, p. 10.

26 *Ibid.*, pp. 13–14.

27 *Ibid.*, p. 26.

28 Engels, 'The Hegelian system as such was a colossal miscarriage', *Anti-Dühring*, p. 30, quoted by Breton, 'The Second Surrealist Manifesto', *Manifestoes*, p. 140.

29 Breton, *ibid.*, p. 141.

30 *Ibid.*

31 Breton, *Surrealism and Painting*, trans. S. W. Taylor, Macdonald, London, 1972, p. 46.

32 Breton, 'The Crisis of the Object', in *ibid.*, p. 279.

33 *Ibid.*, p. 277.

34 Breton, 'The Surrealist Situation of the Oject', *Manifestoes*, p. 259.

35 Hegel, *Aesthetics*, vol. 1, trans. T. M. Knox, Clarendon Press, Oxford, 1975, p. 2.

36 *Ibid.*, p. 9.

37 For an exposition see Ch. 7 of my *Art and Embodiment: From Aesthetics to Self-Consciousness*, Clarendon Press, Oxford, 1993, pp. 119–46.

38 Hegel, *Aesthetics*, p. 576.

39 *Ibid.*, p. 609.

40 *Ibid.*

41 Breton, 'The Poverty of Poetry: The Aragon Affair', *What is Surrealism?*, p. 80.

42 *Ibid.*, pp. 80–81.

43 Breton, 'Anthology of Black Humour', *ibid.*, p. 195.

44 Engels, Ludwig Feuerbach and the End of Classical German Philosophy', in *Marx and Engels: Selected Works*, Lawrence and Wishart, London, 1970, p. 604.

45 Breton, 'Anthology', p. 189.

46 In the *Second Manifesto*, *Manifestoes*, p. 268. For an alternative reading of objective chance based on the Freudian 'uncanny', see Foster, *Compulsive Beauty*, esp. pp. 29–42. It should be emphasized that whatever sexual significance might accrue to objective chance is encompassed within my notion of the existential subconscious.

47 Breton, 'Limits Not Frontiers of Surrealism', *What is Surrealism?*, p. 154.

48 *Marx and Engels*, p. 609.

49 Breton, 'Limits Not Frontiers', p. 155.

50 *Ibid.*

51 See, for example, Breton's extensive discussion in *Surrealism and Painting* and esp. the treatment of Dalí and Ernst in 'The Surrealist Situation of the Object', pp. 274–6.

52 Magritte, quoted in Harry Torczyner (ed.), *Magritte: Ideas and Images*, trans. Richard Miller, Abrams, New York, 1979, p. 49.

53 *Ibid.*, p. 61.

54 *Ibid.*, p. 14.

55 *Ibid.*, p. 66.

56 *Ibid.*, p. 60.

57 *Ibid.*

58 *Ibid.*, p. 102.

59 *Ibid.*, p. 121.

60 *Ibid.*, p. 55.

61 Jackson Pollock, 'Answers to a Questionnaire', in *Art and Theory: 1900–1990*, ed. C. Harrison and P. Wood, Blackwell, Oxford, 1992, p. 561.

62 Pollock, *Possibilities* (Winter 1947), p. 79. Cited in full in *Pollock*, ed. Elizabeth Frank, Abbeville, New York, 1983, p. 109.

63 Pollock, *Art and Theory*, p. 576.

64 *Ibid.*

Chapter 6

1 *The New Art – The New Life: The Collected Writings of Piet Mondrian*, ed. and trans. H. Holzman and M. James, Thames and Hudson, London, 1987, p. 338. In this Chapter I will address Mondrian alone. For a good presentation of the other major De Stijl theorist, van Doesburg, see Joost Baljeu, *Theo Van Doesburg*, Macmillan, New York, 1974.

2 For an excellent discussion, see Robert Welsh, 'Mondrian and Theosophy', in *Piet Mondrian Centennial Exhibition* (exh. cat.), The Solomon R. Guggenheim Museum, New York, 1971, pp. 35–52.

3 *The New Art*, p. 17.

4 *Ibid.*

5 An extremely useful analysis of the philosophical influences on Mondrian can be found in Mark Cheetham, *The Rhetoric of Purity: Essentialist Theory and the Advent of Abstract Painting*, Cambridge University Press, 1994; see esp. pp. 40–64 and 102–38. Cheetham's main analysis concerns the nature and broader historical significance of these influences in a 'rhetoric' of purity. Questions of the logical structure and progression of Mondrian's theory are made secondary to this (though Cheetham's treatment of such issues is very good as far as it goes). I will try to steer a middle course between Cheetham's approach and the rigid formalism exemplified in Kermit Champa, *Mondrian Studies*, University of Chicago Press, 1985.

6 Mondrian, 'The New Plastic in Painting' (1917), *The New Art*, p. 48.

7 *Ibid.*, p. 52.

8 Mondrian, 'Natural Reality and Abstract Reality', (1919–20), *ibid.*, pp. 88–9.

9 'New Plastic', p. 43.

10 *Ibid.*

11 See, for example, the relevant observations in the late 'Folder of Notes' (*c.* 1938–44), *The New Art*, p. 364.

12 'New Plastic', p. 51.

13 *Ibid.*

14 As Paul Overy, *De Stijl*, Thames and Hudson, London, 1991, p. 42, has pointed out, the original Dutch *beeldend* should be rendered in basic English as 'image forming' or

'image creating' and *nieuwe beelding* as 'new image creation' or 'new structure'. It was, however, rendered in French as 'néo-plasticisme' and later translated literally into English as Neo-Plasticism.

15 Mondrian, 'New Plastic', p. 31.
16 *Ibid.*, p. 64.
17 *Ibid.*
18 *Ibid.*, p. 54.
19 *Ibid.*, p. 56.
20 *Ibid.*
21 *Ibid.* For a somewhat gendercentric analysis of the male/female duality see Cheetham, *Rhetoric of Purity*, pp. 119–29.
22 Mondrian, 'New Plastic', p. 36.
23 *Ibid.*, p. 37.
24 The shapes of his diamond and ovoid pictures signified for Mondrian the equlibration of respectively mind/matter and male/female. For more on this see E. A. Carmean, Jr, *Mondrian: The Diamond Compositions*, National Gallery of Art, Washington, D.C. 1979.
25 Mondrian, 'New Plastic', p. 38.
26 *Ibid.*
27 *Ibid.*
28 *Ibid.*, p. 57.
29 *Ibid.*, p. 39.
30 *Ibid.*
31 *Ibid.*, p. 32.
32 Mondrian does not, however, say that art allows an absolute release from the tragedy of the corporeal world.
33 Hegel, *Aesthetics*, vol. 1, trans. T. M. Knox, Clarendon Press, Oxford, 1975, p. 2.
34 Mondrian, 'New Plastic', p. 41.
35 *Ibid.*, p. 41n.

Chapter 7

1 Barnett Newman quoted in Thomas Hess, *Barnett Newman*, Tate Gallery, London, 1972, p. 47.
2 Newman quoted in Harold Rosenberg, *Barnett Newman*, Abrams, New York, 1978, p. 21.
3 Robert Rosenblum, 'The Abstract Sublime', *Art News*, February 1961, p. 38.
4 Edmund Burke, *A Philosophical Inquiry into the Origin of our Ideas of the Sublime and the Beautiful*, ed. J. T. Boulton, Routledge and Kegan Paul, London, 1958, p. 136.
5 Immanuel Kant, *The Critique of Judgement*, trans. J. C. Meredith, Oxford University Press, 1973, p. 90.
6 *Ibid.*, p. 106.
7 Newman, 'The Sublime is Now', *Tiger's Eye*, October 1948, pp. 51–3, reprinted in *Art in Theory, 1900–1990*, ed. C. Harrison and P. Wood, Blackwell, Oxford, 1992, pp. 572–4.
8 Newman, 'The First Man was an Artist', and introduction to 'The Ideographic Picture' (exh. cat.), both 1947, reprinted in *Theories of Modern Art*, ed. Herschel B. Chipp, London, 1968, pp. 551–2 and 550–51, respectively.
9 'The First Man was an Artist', p. 551.
10 *Ibid.*, p. 552.
11 'The Ideographic Picture', p. 550.
12 *Ibid.*
13 *Ibid.*
14 'The Sublime is Now', p. 572.

15 *Ibid.*, p. 573.
16 *Ibid.*
17 *Ibid.*
18 *Ibid.*, p. 574.
19 *Ibid.*
20 *Ibid.*, p. 573.
21 Kant, *Critique of Judgement*, p. 91.
22 Newman, interview with David Sylvester, reprinted in Rosenberg, pp. 245–6.
23 Newman, interview with Dorothy Seckler, reprinted in *The New York School*, ed. Maurice Tuchman, Thames and Hudson, London, 1970, p. 112.
24 *Ibid.*
25 This approach is implied by Franz Kline's comments, for example, quoted in Rosenberg, p. 64.
26 See for example Clement Greenberg, 'After Abstract Expressionism', reprinted in '*Aesthetics: A Critical Anthology*', ed. George Dickie, St. Martin Press, New York, 1977, pp. 425–37.
27 See for example Judd's essay on Newman reprinted in *Modern Art and Modernism: A Critical Anthology*, ed. Francis Frascina and Charles Harrison, Harper and Row, New York and London, 1982, pp. 129–32.
28 For a fuller treatment of these issues see Ch. 7 of my *The Kantian Sublime: From Morality to Art*, Clarendon Press, Oxford, 1989, pp. 152–74.
29 Yve-Alain Bois, *Painting As Model*, M. I. T. Press, Cambridge, Mass., and London, 1993, p. 203.
30 *Ibid.*
31 *Ibid.*, p. 195.

Chapter 8

 1 Marcel Duchamp, 'The Great Trouble with Art in this Country' (1946), reprinted in *The Essential Writings of Marcel Duchamp*, ed. M. Sanouillet and E. Peterson, Thames and Hudson, London, 1975, p. 124.
 2 *Ibid.*, p. 125.
 3 Duchamp, 'Apropos of "Readymades"' (1961), reprinted in *ibid.*, p. 141.
 4 See Kant, *The Critique of Judgement*, trans. J. C. Meredith, Oxford University Press, 1973, pp. 175–6.
 5 See my *Art and Embodiment: From Aesthetics to Self-Consciousness*, Clarendon Press, Oxford, 1993, esp. Ch. 10, pp. 180–200.
 6 Joseph Kosuth, 'Art After Philosophy', reprinted in *Art After Philosophy and After: Collected Writings, 1966–1990*, M. I. T. Press, London, 1991, p. 17.
 7 *Ibid.*
 8 *Ibid.*, p. 16.
 9 *Ibid.*, p. 17.
10 *Ibid.*
11 *Ibid.*, p. 18.
12 *Ibid.*
13 *Ibid.*, pp. 20–21.
14 *Ibid.*, p. 20.
15 *Ibid.*, pp. 21–2.
16 *Ibid.*, p. 24.
17 Terry Atkinson, 'Introduction' in *Conceptual Art* ed. U. Meyer, Dutton, New York, 1972, p. 19.
18 *Ibid.*, p. 15.

19 For a fuller discussion of this see Ch. 8 of my *Art and Embodiment*, pp. 149–79.
20 Kosuth, 'Within the Context: Modernism and Critical Practice' (1977), reprinted in *Art After Philosophy*, p. 162.
21 *Ibid.*
22 Whitney Chadwick, *Women, Art, and Society*, Thames and Hudson, London and New York, 1996, p. 382.
23 See, for example, the selection of their essays in *Minimal Art: An Anthology*, ed. Gregory Battcock, Dutton, New York, 1968.
24 An excellent perspective on Ian Hamilton Finlay's work is given in Yves Abrioux, *Ian Hamilton Finlay: A Visual Primer*, Reaktion, London, 1992.
25 These points are argued in Ch. 4 of my *Critical Aesthetics and Postmodernism*, Clarendon Press, Oxford, 1993, pp. 72–96.

Chapter 9

1 J.-F. Lyotard, *The Postmodern Condition: A Report on Knowledge*, trans. G. Bennington and B. Massumi, Manchester University Press, 1984, p. 76.
2 Jean Baudrillard, *Simulations*, trans. P. Foss, P. Patton and P. Beitchman, Semiotext, New York, 1983, p. 83.
3 *Ibid.*, p. 96.
4 *Ibid.*, p. 97.
5 *Ibid.*, p. 100.
6 *Ibid.*, p. 2.
7 *Ibid.*, p. 41.
8 *Ibid.*, p. 54.
9 *Ibid.*, p. 120.
10 *Ibid.*, p. 121.
11 *Ibid.*, pp. 116–17.
12 *Ibid.*, p. 151.
13 *Ibid.*, pp. 142–3.
14 *Ibid.*, p. 144.
15 *Ibid.*
16 *Ibid.*
17 *Ibid.*, p. 145.
18 *Ibid.*, p. 147.
19 *Ibid.*, p. 151.
20 *Ibid.*, pp. 151–2.
21 Baudrillard, *The Ecstasy of Communication*, trans. B. and C. Schutze, Semiotext, New York, 1988, pp. 89–90.
22 *Ibid.*, pp. 97–8.
23 *Ibid.*, p. 98.
24 See, for example, Halley, 'Nature and Culture', *Arts Magazine*, 58, September 1983, pp. 64–5.

Chapter 10

1 See esp. the writings on language in Jacques Lacan, *Ecrits*, trans. A. Sheridan, Tavistock Publications, London, 1977.
2 Derrida's overall approach is best set out in *Positions*, trans. A. Bass, Athlone, London, 1981; and 'Différance', *Margins of Philosophy*, Harvester, Brighton, 1982, pp. 1–27.
3 A useful exposition of Foucault's approach can be found in 'The Order of Discourse',

in *Untying the Text*, ed. Robert Young, Routledge, London, 1987. A fuller exposition is in *The Order of Things*, Tavistock Publications, London, 1970.
4 The exhibition is discussed in detail in my *Critical Aesthetics and Postmodernism*, Clarendon Press, Oxford, 1993, Ch. 9.
5 Walter Benjamin, *Illuminations*, trans. H. Zohn, Verso, London, 1983, p. 224.
6 Jean Baudrillard, *Simulations*, trans. P. Foss, P. Patton and P. Beitchman, Semiotext, New York, 1983, p. 41.
7 Cornelia Parker, quoted in Jonathan Watkins's introduction to Parker's contribution to a group exhibition, 'Austellunghaus in Grassmuseum Leipzig', 1993.

Chapter 11

1 For a highly readable analysis of some of the conditions surrounding Neue Slowenische Kunst's emergence see Ales Erjavec and Marina Grzinič, *Ljubljana, Ljubljana: The Slovene Art and Culture of the 1980's*, Ljubljana, 1991. Erjavec, 'Avant-Garde and Retrogarde', *Issues in Contemporary Culture and Aesthetics*, 1, April 1995, pp. 21–8, explores some of the specialized interpretative issues.
2 A useful survey of contemporary Slovenian art can be found in Mojca Oblak, 'Neue Slowenische Kunst and New Slovenian Art', in *New Art from Eastern Europe: Identity and Conflict, Art and Design*, Profile no. 35, 9: 3/4, 1994, pp. 8–17.
3 Oblak, *Transcendental Mannerism*, text accompanying the 'Transcendental Mannerism' exhibition at the Mala Galerija, Ljubljana, 30 April–15 June 1996, p. 27.
4 *Ibid.*, p. 9.
5 *Ibid.*, p. 47.

Conclusion

1 Charles Altieri, book review, *Journal of Aesthetics and Art Criticism*, 53: 1, 1995, p. 89.
2 Mark Cheetham confuses trans-historical with ahistorical in his *The Rhetoric of Purity: Essentialist Theory and the Advent of Abstract Painting*, Cambridge University Press, 1994, p. 202.
3 Gilles Deleuze and Félix Guattari, *What is Philosophy?*, trans. G. Burchell and H. Tomlinson, Verso, London, 1994, p. 18. In their linking of art to 'percept' and 'affect' (pp. 163–99) Deleuze and Guattari attempt to establish it on a similar ontological basis to mine, i.e. in terms of its trans-historical, transcultural significance. They also evince some scepticism about Conceptual Art (p. 198). However, much of their analysis tends towards what is at best (and only partially) instructive rhetoric. It is particularly disappointing that they barely consider the vital function of reciprocity, especially given their telling linkage of reciprocal relations to the Other Person in the passage quoted here.

Index of Visual Artworks Discussed and/or Reproduced in the Text

Atkinson, T. and Baldwin, M., *Air Show* 178–9

Bainbridge, D., *Crane* 177
Balla, G., *Dynamism of a Dog on a Leash* 68
Boccioni, U., *The City Rises* 58, 69; *States of Mind II – They Who Go* 60; *Unique Forms of Continuity in Space* 63, 69
Braque, G., *Gran Nu* 34–8, 39; *Violin and Palette* 39; *Candlestick* 42

Carra, C., *Leaving the Theatre* 58; *Funeral of the Anarchist Galli* 60

Dalí, S., *The Persistence of Memory* 88
David, J.-L., *Death of Marat* 38
Duchamp, M., *Nude Descending a Staircase* 40–1; *Fountain* 171

Finlay, I. H., *All Greatness Stands Firm In The Storm* 184; *Utterances of Louis-Antoine Saint-Just* 185; *Corday, Lux* 185

Halley, P., *Two Cells with Circulating Conduit* 197
Hatoum, M., *Corps d'Etranger* 180

Irwin $L + D$ 216
Ingres, J.-A., *Odalisque* 39

Kandinsky, W., *Cossacks* 29
Koons, J., *Rabbit* 194; *New Hoover Celebrity IV* 194
Kosuth, J., *Modus Operandi* 183
Kruger, B., *Your gaze hits the side of my face* 180

Lambert, G., *Moorland Landscape* 20

Mach, D., *Polaris* 213; *101 Dalmations* 219
Magritte, R., *Time Transfixed* 114; *The Human Condition* 116
Malevich, K., *Lamp (Musical Instrument)* 70; *Suprematist Composition: White on White* 79, 85; *Supremus No. 57* 79; *Black Square* 85

Miro, J., *Person Throwing a Stone at a Bird* 124–5

Mondrian, P., *Composition in Oval* 131; *Composition No. 6* 137; *Composition with Colour Planes on White Ground* 139; *Draughts Board Composition, light colours* 140; *Composition with Red, Yellow and Blue* 141; *Composition with Red, Yellow and Blue* 144; *Composition with Two Lines* 147

Newman, B., *Onement 1* 155–7, 159, 160; *Vir Heroicus Sublimis* 157–8; *Who's Afraid of Red, Yellow, and Blue?* 159; *Chartres* 159; *Jericho* 159; *The Moment I* 161

Oblak, M., *Matrix of the System* 223; *Oval Painting* 224; *Jewellery* 225

Parker, C., *Matter and What it Means* 209–10; *Cold Dark Matter – An Exploded View* 210–11
Picasso, P., *Les Demoiselles d'Avignon* 33–44, 39–40
Pollock, J., *The Moon Woman Cuts the Circle* 119; *Summertime* 120; *Full Fathom Five* 125
Potrč, M., *Kampala* 218

Rothko, M., *Untitled* 229–31
Ruisdael, J. van, *Landscape with a Waterfall* 20
Russolo, L., *Houses + Lights + Sky* 60

Severini, G. *Dynamic Hieroglyphic of the Bal Tabarin* 61

Titian, *Charles V* 15

VSSD, *(About) The Soul* 207–9

Warhol, A., *Brillo Boxes* 2, 194, 199; *Marilyn* 194, 199; *Liz* 194, 199; *Campbell's Soup Can* 194, 199

General Index

A

Abrioux, Y. 246n
Abstract Expressionism 152
abstract-real 129–48
action painting 120–22
Adorno, T. W. ix–x, 4, 175, 222, 235n
aesthetic object 18–23, 83, 133–4, 169–71,
 173, 186, 199, 232–3
aesthetic responses 18–23, 133–4, 165, 173–6,
 232–3
ahistoricality ix–x, 168, 232–3, 246n
Ahlberg, L.-O. x
Altieri, C. 230–33, 246n
analogy 63–6
Anderson, T. 239n
antagonism see: contradiction
Aristotle 130, 133, 209
Arp, H. 88
art history ix, 1–3, 165, 168, 186, 233
Art-Language 180
Atkinson, T. 177–9, 244n
automatism 101, 111, 112–28

B

Bainbridge, D. 177
Balakian, A. 240n
Baldwin, M. 178–9
Baljeu, J. 242n
Balla, G. 57
Barthes, R. 1, 235n
Baudrillard, J. 189–202, 245–6nn
Beardsley, M. 18
becoming 51–2, 74–84, 141–2
Bell, C. 18, 175
Benjamin, A. x, 236n
Benjamin, W. 204, 246n
Bergson, H. 4, 32, 51–70, 85, 87, 238–9nn
Bernard, E. 34
biomorphic abstraction 125, 152, 155
Boccioni, U. 51, 56–69, 238–9
Bois, Y.-A. 3, 149, 162–3, 235n, 237n,
 244n
Bolland, G. 130, 133
Boltanski, C. 213
Bramley-Moore, M. xi
Braque, G. 26, 32–48, 127, 166, 237–8nn

Breton, A. 89, 90, 99–112, 113–18, 122–8,
 167, 240–42nn
Bryson, N. 1, 235n
Bulatov, E. 219
Burgin, V. 1, 2, 235n
Burke, E. 149, 154, 243n

C

Carmean, E. J. 243n
Caro, A. 174
Carra, C. 57, 58, 60
Cassirer, E. 4, 236n
Cézanne, P. 5, 33, 34–8, 174
Chadwick, W. 180, 245n
Champa, K. S. 242n
Cheetham, M. 236n, 242n, 243n
Christo 179
Conceptual Art 164, 171–86, 215, 225–6, 227,
 246n
contingency 84, 94–5, 99, 101, 107–8, 110,
 114, 120–22, 127, 147, 143, 145–6, 167,
 179, 196–7, 202, 211–12, 220–27
contradiction 87–8, 91–2, 95–9, 101, 102,
 111–12, 114–16, 123–4, 138–42
Courbet, G. 23, 171
Crary, J. 1, 235n
Cubism 25, 26, 32–48, 51, 62–3, 127, 129,
 134, 153, 166, 174, 194, 237–8nn
Cubo-Futurism 74–6

D

Dadaism 87–8, 153
Dalí, S. 88–9, 112, 113, 118, 124
Danto, A. 2, 235n
David, J.-L. 38
deconstruction 10, 183, 203–12
definition of art 2, 183–4, 185–6, 234
Delacroix, E. 149
Deleuze, G. 233–4, 246n
Derrida, J. 1, 4, 10, 203, 235n, 236n, 245n
dialectic 87–128, 129–48
Dickie, G. 2, 235n
Diderot, D. 149
discourse 203
disinterestedness 22
Dissanayake, E. 3, 235n

Doesburg, T. van 242n
Douglas, C. 239n
Duchamp, M. 2, 40–41, 171–8, 212, 244nn
duration 51–6
Durning, L. xi
Duve, T. de 3, 235–6n

E
eclecticism 189, 218
economic determinism 98, 99, 123
Eddy, D. 194
embodiment 3–4, 11–12, 17, 23, 24
emotional associationism 27–8, 145–6, 155–7,
 168–9
empathy 22, 170–71, 233–4
Engels, F. 90, 95–128, 241nn
Erjavec, A. x, 246n
Ernst, M. 112, 118
Estes, R. 194
existential phenomenology 44–6, 83–4, 103,
 107
existential subconscious 14–15, 24–5, 29, 103,
 123, 125–8, 147–8, 164–71, 190, 200, 213–
 14, 228–30, 241n
experiment 177–8
expressive qualities 27–8, 38–9, 83, 155–7,
 168–9; see also: emotional associationism

F
Fauvism 23
feeling 83–4; see also: aesthetic response,
 empathy
finality 122
Finlay, I. H. 184–5, 219
formalism 3, 18, 22, 129, 149, 166, 168, 172,
 173–6, 215
Foster, H. 88, 240nn, 241n
Foucault, M. 1, 203, 245–6n
fourth dimension 71–6
Freud, S. 88, 89, 90, 100, 109, 110, 120–21,
 122, 240nn
Fried, M. 3, 24, 235n
Fry, R. 18
Futurism 24, 25, 48, 51–70, 87, 127, 146,
 166–7, 194, 238–9nn

G
Gadamer, H.-G. 4, 36
Gamwell, L. 237n
Gardiner, P. x
genealogical reductionism ix, 1–3, 232–3
geometric abstraction 29–30, 79–86, 129–48,
 151–2
German Expressionism 5, 87
Gleizes, A. 32, 238n
Golding, J. 39–40, 238n
Goodman, N. 236n
Gormley, A. 219
Green, M. 240n

Greenberg, C. 3, 18, 34, 160, 174, 226, 229,
 235n, 237n, 244n
Gržinič, M. 246n
Guattari, F. 233–4, 246n

H
Halley, P. 194–6, 201, 245n
Harkness, M. 111
Harrison, A. x, 236–7nn
Hatoum, M. 180–82
Hegel, G. W. F. 4, 33, 90–128, 133, 138, 142–
 4, 175, 221, 237n, 240–41nn, 243n
Heidegger, M. 45
Hess, T. 149
historical change 93–9, 132, 215–20
historical mediation x, 5, 19–20, 81, 168, 182–
 3, 215–18, 231–3
historicity ix, x, 2, 19–20, 164, 169–71,
 231–4
Hockney, D. 194
Hofmann, H. 120
Hoyland, J. 174
Huelsenbeck, R. 87–8, 240nn
Husserl, E. 44
hyperreal 191–2

I
ideograph 152
imagination 9–15, 15–23, 55–6, 70, 125–8,
 164–5, 236n, 237n
Impressionism 23
infinity 78, 123–4, 155–7
Ingres, J.-A. 39
installation and assemblage art 206–14
intuition 55–6, 67, 78
Irwin 216
Iser, W. 236n
iterability 4, 9–15, 20, 24, 42, 46–8, 69–70,
 84–6, 124–8, 145–8, 157, 162–3, 164–71,
 186, 190, 198, 228–9, 232–3

J
Jakše, M. 218
Judd, D. 160, 183, 244n
Jungianism 119, 120

K
Kahnweiler, D.-H. 32, 237n
Kandinsky, W. 9, 26, 27–31, 84, 125, 129,
 146, 168, 237n
Kant, I. 4, 17, 44, 149, 150, 154, 175, 221,
 222, 236n, 237n, 244n
Kemp, M. x, xi
Kline, F. 244n
Koons, J. 194, 207, 213
Kosuth, J. 164, 171–86, 244–5
Krauss, R. 1, 2, 235n, 236n
Kruger, B. 180

L

Lacan, J. 235n
Lambert, G. 20
Latham, J. 220
Le Witt, S. 183
lines of force 60–63, 166
Lodder, C. x, 237n
logocentrism 203
Louis, M. 174
Lyotard, J.-F. 189, 190, 204–5, 245n

M

Mach, D. 207, 213, 219
Magritte, R. 112–18, 123, 124
Malevich, K. 25, 29, 71, 86, 125, 127, 146, 167, 168, 189, 239–40nn
making 170–71
Mallarmé, S. 65
Malraux, A. 33
Manet, E. 23, 174
mannerism 217–20
Man Ray 112, 118
Marinetti, F. 51, 56, 65
market values 179–83
Martin, J. 160
Marx, K. 7, 110, 118
Masson, A. 112, 125
Mathews, J. H. 240n
Matisse, H. 5
Matta 112
meaning x, 9–11, 23–4, 26, 31, 40–41, 203–4
memory 12–14, 36, 54–5, 70, 164–5
Merleau-Ponty, M. ix, x, 4, 29, 39, 45–6, 85–6, 162–3, 175, 229, 235n, 236n, 238n
Metzinger, J. 32, 238n
Michelangelo 152
Minimal Art 183, 245n
Miro, J. 124–5
Modernism 23–4, 51, 67–8, 108, 134, 144, 171, 216
Modernity see: Modernism
Mondrian, P. 27, 29, 84, 129–48, 167, 242–3nn
Morley, M. 200–01
Morris, R. 183

N

Nadeau, M. 240n
Nash, J. 42, 238n
nature 134–5, 136–42
Nazism 144
necessity 84, 99, 120, 202, 211–12, 220–27
negation see: contradiction
Neo-Geo 194–6, 201
Neue Slowenische Kunst 216–18
Newman, B. 25, 144, 149–63, 167, 168–9, 189, 201, 243–4nn
Nietzsche, F. 4, 32, 42, 56–7, 87

O

objective chance 89, 110–11, 118, 241n
objective humour 107, 108–10, 118
Oblak, M. 220–27, 239n, 246n
Olitski, J. 174
Ontological Argument, the 240–41n
Oppenheim, M. 118
Osborne, H. 18
Ouspensky, P. 71–6, 239n
Overy, P. 242–3n

P

Panofsky, E. 218
papier-collé 42–3
Papini, G. 57
paradigms 215–20, 226–7
paranoiac-critical 88–9
Parker, C. 209–14, 219, 246n
Picasso, P. 26, 32–48, 127, 153, 166, 237n
pictorial representation 15–23, 24, 27–8, 164–5, 228–9, 236–7nn
planar flatness 3, 37, 40, 136
Podro, M. x
Pogačar, T. 218
Poggi, C. 238n
political correctness 180–83, 205
Pollock, G. 1, 235n
Pollock, J. 112, 113, 119–27, 159, 176, 242nn
Pop Art 193
Postmodernism 189–202, 203–14, 217, 219
Potrč, M. 218
primitive art 33–9
Pusenkoff, G. 219

R

reciprocal relations 20, 23, 24–5, 28–9, 47–8, 84–6, 123–4, 125–8, 130, 140–41, 146–8, 162–3, 165, 199–200, 211–12, 228–30, 246r
reciprocity x, 3–4, 4–5, 11–12, 14, 18–19, 23–6, 28–9, 32, 47–8, 51, 103, 125–8, 140–41, 146–8, 155–7, 164–71, 202, 205–7, 215, 220–27, 228–30
Reinhardt, A. 183
Reynolds, Sir J. 149, 171
Richardson, J. x
Rimbaud, A. 65
Robbe-Grillet, A. 193
Robert, B.-H. 240n
Rosenberg, H. 149
Rosenblum, R. 149, 243n
Rothko, M. 153, 229–31
Rubin, W. 38, 237n
Ruisdael, J. van 20
Russolo, L. 60

S

Salmon, A. 33, 237n
Sartre, J.-P. 39, 45–6, 238n

Schier, F. 236n
Schnabel, J. 218
Schopenhauer, A. 71, 76–86, 132, 133, 175,
 239n
sculpture x, 106
self-consciousness 9–15, 17, 53–5, 74, 164–5,
 167, 173, 207–8, 233–4
self-referentiality 175–8
Severini, G. 57, 63–5, 68, 239n
Sherman, C. 219
Shiff, R. 236n
simulation 189–202
simultaneity 39–40, 67–8
Siqueiros, D. 120
Slovenian mannerism 217–18
Sobel, J. 120
Soffici, A. 57
Soviet Communism 81, 83, 144
state, the 98–9, 104–5, 118
Still, C. 201
Strawson, P. F. 236n, 237n
sublime, the 149–63
substance 207, 208
Super Realism 194, 200–01
Suprematism 78–86, 226
Surrealism 24, 84, 87–128, 143, 226
system 220–27

T
Tanguy, Y. 112, 118, 124–5
Teasdale, G. 235n

temporality 12, 15, 19, 39–40, 41–2, 51–70,
 71–6, 116, 127, 147–8, 166–7
Theosophy 129, 146
Titian 15
tragedy 130–32, 134, 141–2
transcendental 22, 237n
Transcendental Mannerism 220–27
transhistorical/transcultural 2, 230–34

U
uncanny, the 240n, 241n
unconscious, the 120–22

V
Van Gogh, V. 161
vssd 207–9, 213, 218

W
Walton, K. 236n
Ward, J. 160
Warhol, A. 2, 194, 198–200
Watteau, A. 161
Weiss, J. 237n
Welsh, R. 242n
Whistler, J. M. 175
Wilde, C. x
will, the 76–84

Z
Zeno of Elea 55
Žižek, S. 218, 235n

Photograph Credits

In most cases, illustrations have been made from the photographs kindly provided by the owners or custodians of the works. Those plates for which further credit is due are listed below:

© ADAGP, Paris and DACS, London 1997: 3, 5, 6, 10, 16, 17

© Succession Picasso/DACS 1997: 4

© DACS 1997: 9

Oeffentliche Kunstsammlung Basel, Martin Bühler: 11

© DEMART PRO ARTE BV/DACS 1997: 15

© ARS, NY and DACS, London 1997: 18, 19, 20, 28, 29, 30, 35, 47

Photo by Michael Varon: 28

Photo by Zindman/Fremont: 31

Antonia Reeve Photography: 32, 33

Photo by Werner J. Hannappel: 34

Photo by Pollitzer, Strong & Meyer: 35

Photo by Fred Scruton: 36

Photo by Edward Woodman: 39

Photo by Hugo Glendinning: 40

Photo by Barry Lewis: 41

Photo by Geraldine T. Mancini: 47